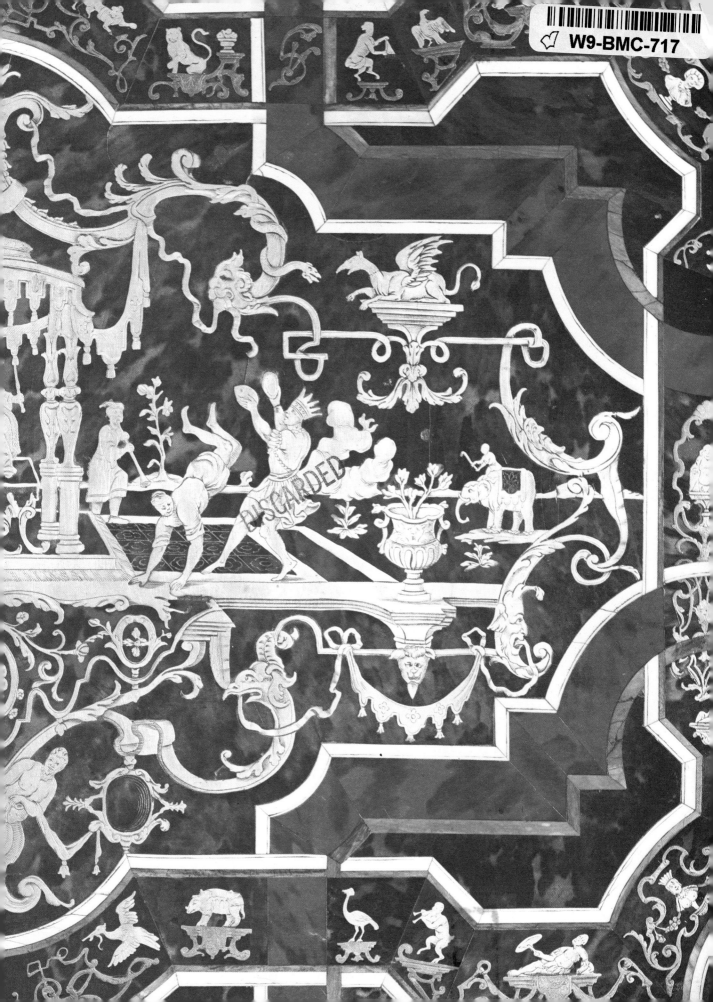

Art at Auction 1972-73

A Castel Durante portrait dish, probably painted by Nicola
Pellipario. *Circa* 1525-30, 9½in
London £8,200 ($20,500). 20.III.73
From the collection of Dr Giuseppe Caruso

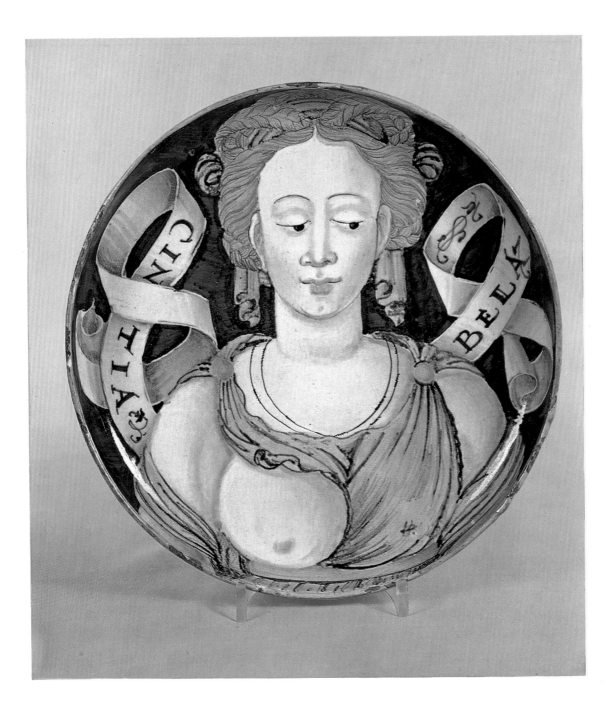

Art at Auction

The Year at Sotheby Parke Bernet
1972-73
Two hundred and thirty-ninth season

A Studio Book
The Viking Press, New York

A mid-eighteenth century
brass architect's proportional
sector and arc, the adjustable
limbs with finely engraved
joint, equally divided in
eighteen parts, sub-divided
into twelfths, the two sides of
the arc with concentric scales
for heights, widths and inter-
stices and with proportions
for doors, pedestals, archi-
traves, friezes, cornices and
capitals, radius of limb
290mm
London £420 ($1,050).
23.VII.73

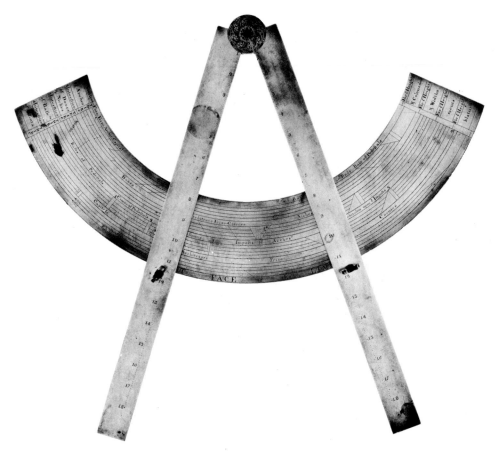

Published in 1974 by The Viking Press, Inc.
625 Madison Avenue, New York, N.Y. 10022

Published simultaneously in Canada by The Macmillan Company of Canada Limited

SBN 670-13404-x
Library of Congress catalog card number: 67-30652

Edited by Annamaria Edelstein assisted by Joan Sarll (UK) and Letitia Roberts (USA)

Jacket photograph by Norman Jones AMPA ARPS

Printed and bound in Great Britain by Shenval Press

Contents

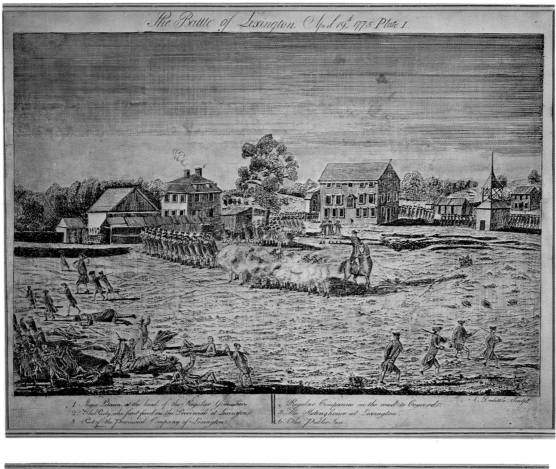

The Battle of Lexington, April 19th 1775. Plate I.

1. Major Pitcairn, at the head of the Regular Grenadiers.
2. The Party who first fired on the Provincials at Lexington.
3. Part of the Provincial Company of Lexington.
4. Regular Companies on the road to Concord.
5. The Meetinghouse at Lexington.
6. The Public Inn.

A. Doolittle. Sculpt.

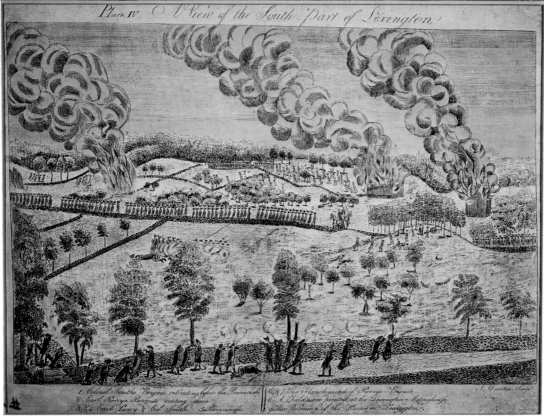

Plate IV. A View of the South Part of Lexington.

1. Colonel Smith's Brigade retreating before the Provincials.
2. Earl Percy's Brigade meeting them.
3. L.d Earl Percy & Col. Smith.
4. Provincials.
5. The Flanckguards of Percy's Brigade.
6. A Fieldpiece pointed at the Lexington Meetinghouse.
7. The Burning of the Houses in Lexington.

A. Doolittle. Sculpt.

Contents *continued*

For the sake of consistency all exchange rates have been estimated at $2.50 to the £1 despite fluctuations.

AMOS DOOLITTLE
The set of four coloured engravings after Ralph Earl's
drawings of the first military engagement of the Revolution:
Plate I *The Battle of Lexington* (illustrated)
Plate II *A View of the Town of Concord*
Plate III *The Engagement at the North Bridge in Concord*
Plate IV *A View of the South Part of Lexington* (illustrated)
New Haven, 1775, 11⅝in by 17¾in. Fewer than ten complete
sets are known.
New York $82,500 (£33,000). 18.v.73
From the Middendorf Collection

Paintings, drawings & sculpture

JAN VAN DER HEYDEN
A view in Cologne
On metal, 4¾in by 6¾in
London £42,000 ($105,000).
11.VII.73
The figures are by Adriaen van de Velde

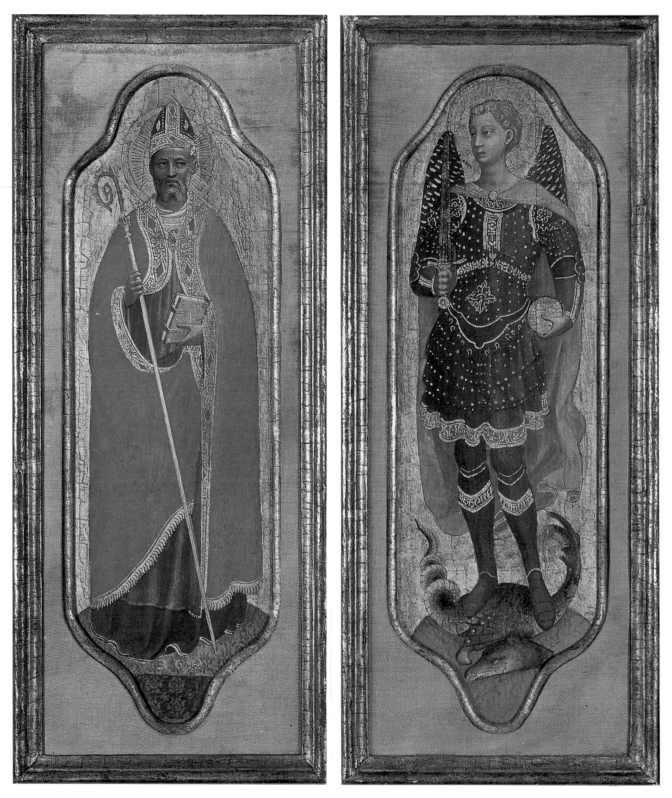

Opposite page
GUIDO DI PIETRO, known as FRA ANGELICO
St Nicholas of Bari and *St Michael*
A pair, on panel, each 13¾in by 4⅜in
London £230,000 ($575,000). 6.XII.72
According to inscriptions in Italian on the backs, these two
panels formed part of a series of ten from an altar piece in the
church of San Domenico, San Domenico di Fiesole
From the collection of Mr and Mrs Deane Johnson of Bel Air,
California.
Formerly in the collection of Rev A. Hawkins-Jones, Sheffield

Right
GUIDO DI PIETRO, known as FRA ANGELICO
St Peter
On panel, inscribed *SC . . . TRV*, 18⅛in by 6¼in
London £130,000 ($325,000). 6.XII.72
From the collection of Mr and Mrs Deane Johnson of
Bel Air, California

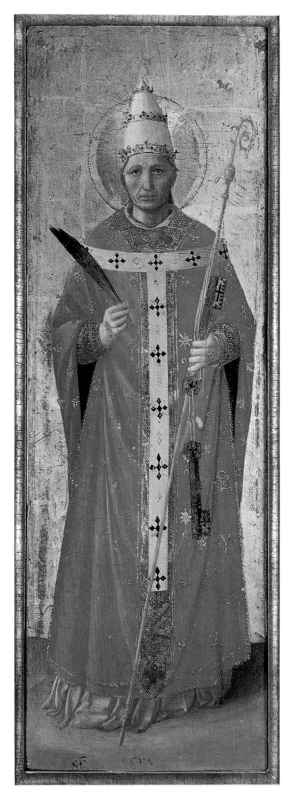

Opposite page
VENETIAN SCHOOL
St Sigismund of Burgundy
and
St Catherine of Alexandria
A pair, on panel, *circa* 1420–
30, each 38½in by 14½in
New York $80,000 (£32,000).
4.IV.73

Right
PAOLO VENEZIANO
*The Madonna and Child
enthroned*
On panel, 44in by 24in
London £29,000 ($72,500).
6.XII.72
From the collection of
the late A. E. Allnatt

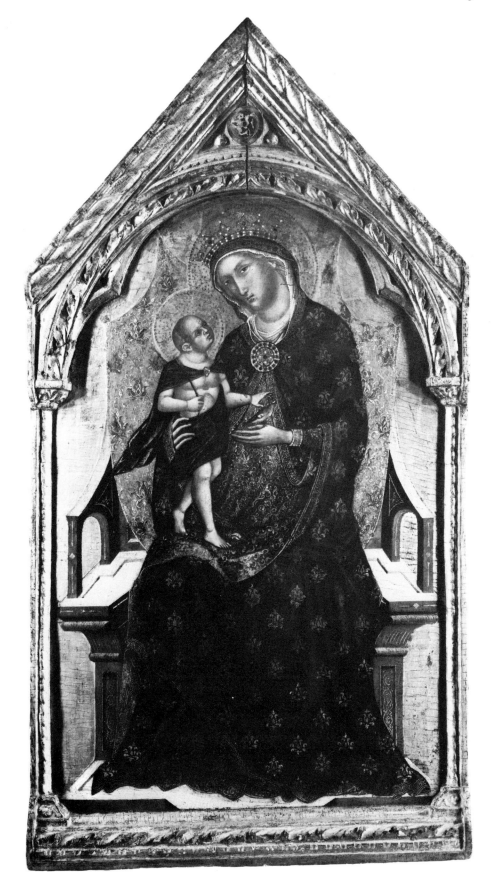

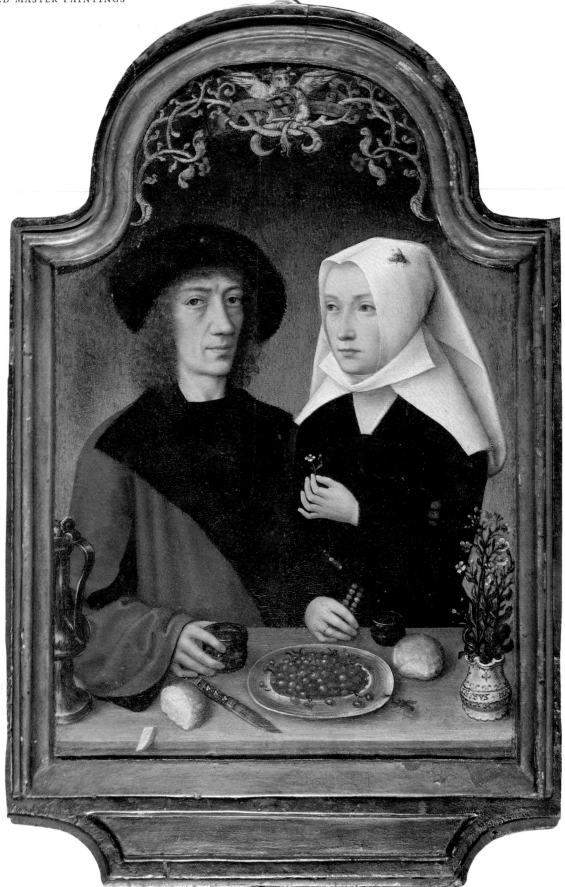

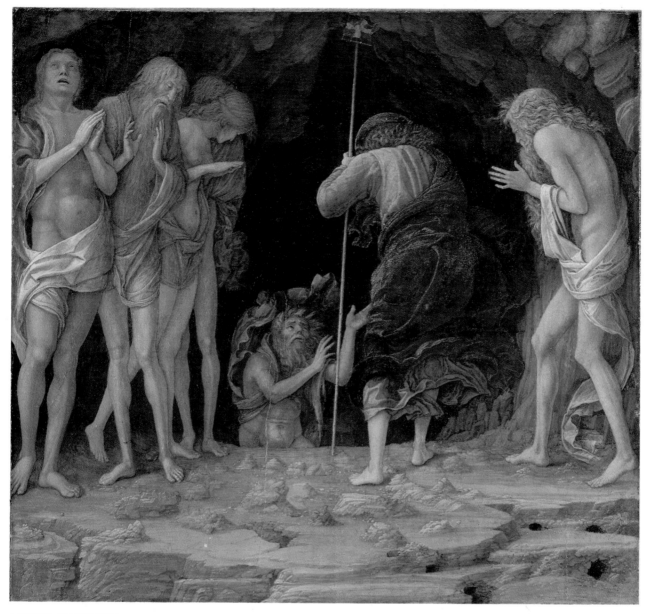

ANDREA MANTEGNA
Christ's descent into Limbo
On panel, 15⅛in by 16½in
London £490,000 ($1,225,000). 11.VII.73

Opposite page
THE MASTER OF FRANKFORT
The painter and his wife
The original frame inscribed below with date and ages of the artist and his wife *36 . 1496 . 27,*
14¾in by 10½in
London £59,000 ($147,500). 11.VII.73

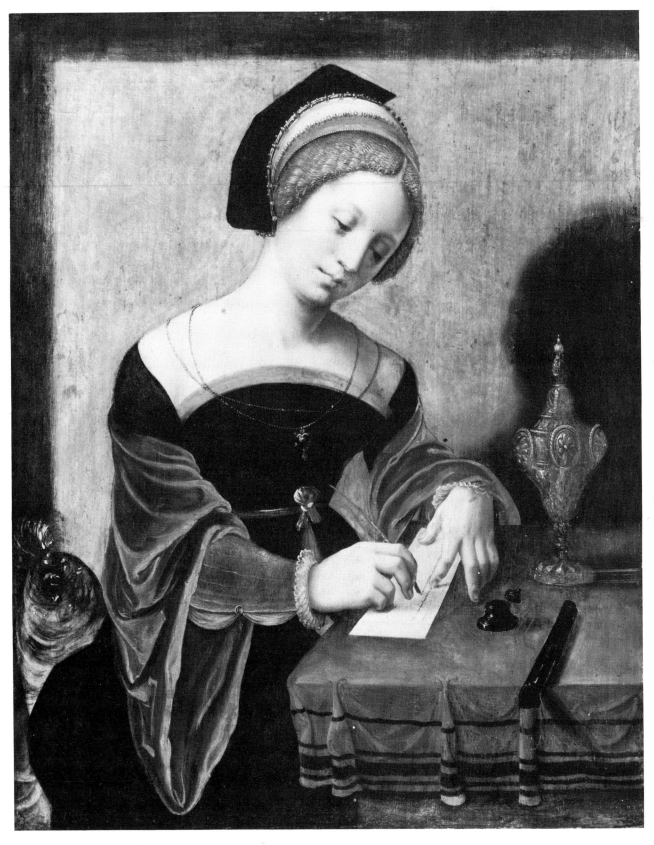

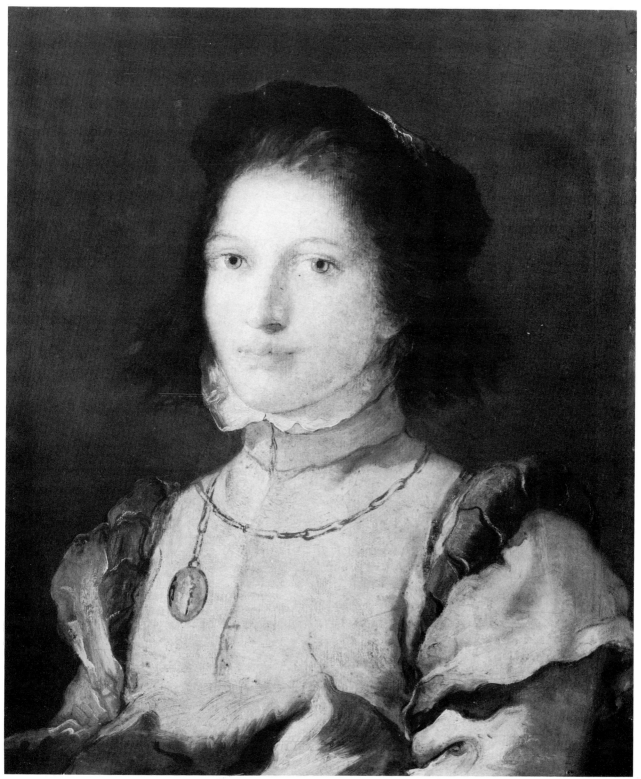

GIOVANNI BATTISTA TIEPOLO
A girl in sixteenth-century page's costume
23¼in by 19½in
London £21,000 ($52,500). 6.XII.72
Formerly in the collection of the late Sir William Van Horne,
KCMG

Opposite page
MASTER OF THE FEMALE HALF-LENGTHS
Portrait of a lady as the Magdalen
On panel, 21½in by 17¼in
London £14,000 ($35,000). 6.XII.72

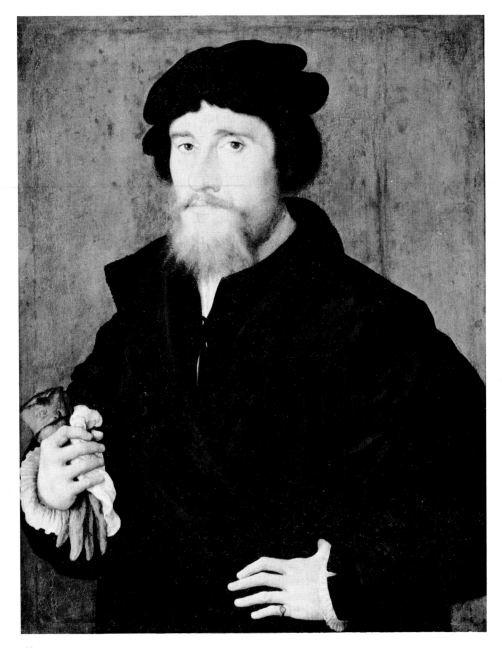

Above
SCHOOL OF AUGSBURG, SIXTEENTH CENTURY
Portrait of a gentleman
On canvas transferred from panel, inscribed *AB* (?), 18½in by 14½in
London £24,000 ($60,000). 6.XII.72

Opposite page
ADRIAEN YSENBRANDT
Portrait of a lady as the Magdalen
On panel, 15¾in by 12½in
London £21,500 ($53,750). 6.XII.72

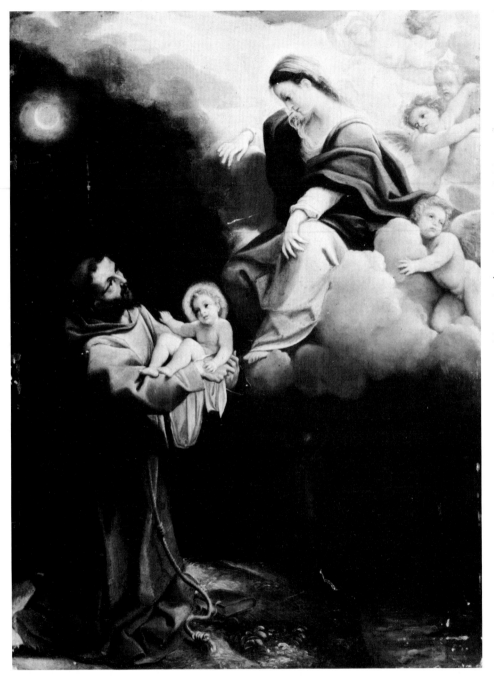

LODOVICO CARRACCI
A vision of St Francis
On metal, 14½in by 11¼in
London £9,000 ($22,500).
30.V.73

Opposite page
Above
GIOVANNI FRANCESCO
BARBIERI, called IL
GUERCINO
Samson and Delilah
Painted in 1646, 45¾in by
60in
London £16,000 ($40,000).
21.III.73

Below
JACOPO DA PONTE, called
JACOPO BASSANO
Jacob's journey
52in by 73½in
London £30,000 ($75,000).
11.VII.73
From the collection of the
Rt Hon.the Viscount
Cobham KG, PC, GCMG, TD

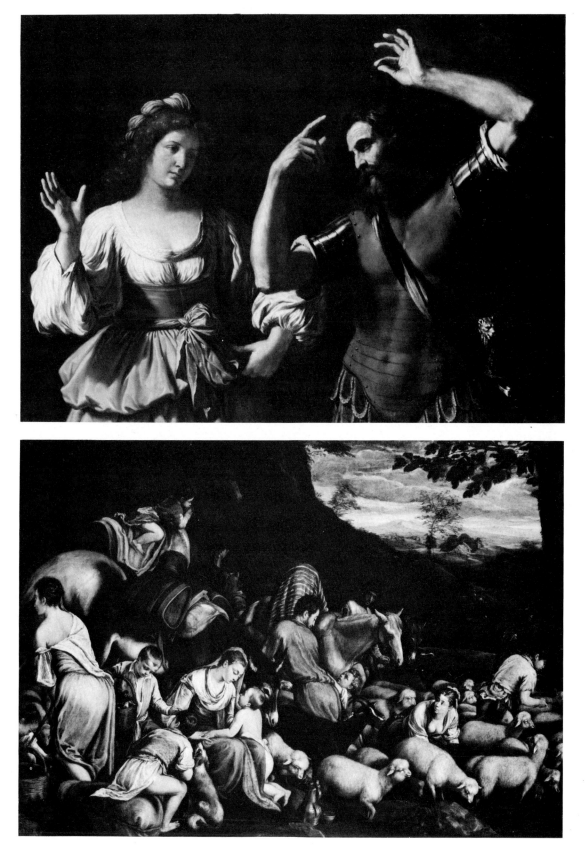

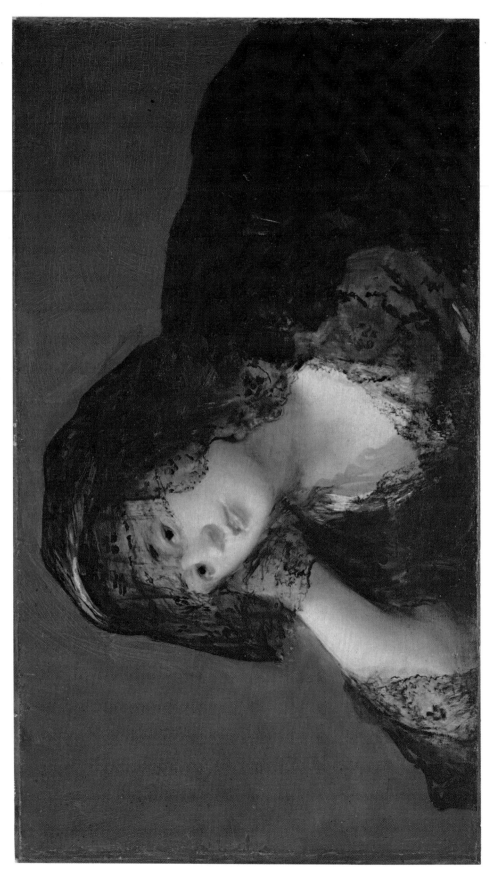

FRANCISCO JOSE DE GOYA Y LUCIENTES
The actress Rita Molinos
Sitter's name inscribed on the reverse, 17½in by 29¾in
London £160,000 ($400,000). 6.XII.72

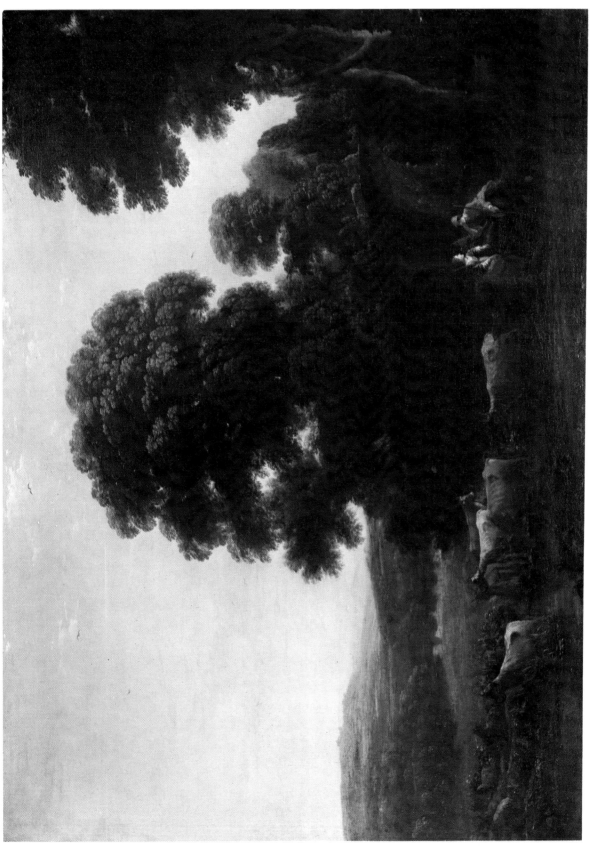

CLAUDE GELÉE, called CLAUDE LORRAIN
A pastoral landscape
38¼in by 52¾in
London £112,000 ($280,000). 21.III.73

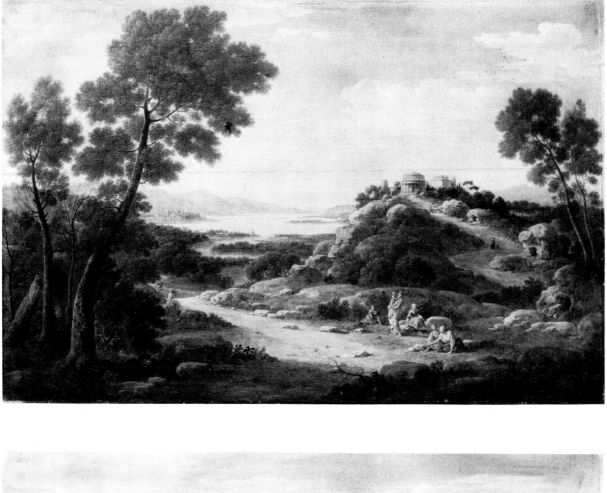

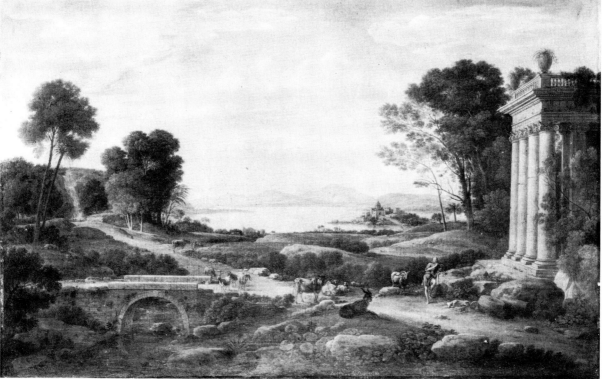

Opposite page
HENDRICK VAN LINT,
called STUDIO

*Above A classical landscape
with a lake*

*Below A classical landscape
with a temple*
A pair, signed and dated
Rome 1748, 18¼in by 28¼in
London £17,000 ($42,500).
11.VII.73

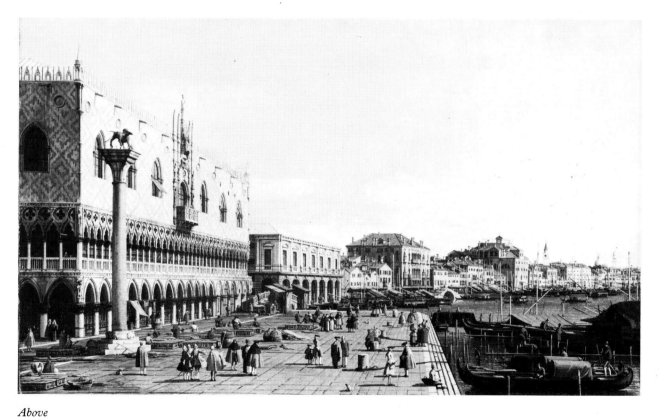

Above
FRANCESCO GUARDI
Capricci
Left A landscape with a statue
Right A landscape with a farmhouse
A pair, on panel, each 7¾in by 6⅛in
London £25,000 ($62,500). 11.VII.73
From the collection of Mr J. Theodor Cremer of New York

Below
ANTONIO CANALE, called CANALETTO
Venice: the Doge's Palace and the Molo (illustrated) and the
Entrance to the Grand Canal seen from the Molo
A pair, each 18¼in by 30¼in
London £90,000 ($225,000). 11.VII.73
Formerly in the collection at Kylemore Castle, Connemara

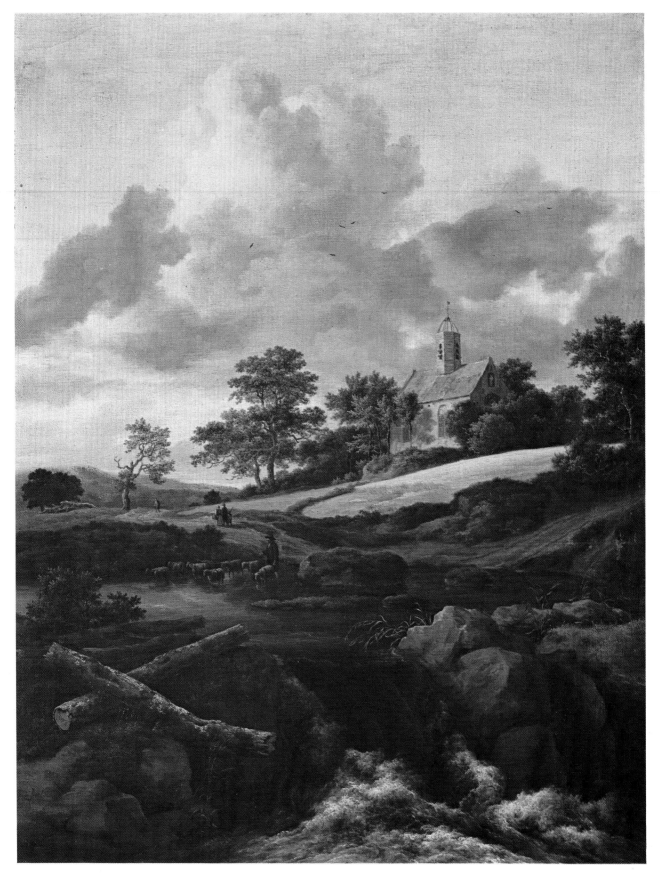

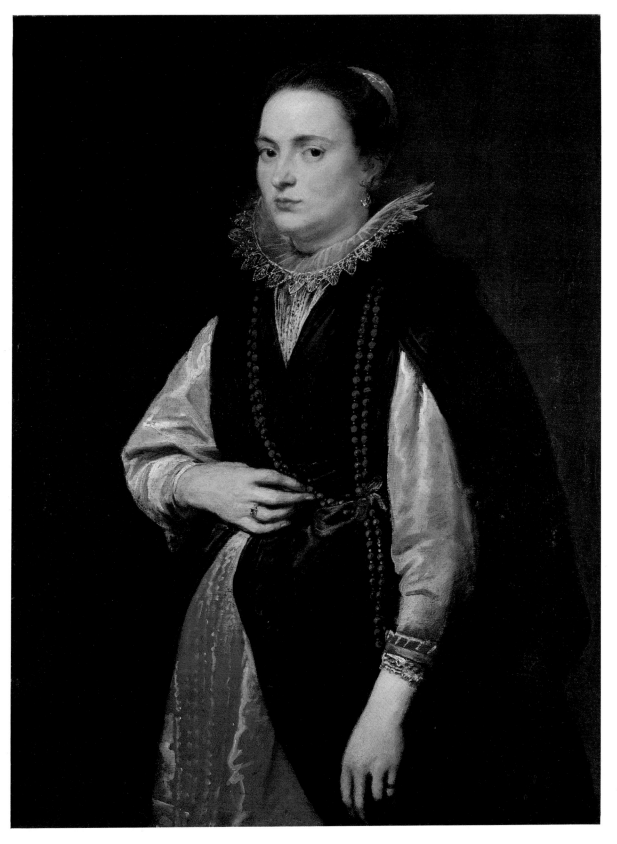

Previous pages
Left
JACOB VAN RUISDAEL
Landscape with a stream
Signed, 26¾in by 20½in
London £64,000 ($160,000).
6.XII.72

Right
SIR ANTHONY VAN DYCK
Marchesa Lomellini-
Durazzo
Painted between 1622 and
1627, 38¾in by 29¼in
London £180,000
($450,000). 11.VII.73
From the collection of the
Norton Simon Foundation,
Los Angeles

GIOVANNI BATTISTA
PITTONI
An allegorical monument to
Sir Isaac Newton
Painted between 1720 and
1730, 84¾in by 54½in
London £28,000 ($70,000).
21.III.73
From the collection at
Ushaw College, Durham

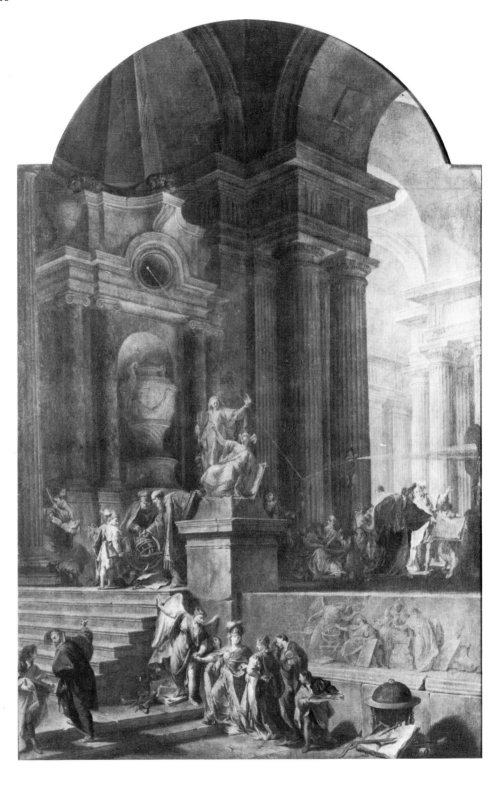

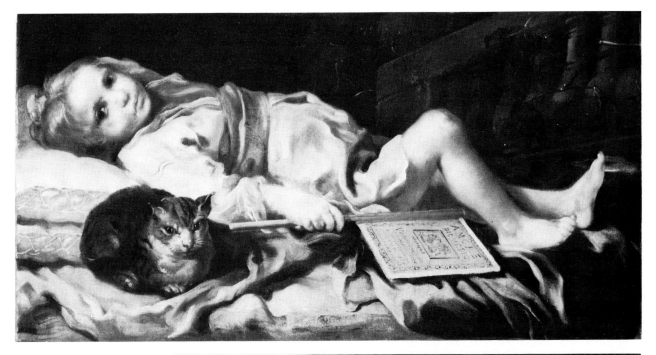

Above
EBERHARD KEIL, called
MONSU BERNARDO
A little girl with a cat
19½in by 37¾in
London £9,000 ($22,500).
11.VII.73

Right
GIOVANNI BATTISTA
TIEPOLO
*Alexander and Campaspe in
the studio of Apelles*
16¼in by 19¼in
London £21,000 ($52,500).
6.XII.72
From the collection of the
late A. E. Allnatt

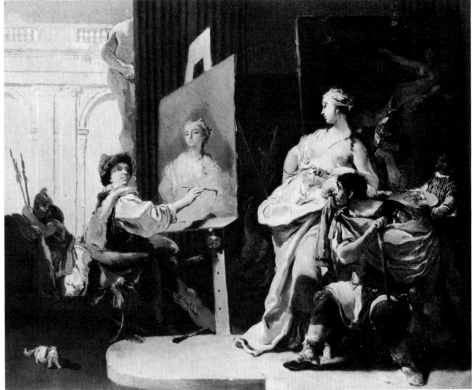

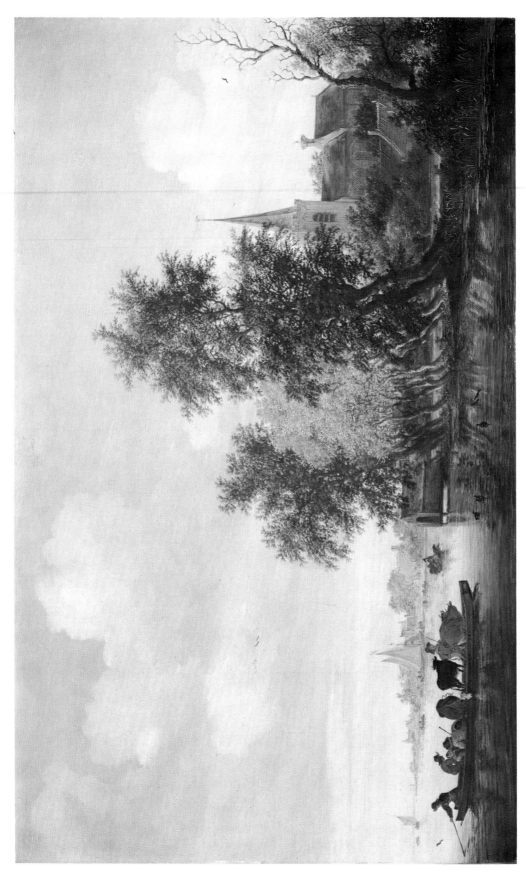

SALOMON VAN RUYSDAEL
A river landscape with a ferry
On panel, signed and dated 1650, 20¾in by 33in
London £89,000 ($222,500). 6.XII.72
From the collection of the late A. E. Allnatt

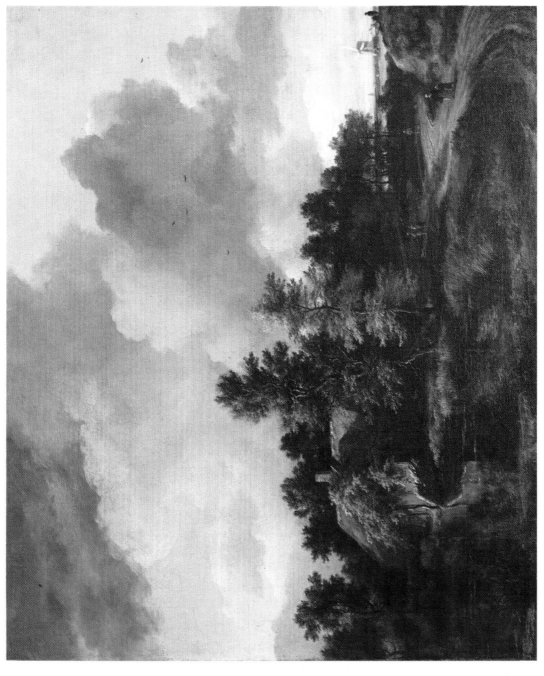

JACOB VAN RUISDAEL
A wood with a cottage by a stream
Signed, 15in by 17½in
London £87,000 ($217,500). 21.III.73

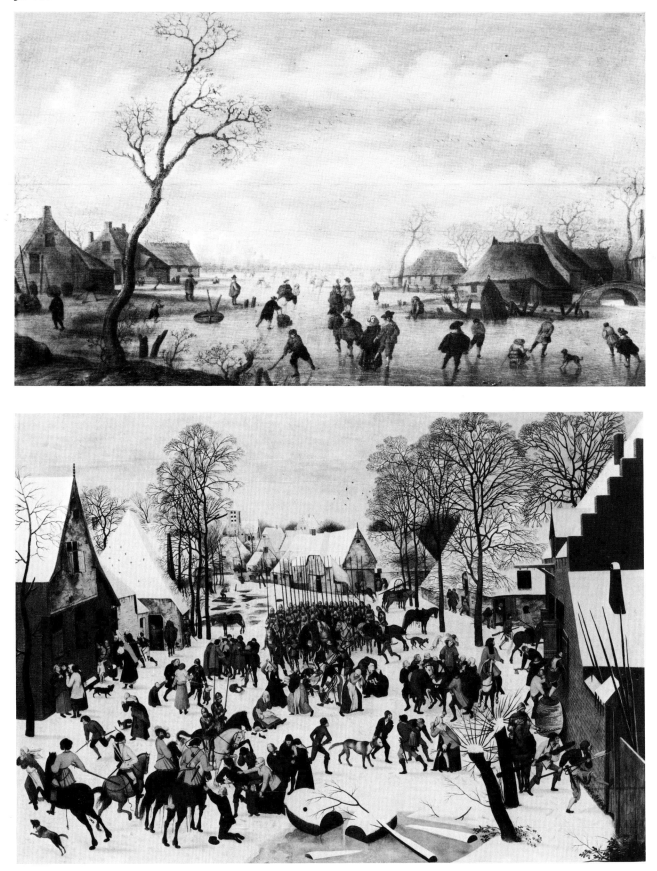

Opposite page
Above
ANTHONIE VERSTRAELEN
A winter scene with skaters
On panel, signed in
monogram, 13in by 22½in
London £20,000 ($50,000).
11.VII.73

Below
PIETER BRUEGHEL THE
YOUNGER
*A winter scene with the
Massacre of the Innocents*
On panel, 47½in by 66½in
London £90,000 ($225,000).
21.III.73
Formerly in the Grisard
Collection, Antwerp

Above right
ADRIAEN VAN STALBEMT
A village green
On panel, signed and dated
1614, 21¾in by 33in
New York $47,500 (£19,000).
4.IV.73

Below right
PIETER BRUEGHEL THE
YOUNGER
A winter scene with a bird-trap
On panel, 16in by 22¼in
London £32,000 ($80,000).
11.VII.73
From the collection of the
late Dr and Mrs A. V.
McMaster of Cambridge

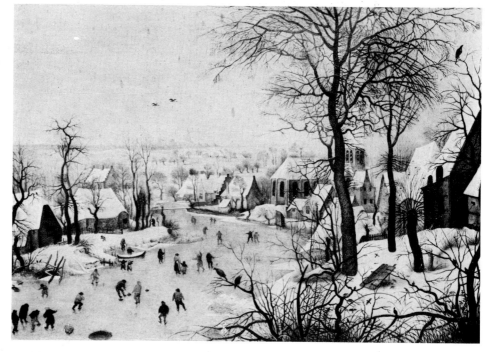

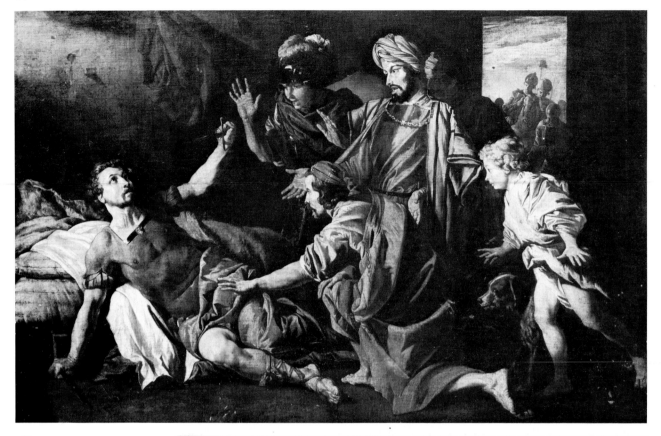

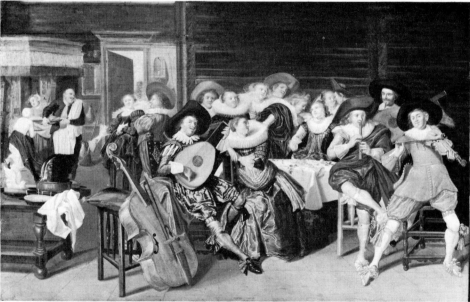

Above
MATTHIAS STOMER
Death of Brutus
51¾in by 83½in
Florence Lire 9,000,000
(£6,000; $15,000). 13.X.72

Right
DIRCK HALS
Merrymakers in an inn
On panel, signed and dated
1625, 17¾in by 27½in
London £17,500 ($43,750).
21.III.73

SIR PETER PAUL RUBENS
*Minerva and Hercules
driving away Mars*
On panel, brown mono-
chrome with touches of white
and red, 13⅞in by 20⅞in
London £50,000 ($125,000).
21.III.73
From the collection of the
late Mrs M. James

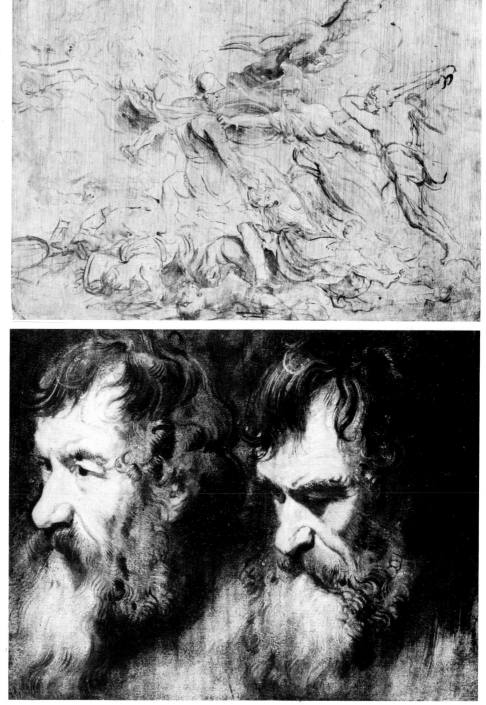

SIR ANTHONY VAN DYCK
Two studies of a man's head
Oil on paper laid on canvas,
15¾in by 21in
London £17,000 ($42,500).
6.XII.72
Formerly in the collection of
Count Edward Raczynski

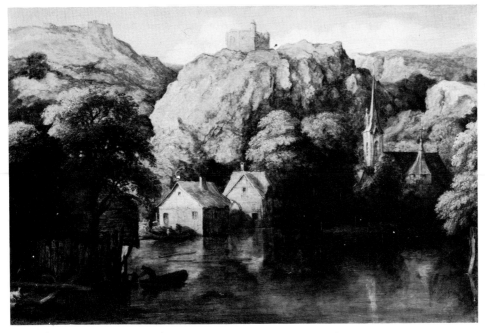

Left
ALLART VAN EVERDINGEN
A Norwegian Fjord
On panel, signed and dated
1644, 12½in by 19in
London £15,000 ($37,500).
21.III.73
Formerly in the collection of
Captain Eric C. Palmer

Below
QUIRYN VAN
BREKELENKAM
The interior of a Dutch house
On panel, 23¼in by 32¾in
London £27,000 ($67,500).
6.XII.72
Formerly in the collection of
the late Sir William Van
Horne, KCMG

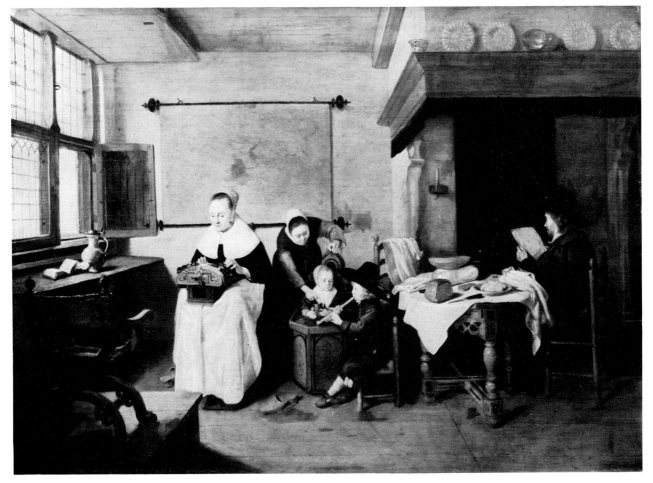

Above
JAN VAN DER HEYDEN
A view in Cologne
On panel, signed, 13in by
17¾in
London £46,000 ($115,000).
6.XII.72
From the collection of the
late A. E. Allnatt

Right
FRANS POST
Brazilian landscapes
A pair (one illustrated) on
panel, signed, 7½in by 10in
London £44,000 ($110,000).
21.III.73

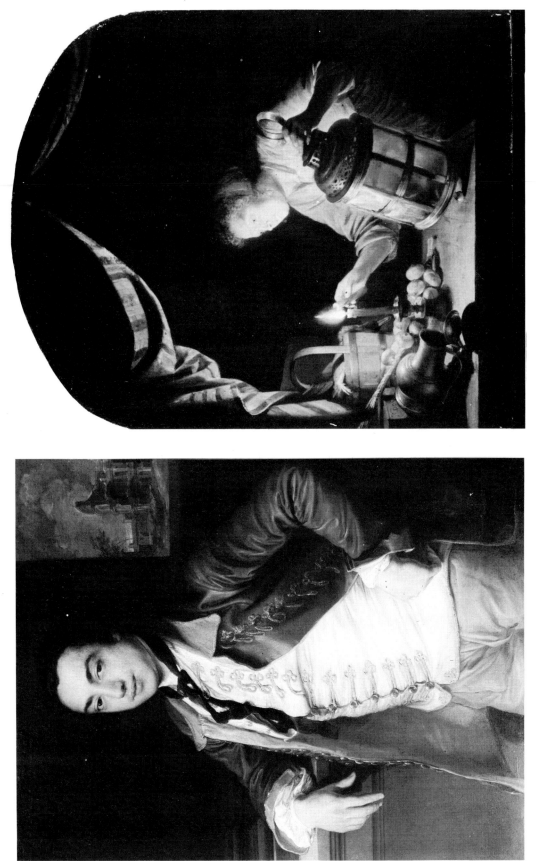

GERARD DOU
A girl at a window lighting a candle
On panel, signed, 11⅛in by 8⅞in
London £27,000 ($67,500). 6.XII.72

POMPEO GIROLAMO BATONI
Portrait of James, First Earl of Charlemont
38in by 28½in
New York $52,500 (£21,000). 4.IV.73

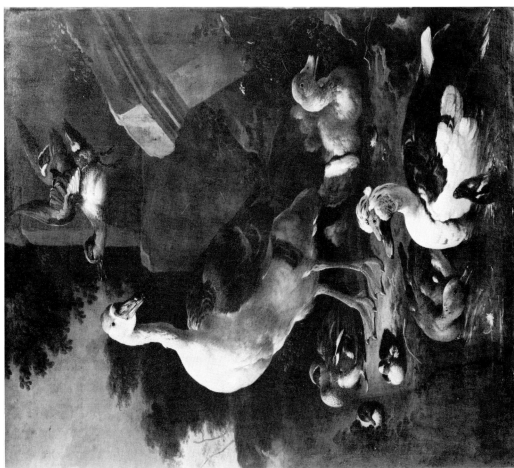

MELCHIOR DE HONDECOETER
Waterfowl in a landscape
Signed, 48½in by 41in
New York $37,000 (£14,800). 4.IV.73
From the collection of the late Miss Paula Uihlein of
Milwaukee, Wisconsin

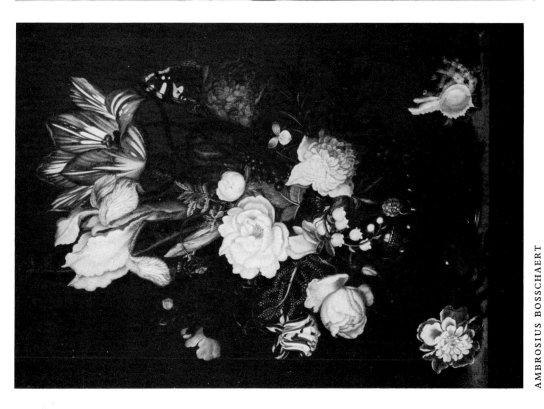

AMBROSIUS BOSSCHAERT
Flowers in a vase
On metal, signed in monogram and dated 1627, 13¼in by 9¼in
London £26,000 ($65,000). 6.XII.72

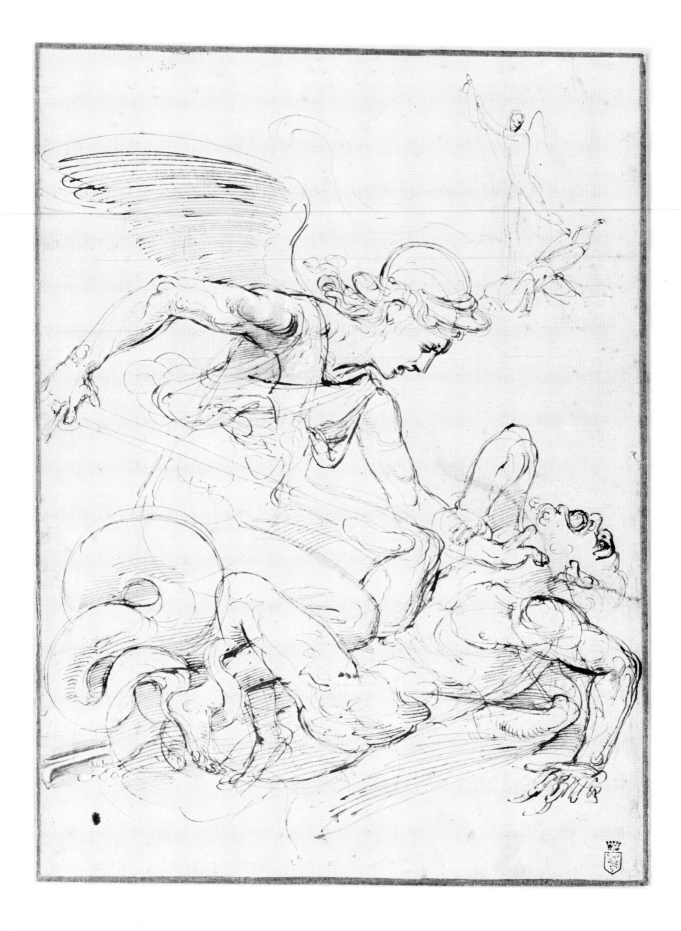

Giulio Romano drawings from the Ellesmere Collection

BY JULIEN STOCK

The sale of Giulio Romano drawings on 5th December 1972 comprised the last complete section to survive in private hands of the celebrated collection of old master drawings of all schools formed by the portrait painter, Sir Thomas Lawrence, PRA. At his death in 1830 Lawrence left instructions that the whole collection should be offered to the nation for £18,000 – about half the price realised for just one of Giulio's drawings in the recent sale – but for various reasons the offer was refused and the collection was purchased by the dealer Samuel Woodburn who subsequently offered it on the open market. Lord Francis Egerton, later first Earl of Ellesmere, bought the groups of drawings by the Carracci and Giulio Romano *en bloc*.

Giulio Romano (*circa* 1492–1546) was Raphael's most gifted pupil and was an exciting and original painter and architect in his own right. His art is characterised by a highly personal decorative sense, a profound knowledge of classical antiquity and a refreshing comic element. It was probably in the field of drawing that Giulio found his happiest medium. Vasari in his *Lives* tells us that 'he was always happier in expressing his ideas in drawing than in painting, obtaining more vivacity, vigour and expression, possibly because a design is made in the heat of the moment, while a painting takes months and years'. This, no doubt, is the reason why his drawings have been so highly appreciated by a whole succession of collectors and connoisseurs from the earliest times.

The sale totalled £184,010, a far cry from the original purchase price of £800. The drawing that commanded most attention was the study of St Michael datable *circa*

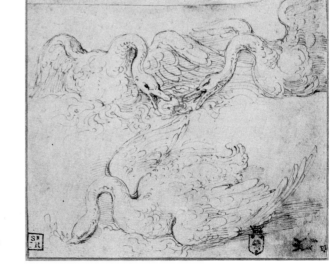

Opposite page
GIULIO ROMANO
St Michael
Pen and brown ink, 386mm by 290mm £31,000 ($77,500)
From the collections of Dr Richard Mead; John Barnard

Right
GIULIO ROMANO
Studies of swans
Pen and brown ink, 146mm by 165mm £4,800 ($12,000)
From the collections of Sir Peter Lely; Jonathan Richardson senior; Sir Joshua Reynolds

1527 (page 40). It realised £31,000, a price that would have secured a drawing by Raphael as recently as 1964! It was bought by the National Gallery of Art, Washington. There was keen bidding on the important group of twenty-two studies connected with Giulio's most famous work, the Palazzo del Te in Mantua, executed between 1526-35. Two studies for the Sala dei Giganti, *Jupiter hurling his thunder-bolt* (page 43), a powerful drawing of equal quality to the *St Michael* and an amusing study for one of the *Giants* (page 42) fetched respectively £8,000 and £4,500. Of this 'Room of the Giants' Vasari wrote: 'No more terrible work of the brush exists, and anyone entering the room and seeing the windows, doors and other things so twisted that they appear about to fall, and the tumbling mountains and ruins, will fear that all is about to come about his ears, especially as he sees the gods fleeing hither and thither'. Other fine drawings to fetch high prices were the *Neptune in a chariot drawn by sea horses* (page 44), a study for a small inset painting in the ceiling of the Sala dei Venti (£11,000) and two preparatory studies for Federico Gonzaga's exotic bedroom, the Sala delle Aquile, the *Rape of Europa* (page 45) and an *Eagle's head* (page 43). *Jupiter's eagle bringing Psyche water from the Styx* (page 45) and the very Raphaelesque *River God* (page 44), both studies for the fable of Cupid and Psyche decorating the sumptuous Sala di Psiche, realised £10,000 and £5,000.

In the limited amount of space at our disposal we can illustrate only two more drawings from this fascinating and historic sale; an angry *Satyr* which is a study for one of the over life size stucco reliefs in the Sala dei Fauni (page 43) and a sheet with *Studies of swans* (page 41), the first idea for the border of a dish. The latter represents an important side of this versatile artist's genius, his acting as a designer of gold-smith's work.

Detail of 'The room of the Giants', Palazzo del Te, Mantua

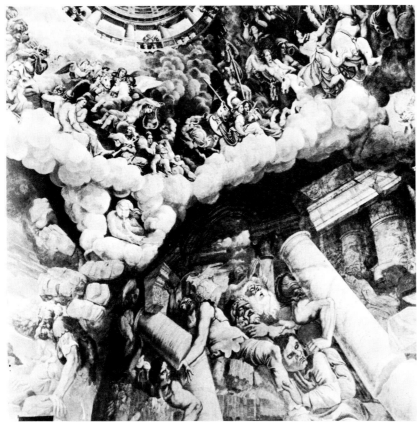

GIULIO ROMANO
A Giant
Pen and brown ink and wash over black chalk heightened with white, 406mm by 275mm £4,500 ($11,250) From the Paignon-Dijonval Collection

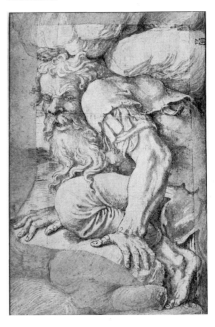

Right
GIULIO ROMANO
Jupiter hurling a thunderbolt
Pen and brown ink and wash,
168mm by 193mm £8,000
($20,000)

Below
GIULIO ROMANO
A Satyr
Pen and brown ink, 219mm
by 114mm £5,500 ($13,750)

Below right
The head of an eagle
Pen and brown ink and wash,
149mm by 222mm £4,300
($10,750)
From the collection of
Jonathan Richardson senior

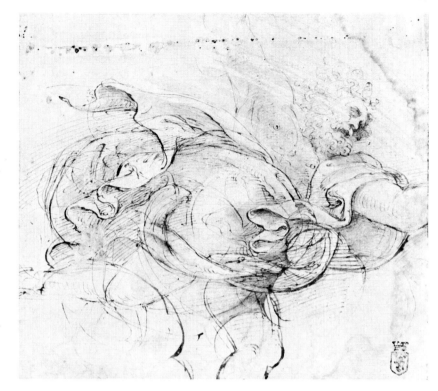

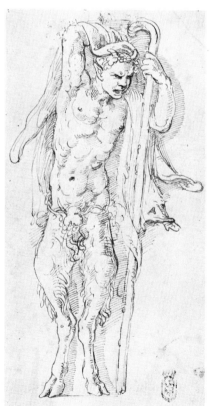

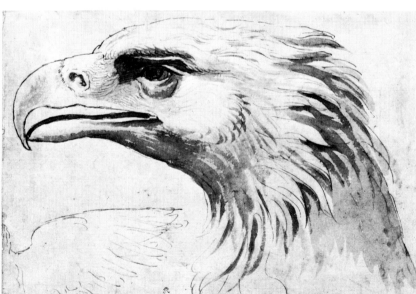

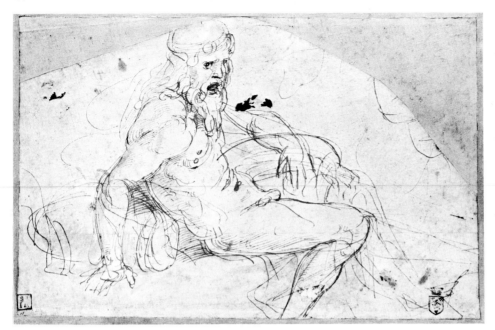

GIULIO ROMANO
A River God
Pen and brown ink, 170mm
by 275mm £5,000 ($12,500)
From the collection of
Sir Joshua Reynolds

GIULIO ROMANO
*Neptune in a chariot drawn by
sea horses*
Pen and brown ink and wash,
255mm by 405mm £11,000
($27,500)
From the collection of
Jean-Baptiste Wicar

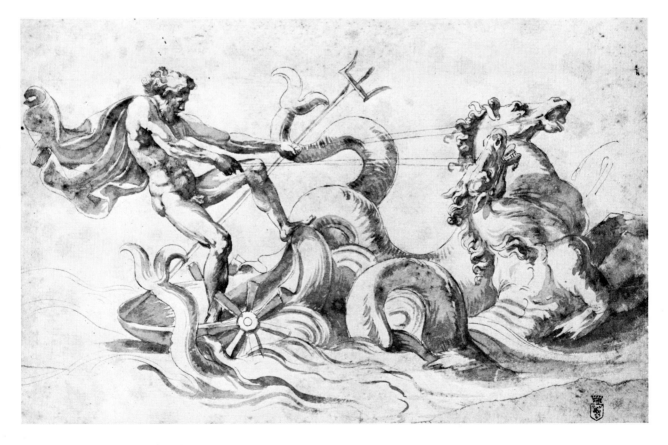

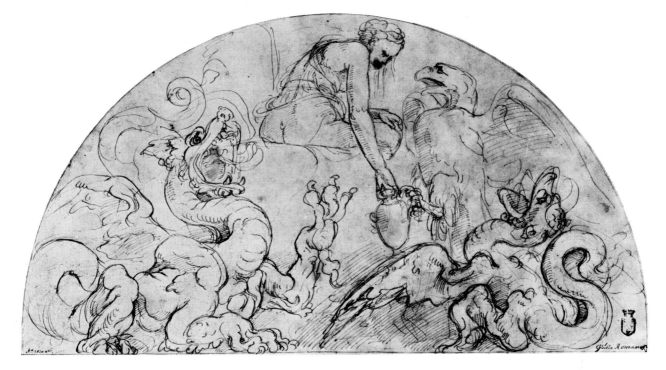

Above
GIULIO ROMANO
Jupiter's eagle brings Psyche water from the Styx
Pen and brown ink, 205mm by 389mm £10,000 ($25,000)
From the collection of Mr Wilenbroek

Below
GIULIO ROMANO
The Rape of Europa
Pen and brown ink and wash over black chalk, 195mm by 234mm £6,700 ($16,750)
From the collections of Prosper Henry Lankrink; Jonathan Richardson senior; Richard Houlditch

HANS BALDUNG GRIEN
The head of a Saint, possibly St John the Baptist
Black chalk, signed with a monogram and dated 1516,
336mm by 291mm
London £24,000 ($60,000). 21.III.73

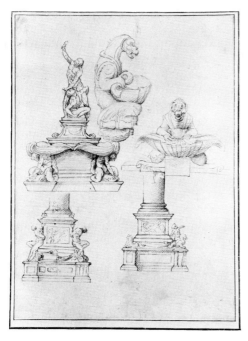

Above left
PIETRO TACCA
Pen and brown ink over
traces of black chalk,
302mm by 227mm *Recto*
(illustrated) two alternative
designs for the statue of the
Grand Duke Ferdinand I in
Livorno; two designs for the
grotesque fountains in the
Piazza dell'Annunziata in
Florence; a design after
Giovanni Bologna
London £3,500 ($8,750).
9.VII.73
From the collection of the
Rt Hon the Earl Beauchamp

Above right
LOUIS DE BOULLOGNE
THE YOUNGER
A study of a satyr
Red and black chalks,
heightened with white, on
blue paper, 402mm by
274mm
London £750 ($1,875).
8.XII.72
From the collection of
Hardy Amies Esq

Centre
DOMENICO BECCAFUMI
St Anthony
Pen and brown ink,
204mm by 127mm
London £2,200 ($5,500).
22.III.73
From the collection of
Jan Mitchell of New York
City

Far right
AMICO ASPERTINI
Recto (illustrated) studies
after the antique: the death
of Adonis and male torsos
Pen and brown ink over
black chalk, 393mm by
249mm
London £3,100 ($7,750).
9.VII.73
From the collection of the
Rt Hon the Earl Beauchamp

Opposite page
Above left GIOVANNI DOMENICO TIEPOLO
The Adoration of the Magi
Pen and black ink and wash, 200mm by 288mm
London £2,000 ($5,000). 8.XII.72
From the collection of Mrs F. M. Humphreys

Above right SALVATOR ROSA
A landscape with peasants seated by a rocky outcrop
Pen and brown ink, 229mm by 416mm
London £600 ($1,500). 16.XI.72. From the collection of Signor Ferruccio Asta

Below left WILLEM VAN NIEULANDT THE YOUNGER.
A view of Tivoli with the Temple of the Sibyl
Pen and brown ink and brown and blue wash, 259mm by 366mm
London £1,300 ($3,250). 21.III.73

Below right JEAN-ANTOINE WATTEAU
A sheet of figure studies
Red chalk heightened with white, 142mm by 220mm
London £4,000 ($10,000). 8.XII.72. From the collection of Mrs E. F. Hutton

GIOVANNI BATTISTA PIAZZETTA
A young boy wearing a plumed hat, and a girl
Black and white chalks, on blue paper, 400mm by 301mm
London £6,000 ($15,000). 22.III.73

Right GIOVANNI FRANCESCO BARBIERI called IL GUERCINO
A young girl studying a drawing
Pen and brown ink, 180mm by 192mm
London £2,200 ($5,500). 22.III.73

Return of the Duveen Market?

BY GERALD REITLINGER

It is a safe assumption in the year of the Floating Pound that the art market can sustain a picture at £100,000 from *any* school. There may be a few schools that have not produced such a picture, but no one is going to be surprised when they do. The £100,000 picture can range from a Ferdinand Georg Waldmuller to a Paul Klee, from a Thomas Pollock Anschutz to a Yasuo Kuniyoshi, from the stodgiest Jacob van Ruisdael to the aeriest Matisse. In 1972–3 two Gainsboroughs, a Reynolds and a Romney joined the company, a very modest quota seeing that this school could command $400,000 for an indifferent Gainsborough replica sixty years ago – and it would be a very cautious estimate to call that a million in the pounds of 1973.

In the 1960s, whenever an English eighteenth-century portrait with a nice pedigree behind it departed – as it generally did – at a most unenterprising price, a sigh could be heard, 'Ah yes, that was the Duveen Market! Those days will not return.' But what *was* the Duveen Market? Selling eighteenth-century English portraits was only one of the many facets of Duveen's enormous operations and possibly less important to him than legend has made out, nor was the fashion for such portraits in any sense his own creation, for they had reached a market status far above their relative position in the history of art at a time when Duveen Brothers was a provincial shop selling furnishing objects. Nor was Joseph Duveen Junior, later Lord Duveen, the first to interest American millionaires in this taste. He bought his first English eighteenth-century portrait in 1901, whereas the father of James Pierpont Morgan all but bought that very questionable Gainsborough, the famous 'disappearing duchess', as early as 1876.

Since throughout the period of Duveen's dealings in this school there were always plenty of cheap examples to be had, the Duveen market involved portraits which only multi-millionaires could afford, which only Duveen and a few of his rivals could sell and only families retaining great estates could still produce. The choice was limited to the six most fashionable portrait painters who had functioned between 1750 and 1830. All had painted with such furious industry that at least 12,000 portraits must have survived, but the portion that leant itself to such transactions was quite minute. The portraits, if they were selected for clients who had never looked at an original painting before, had to be showy but there were no fixed rules. Sometimes the sitter was not even good-looking. A duke need not be priced higher than an earl, there was no handicap in portraying an obscure commoner and, though size counted for a great deal, a half-length could sometimes be as dear as any full-length. In general wives commanded more than husbands and still more if accompanied by dancing or romping children. A nymphish *negligé* was occasionally tolerated in the very young, but dress mattered a great deal and had to be either frilled and fluffy or billowing with drapes. Simplicity of vision was not wanted at all and early works were definitely out. In 1923,

when both a Gainsborough and a Reynolds portrait had approached the region of £150,000, the National Gallery obtained Gainsborough's unfinished picture of his two little daughters for £3,349. *Mr and Mrs Andrews* (£130,000 in 1960) and *The Gravenor Family* (£280,000 in 1972) would have attracted no competition from Duveen, had they been on the market in 1923. The price of innocence and absolute artistic integrity might not have risen to £5,000 apiece.

Duveen was obliged to select the showiest. One is tempted to think that he never sold the best. If his genius consisted in mating unlikely buyers with unlikely sellers at still more unlikely prices, that same genius forbade him to be original. The snobbish and provincial tradition that it was smart to spend a fortune on another man's ancestor was nearly two generations old in 1901. So, far from being a creation of Duveen, it was Duveen who killed the tradition since he worked up the ancestors to such a price that there could be no hope of the tradition surviving the slump of the 1930s. Yet the commodity which, before Duveen's day, stimulated the competition of the Marquess of Hertford, the Earl of Dudley and several Rothschilds, had been viewed with a cool eye when it was new. The English portraitists charged a fixed rate for the job according to size but there was a strict limit. It was only after the Napoleonic wars had familiarised the public with inflation that Sir Thomas Lawrence was able to surpass Reynolds's highest fee of 200 guineas for a full-length portrait. In the late 1820s he was able to charge as much as 700 guineas, but for Gainsborough, Romney and Hoppner the limit had been 160 guineas and for Raeburn, practising in Edinburgh, 100 guineas.

JOHN HOPPNER
The Frankland sisters
59in by 48in
Bought by Sir Charles
Tennant in 1899 for £14,700.
Bought by Knoedler's in 1923
for £40,000
Collection: The National
Gallery of Art, Washington,
DC
(Reproduced by courtesy of
The Connoisseur Magazine)

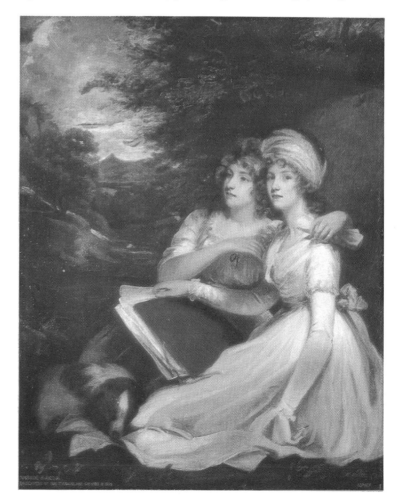

Unless they had a licence to be prodigal in fancy dress and ancillary nymphs and cherubs, the painters regarded most of their portraits as potboilers. Gainsborough enjoyed painting imaginary landscapes, the ambition of Reynolds, Romney and Hoppner was to paint subject pictures or portraits that looked like them. Reynolds, with the biggest order-book of all, considered that his normal 200 guineas full-length fee entailed no obligation beyond painting the face; the rest could be filled in by the property-man. Narrative compositions, religious, mythological or Shakespearian, were then considered the highest aim in art and he could make several times as much on them, but they took too long to design and complete, so the order-book won. That was fortunate for Duveen because Reynolds's subject pictures, so popular in early Victorian times, had gone clean out of fashion.

The portraits which normally became worthless the moment they left the family began to be sought after in the 1850s. An important example was set by the Marquess of Hertford in 1859 when he paid 2,500 guineas for *Mrs Hoare nursing her child* (Wallace Collection), a Reynolds neither in the Grand Manner nor on the full-length scale. By 1886 when Duveen was only seventeen years old, the scale of prices for English eighteenth-century portraits in relation to the art of the rest of the world was just as high as in his heyday; perhaps higher since two portraits now ranked among the eight most expensive works of art that had ever been sold. Lord Rothschild paid more than £20,000 for *Garrick between Tragedy and Comedy* while Sir Charles Tennant bought the Duke of Marlborough's Reynolds, *The little fortune teller*, through Agnew for 15,000 guineas. As a *Duveen* the latter was to cost H. E. Huntington $300,000 in 1923.

At that time only Reynolds and rather doubtfully Gainsborough could command such figures, but at the end of the century there was the same competition for Romney, Hoppner, Lawrence and Raeburn. In 1899 Sir Charles Tennant paid Agnew 14,000 guineas for Hoppner's *The Frankland sisters*, a pretty enough thing, but the debt to Reynolds was painfully obvious. Hoppner's claim to be among the six was weak since he alone was an entirely derivative painter. Yet between Reynolds's death in 1792 and his own in 1810 Hoppner's order-book stood up to the competition first of Romney and then of Lawrence. It was the result of a royal patronage so extensive that Hoppner was thought to be a son of George III. The taste of George III was destined to dictate to the market for some time to come since *The Frankland sisters*, now in the National Gallery, Washington, cost Knoedler £40,000 in 1923 before he sold it to Andrew Mellon.

It was in fact *The Frankland sisters* who brought Duveen into this market. Spurred on by their success he was induced in 1901 to bid for a much duller Hoppner, *Louisa Lady Manners*. The picture cost him exactly 50 guineas more (£14,752.10s). It was intended for James Pierpont Morgan who thought of eighteenth-century portraits in £20,000 terms, but not apparently when they were by Hoppner. *Lady Manners* was sold at a loss. However in 1926 Duveen bought her back for 18,000 guineas. Hoppner was now a safe proposition since in 1914 he had sold E. T. Stotesbury *The tambourine girl* for $350,000 which was at that time worth £72,300. It was always easy to push Hoppner too far and *The tambourine girl* turned out to be the only one of the really expensive Duveen pictures which, not being tucked away in a foundation, had to face the slump. On Stotesbury's death in 1944 it was sold at open auction for $10,000 (then £2,500). Another Hoppner remained in Duveen's stock-room to emerge into the open in June, 1973. *Elizabeth, Countess of Mexborough* figured in the Norton Simon sale at Sotheby's at £7,000. Only one Hoppner had made more in the postwar salerooms. *The*

Duchess of Bedford was sold at Sotheby's in 1963 for £9,000. Both pictures had been sent over for sale from the USA and both were bought by the direct descendants of the sitters. Without a word of comment from anyone the Duveen traffic had gone into reverse.

In 1913 the limit of extravagance for English portraits was still under £50,000, but in that year Duveen sold Henry Clay Frick Gainsborough's portrait of *The Hon. Miss Frances Duncombe* for $400,000 (then worth £82,450) though it was known to be a replica of a portrait at Longford Castle. But the incredible can be believed. The sale was mentioned at the time in *American Art News* and repeated in the obituary notices on Frick's death in 1919 when René Gimpel recorded in his diary that the figure was correct to his certain knowledge. Even the Duke of Westminster's Gainsborough, *Master Jonathan Buttall* or *The Blue Boy*, which Duveen sold to H. E. Huntington in 1921 for $620,000, was cheap compared with *Miss Duncombe*, though a fall in the pound from $4.86 to $4.20 made the price equivalent to £148,000, no less. In terms of the money of 1973 that might mean £1,150,000. It is a nice academic question (and totally unanswerable) whether the notoriety of *The Blue Boy* would make it a million pound picture under present day conditions.

The sale of *The Blue Boy* attracted a publicity which was generally lacking in Duveen's bigger transactions. The press predictably attacked the greed for dollars which allowed such a national treasure to leave these shores, though some dared whisper that California was the right place for so vulgar a picture. *The Blue Boy* rumpus is still a persistent memory, so persistent that it has obscured an interesting

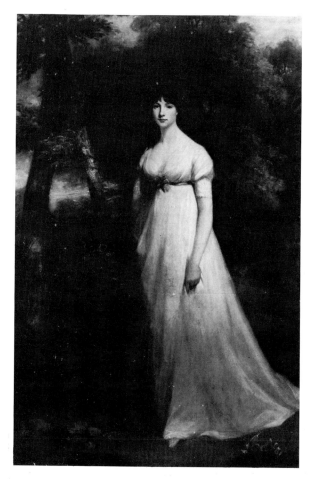

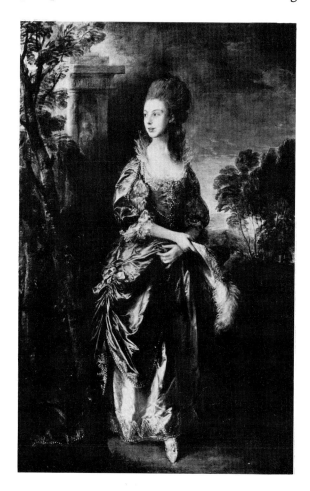

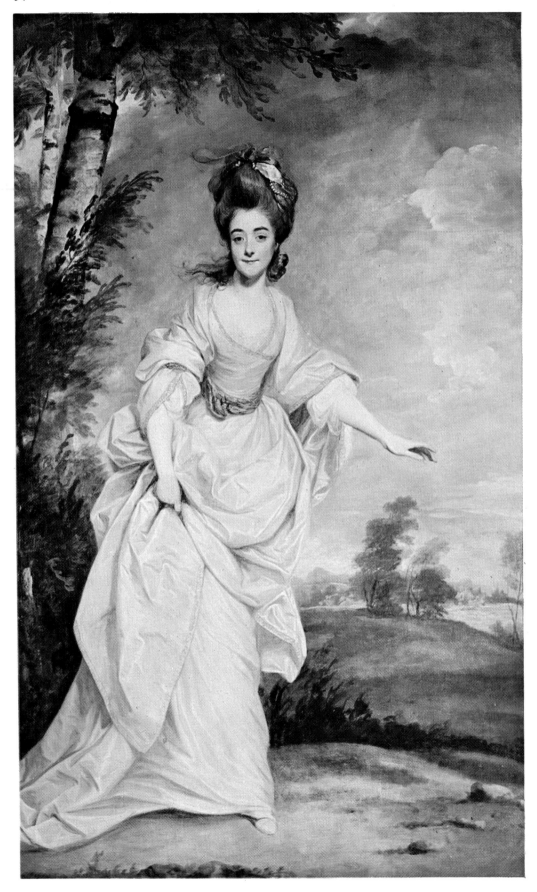

question. Did Duveen sell any other English portraits at £150,000? The researches of Mr James Dugdale suggest that H. E. Huntington had to pay as much for a Reynolds as he had paid for his Gainsborough. The full-length likeness of *Diana, Viscountess Crosbie*, advancing across a lawn in swirling draperies, had been sold by Agnew to Sir Charles Tennant in 1890 for £9,900. It cost Duveen with commission and expenses £60,599 in 1923, but he sold it to Huntington, together with *The little fortune teller* and 'some garden statuary' for a million dollars. Since *The little fortune teller* had cost Duveen less than half as much, it is unlikely that *Viscountess Crosbie* counted for less than $600,000, even allowing for 'garden statuary'. It was double the price Huntington had paid for Reynolds's *Sarah Siddons as the Tragic Muse* in 1921 and the pound was now worth not much more than 4 dollars.

In 1936 both Frick and Huntington were dead and the great depression had struck the market, yet Duveen, struggling to keep up the saleroom price of some of his former pictures, contrived the largest package-deal of all. The prices were fully up to the standard of the 1920s, though lower in terms of pounds which had returned to the

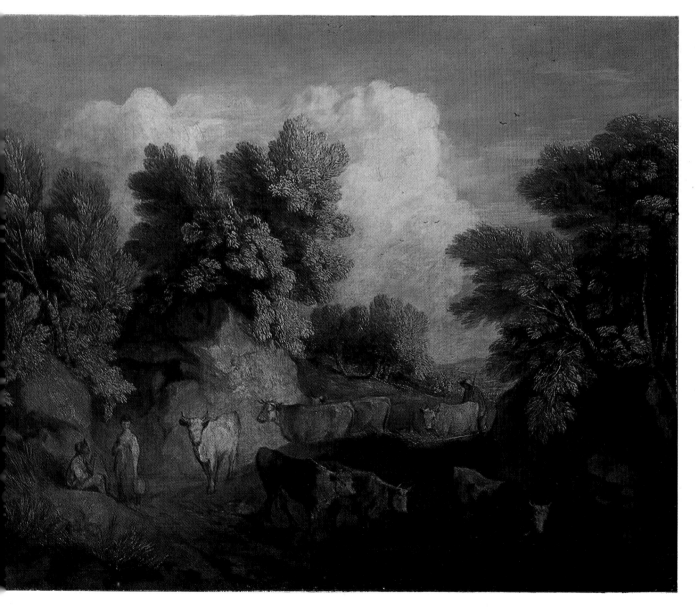

normal parity of $4.86. According to H. R. Rush, he charged Andrew Mellon $500,000 (£103,300) for Reynolds's *Lady Compton* and $300,000 (£61,750) for *Lady Caroline Howard*. Gainsborough's *Georgina, Duchess of Devonshire*, formerly at Althorp, cost $400,000 (£82,450) and *Mrs Sheridan*, acquired from the Rothschild family, £80,000. Duveen died in 1939 – even the choice of date was symbolical – and these were the last of his Grand Manner prices. The fate of several Duveenish Gainsboroughs which reached the market after the great depression has been too diverse to help decide the question whether these prices, multiplied by nearly eight in terms of devalued money, would hold today. Here are some examples.

The double portrait of *Lady Ernle and Lady Dillon* made $100,000 in the Urschel sale of 1971 but it had cost Charles Urschel $100,000 forty years earlier. Those dollars were worth twice as much in English money in 1971 (£41,666 as against £20,570), yet they were the same dollars. *Dorothea, Lady Eden,* cost $35,000 at the Cintas sale of 1963, but according to René Gimpel's diary John W. Simpson had paid $76,000 as far

SIR JOSHUA REYNOLDS
Lady Elizabeth Compton
Bought by Andrew Mellon
from Duveen in 1936 for
$500,000 (£103,300)
Collection: The National
Gallery of Art, Washington,
DC

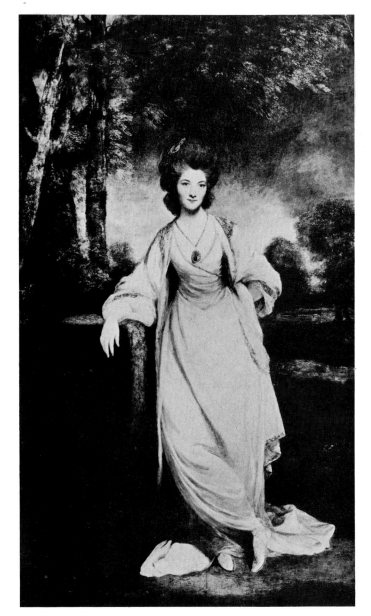

back as 1906. The *Countess of Chesterfield*, £17,850 at the Caernarvon sale of 1925, rose to £34,000 in 1959. Since the pound had lost more than half its purchasing power since 1959 there was nothing surprising in a Gainsborough double portrait making £110,000 at Sotheby's in June 1973. *The Cruttenden sisters* was the dearest of the pictures from the Duveen stock-room in the Norton Simon sale and the price was equivalent to less than £14,000 in the 1920s and 1930s. The fact that the picture had been hidden from the market so long suggests that Duveen had been unable to think in such lowly terms.

Comparisons with *The Gravenor Family* which made £280,000 at Sotheby's in 1972, are meaningless because this was so definitely not a picture in the Duveen taste. Nevertheless Duveen was not always wedded to flowing draperies and affected grandeur. Because of the essentially conservative nature of his market he had to work up the prices of Gainsborough's landscapes. They had few of the characteristics that Duveen needed but tradition decreed that they should be expensive. In 1867 a landscape called *The harvest wagon* (now in the Barber Institute, Birmingham) was the

THOMAS GAINSBOROUGH
The Cruttenden sisters, Elizabeth and Sarah
44¼in by 58¾in
London £110,000 ($275,000). 27.VI.73
From the collection of the Norton Simon Foundation, Los Angeles
Formerly from the Duveen Collection

first Gainsborough to make 3,000 guineas. *The cottage door* was one of the Duke of Westminster's pictures sold to Duveen in 1921. Having cost Lord Grosvenor 500 guineas in 1827, it was sold to Huntington for $300,000, then worth £73,000, and perhaps the equivalent of £560,000 in 1973. Yet another *Harvest wagon* which cost 4,500 guineas in 1894, was bought by Duveen in 1913 for 20,000 guineas and sold for £34,000. In 1928 Duveen was so determined to get this painting back that it cost him more than he had charged Huntington for *The cottage door*. Having bid $360,000 (then £74,400) at the Gary sale in New York, he was still able to sell it for $450,000 or £92,700 to Frank P. Wood who left it to Toronto where it was badly slashed in the robbery of 1959. An English landscape at £720,000 or thereabouts would indeed raise some eyebrows even in 1973 and Gainsborough's are by no means the dearest of English land-

THOMAS GAINSBOROUGH
The harvest wagon
£4,725 in 1894. Bought by Duveen in 1913 for £21,000. Bought by him again at the Gary sale in 1928 for $360,000 (£74,400). Sold to Frank P. Wood for $450,000 (£92,700)
Collection: Toronto Art Gallery

scapes. For the Duke of Sutherland's landscape the National Gallery, Edinburgh, was said to have paid £55,000 in 1962, but in the post-war salerooms only two unusually good examples out of a fair number of Gainsborough landscapes have exceeded £30,000. Their recorded progress during the years of inflation was not exciting. *Cattle returning at evening* rose from £29,400 in 1968 to £35,000 at Sotheby's in June, 1973. A mountainous landscape, dated 1784, rose from £36,000 in 1968 to £37,800 in 1972.

Only the most recent dose of inflation could kindle life in the Reynolds market which was depressed by the worsening condition of his canvases as well as by the death of an uncritical cult. In the course of a long working life and with the aid of assistants Reynolds churned out more than 4,000 portraits. There are still some which came out of his painting room and yet cannot make £1,000, but the dearest works on the post-war market have not been those possessing Duveen qualities. The unfinished head of *Omai, the Tahitian* made £22,000 in 1963, the price of its gay spontaneity, the last thing Duveen's richest clients would have wanted. The businesslike but unseductive likeness of *James Boswell* made £25,000 in 1965 because of its value to the National Portrait Gallery. 'Duveen market' pictures have not been lacking but none made as much as £20,000 before 1972 or £4,000 before 1960. Two have even been notable. *Lord Ligonier at the battle of Dettingen* made 9,000 guineas at the Duke of Sutherland's sale in 1961 and the same price was paid at the Spencer Churchill sale of 1965 for a full-length likeness of *Elizabeth, Duchess of Hamilton,* majestically leaning on a sarcophagus. In the 1920s Duveen had offered 60,000 guineas for it and that by 1965 meant £300,000.

In June, 1972 the Hillingdon portraits changed the look of the Reynolds market but the change was predictable. *Mrs Abingdon as Miss Prue in All for Love* made 100,000 guineas at Christie's and *Mrs Sarah Woodhouse* 55,000 guineas. From another collection the full-length of *Sir Richard Peers Symons* with greyhound, ancient marbles and all the right ingredients, made 38,000 guineas, but the dearest picture might not have appealed to Duveen at all. Mr S. N. Behrman has described the difficulties Duveen had with Mrs Huntington because Sarah Siddons had been an *actress* – and furthermore Mrs Abingdon seemed to be leaning on the back of a Chippendale chair and sucking her finger, besides being a mere 30 by 27 inches.

Far different was the Duchess of Sutherland's Romney, *The Children of Earl Gower* which was sold the same day for 140,000 guineas. It was not so much a Duveen picture as a super-Duveen, for Duveen never sold a Romney group with so many of the right components. One can imagine his price for those dancing (did I hear someone say mincing?) children in the 1920s. It would have been something at least equivalent to half a million in 1973. By the end of 1972 Sotheby's could sell quite a modest Romney, only half-length in scale, for £70,000, the final cost to the Scottish National Gallery of *The Duchess of Gordon and her son* being £77,000. But note the history of Romney's *Mrs Charteris and her children,* sold in the same month for 18,000 guineas. It was said to have cost Solly Joel £15,000 in the 1920s, but in 1935 it became one of the worst casualties of the slump. With no Duveen to protect it the best bid was 560 guineas.

Romney seems habitually to be dearer than Reynolds but so he was during the earlier years of the Duveen market. In 1913 Duveen paid £41,370 for *Anne de la Pole,* a picture which he bought back in 1926 for £46,200 and sold for £60,000. At the second Hamilton Palace sale in 1919 he bought *The Beckford sisters* for £54,600, at that time the highest sum to be bid at an English auction. Two years later the sisters cost Huntington as much as he paid for *Sarah Siddons* and *The cottage door,* $300,000 or £73,000. About as much was paid in 1926 by Andrew Mellon for *Mrs Davenport,* for which Duveen

had had to pay £60,900 at the Michelham sale against the competition of Knoedler through whom in the end he sold his picture. These were the dearest Romneys for, after 1926, prices fell off noticeably. Since they should be multiplied by nearly eight in the currency of 1973, the Romney recovery has still far to go.

And the Lawrence recovery even more so. *The children of John Angerstein* (Sotheby's, 1967) is still the dearest at £23,000 on the post-war market. It was also, with all allowance for devalued pounds, the dearest since the 1930s. If one can imagine a £100,000 picture by Lawrence, it is surely this one, but at the moment Lawrence is no more in demand than Hoppner and Raeburn. Seldom has a Lawrence painting made £3,000 and that in real money terms is no more than the 150 guineas which Lawrence could get for an ordinary portrait-head in the 1820s. One of the puzzles of the prices,

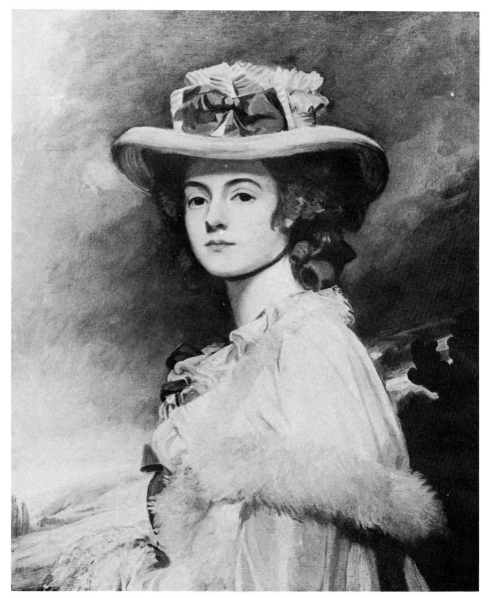

GEORGE ROMNEY
Mrs Davenport
Bought by Duveen at the Michelham sale in 1926 for £60,900 and sold to Andrew Mellon
Collection: The National Gallery of Art, Washington, DC

formerly paid for Lawrence portraits, is that most of them were out of character with the Duveen market. Having been born two generations later than Reynolds and Gainsborough, Lawrence died, overwhelmed with portrait commissions, in 1830 when clothes were black and backgrounds smoky and menacing. Lawrence was nevertheless absorbed into the Duveen market because in 1900 James Pierpont Morgan had paid £20,000 apiece for *Nelly Farren* and *Miss Croker*, the one painted in the lifetime of Reynolds, the other almost Victorian. Having paid a Reynolds or Gainsborough price for *Miss Croker* who had been painted in 1827, Morgan learnt from her that she was still alive. She even sent him her photograph. However, when the real peak of the Lawrence market was reached, a whole generation had passed and the sitters were unlikely to send photographs. In 1920 Duveen sold *Miss Mary Moulton-*

SIR THOMAS LAWRENCE
The children of John Angerstein 76in by 56¾in
Sold at Sotheby's on
12th July 1967 for £23,000

Barrett, a child-portrait more widely known as *Pinkie*, to Lord Michelham for £60,900. When *Pinkie* re-appeared at the Michelham sale in 1926, Andrew Mellon was determined to have her, but Duveen was equally determined that he should not have her through the firm of Knoedler, so, having left an open bid, he paid what was at that time the highest auction price in history, £77,700. It was too high for Mellon and in the end Huntington got *Pinkie* at a little over cost-price and in California she reigns.

After the sale it was rumoured that the Earl of Durham owned an even better Lawrence child-portrait, *Master Lambton* or *The Red Boy* for which he wanted two million dollars. Then came the Wall Street crash of 1929 and in April, 1932, when the pound had been devalued by a third, *The Red Boy* was put up for sale at Lambton

SIR THOMAS LAWRENCE
Miss Mary Moulton-Barrett
(*Pinkie*)
Bought by Duveen at the
Michelham sale (Hampton's)
1926 for £77,700
Collection: Henry E.
Huntington Library and Art
Gallery, California

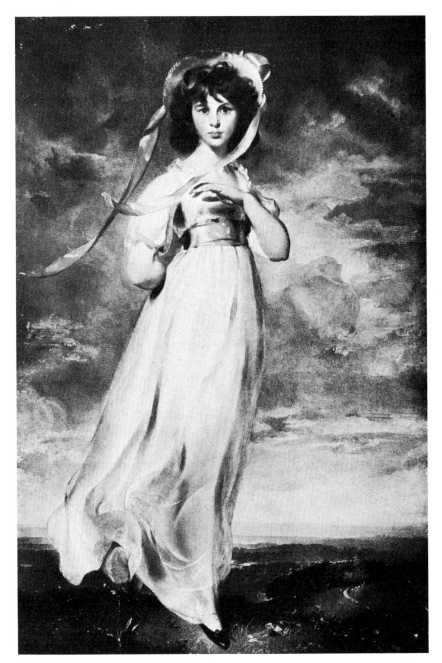

Castle. No one knew whether the buying-in price of £95,000 concealed an under-bid from Duveen. In 1935 the Metropolitan Museum could still pay $200,000 for *Nelly Farren* but a truer market indicator was a head of *Lord Castlereagh*, bought in 1928 for 4,200 guineas and sold in 1938 for 540.

The fall in value of Raeburn portraits appears less drastic because it is doubtful whether Duveen succeeded in promoting them to the $300,000 class. The wonder indeed is that this industrious commemorator of the deadly plain ever became a Duveen painter at all. In Duveen's day however, vast wealth was rather more likely to be linked with Scottish descent than it is today. In 1911 when he paid £23,415 for *Mrs Robertson-Williamson*, it was probably as much as he had given for any eighteenth-century portrait, but in 1926 he was not so anxious to have it back as he was for his Romneys and his Lawrence. He let it go to Knoedler for £24,675, and in 1954 it was sold in New York for $14,000 or £5,000. The dearest Raeburns tended to stay on this side of the Atlantic, as for instance *The McNab in the uniform of the Breadalbane Fencibles*, at one time famous as a whisky advertisement, which achieved £24,510 at Christie's in the middle of the graver pre-occupations of 1917. In the 1920s Duveen was believed to have offered £50,000 for *The McNab* and that might be nearly £400,000 today. But the dearest Raeburn on the post-war market has been *Quintin Adam as a boy* at $60,000 (then worth £21,428) in the Erickson sale of 1961. This was a very exceptional price; *Lady Hepburn*, bought from Knoedler in 1929 for $75,000 or £15,450, was bought in at £7,350 in 1969, and at £5,750 in 1970.

It seems that romantic cults of the past determine the picture market more than aesthetic principles. When a romantic cult becomes overworked it cannot avoid being silly, but was the cult of the English eighteenth-century portrait the silliest? Before that cult reached them, America's new millionaires bought the romantic past from living fancy-dress performers, especially Meissonier, the founder of the *red cardinal* school for which Duke Street is justly famed. Will anyone assert that cults have been more sensible since Duveen? Is there any sane reason why one of Gainsborough's best landscapes is at present worth £35,000 while an adolescent derivative Picasso of 1901 fetches £270,000?

Footnote In estimating the relative purchasing power of the pound in the Duveen period as compared with midsummer, 1973, I have assumed that it bought twelve times as much before the First World War and 7·8 times as much in 1919–1939. This basis may be too conservative in view of the immense increase in the cost of land and housing in the past two years. The prices which were paid in dollars have been given their Sterling equivalent at the time of sale. This varied considerably. The parity of 4·86 dollars to the £ was abandoned in 1919–1925 and again in 1931–1933.

For the prices paid for pictures from Sir Charles Tennant's collection I am indebted to the researches of his grandson, Mr James Dugdale (Sir Charles Tennant, the story of a Victorian collector, *The Connoisseur*, September, 1971).

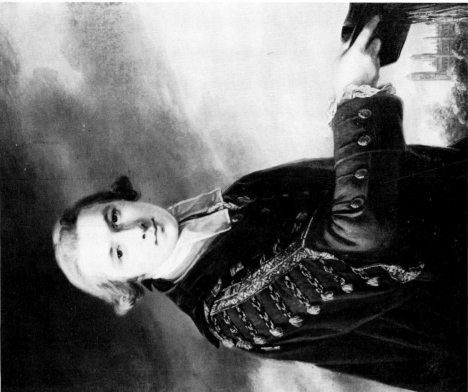

FRANCIS COTES, RA
Portrait of Luke Gardiner, 1st Viscount Mountjoy
35½in by 28in
London £18,000 ($45,000). 4.IV.73

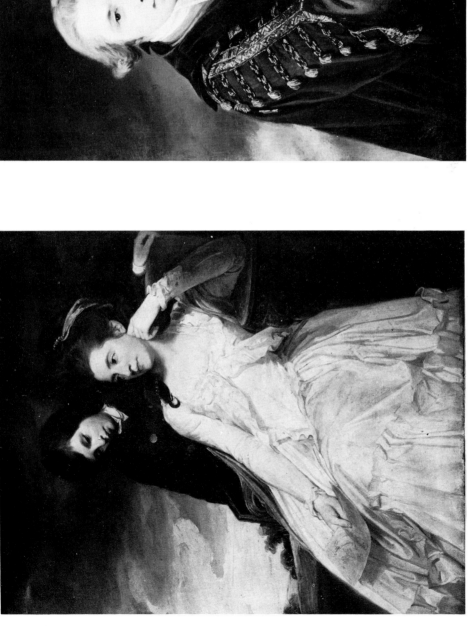

GEORGE ROMNEY
Portrait of Jane, Duchess of Gordon and her son George,
1st Marquis of Huntly
Painted in 1778, 49¾in by 40⅜in
London £70,000 ($175,000). 13.XII.72
Formerly in the collection of the late Sir William Van Horne,
KCMG

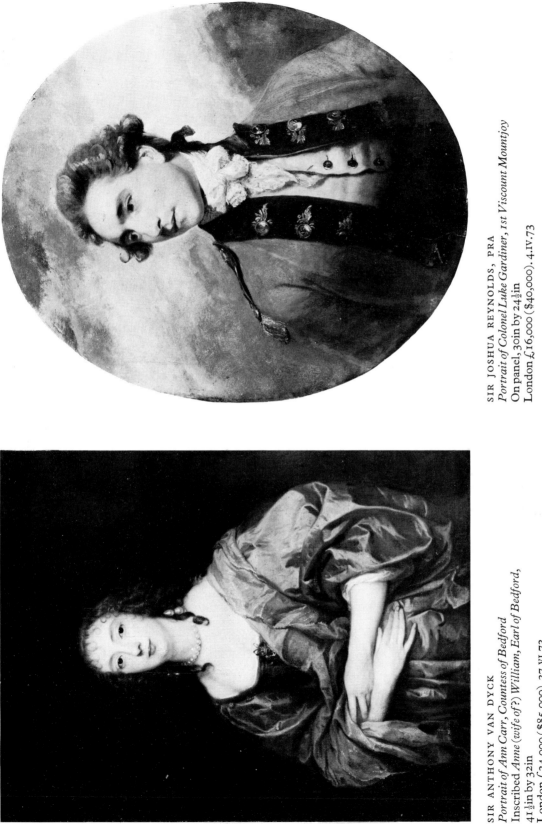

SIR JOSHUA REYNOLDS, PRA
Portrait of Colonel Luke Gardiner, 1st Viscount Mountjoy
On panel, 30in by 24½in
London £16,000 ($40,000). 4.IV.73

SIR ANTHONY VAN DYCK
Portrait of Ann Carr, Countess of Bedford
Inscribed *Anne (wife of?) William, Earl of Bedford*,
41½in by 32in
London £34,000 ($85,000). 27.VI.73
From the collection of the Norton Simon Foundation,
Los Angeles
Formerly in the collections of the Dukes of Bedford (until
1827) and the Earls Spencer, Althorp House (until 1936)

JOSEPH MALLORD WILLIAM TURNER, RA
Bonneville, Savoy
Painted in 1803, 36in by 48in
London £180,000 ($450,000). 27.VI.73

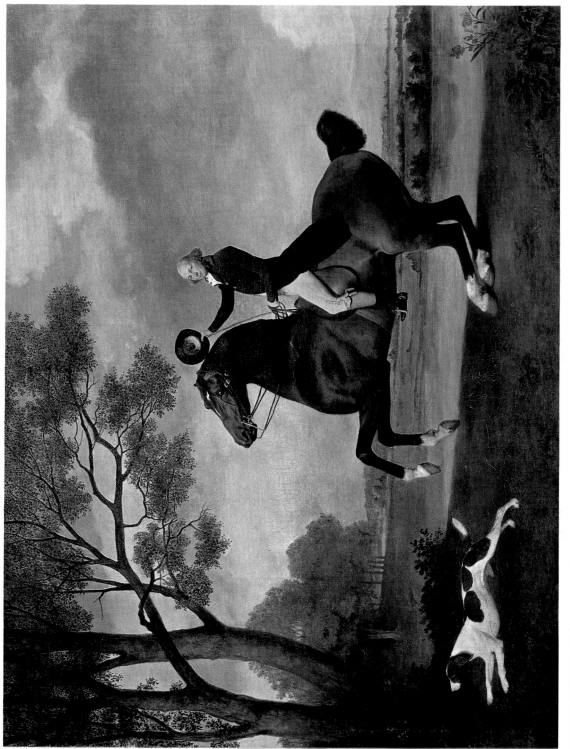

GEORGE STUBBS, ARA
The Baron de Robeck riding a bay cob
Signed and dated 1791, 39¾in by 50in
London £130,000 ($325,000). 13.XII.72
From the collection of the late E. A. Allnatt
Formerly in the collection of Brigadier the Baron de Robeck, great-grandson of the sitter,
sold at Sotheby's on 7th December 1960 £20,000

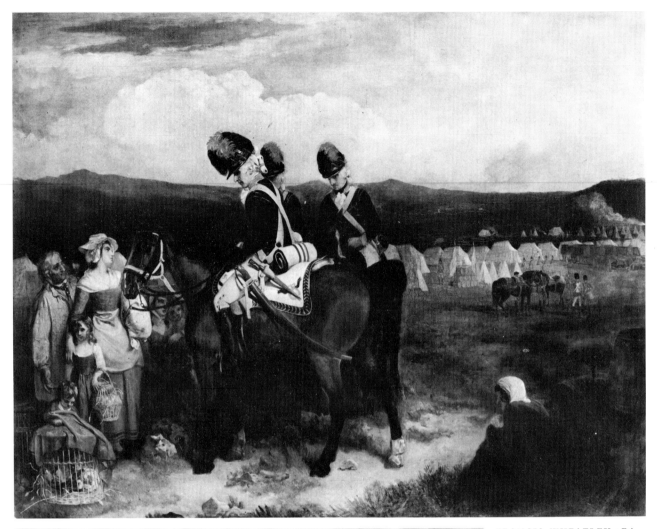

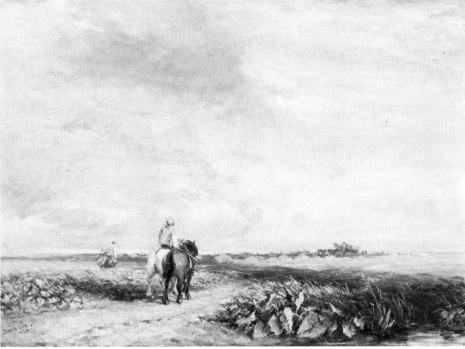

FRANCIS WHEATLEY, RA
Mounted soldiers buying chickens
Signed and dated 1788,
40in by 50in
London £23,000 ($57,500).
4.IV.73
From the collection of
Major W. H. Callander

DAVID COX SNR, RWS
Crossing the heath
Signed and dated 1848,
22½in by 33in
London £10,000 ($25,000).
27.VI.73
From the collection of the
Hon. Colin Tennant,
formerly in the collection of
Sir Charles Tennant

Right
THOMAS GAINSBOROUGH, RA
A country road
13½in by 12in
London £28,000 ($70,000). 13.XII.72
From the collection of L. Harper Esq

Below
THOMAS PATCH
A panoramic view of Florence from Bellosguardo
Signed and dated 1775, 37in by 61½in
London £9,000 ($22,500). 27.VI.73
From the collection of the Norton Simon Foundation,
Los Angeles

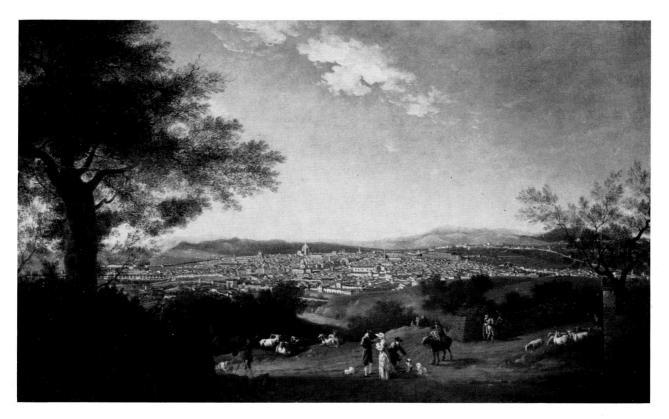

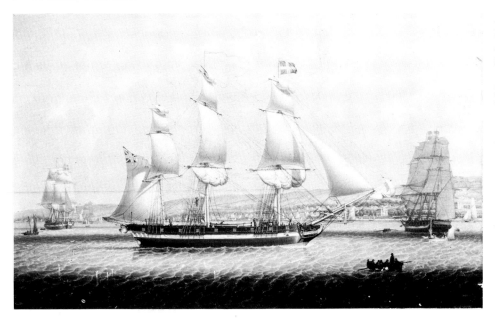

Left
ROBERT SALMON
A British Corvette in three positions
Signed with initials and
dated 1818, 23in by 37in
London £9,000 ($22,500).
13.XII.72
From the collection of
Mrs Percy

Below
WILLIAM JAMES
*Regatta day on the Bacino,
Venice*
36½in by 59½in
London £19,000 ($47,500).
4.IV.73

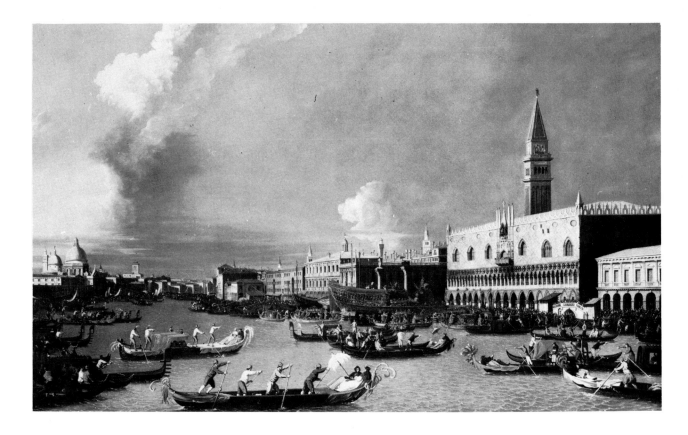

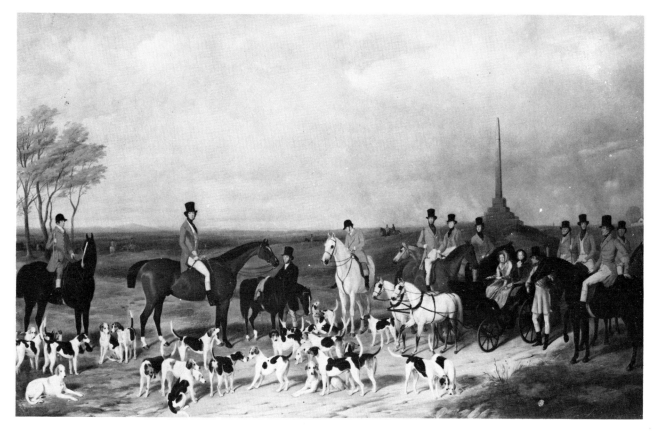

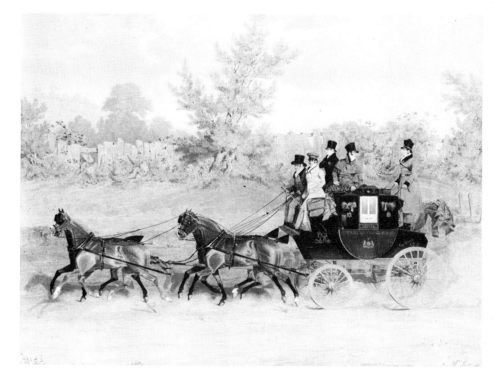

Above
WILLIAM AND HENRY
BARRAUD
*A Meet of Sir John Gerard's
hounds by a monument in an
extensive landscape*
Signed and dated 1842 by
both artists, 57¼in by 93¼in
London £20,000 ($50,000).
4.IV.73
From the collection of the
Hon Mrs M. D. F. Stevenson

Left
JAMES POLLARD
Royal Mail coach
Signed and dated 1820,
30in by 40in
London £35,000 ($87,500).
13.XII.72
Formerly in the collection of
Prince Esterhazy, by whom it
was commissioned

Opposite page
Above left
WILLIAM WESTALL, ARA
A view from the terrace, Richmond Hill
On panel, 12in by 20in
London £6,000 ($15,000). 13.XII.72

Below left
JULIUS CAESAR IBBETSON
The Bridge of Beauty, Pontypridd, Glamorgan
On panel, signed and dated 1790, 17½in by 25in
London £11,500 ($28,750). 27.VI.73
From the collection of the late
Dr and Mrs A. V. McMaster of Cambridge

Above right
FRANCIS WHEATLEY, RA
A soldier buying ribbons
Signed and dated 1788, 40in by 50in.
London £29,000 ($72,500). 4.IV.73
From the collection of Major W. H. Callander

Below right
JOSEPH WRIGHT OF DERBY, ARA
*The Convent of St Cosimato and remains of
the Claudian aqueduct on the River Arno*
On panel, signed and dated 1789, 24in by 32in
London £20,000 ($50,000). 13.XII.72
From the collection of J. C. Blundell Turner, Esq

Above
JOHN LINNELL
Portrait of William Denny
On panel, signed with initials and dated 1821 and
signed and inscribed on the reverse, 8½in by 6¼in
London £10,000 ($25,000). 27.VI.73
Formerly in the collections of J. F. Denny Thomas,
The Rev. Sir H. LL. Denny and General Sir Ivor Thomas

Left
RICHARD PARKES BONINGTON
Young musicians at a window
On panel, signed with initials, 10in by 9¼in
London £15,000 ($37,500). 27.VI.73

Left
THOMAS ROWLANDSON
Four o'clock in the country
Pen and ink and coloured
wash, 9½in by 12in
London £2,600 ($6,500).
5.IV.73
From the collection of
Mrs C. Carr

Below
EDWARD FRANCIS BURNEY
Amateurs of tie-wig music
18¼in by 27¾in
London £2,800 ($7,000).
5.IV.73
From the collection of
A. R. Martin Esq

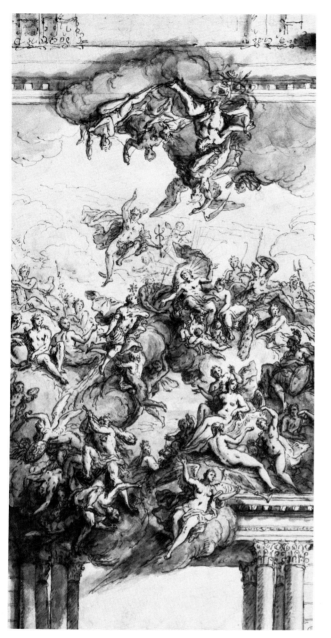

Left
SIR JAMES THORNHILL
A design for a ceiling
Pencil, sepia ink and wash,
16in by 8in
London £2,000 ($5,000).
19.VII.73
From the collection of
D. Le Poer Trench Esq
Formerly in the collection of
the Earl of Warwick

Below
SAMUEL PALMER, RWS
Study for 'The Shearers'
Pencil and sepia and grey
washes, 10¼in by 14in
London £3,800 ($9,500).
19.VII.73
From the collection of
H. I. Richmond Esq
Formerly in the collections of
George Richmond, RA and
Walter Richmond

DAVID COX SNR, RWS
Going to the hayfield
Pencil and coloured wash,
signed, 12½in by 18in
London £2,500 ($6,250).
19.VII.73
From the collection of the
Hon. Mrs Hepburne-Scott
Formerly in the collection of
James Houldsworth

SAMUEL DANIELL
Near Eucheconing Point, Java
14¾in by 21¼in
London £2,500 ($6,250).
5.IV.73

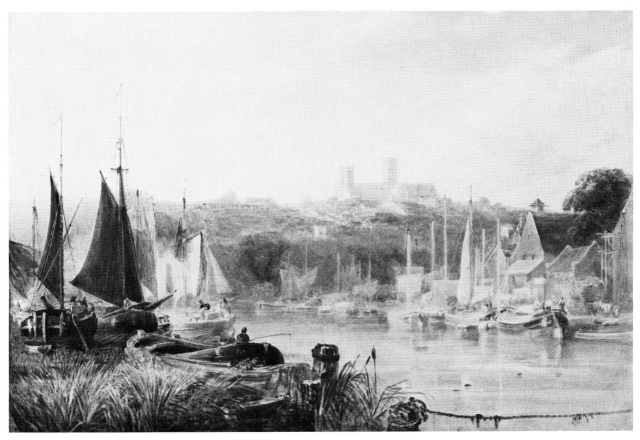

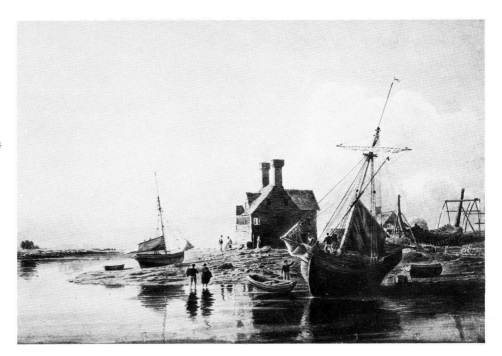

Above
PETER DE WINT, RWS
Lincoln, early morning
26¼in by 39¼in
London £10,500 ($26,250).
19.VII.73
From the collection of
Mrs R. A. Macgeorge
Formerly in the collection of
Sir John Pender, GCMG, KCMG

Right
CORNELIUS VARLEY
*Teguin Ferry, with Harlech
Castle in the distance*
Signed and dated *Oct. 1828*,
12in by 18¾in
London £2,300 ($5,750).
19.VII.73
From the collection of
Mrs M. J. Hannibal

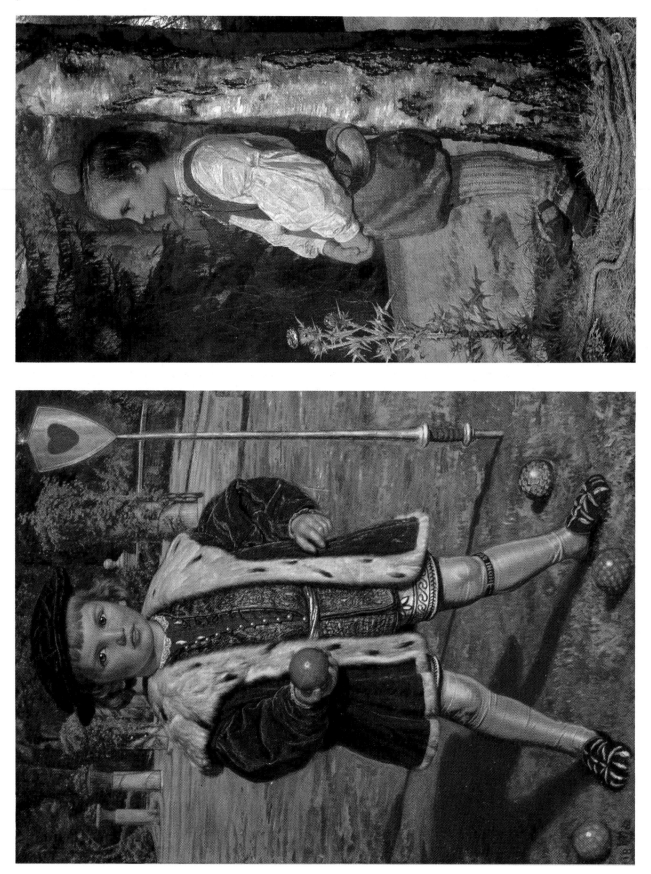

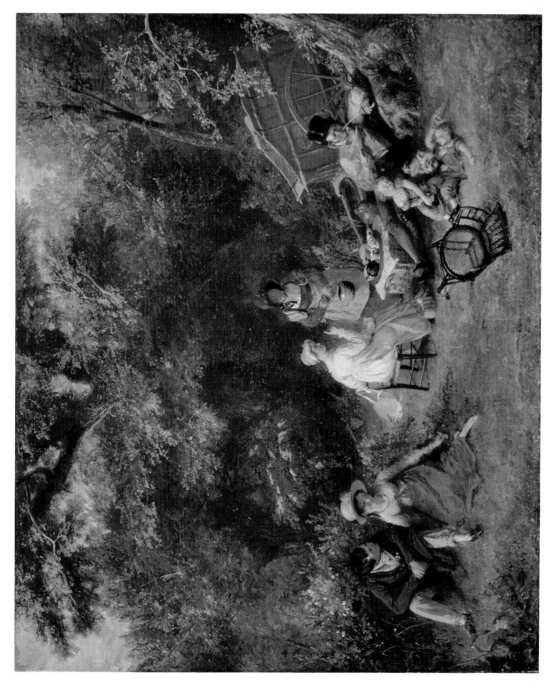

Right
CHARLES ROBERT LESLIE,
RA
Londoners gipsying
Signed and dated 1820,
32¼in by 39in
London £6,000 ($15,000).
10.VII.73
From the collection of the
Hon. Colin Tennant
Formerly from the collections
of Colonel Holdsworth of
Halifax and Sir Charles
Tennant

Opposite page
Right
WILLIAM SHAKESPEARE
BURTON
The first shot to freedom,
Switzerland
Inscribed *Painted with Zinc*
White and signed with
initials on the reverse,
24½in by 13½in
London £9,000 ($22,500).
10.VII.73
Formerly in the collection of
the 2nd Marquis of Dufferin
and Ava

Left
WILLIAM HOLMAN
HUNT, OM, ARSA, RWS
The King of Hearts
Signed with monogram and
dated 1862, on panel,
15in by 11in
London £24,000 ($60,000).
10.VII.73

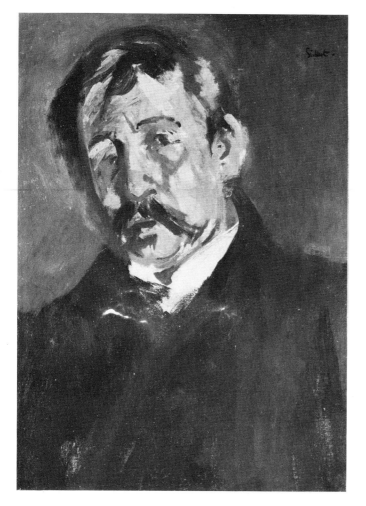

Left
WALTER RICHARD
SICKERT, ARA
*Portrait of a man with a
moustache*
Signed, painted *circa* 1896–98
18¼in by 14¼in
London £16,000 ($40,000).
18.VII.73

Below
JAMES DICKSON INNES
*Sunset, Collioure, Canigou in
the distance*
Painted *circa* 1912, 10¾in by
14½in
London £6,800 ($17,000).
14.III.73

Right
HAROLD GILMAN
Nude on a bed
Canvas mounted on board,
19¾in by 13¾in
London £5,000 ($12,500).
18.VII.73
From the collection of
R. G. Hobbs Esq

Below
ROBERT BEVAN
Under the hammer
Painted *circa* 1914, 15¼in by
21½in
London £12,000 ($30,000).
14.III.73
From the collection of
Mrs F. A. Girling

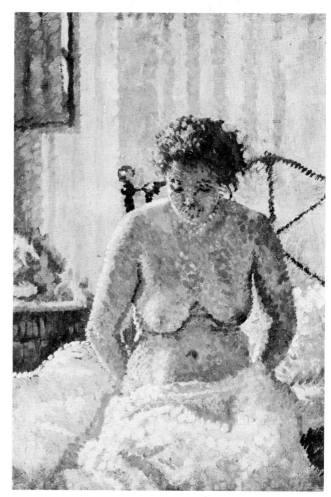

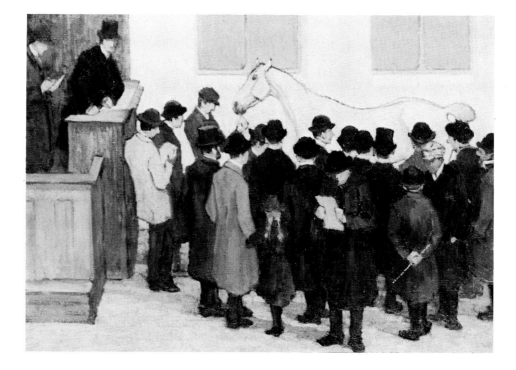

Left
DAVID JONES
A hillside with sheep
Pencil and watercolour,
heightened with bodycolour,
signed and dated 1926,
21¾in by 14¾in
London £2,800 ($7,000).
18.VII.73
From the collection of
H. W. Yoxall Esq

Right
DAVID JONES
A town garden
Pencil and watercolour,
signed and dated '26,
21½in by 14½in
London £2,400 ($6,000).
18.VII.73
From the collection of
H. W. Yoxall Esq

CHRISTOPHER RICHARD
WYNNE NEVINSON, ARA
Flooded trench on the Yser,
1915
Signed, 19½in by 23½in
London £7,500 ($18,750).
18.VII.73

Left
SIR STANLEY SPENCER, RA
The Last Supper
On board, 14¼in by 23½in
London £15,500 ($38,750).
18.VII.73
From the collection of the
late Lady Gollancz

Below
SIR STANLEY SPENCER, RA
View from Cookham Bridge
27½in by 36½in
London £13,000 ($32,500).
18.VII.73

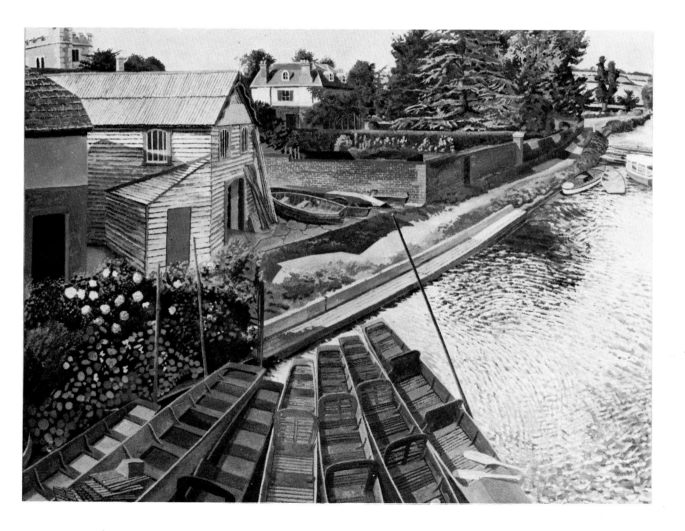

Right
WILLIAM ROBERTS, RA
Bank Holiday in the park,
1923
Signed, 59in by 47in
London £8,000 ($20,000).
22.XI.72
From the collection of
Ernest Cooper Esq

Below
JACK BUTLER YEATS
By Streedagh Strand,
Sligo, 1940
Signed and inscribed on the
reverse, 24in by 36in
London £9,500 ($23,750).
22.XI.72
From the collection of
R. R. Figgis Esq

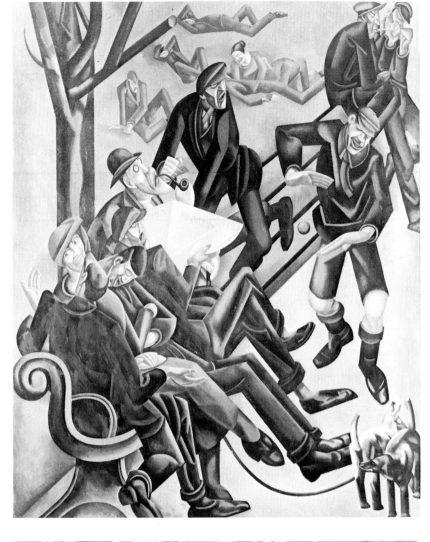

Right
LUCIAN FREUD
Girl in a dark jacket
On panel, 18¾in by 15in
London £14,000 ($35,000).
18.VII.73
From the collection of
A. Griffin Esq

Below
CHRISTOPHER WOOD
*La Trémouille Church,
Tréboul, 1930*
Signed and dated (Tréboul)
on the reverse, 19½in by 24in
London £5,800 ($14,500).
18.VII.73
From the collection of
R. G. Hobbs Esq

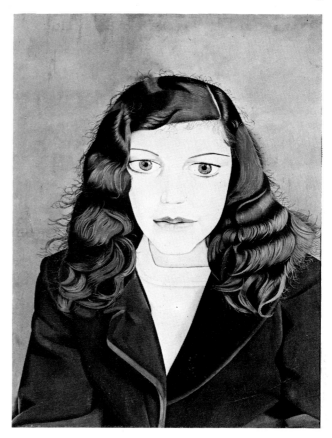

BEN NICHOLSON, OM
White relief (decor for the Seventh Symphony) 1939
Oil on carved board, signed, inscribed and dated on the reverse, 15in by 19½in
London £24,000 ($60,000).
18.VII.73
From the collection of Michael Spens Esq

TRISTRAM HILLIER, RA
Yport
Signed, painted in 1940, 23¼in by 31½in
London £3,400 ($8,500).
18.VII.73
From the collection of Etienne Amyot Esq

FRANCIS BACON
Study for portrait V (after the life mask of William Blake,) 1956
Signed, inscribed and dated on the reverse, 14¼in by 12in
London £17,000 ($42,500). 22.XI.72
From the collection of Michael Magan Esq

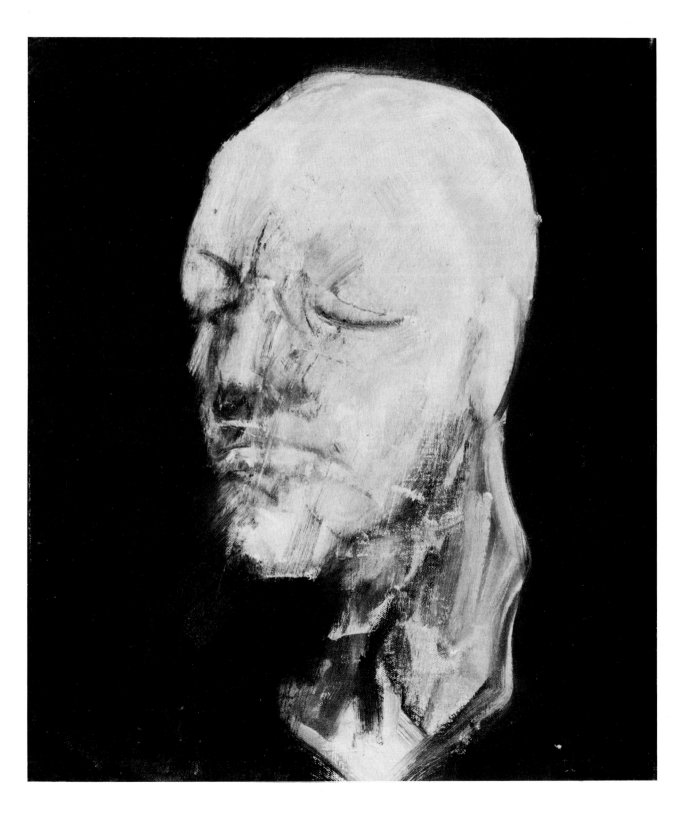

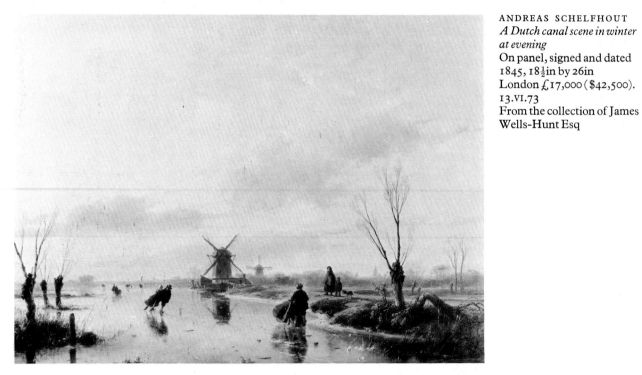

ANDREAS SCHELFHOUT
*A Dutch canal scene in winter
at evening*
On panel, signed and dated
1845, 18½in by 26in
London £17,000 ($42,500).
13.VI.73
From the collection of James
Wells-Hunt Esq

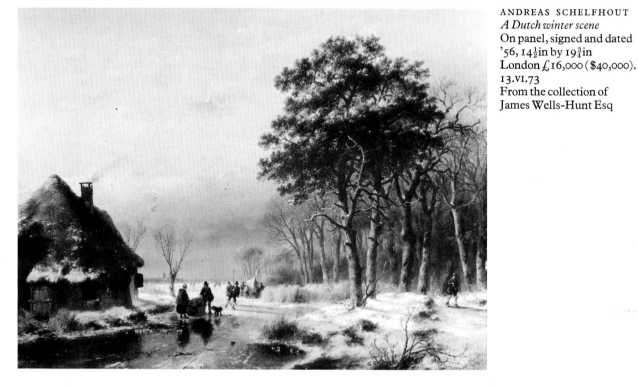

ANDREAS SCHELFHOUT
A Dutch winter scene
On panel, signed and dated
'56, 14½in by 19¾in
London £16,000 ($40,000).
13.VI.73
From the collection of
James Wells-Hunt Esq

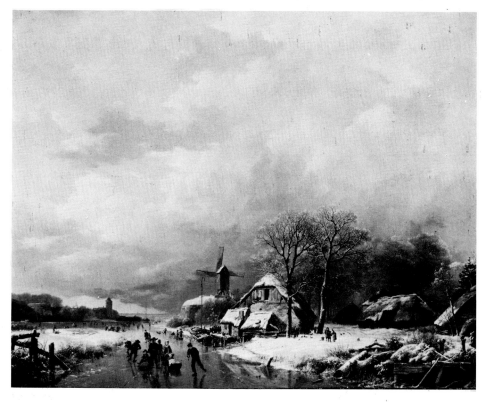

BAREND CORNELIS
KOEKKOEK
*An extensive Dutch winter
landscape*
Signed and dated '38,
25in by 31in
London £15,000 ($37,500).
13.VI.73
From the collection of
A. Higham Esq

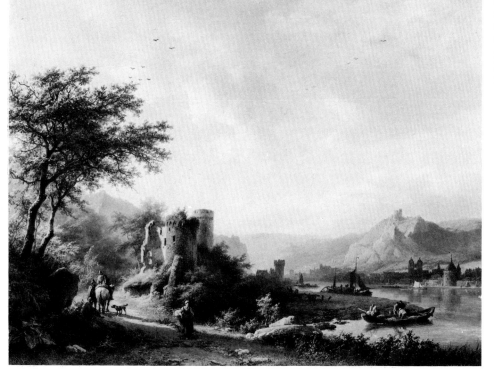

BAREND CORNELIS
KOEKKOEK
On the Moselle
On panel, signed and dated
1855, 14in by 18¾in
London £15,000 ($37,500).
13.VI.73

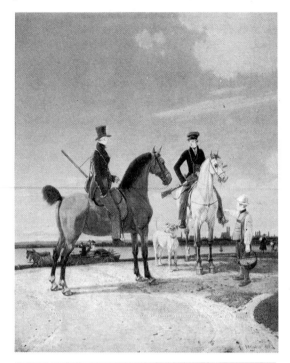

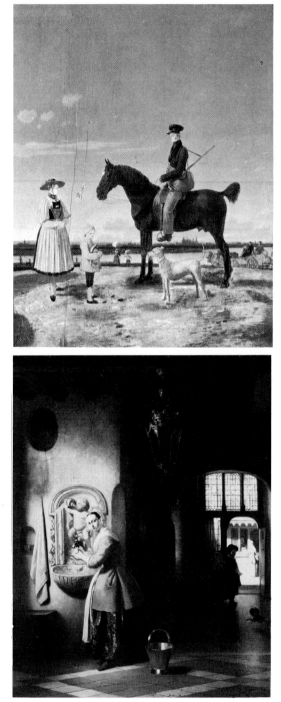

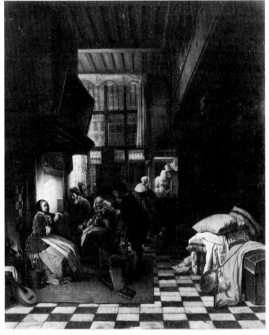

Above
WILHELM ALEXANDER WOLFGANG VON KOBELL
Two riders in a landscape and *The afternoon ride*
A pair, on panel, the former signed and dated 1823, 9½in by
7¾in
New York $75,000 (£30,000). 14.VI.73

Below left
BARON HENDRIK LEYS
A Dutch family in an interior
On panel, signed, 35½in by 30in
London £11,000 ($27,500). 13.VI.73
From the collection of Mrs Joan Rimer

HUBERTUS VAN HOVE
A Dutch interior scene
On panel, signed and dated 1849, 25¼in by 21¼in
London £8,000 ($20,000). 28.II.73
From the collection of Mrs C. M. Benabo

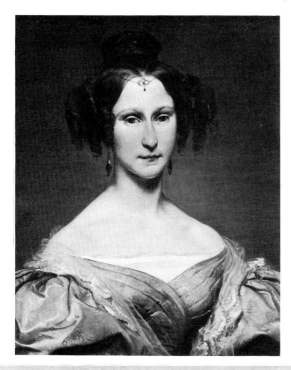

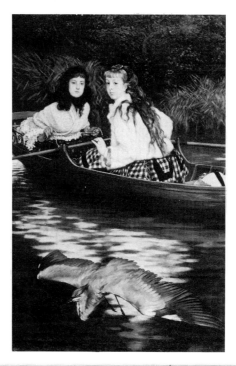

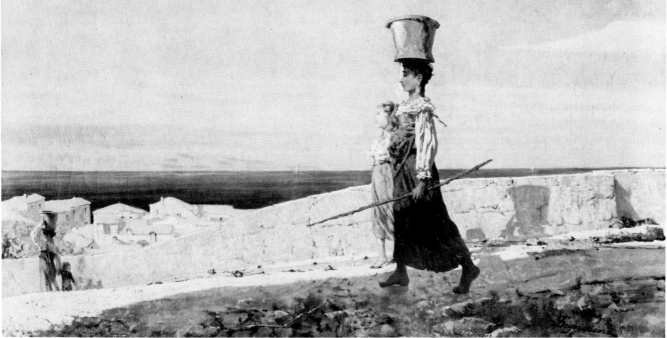

Above left
FRANCESCO HAYEZ
Portrait of the Contessa Litta Greppi Albani
33¼in by 28in
Florence Lit 8,500,000 (£5,500; $13,750). 24.V.73
From the collection of Conte Francesco Castelbarco Albani

Above right
JAMES JOSEPH TISSOT
The heron
Signed, 35½in by 23in
Los Angeles $32,000 (£12,800). 9.IV.73

Below
TELEMACO SIGNORINI
Returning from the well
Signed twice, 24in by 47in
London £11,000 ($27,500). 28.II.73

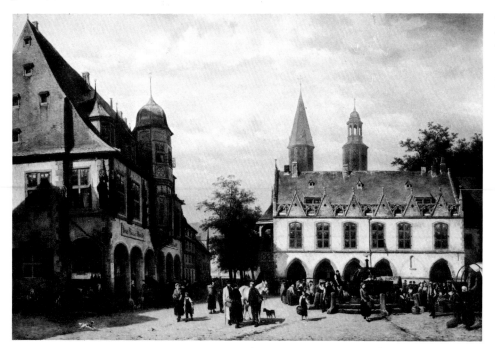

CORNELIUS SPRINGER
*A view in the Square of the
Hotel Kaiser Worth*
Signed and dated 1879,
37in by 55½in
London £24,000 ($60,000).
28.11.73

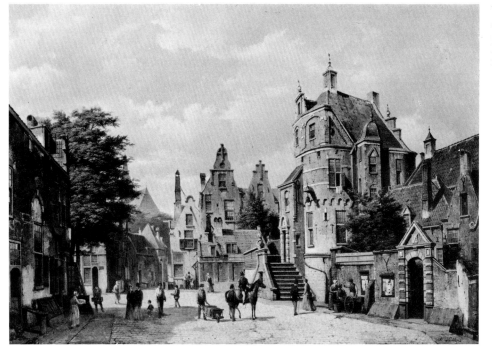

WILLEM KOEKKOEK
A street scene in a Dutch town
Signed, 31½in by 47¼in
London £30,000 ($75,000).
28.11.73

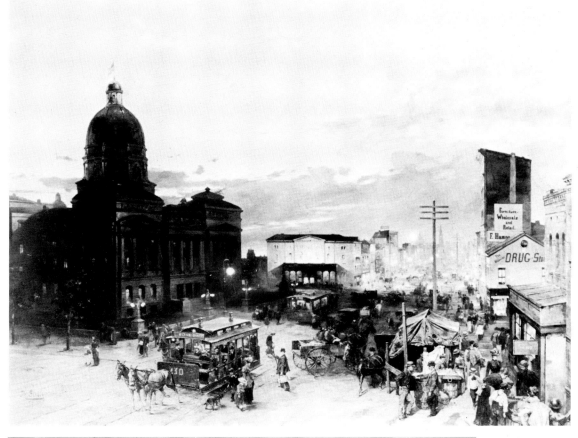

Above
THEODOR GROLL
An extensive view down
Washington Street,
Indianapolis, at dusk
Signed and inscribed
D.F. (Düsseldorf),
76in by 98½in
London £18,000 ($45,000).
8.XI.72
From the collection of
E. Jetter Esq

Below
EUGENE DE BLAAS
The wedding breakfast
On panel, signed and dated
1881, 26in by 35¾in
London £9,500 ($23,750).
8.XI.72
From the collection of
J. Levy Esq

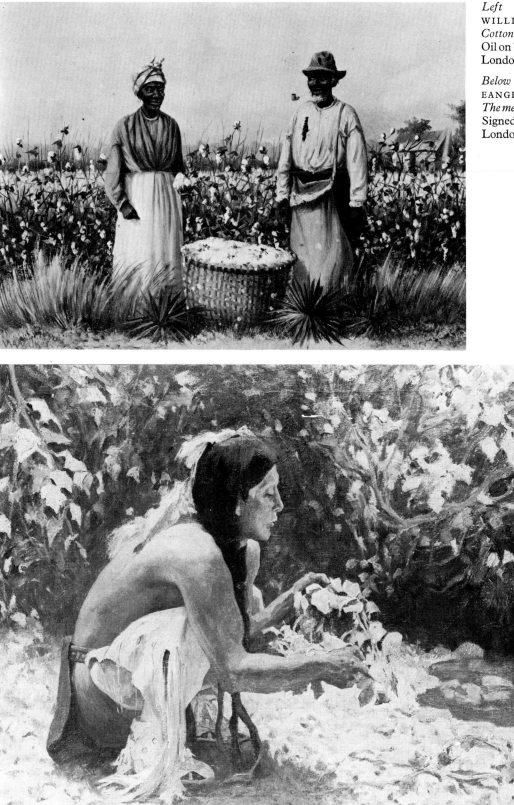

Left
WILLIAM AIKEN WALKER
Cotton pickers
Oil on board, signed, 8½in by 11⅞in
London £1,200 ($3,000). 20.III.73

Below
EANGER-IRVING COUSE, NA
The medicine picker
Signed, 23¾in by 28¾in
London £1,050 ($2,625). 20.III.73

Above
JASPER FRANCIS CROPSEY, NA
Indian Summer on the Susquehanna
Signed, dated 1861, 23¾in by 40¾in
London £8,000 ($20,000). 20.III.73
From the collection of Mrs E. Willis

Below
ENGLISH SCHOOL, NINETEENTH CENTURY
A view of a town thought to be Cholula in the state of Puebla
Oil on board, *circa* 1840, 10in by 19¼in
London £600 ($1,500). 20.III.73

Above
JOHN BARR CLARKE HOYTE
Sydney Harbour
Watercolour, signed,
circa 1880
14in by 22½in
London £580 ($1,450).
20.III.73

Left
SIR HANS HEYSEN
Landscape with gum trees
Watercolour, signed, dated
1948, 12¾in by 15⅝in
London £540 ($1,350).
20.III.73

Above
GEORGE FRENCH ANGAS
*Pepepe, Church Missionary
Station on the Waikato river*
Watercolour, inscribed
Pepepe, 5⅞in by 8⅝in
London £800 ($2,000).
20.III.73

Left below
GEORGE FRENCH ANGAS
Motupoi Pah with Tongariro
Watercolour, inscribed,
9in by 12¾in
London £1,150 ($2,875).
20.III.73

Opposite above
THOMAS W. BOWLER
View of Camps Bay
Watercolour, heightened with white, signed, dated 1859, 9¼in by 22¼in
Johannesburg R. 4,800 (£2,400; $6,000). 11.x.72

Opposite below
THOMAS W. BOWLER
View from Mr Kuhr's garden in Rondebosch looking across the Cape Flats
Pencil and watercolour, heightened with white, 12¾in by 18¾in
Johannesburg R.5,000 (£2,500; $6,250). 11.x.72

Below
THOMAS W. BOWLER
View of Table Bay from the sea
Watercolour, heightened with white, signed, dated 1859, 15½in by 23¼in
Johannesburg R.11,500 (£5,750; $14,375). 11.x.72
The drawings illustrated on this and the opposite page come from the collection of Mrs E. D.
Savory, granddaughter of Mr Conrad Wilhelm Kuhr who acquired the drawings from the artist

EASTMAN JOHNSON, NA
The wounded drummer boy
Signed, painted *circa* 1870, 46in by 37in
New York $125,000 (£50,000). 11.IV.73
From the collection of Baron M. L. van Reigersberg Versluys

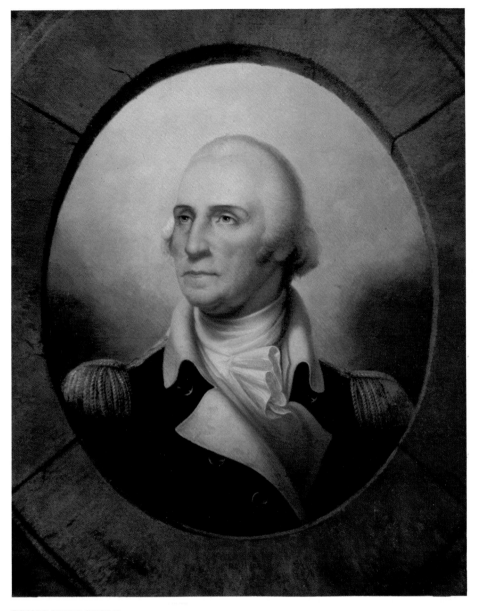

REMBRANDT PEALE
Portrait of George Washington
Signed, 36in by 29in
New York $82,500 (£33,000). 19.X.72

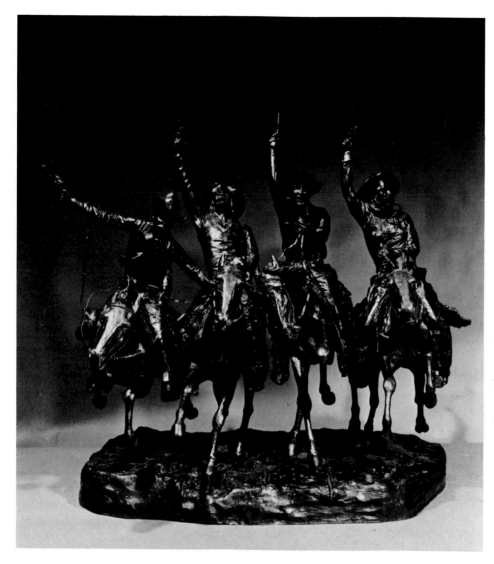

FREDERIC REMINGTON, ANA
Coming through the Rye
Bronze, brown patina, signed
and copyrighted 1902,
height 28½in, length 33½in
New York $125,000
(£50,000). 19.X.72

Opposite page
Above
CHARLES M. RUSSELL
Captain Lewis meeting the
Shoshones
Water and gouache, signed
and dated 1903,
14in by 20½in
New York $45,000 (£18,000)
19.X.72
From the collection of
Fred A. Rosenstock

Below
CHARLES M. RUSSELL
When the trail was long
between camps
Watercolour and gouache,
signed and dated 1901,
11½in by 17½in
New York $45,000 (£18,000)
19.X.72
From the collection of
Fred A. Rosenstock

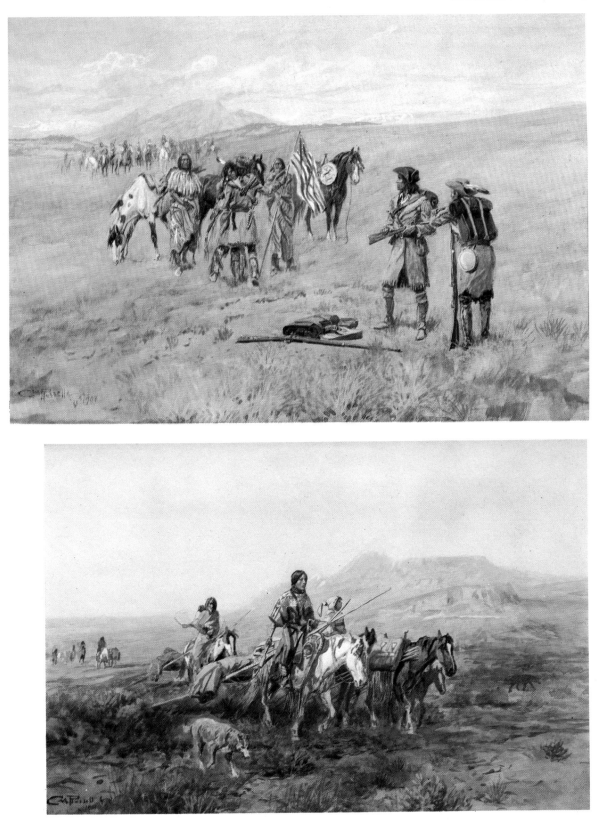

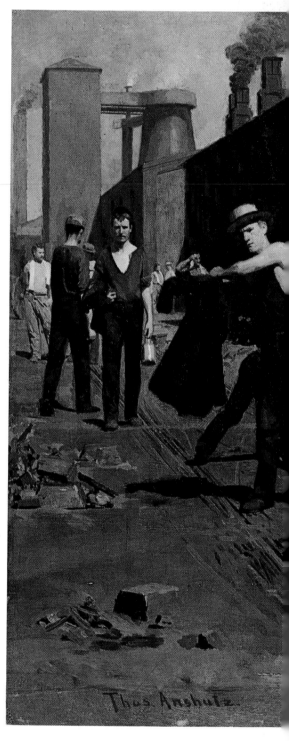

THOMAS POLLOCK ANSHUTZ
Steelworkers – Noontime
Signed, painted *circa*
1880–82, 17in by 24in
New York $250,000
(£100,000). 18.X.72
From the collection of
Dr and Mrs Irving F. Burton

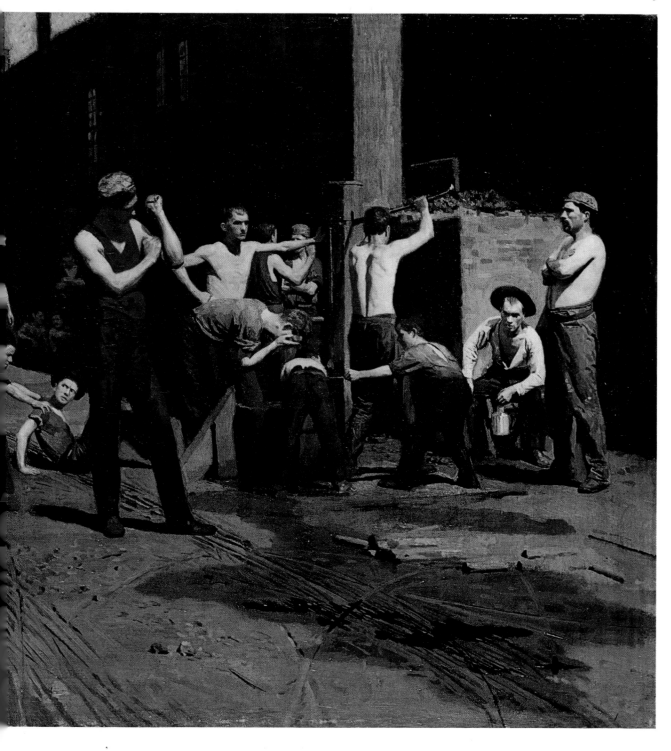

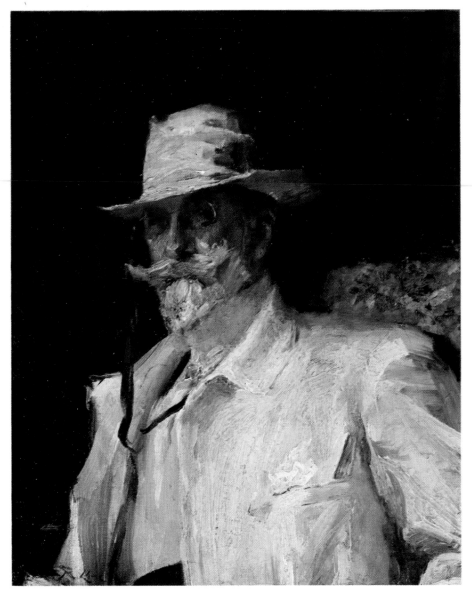

WILLIAM MERRITT CHASE, NA
Self-portrait
Signed, 30in by 25in
New York $47,500 (£19,000). 11.IV.73

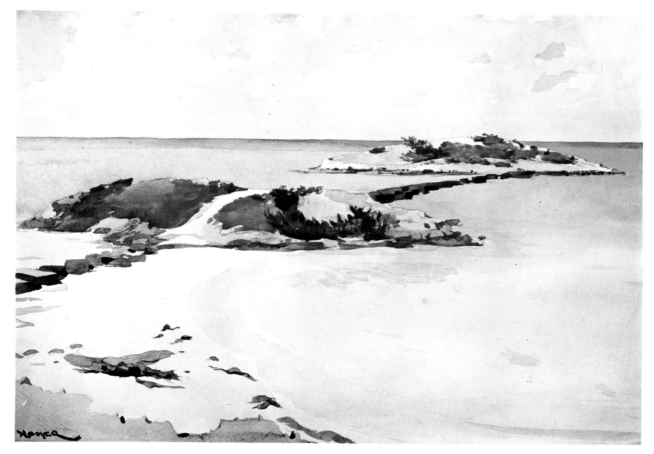

WINSLOW HOMER, NA
Gallows Island (Bermuda)
Watercolour, signed, painted *circa* 1899/1901, 13½in by 20½in
New York $65,000 (£26,000). 19.X.72
From the collection of the late O'Donnell Iselin of New York

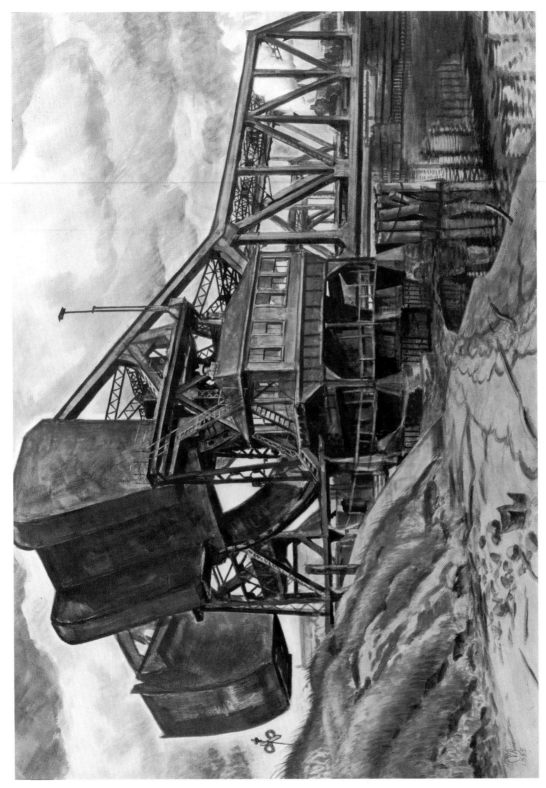

CHARLES BURCHFIELD, NA
Black iron (Erie and New York Central Railroad Bridges over Buffalo River)
Watercolour, signed with monogram and dated 1935, 29in by 41in
New York $65,000 (£26,000). 18.x.72
From the collection of Dr and Mrs Irving F. Burton

EDWARD HOPPER
Light at Two Lights
Watercolour, signed and inscribed *Two Lights, Me.*, painted in 1927, 14in by 20in
New York $50,000 (£20,000). 18.x.72
From the collection of Dr and Mrs Irving F. Burton

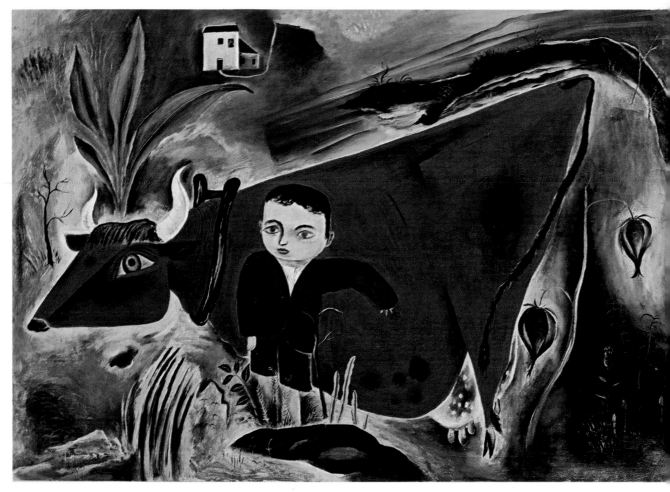

YASUO KUNIYOSHI
Little Joe with cow
Signed and dated '23, 28in by 42in
New York $220,000 (£88,000). 14.III.73
From the collection of Edith G. Halpert

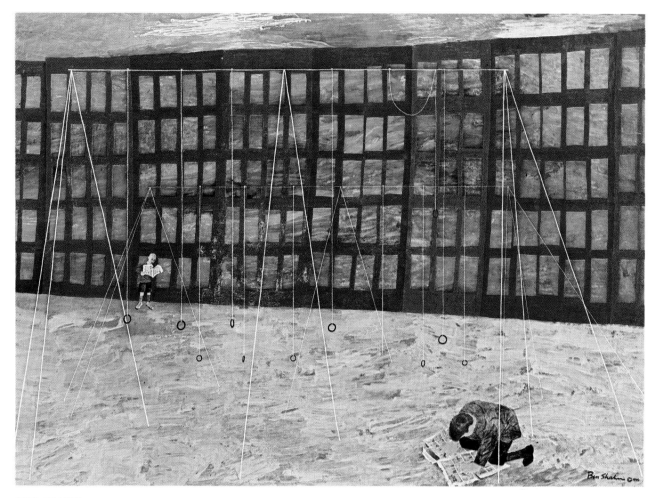

BEN SHAHN
World's greatest comics
Tempera on panel, signed and dated © 1946, 35in by 48in
New York $90,000 (£36,000). 14.III.73
From the collection of Edith G. Halpert

Twentieth-century American Paintings and the Edith G. Halpert collection

BY ROXANA B. ALGER

The week before the Edith G. Halpert sale of twentieth-century American paintings at Parke-Bernet, we received a telephone call from a dealer in French Impressionist paintings, who said that he had never bought American paintings as he did not particularly like them, but then inquired, almost apologetically, about some of the pictures in this sale, asking us whether we thought, as he did, that they were rather good. When we agreed with him, he tried to explain his apparent inconsistency by saying: 'They're not really very American, are they?'

The notion that 'good paintings' exclude American works is one that has been upheld among artists, critics and museums for more than two centuries. This is evident when one considers that the focus of the collections in our major institutions has been overwhelmingly European until very recently.

Just after the turn of the century, when European artists were beginning to express themselves in abstract forms, rebelling against the lyricism of the Impressionists, American painters were still firmly entrenched in the traditions of representational art. Although a handful of American painters were involved in the abstract movement in Europe, it was not until the Armory Show of 1913 that there was any significant response to the new school in this country. In the *avant-garde* of the American modern movement were Georgia O'Keeffe, Arthur G. Dove, John Marin, Marsden Hartley, Stuart Davis, Alfred Maurer, Charles Sheeler, Max Weber, and Charles Demuth. Although most of these painters were students of the schools of William Merritt Chase and Thomas Eakins, they were more radically affected by the revelation of 1913 than by the best of the traditional art of nineteenth-century America. The Armory Show offered a plethora of new ideas, and as a result abstract painting both here and abroad took on many forms. These Americans, however, moved in a direction of their own and, pursuing individual goals, formed a new movement in American art.

As this movement began to achieve momentum, two important figures came forward in its support: Gertrude Vanderbilt Whitney, a collector and dedicated patron of the arts, and Alfred Stieglitz, a talented photographer of enormous energy and diverse interests. Stieglitz opened the well-known '291 Gallery', and, undeterred by the public's indifference, sometimes even ridicule, showed and encouraged the work of the nascent American movement. Gertrude Whitney, intrigued and excited by the paintings, collected them and encouraged her friends to do the same. In the 1940s the entire Stieglitz stable was taken on by Edith Gregor Halpert, who had shown works by John Sloan, John Marin, Arthur G. Dove and other members of the group since the 1920s.

Using the concept of abstraction that the Armory Show had illustrated, the

Stieglitz-Halpert group absorbed the ideas but discarded the methods of the Europeans. While the image of expressive form was explored, the sombre colours and geometric shapes of Cubism were rejected. American subject matter became all-important: scenes with a specifically American content were treated with level-headed clarity and a careful precision of form. John Marin and Joseph Stella expressed the resounding harmonies of the steel construction lines of the Brooklyn Bridge, Charles Sheeler returned to the primitive elements of the landscape, the long clean outlines of eighteenth-century farmbuildings and the dynamic austerity of the burgeoning industrial scene. Georgia O'Keeffe and Arthur Dove became involved with the celebration of the land forms themselves, painting vibrant biomorphic and geological shapes. Stuart Davis explored the physical nature of American life, using bold poster-paint colours to compose complex and intricate patterns from everyday objects.

There is a fine, keen excitement in these paintings, and an awareness of a fresh new landscape. The best of them are sparse and clean, the forms forthright and the colours vigorous, the products of an art that is serious and self-assured.

The response of the auction market to the paintings in Edith Halpert's collection was predictable, although no one quite foresaw the fever pitch that was to be reached. The collection was an eclectic one, containing nearly one thousand paintings and drawings. Naturally not all of them were of top quality, but Mrs Halpert had a

CHARLES SHEELER
White sentinels
Tempera on paper. Signed and dated 1942. 14¾in by 22in
New York $65,000
(£26,000). 14.III.73

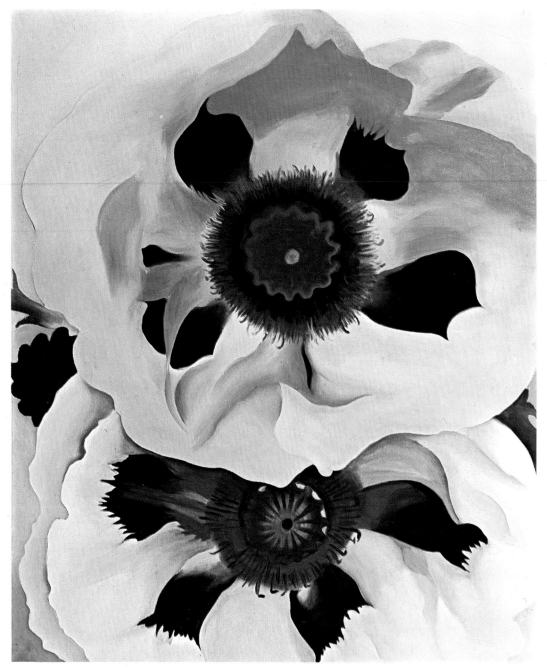

GEORGIA O'KEEFFE
Poppies
Painted in 1950. 36in by 30in
New York $120,000 (£48,000). 14.III.73

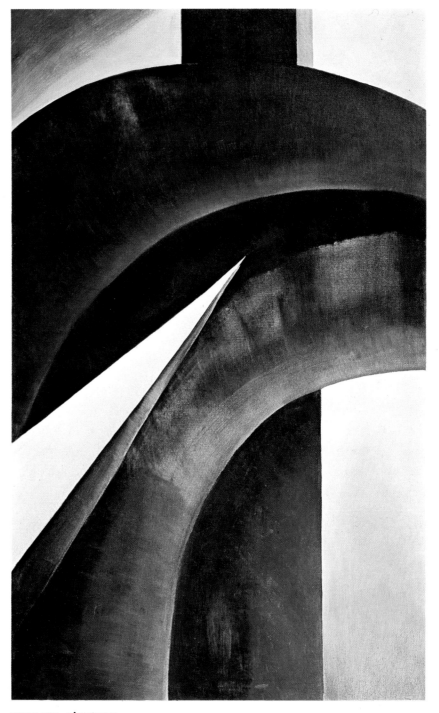

GEORGIA O'KEEFFE
Black white and blue
Signed, titled and dated 1930. 48in by 30in
New York $47,000 (£18,800). 14.III.73

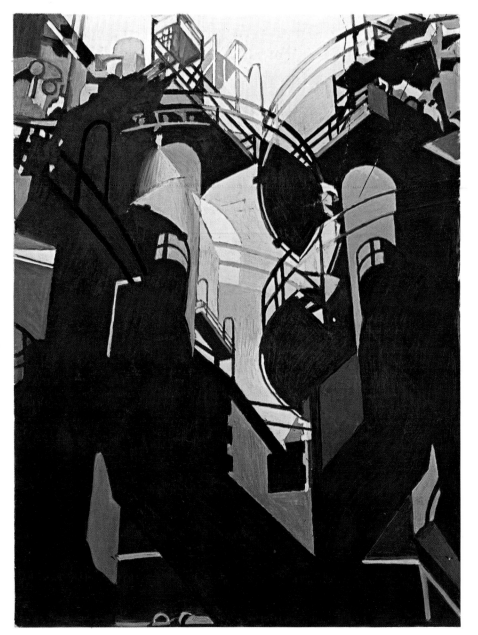

CHARLES SHEELER
Ore into iron
Tempera on plexiglass.
Painted in 1953. Another
version of this subject was
painted in oil in 1953. 9in by
6¾in
New York $18,000
(£7,200). 14.III.73

Opposite above
CHARLES SHEELER
Wind, sea and sail
Signed and dated '48. 20in by
24in
New York $75,000
(£30,000). 14.III.73

Opposite below
JOHN MARIN
*Movement : boat off Deer Isle,
Maine No 7*
Watercolour. Signed and
dated '26. 15in by 21in
New York $47,500
(£19,000). 14.III.73

discerning eye, and the best pictures in her collection were among the most important works by these artists. These paintings fetched high prices, the gross total of the sale, $3,670,675, was the largest ever reached by a single sale of American pictures at auction. Although the figures are not remarkable when compared with current prices for equivalent European works, American art has, at long last, come into its own. Its fresh, honest and energetic quality is neither a provincial effort nor the slavish copy of a more sophisticated school.

Some dealers in French paintings will still be reluctant to overcome their prejudice, but they will soon accept that *American* art is good and different.

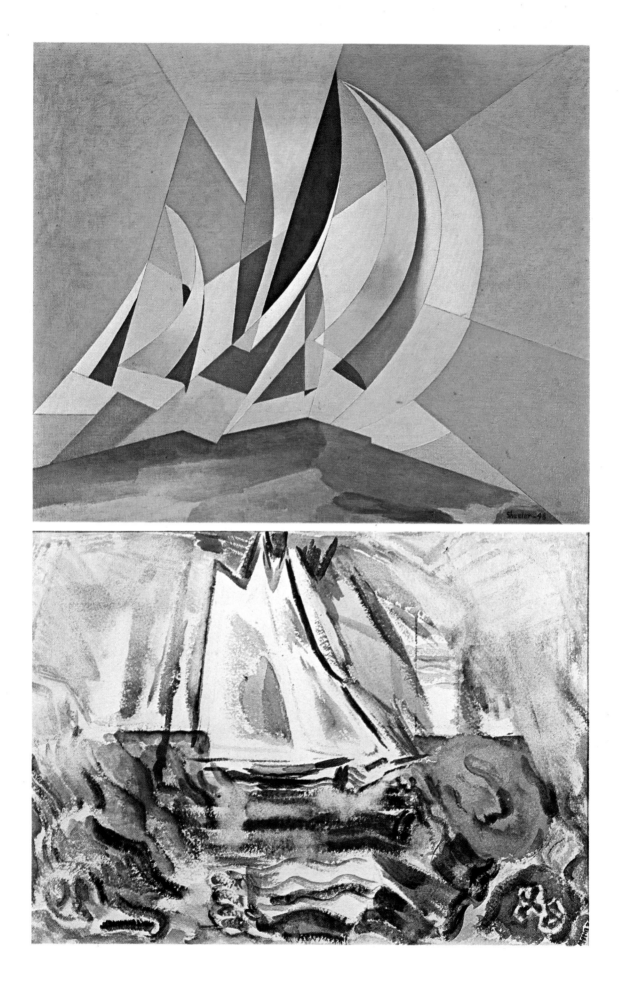

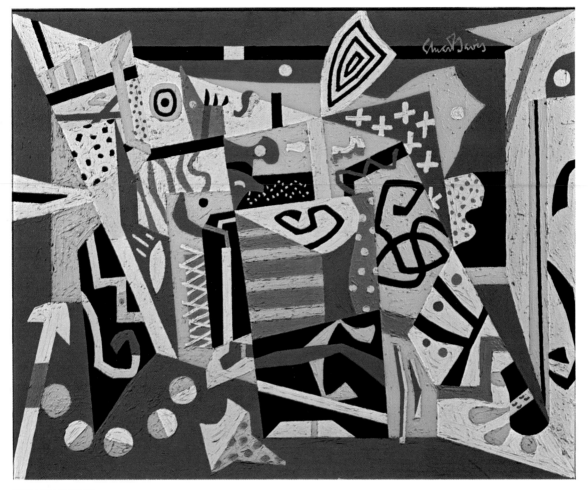

STUART DAVIS
Hot still-scape for 6 colours
Signed and dated *New York, Aug. 1940.* 36in by 45in
New York $175,000 (£70,000). 14.III.73

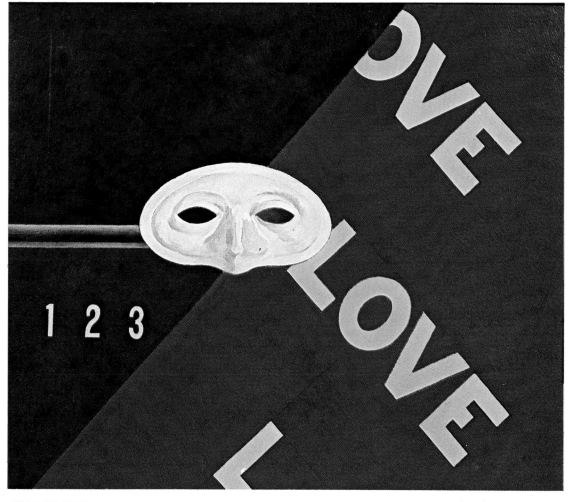

CHARLES DEMUTH
Love, love, love (homage to Gertrude Stein)
On board. Painted *circa* 1928. 20in by 23¾in
New York $32,500 (£13,000). 14.III.73

ELIE NADELMAN
Tango: a pair of figures
Painted gesso on wood, executed *circa* 1918. Height 33½in
New York $130,000 (£52,000). 14.III.73
From the Edith G. Halpert Collection

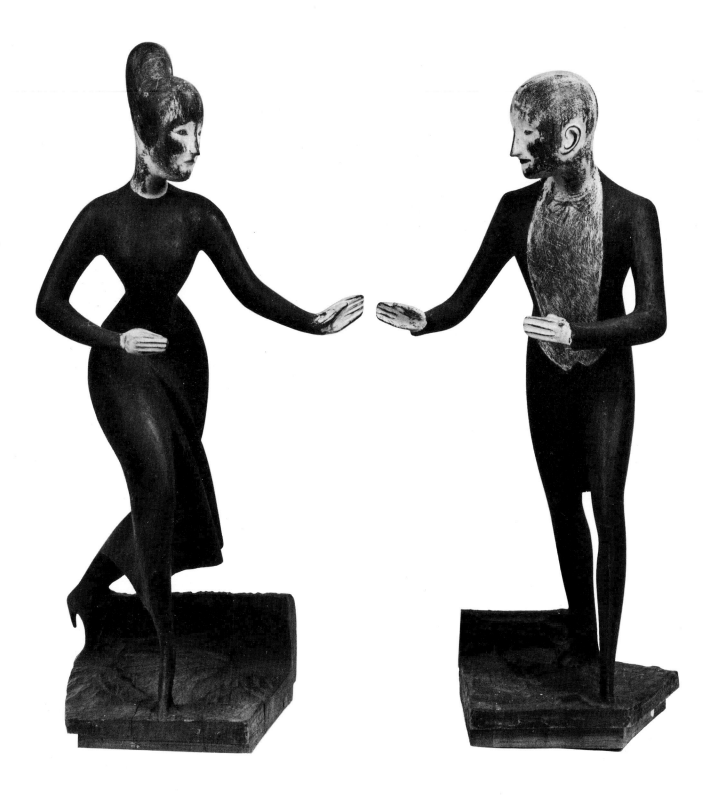

PAUL CEZANNE
Vase de tulipes
Oil on paper mounted on
board, painted *circa* 1890–2,
28in by 16½in
New York $1,400,000
(£560,000). 2.v.73
From the Norton Simon
Collection

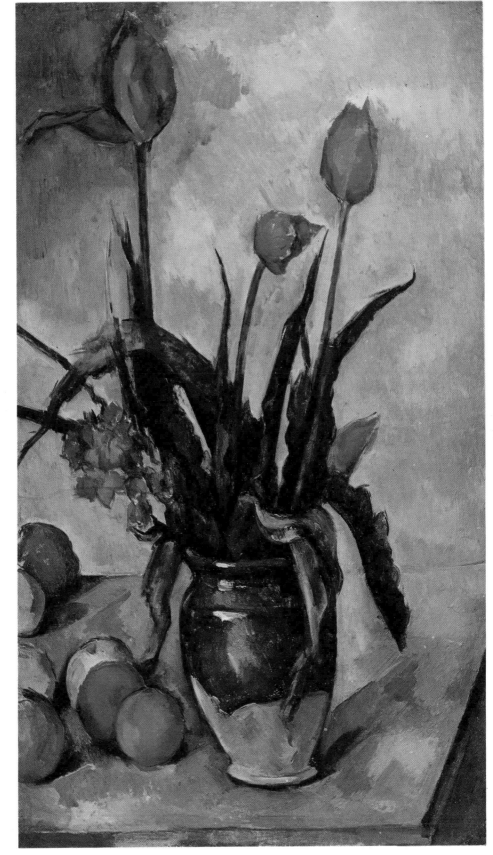

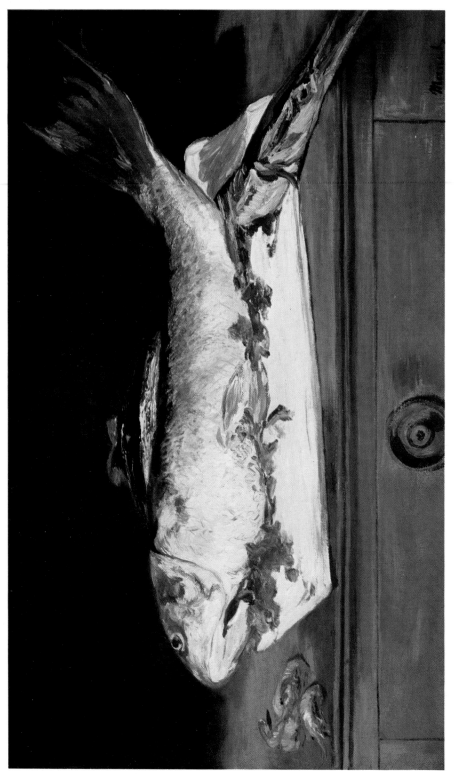

EDOUARD MANET
Nature morte aux poissons
Signed, painted in 1864, 17½in by 28¼in
New York $1,400,000 (£560,000). 2.v.73
From the collection of the Norton Simon Foundation

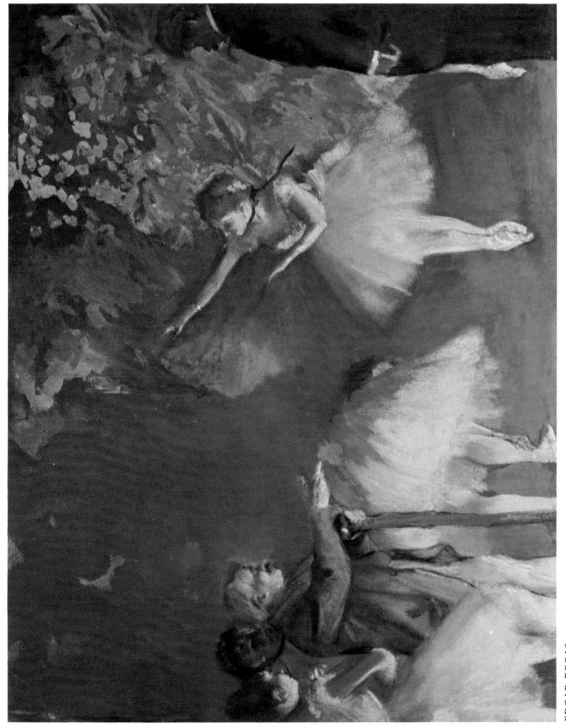

EDGAR DEGAS
Répétition de ballet
Gouache and pastel, signed, executed in 1875, 21¾in by 26¼in
New York $780,000 (£312,000). 2.v.73
From the Norton Simon Collection
Formerly in the collection of George C. Frelinghuysen, sold at Parke-Bernet in 1965 for
$410,000 (£146,370)

EUGENE BOUDIN
Crinolines sur la plage
On panel, signed and dated '68, 8in by 13⅞in
London £42,000 ($105,000). 28.III.73

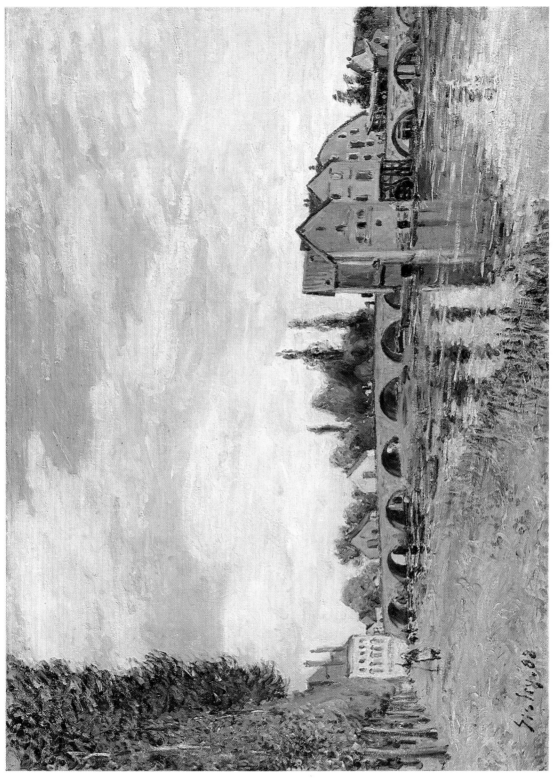

ALFRED SISLEY
Le Pont de Moret en Eté
Signed and dated '88, 21¼in by 28¼in
London £70,000 ($175,000). 29.XI.72

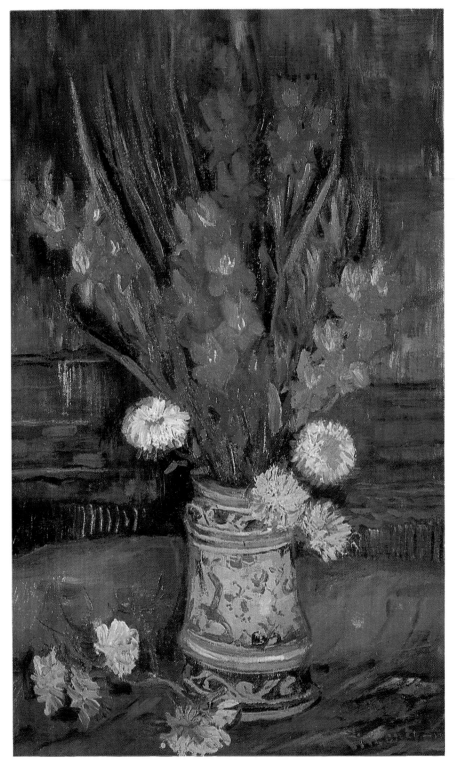

VINCENT VAN GOGH
Nature morte, glaïeuls
Signed, painted in Paris in the late summer of 1886, 25½in by 15¾in
London £113,000 ($282,500). 3.VII.73
From the collection of the late Dr A. Blum of Short Hills, New Jersey
Formerly in the collection of Hugo Perls, sold at Parke-Bernet in March 1944 for $11,000
(£2,750)

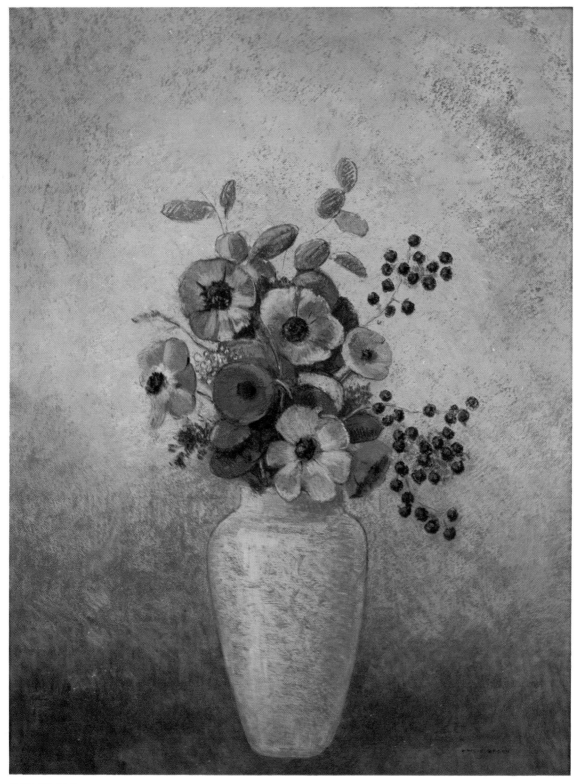

ODILON REDON
Vase de fleurs
Pastel, signed, executed *circa* 1912–16, 25½in by 20in
New York $225,000 (£90,000). 2.v.73
From the collection of the Norton Simon Museum of Art

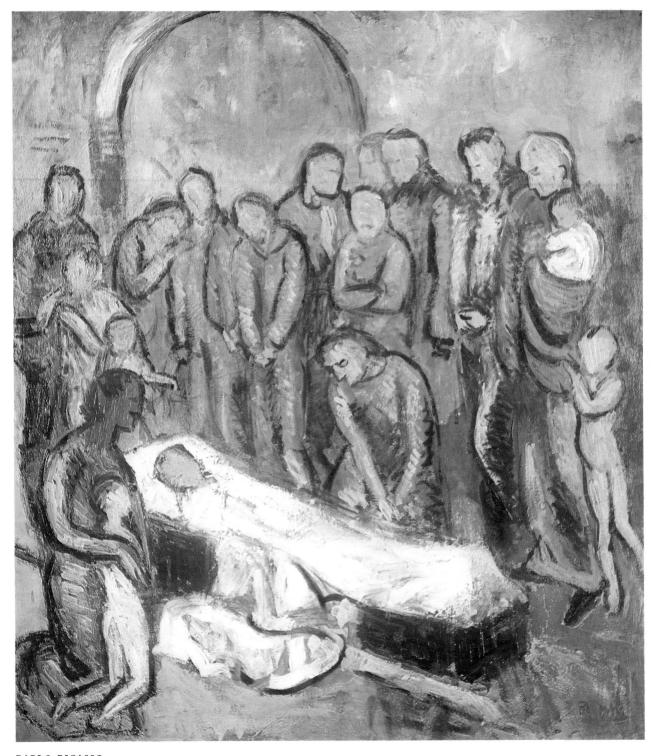

PABLO PICASSO
Le mort (la mise au tombeau)
Signed, painted in 1901, 39½in by 35⅝in
In the early spring of 1901 the poet Casagemas, who had accompanied Picasso to Paris, committed suicide. This painting is an allusion to the young painter's sorrow at the loss of his friend.
London £270,000 ($675,000). 3.VII.73
Formerly in the Edward G. Robinson Collection

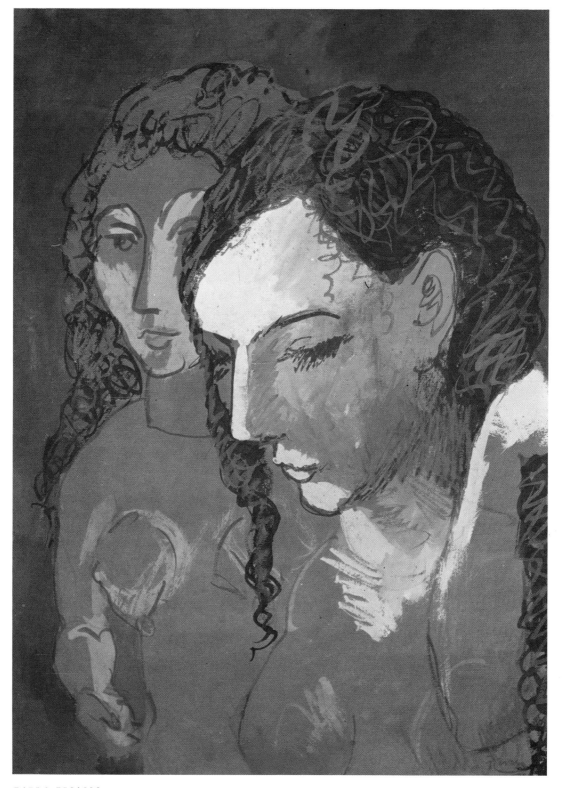

PABLO PICASSO
Deux têtes de femmes
Gouache on brown paper, signed, executed in 1905, 22½in by 16in
New York $250,000 (£100,000). 2.v.73
From the collection of the Norton Simon Foundation

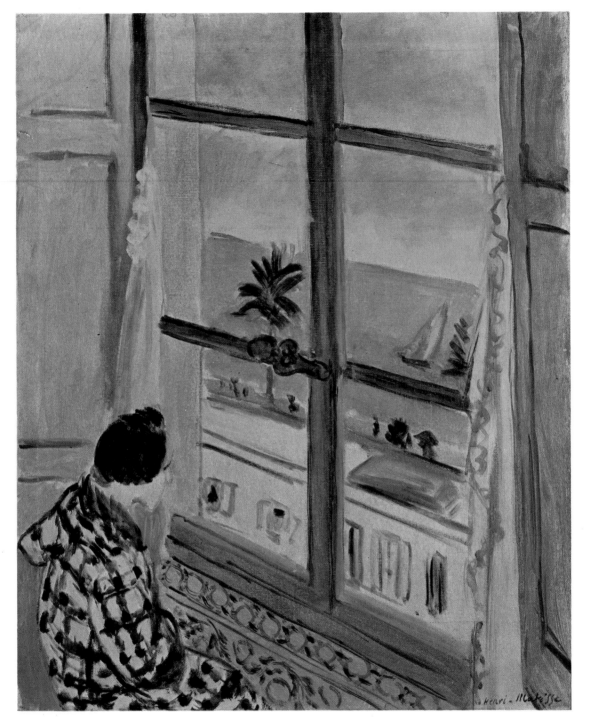

HENRI MATISSE
Femme à la fenêtre, Nice
Signed, painted in 1918, 28½in by 23½in
London £140,000 ($350,000). 4.VII.73
From the collection of Mrs Ernest W. Boissevain
 of Brattleboro, Vermont

Opposite page
Above
PIERRE BONNARD
Paris sous la neige (la Place Blanche)
Oil on paper laid down on canvas, signed, painted *circa* 1901, 22¾in by 31¼in
London £55,000 ($137,500). 3.VII.73
Formerly in the Edward G. Robinson Collection

Below
EDOUARD VUILLARD
Déjeuner du matin
On board, signed, painted *circa* 1902, 19¼in by 22¾in
London £45,000 ($112,500). 3.VII.73
Formerly in the Edward G. Robinson Collection

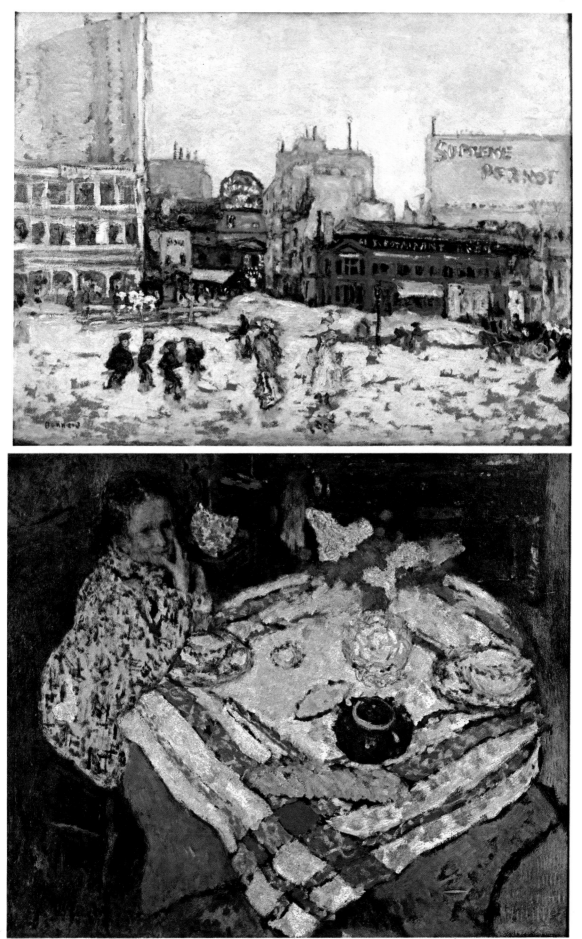

ANDRE DERAIN
Collioure
Signed, painted in 1905, 23¾in by 30in
New York $190,000 (£76,000). 25.x.72
From the Ritter Collection, New York

ALBERT MARQUET
La Passerelle de Sainte Adresse
Signed, painted in 1906, 15in by 24in
New York $130,000 (£52,000). 3.V.73
From the collection of Mrs Beverly Kean of New York

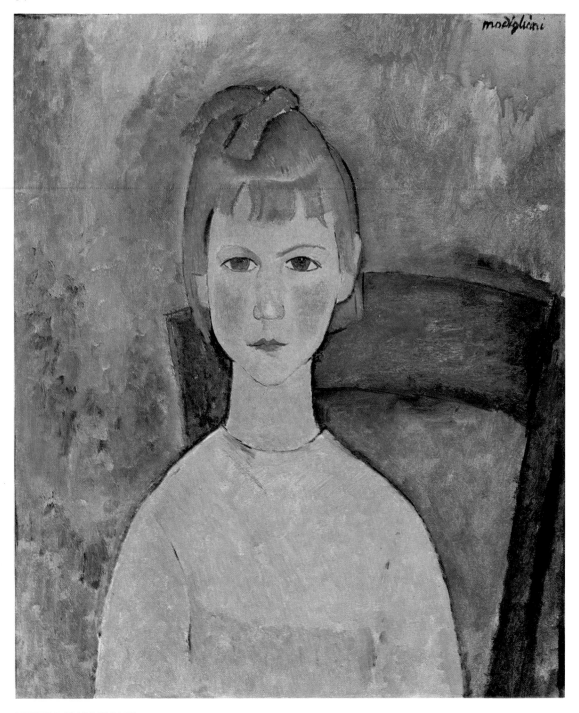

AMEDEO MODIGLIANI
La fillette en bleu
Signed, painted *circa* 1918, 21½in by 18in
London £100,000 ($250,000). 4.VII.73
From the collection of the late Lady Gollancz

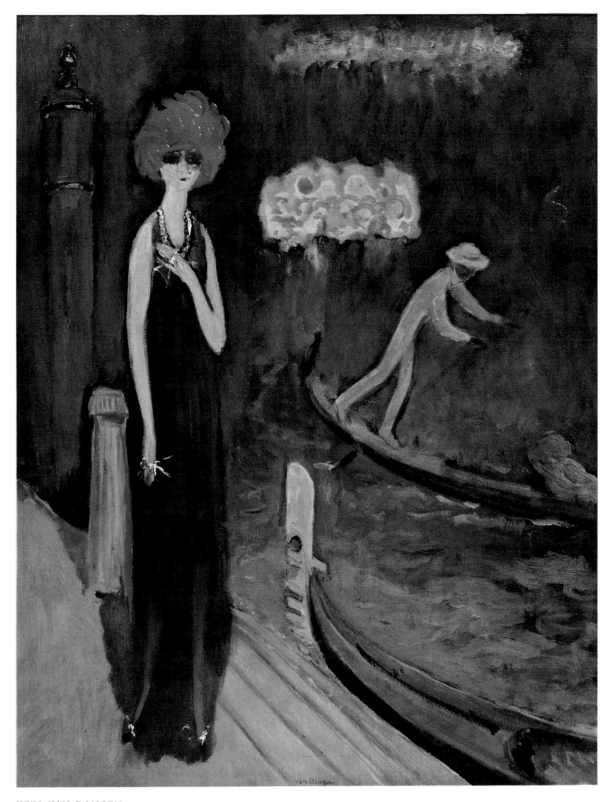

KEES VAN DONGEN
Le Quai, Venise
Signed, painted *circa* 1921, 36¼in by 28¾in
New York $120,000 (£48,000). 3.V.73
From the collection of the late Norman Norell of New York
Formerly in the collection of Mrs Alexander Lieberman sold at Parke-Bernet in February 1944
for $105 (£26)

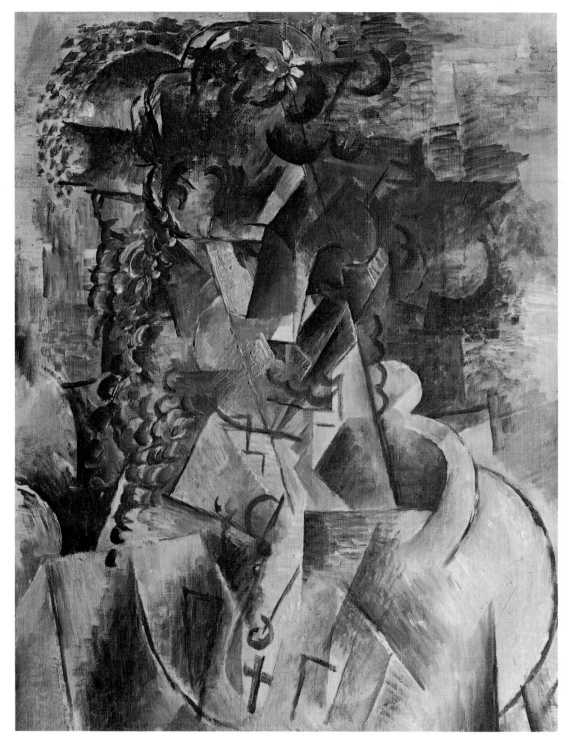

GEORGES BRAQUE
Buste de jeune fille (*Femme à la croix*)
Signed on reverse, painted in 1910, 21¾in by 17in
New York $270,000 (£108,000). 25.X.72
From the collection of Mrs K. Bralove

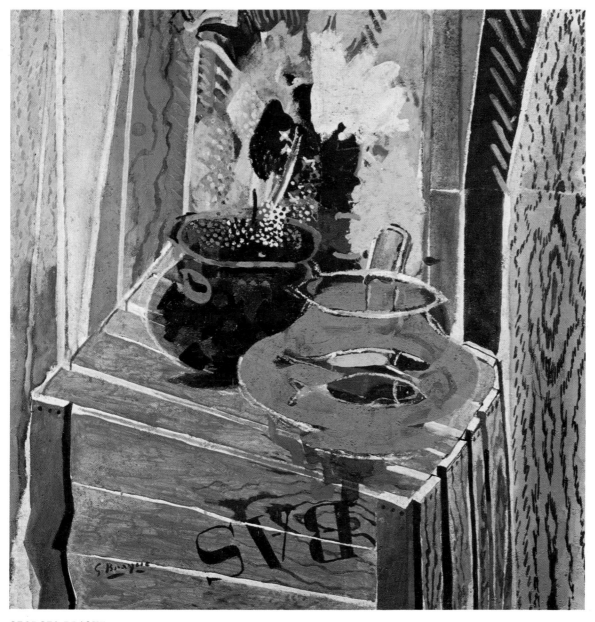

GEORGES BRAQUE
La caisse d'emballage
Signed, painted in 1947, 36¼in by 36¼in
New York $330,000 (£132,000). 3.v.73
From the collection of Mrs Ernest W. Boissevain of Brattleboro, Vermont

FERNAND LEGER
Nature morte (l'as de carreau)
Signed and dated 1927, also
signed, dated and titled on
reverse, 35½in by 28¼in
New York $155,000
(£62,000). 3.V.73
Previously sold at Parke-
Bernet in April 1972 for
$72,000 (£26,750)

Opposite page
Above
ALEXEJ JAWLENSKY
Landschaft bei Murnau
On board, signed in Russian
and dated '08, 15¾in by 12½in
London £30,000 ($75,000).
4.VII.73
From the collection of
Madame Clotilde Sakharoff
Below
HEINRICH CAMPENDONK
Pferde Komposition
On board, signed and dated
1912, 25in by 32in
London £16,000 ($40,000).
28.III.73
From the collection of
Dr Mensching of Osterhofen,
Niederbayern

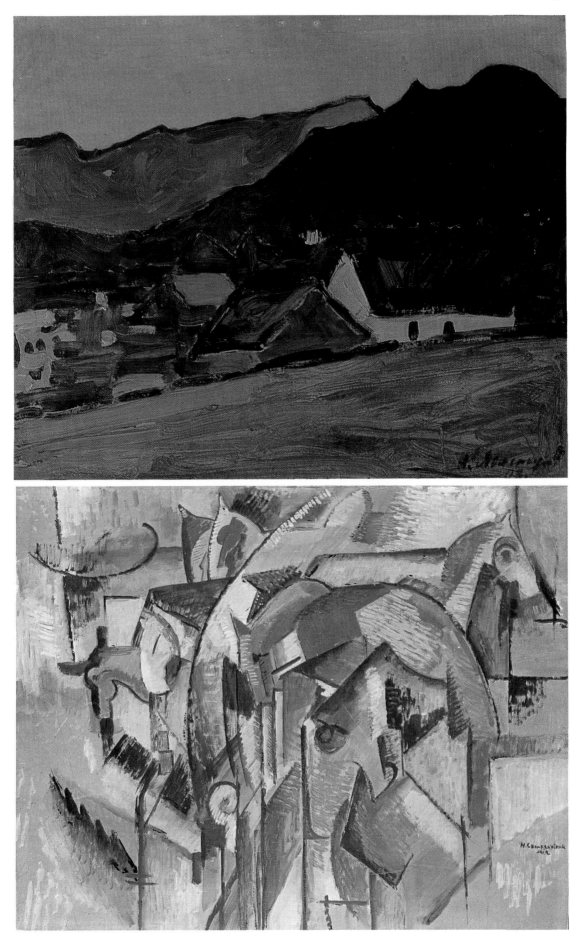

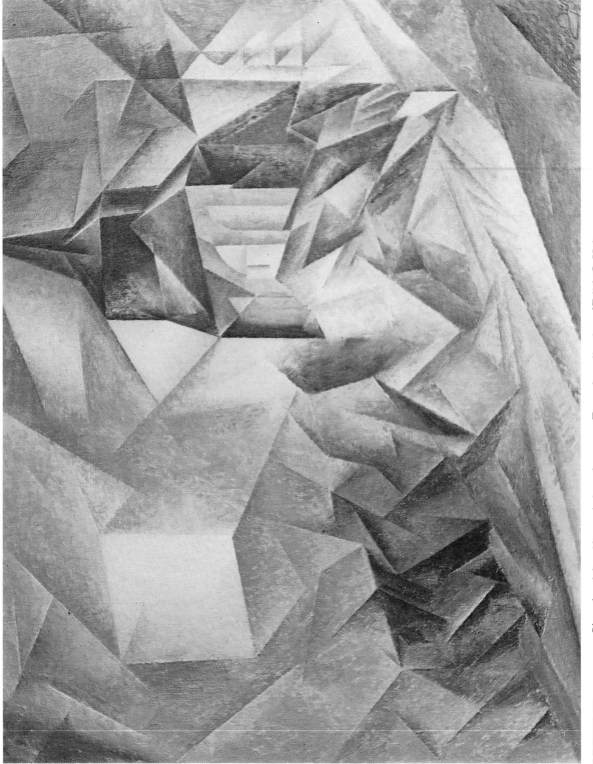

LYONEL FEININGER
Church (*Zirchow II*)

Signed and dated '13, 31in by 39in
New York $160,000 (£64,000). 14.III.73

From the collection of Edith G. Halpert
of New York

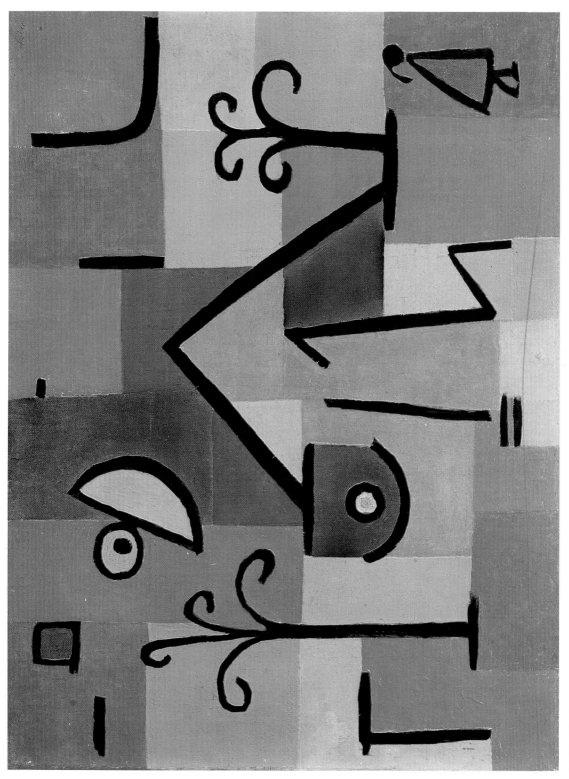

PAUL KLEE
Ostlich-süss
Oil on paper laid down on burlap, signed, titled and dated 1938
H 20 on the stretcher, 19¾in by 26in
London £128,000 ($320,000). 4.VII.73

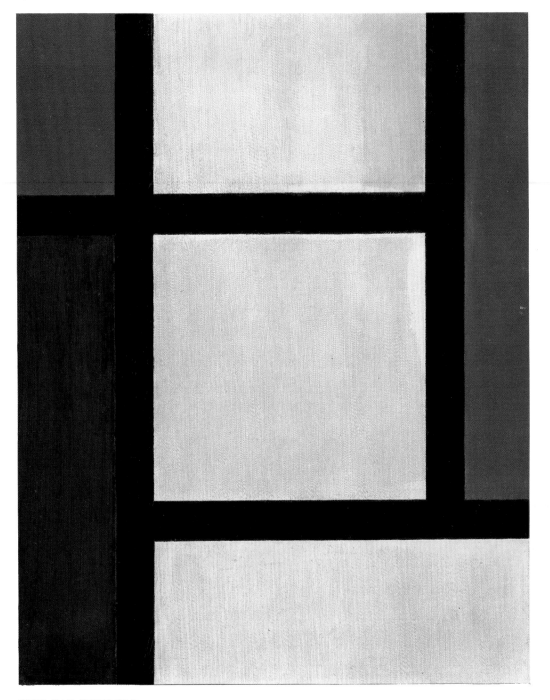

THEO VAN DOESBURG
Contra-composition
On panel, signed on reverse, painted *circa* 1927, 15¼in by 12¼in
London £29,000 ($72,500). 28.iii.73

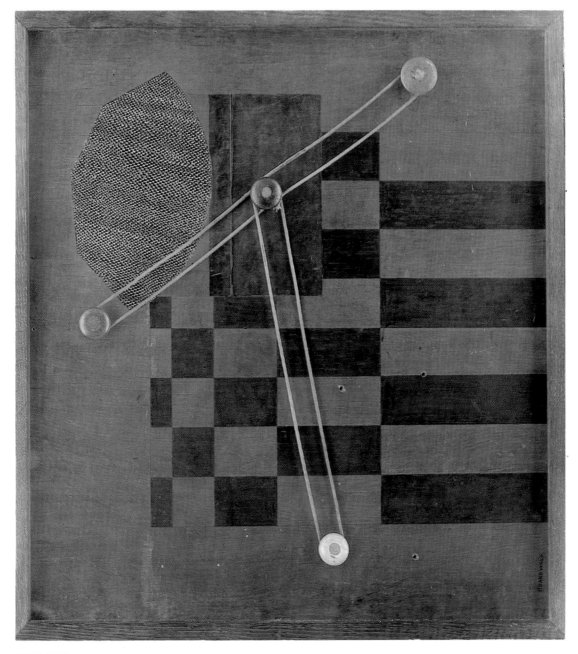

MAN RAY
Boardwalk
Oil on wood with furniture knobs, cord and bullet holes, signed, inscribed and dated 1917,
25½in by 28in
London £24,000 ($60,000). 28.III.73

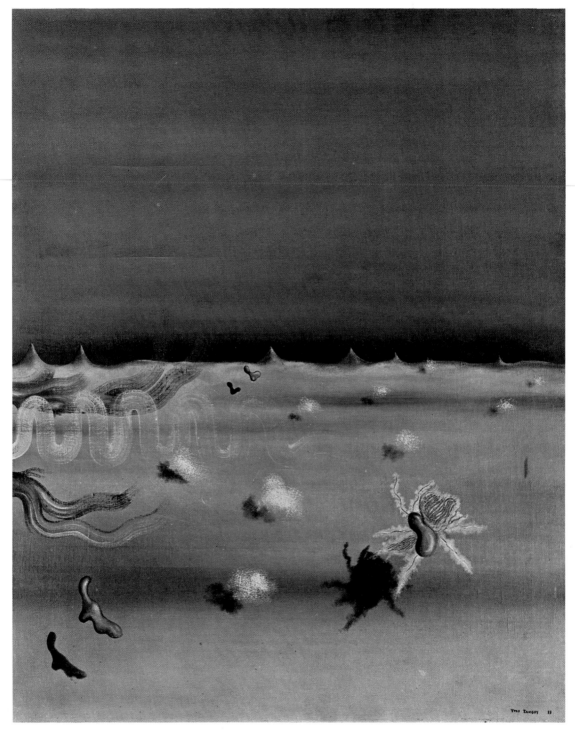

YVES TANGUY
Le regard d'ambre
Signed and dated '29, 39½in by 32in
London £80,000 ($200,000). 4.VII.73
Formerly in the collection of E. L. T. Mesens, London

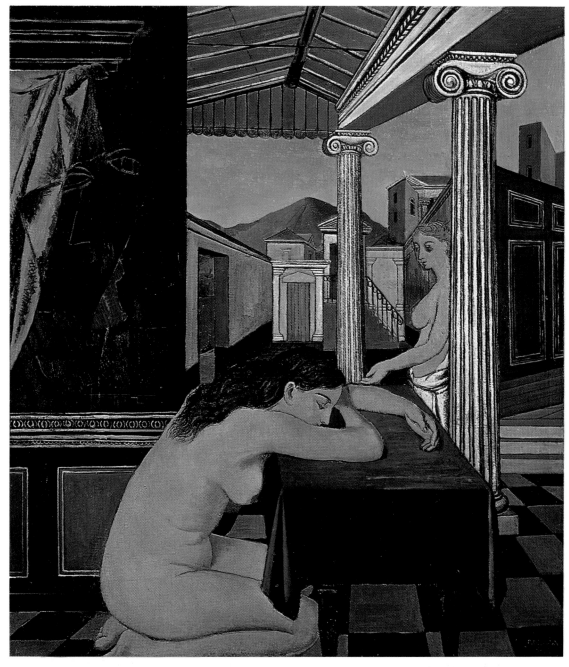

PAUL DELVAUX
La table
Signed and dated 5–46, 34in by 30in
London £34,000 ($85,000). 4.VII.73

RENE MAGRITTE
L'idée fixe
Signed, painted *circa* 1927, 32in by 45¼in
London £43,000 ($107,500). 29.XI.72

NICOLAS DE STAEL
Nature morte à la bouteille bleue
Signed, painted in 1954. 23in by 31¼in
London £47,000 ($117,500). 4.VII.73
From the collection of Mr and Mrs Arnoud Waller of Rotterdam

MAX ERNST
Les aveugles dansent la nuit
Signed and dated '56, 77¼in by 45in
London £33,000 ($82,500). 29.XI.72

VICTOR BRAUNER
Autoenroulement
Signed, titled and dated IV 1961, 31¼in by 25in
London £28,000 ($70,000). 4.VII.73

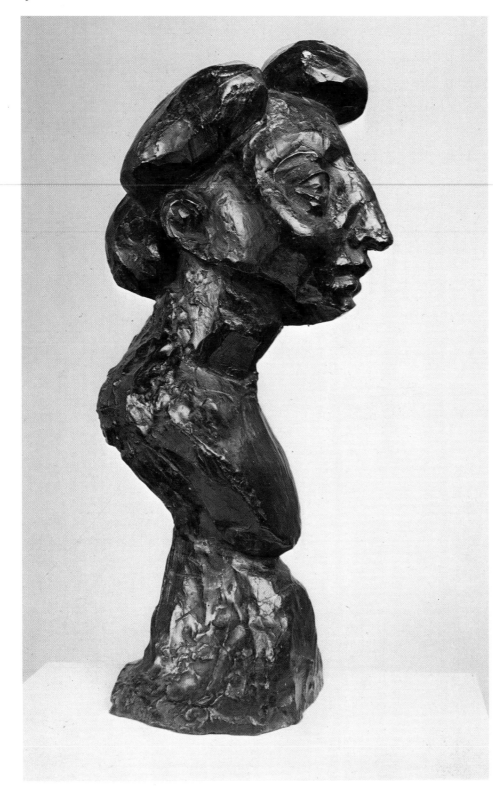

HENRI MATISSE
Jeanette III
Bronze, signed with initials, numbered 2 and stamped *Cire Perdue Valsuani*, height 24in
New York $160,000 (£64,000). 2.V.73
From the collection of the Norton Simon Foundation

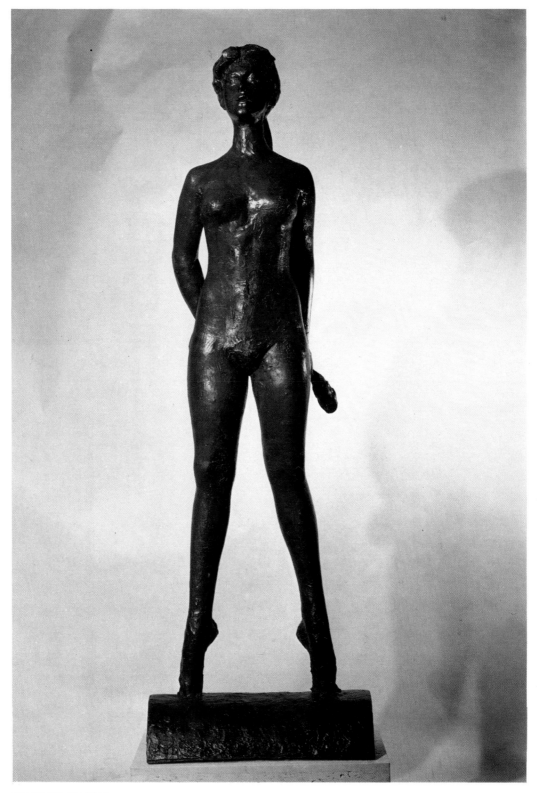

GIACOMO MANZU
Dance step
Bronze, signed and stamped *Manzu Fonderia Maf Milano*. Height 82in
New York $135,000 (£54,000). 2.v.73

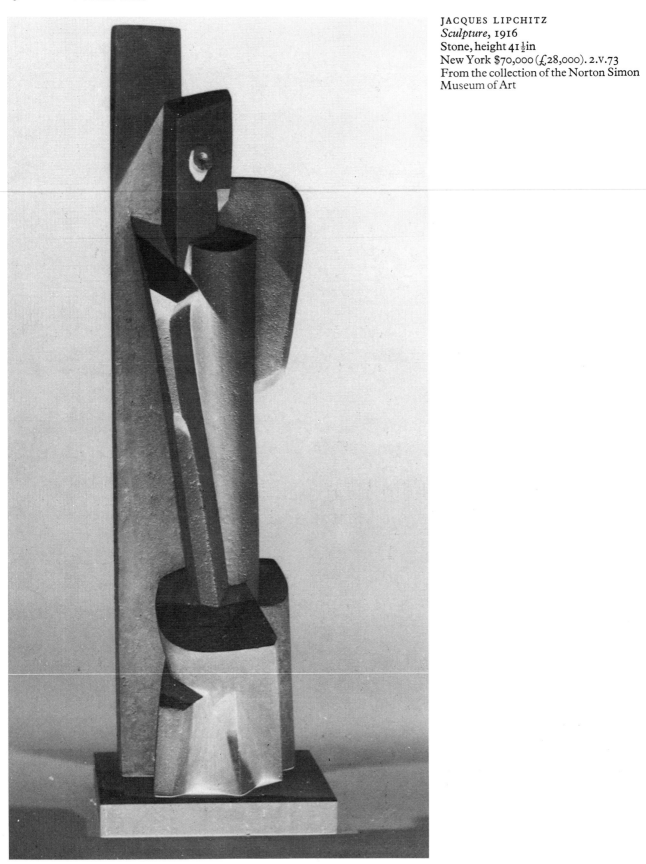

JACQUES LIPCHITZ
Sculpture, 1916
Stone, height 41½in
New York $70,000 (£28,000). 2.v.73
From the collection of the Norton Simon
Museum of Art

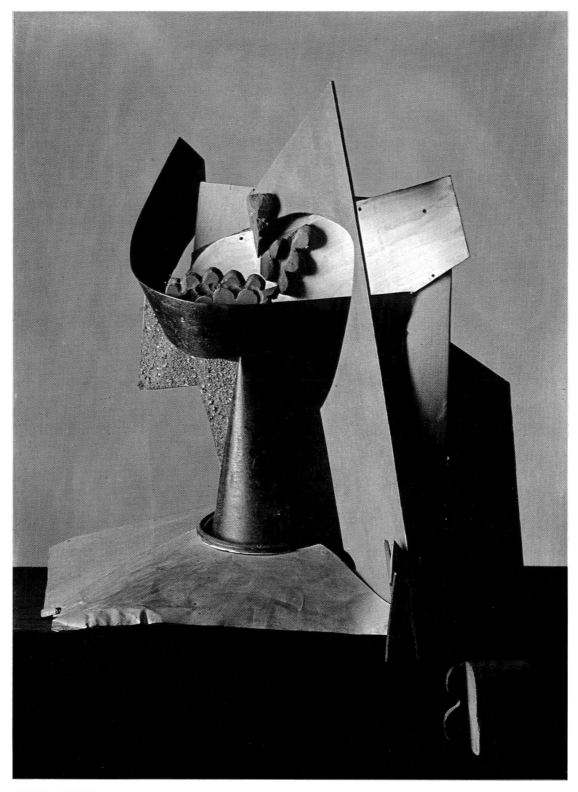

HENRI LAURENS
Compotier aux raisins
Painted wood and sheet metal, executed in 1918, height 25¼in
London £40,000 ($100,000). 28.III.73

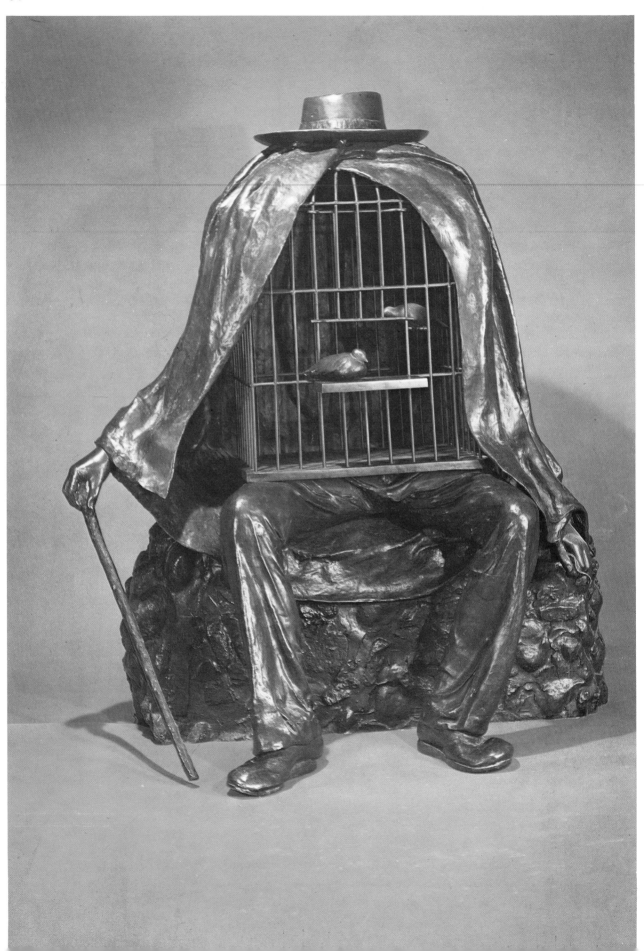

Opposite page
RENE MAGRITTE
Le Thérapeute
Bronze, signed and numbered 1/5, executed in 1967, height 63in
New York $80,000 (£32,000). 4.v.73

HENRY MOORE OM, CH
Rocking chair No. 1, 1950
Bronze, height 12¾in
London £28,500 ($71,250). 14.III.73

Left
MIKHAIL LARIONOV
Portrait of Tatlin
Painted *circa* 1907–9, 30¼in by 23¼in
London £10,500 ($26,250). 29.III.73

Centre
VASSILY ERMILOV
Window
Oil, metal and sand on shaped panel, executed in 1922, 27½in by 20¾in
London £5,000 ($12,500). 29.III.73

Right
DAVID BURLIUK
Sitting nude
Painted *circa* 1912, 32¾in by 26¾in
London £2,800 ($7,000). 29.III.73

Below right
ALEXANDER BOGOMAZOV
Composition in grey, black and white
Oil on canvas, signed with initials, dated 1916, 9¼in by 9½in
London, £1,250 ($3,125). 29.III.73

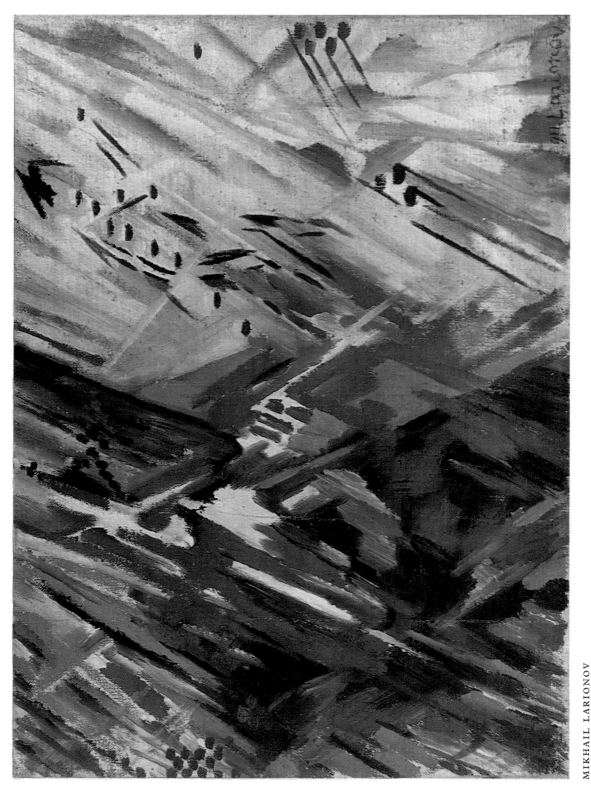

MIKHAIL LARIONOV
Rayonnism in red and blue (*Sea Beach – Red structure*)
Oil on canvas, signed; inscribed *Larionov, Moscow, 1911* on reverse, 21¼in by 27½in
London £22,000 ($55,000). 29.III.73

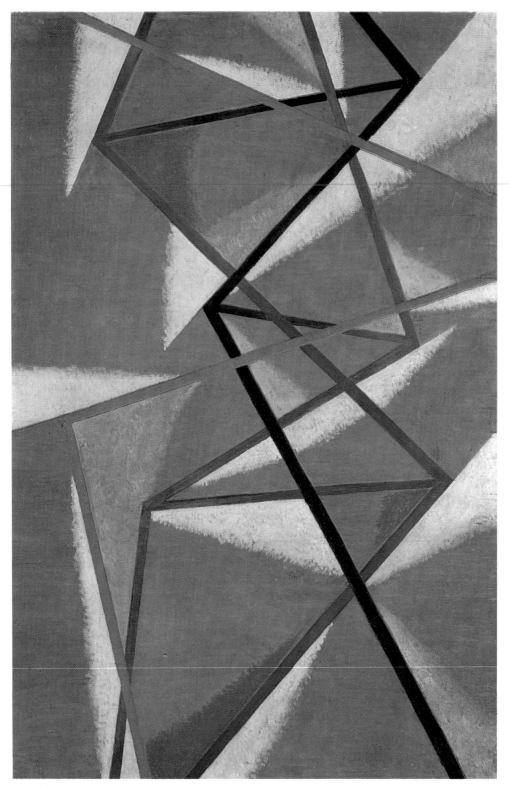

LIUBOV POPOVA
Constructivist composition
Oil on panel, inscribed in Russian *192–N80 L. POPOVA* on reverse, painted in 1921,
36½in by 24¼in
London £22,500 ($56,250). 29.III.73

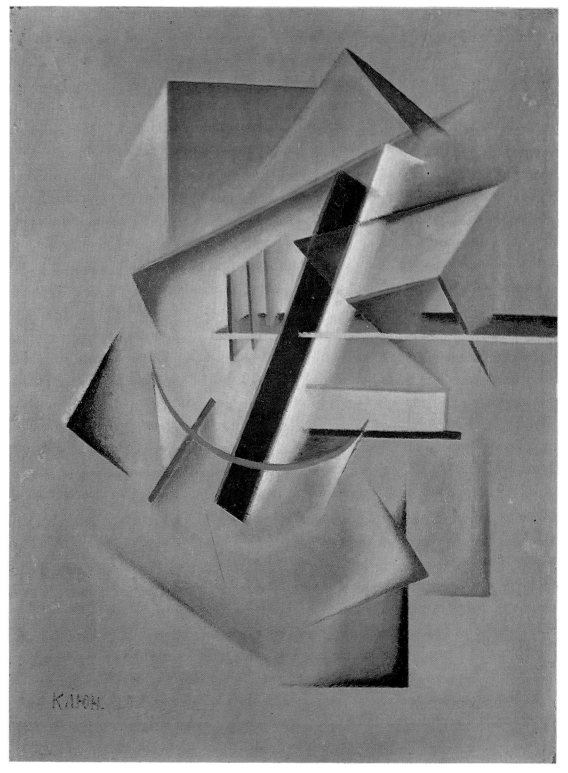

IVAN KLIUN
Architectonic composition
Oil on board, painted *circa* 1922, 21¾in by 16½in
London £17,500 ($43,750). 29.III.73

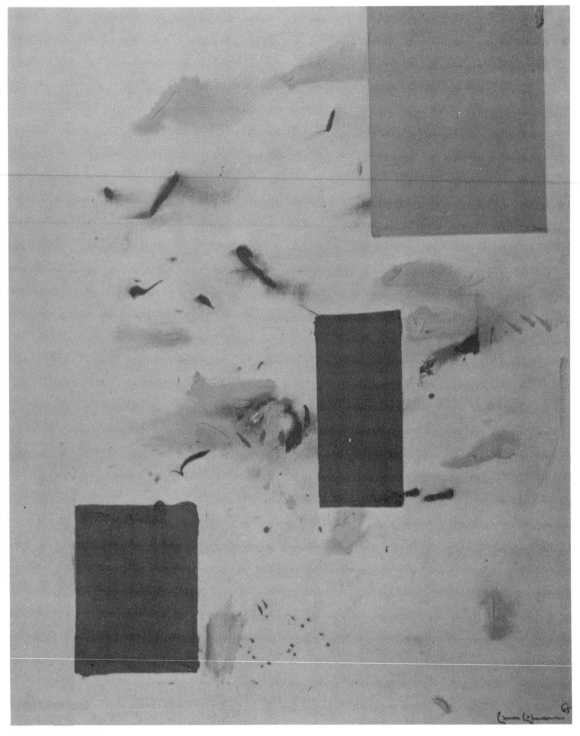

HANS HOFMANN
Joy Spark of the Gods
Signed and dated '65, 72in by 60in
New York $50,000 (£20,000). 4.v.73
From the collection of Mr and Mrs Kenneth Owen of Corpus Christi, Texas

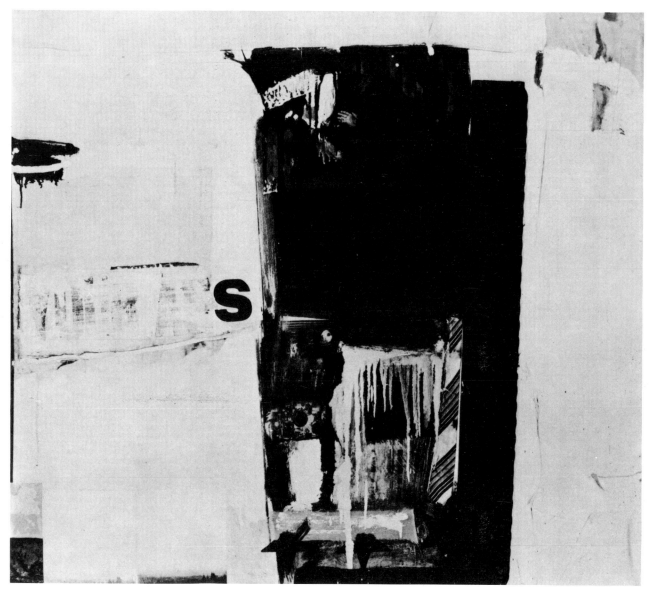

ROBERT RAUSCHENBERG
Photograph
Mixed media on canvas, signed on reverse and dated '59, 47½in by 55in
New York $70,000 (£28,000). 4.v.73
From the collection of Donald M. and Betty Weisberger of New York

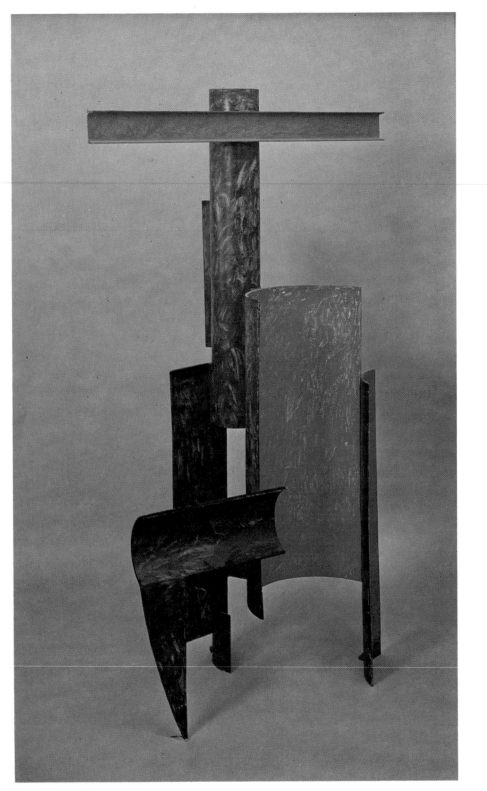

DAVID SMITH
Zig II
Painted steel, signed, titled and dated 2–18–1961, 100⅔in by 59¼in by 36½in
New York $80,000 (£32,000). 26.X.72

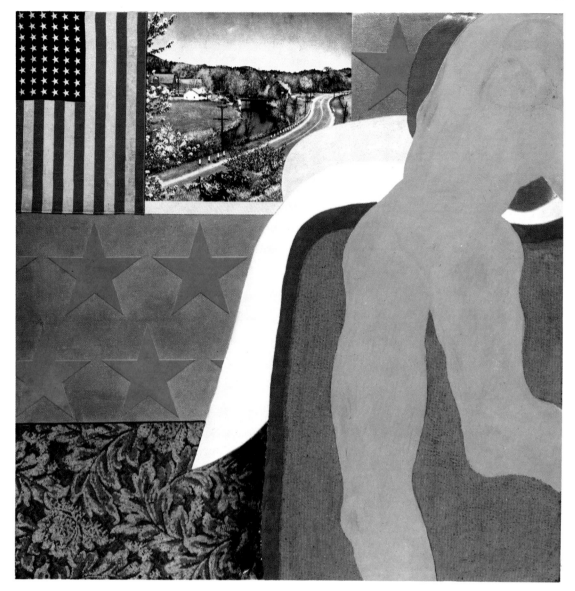

TOM WESSELMANN
The Great American Nude 5
Oil, collage and mixed media on board, signed and dated '61, 47½in by 47½in
London £8,500 ($21,250). 5.VII.73

KENNETH NOLAND
Extent
Acrylic resin on canvas, signed, titled and dated 1959 on stretcher, 70in by 68in
London £15,500 ($38,750). 5.VII.73

JOSEF ALBERS
Homage to the Square – Nowhere
Oil on masonite, signed with monogram and dated '64, signed, titled and dated on reverse,
32in by 32in
London £25,500 ($63,750). 5.VII.73

ANDY WARHOL
Single Elvis
Silkscreen on canvas (silver), executed in 1963, 82¼in by 36in
London £14,000 ($35,000). 5.VII.73

DAN FLAVIN
6B/untitled
Three red and three yellow neon tubes, total length 120in
London £4,000 ($10,000). 5.VII.73

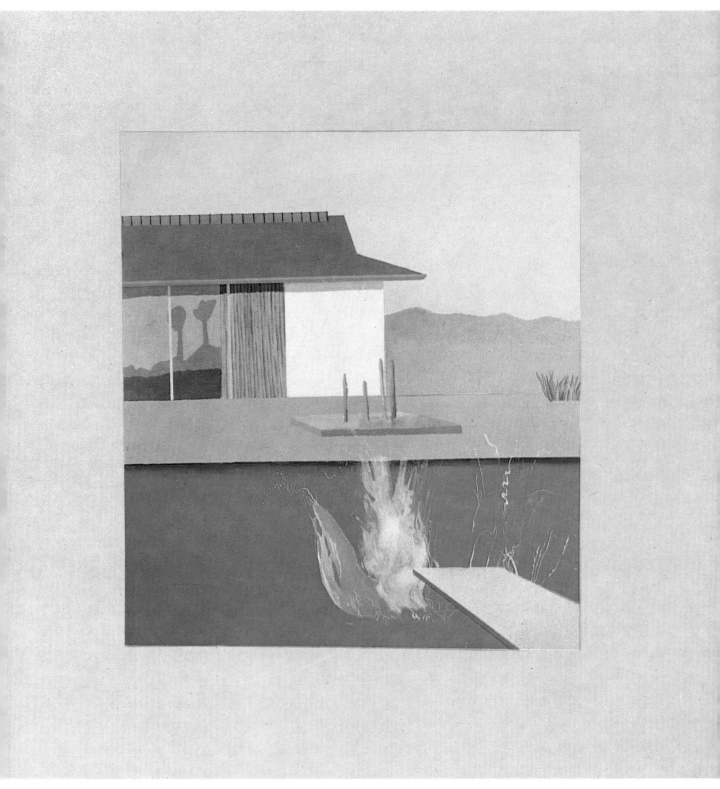

DAVID HOCKNEY
The splash
Acrylic on canvas, painted in 1966, 72in by 72in
London £25,000 ($62,500). 5.VII.73

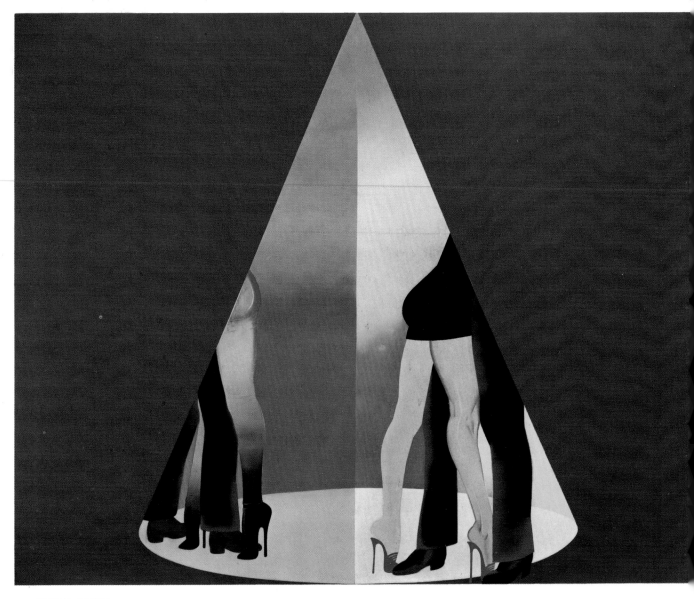

ALLEN JONES
A figment in pigment
Oil on canvas, painted in 1969, 84in by 120in
London £6,000 ($15,000). 5.VII 73

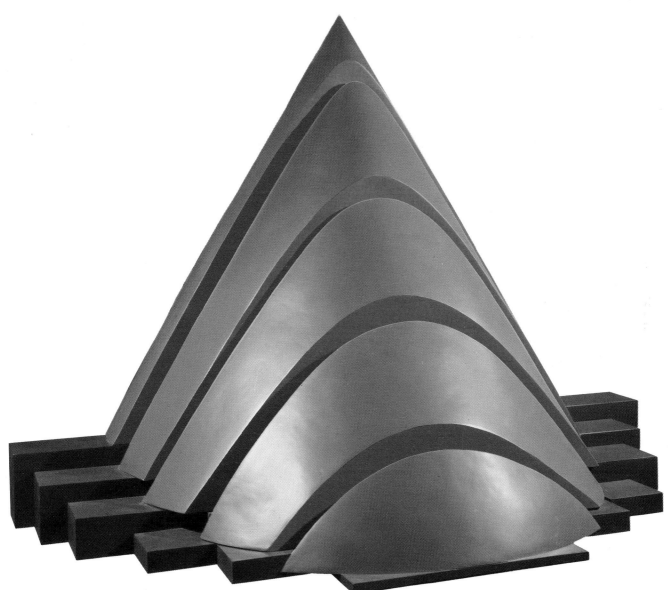

PHILLIP KING
Through
Painted fibreglass, executed in 1965, height 84in, width 180in, depth 132in
London £5,000 ($12,500). 5.VII.73

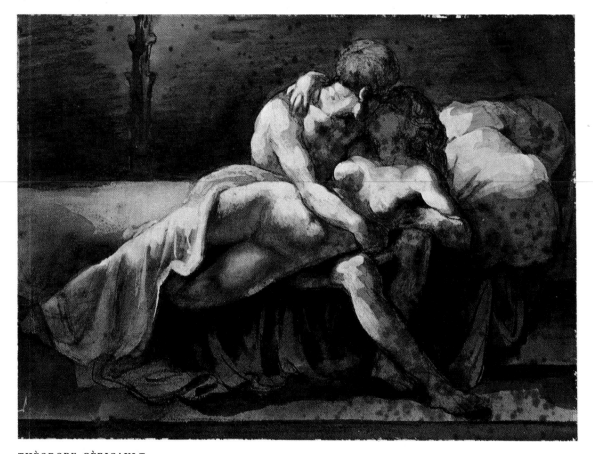

THÈODORE GÈRICAULT
Le baiser
Sepia and black chalk, heightened with white,
executed *circa* 1822, 8in by 10½in
New York $160,000 (£64,000). 2.V.73
From the collection of Norton Simon

Opposite page
Above
ALFRED KUBIN
Der beste Arzt
Pen and ink and wash, signed and titled, 10¾in by 15¼in
London £3,800 ($9,500). 29.XI.72
From the collection of the late Max Morgenstern, of Vienna

Below
PIERRE PUVIS DE CHAVANNES
Le bois sacré
Watercolour, signed, executed in 1884, 11in by 16in
New York $30,000 (£12,000). 2.V.73
From the collection of the Norton Simon Museum of Art

PAUL CÉZANNE
Nature morte au pot-au-lait bleu
Watercolour, executed *circa* 1900–06, 18¼in by 24¼in
New York $620,000 (£248,000). 2.v.73
From the collection of Norton Simon

VINCENT VAN GOGH
Cabanes à Sainte-Marie
Reed pen and pencil, executed in June 1888, 11⅞in by 18in
New York $95,000 (£38,000). 25.x.72
From the Ritter Collection, New York

Opposite page
HENRI DE TOULOUSE-
LAUTREC
Madame Berthe Bady
Sanguine on blue-grey
paper, stamped with the
monogram, executed in 1897,
21¼in by 14½in
New York $59,000 (£23,600).
25.X.73
From the Ritter Collection,
New York

Right
HENRI MATISSE
Nu couché
Pen and ink, signed, executed
circa 1922–23, 11in by 15½in
New York $31,000 (£12,400).
2.V.73
From the collection of the
Norton Simon Museum of
Art

Below
MAURICE DE VLAMINCK
Banlieue de Paris
Gouache, signed, 18¼in by
22in
London £8,000 ($20,000).
4.VII.73

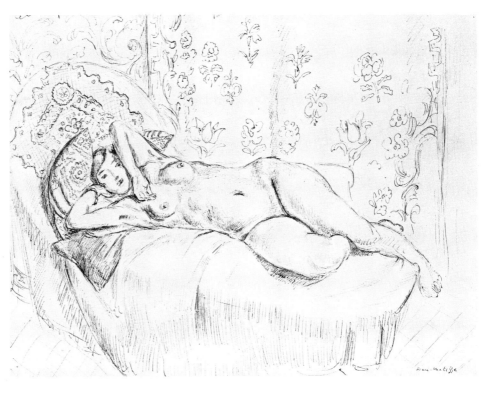

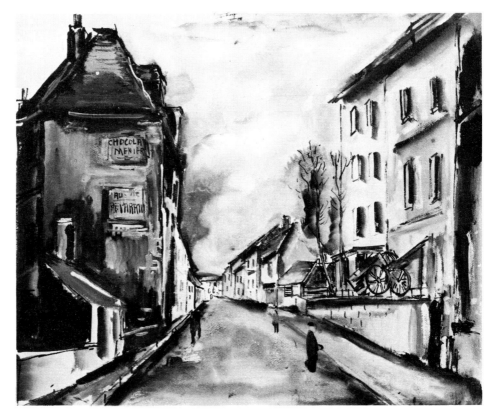

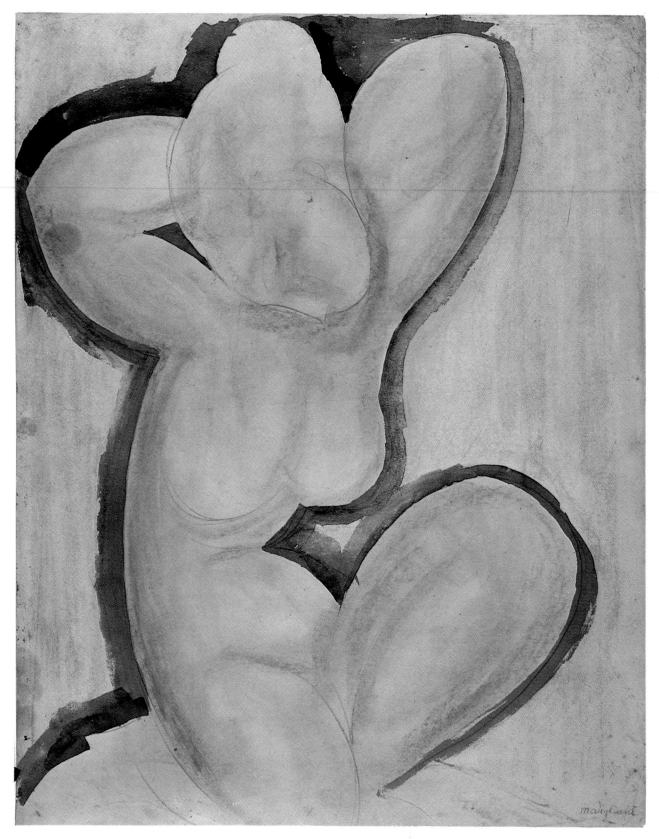

AMEDEO MODIGLIANI
Cariatide
Pencil, pastel and watercolour, signed, executed *circa* 1912–14, 22¼in by 17½in
New York $75,000 (£30,000). 3.v.73

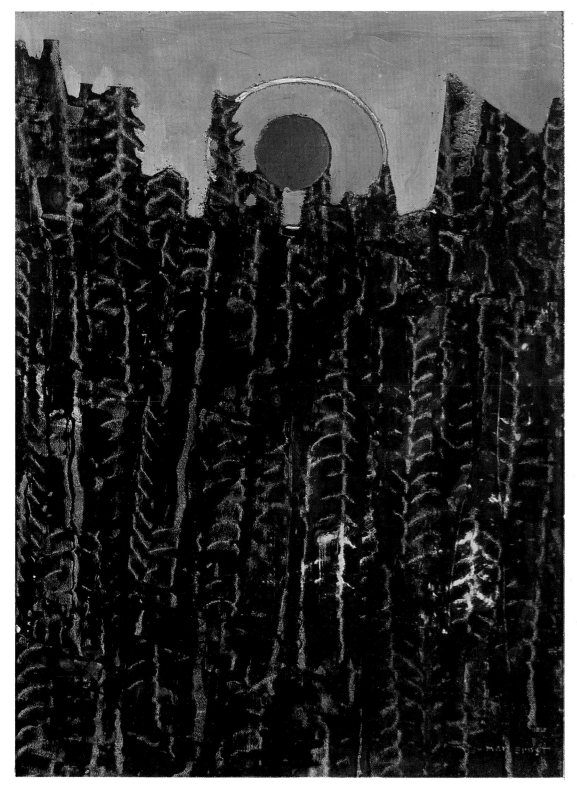

MAX ERNST
La forêt
Gouache, signed, executed in 1930, 12in by 8¾in
London £16,800 ($42,000). 4.VII.73

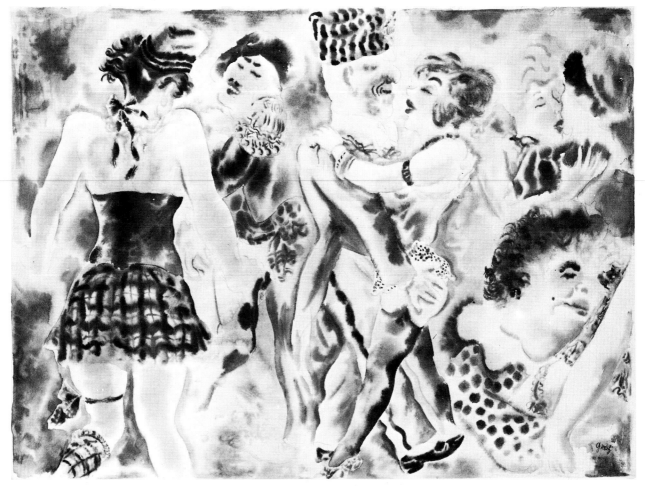

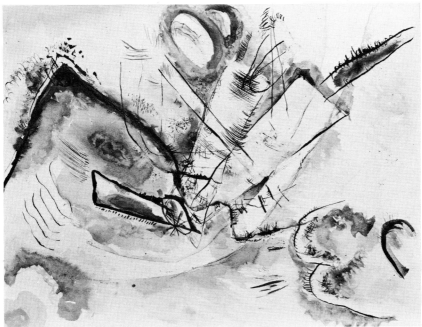

Above
GEORG GROSZ
Maskenball
Watercolour, signed, execu-
ted in 1930, 19in by 25½in
London £6,600 ($16,500).
28.III.73

Below
VASSILY KANDINSKY
Komposition
Watercolour, pen, brush and
indian ink, signed by the
artist's wife on reverse,
executed *circa* 1912, 9½in by
12¾in
London £19,500 ($48,750).
29.XI.72

Above left
FRANCIS PICABIA
Jumelle
Watercolour, signed and titled, executed *circa* 1920–22,
25½in by 19¾in
London £9,500 ($23,750). 28.III.73

Above right
ALEXANDER CALDER
Untitled
Gouache, pen and indian ink, signed and dated 1932,
22¾in by 30¾in
London £3,800 ($9,500). 28.III.73

Below left
KURT SCHWITTERS
Mz 281. Achtundfünfzig
Collage, signed, titled, inscribed *für O. Schlemmer* and dated
1921, 7in by 5½in
London £5,200 ($13,000). 29.XI.72

Below right
FRANK KUPKA
Formes irrégulières
Watercolour and gouache, signed, executed *circa* 1911–12,
13¼in by 13¼in
London £6,000 ($15,000). 4.VII.73

PAUL KLEE
Burg auf dem Riff
Watercolour, gouache, pen and indian ink, signed, titled and dated 1927, 12in by 18in
London £28,000 ($70,000). 29.XI.72
From the collection of Lady Faber

JOAN MIRO
La Plage
Drawing-collage on sanded paper laid down on plywood, signed and dated 15.8.33 on reverse,
28½in by 41½in
London £28,000 ($70,000). 28.III.73

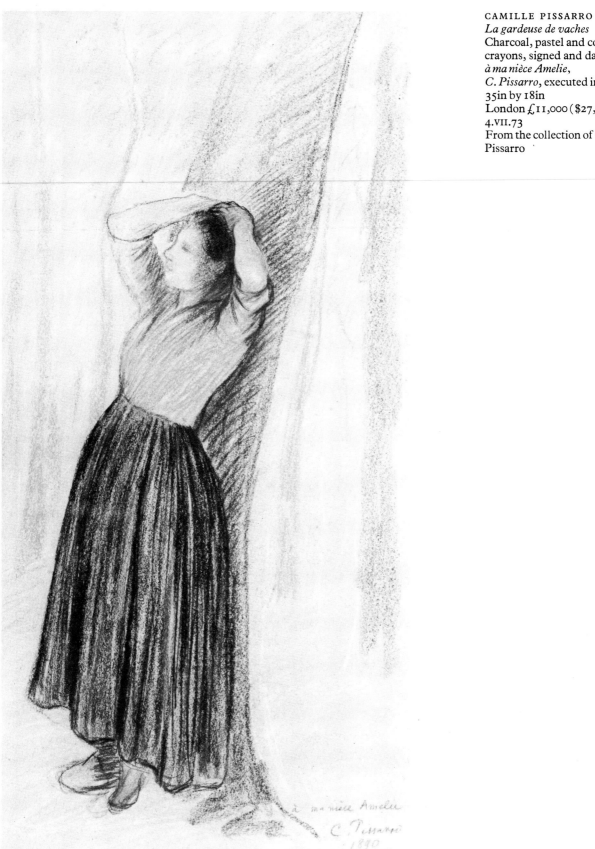

CAMILLE PISSARRO
La gardeuse de vaches
Charcoal, pastel and coloured
crayons, signed and dated
à ma nièce Amelie,
C. Pissarro, executed in 1890,
35in by 18in
London £11,000 ($27,500).
4.VII.73
From the collection of Carl
Pissarro

Prints

THE MASTER E. S.
The Adoration of the Magi
(actual size)
Engraving printed with tone
on paper, 148mm by 103mm
London £26,000 ($65,000).
20.III.73
From the collection formed
by Richard Bull and his
daughter, Miss Elizabeth
Bull (1749–1809)

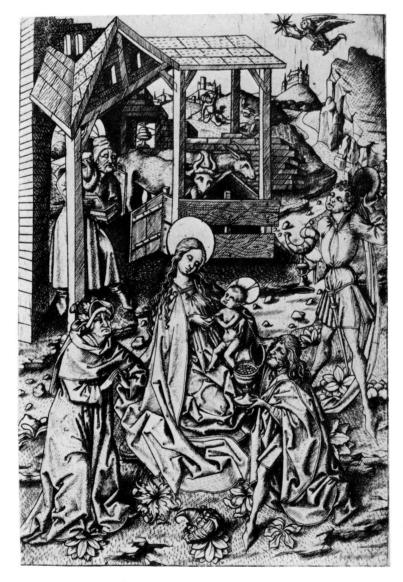

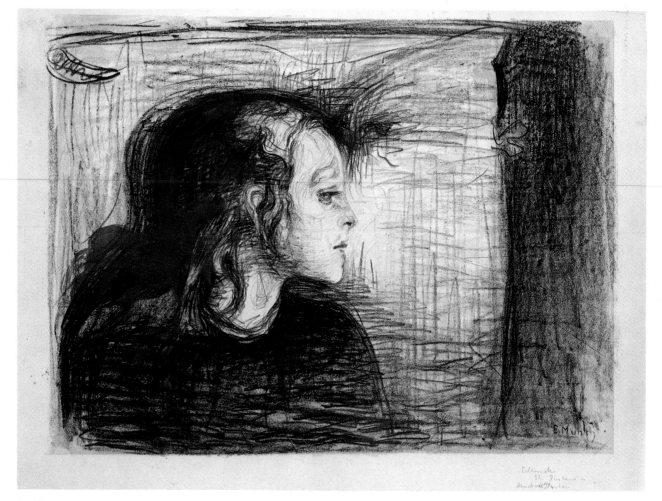

EDVARD MUNCH
Das kranke Mädchen
Lithograph printed in colours, on vélin, signed in pencil, 1896, 427mm by 575mm
London £9,500 ($23,750). 10.x.72
Formerly in the collection of Arthurii de Framquet

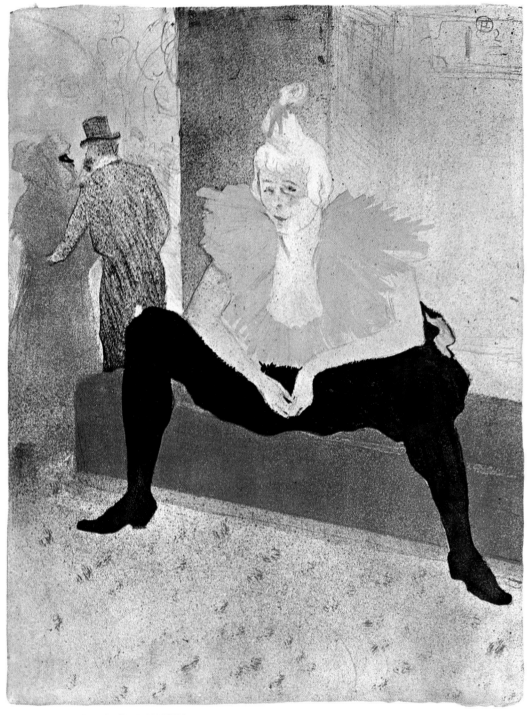

HENRI DE TOULOUSE-LAUTREC
La clownesse assise
Lithograph printed in colours, 523mm by 400mm
New York $25,500 (£10,200). 11.v.73

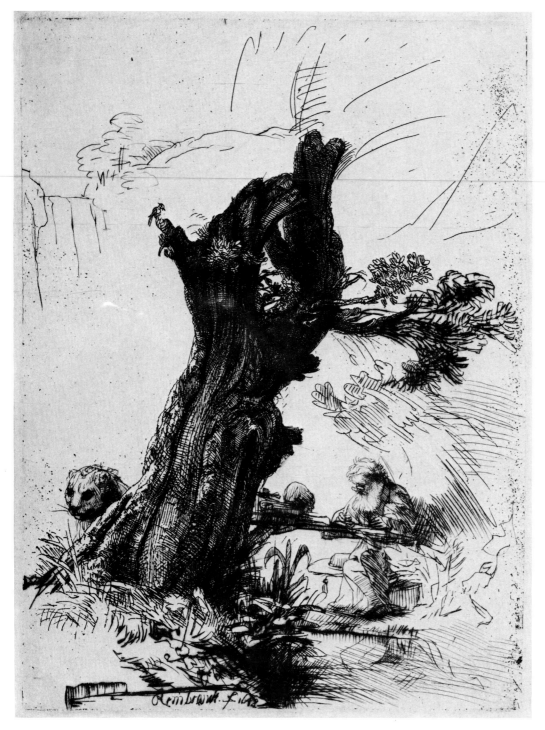

REMBRANDT HARMENSZ. VAN RIJN
St Jerome beside a pollard willow
Etching and drypoint, 178mm by 132mm
New York $48,000 (£19,200). 10.v.73

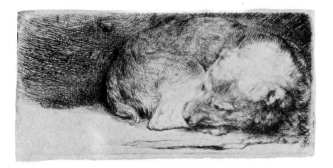

The etchings illustrated on this page were from the Viscount Downe Collection sold in London on 7th December 1972

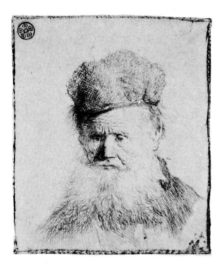

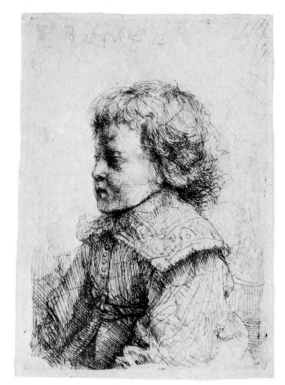

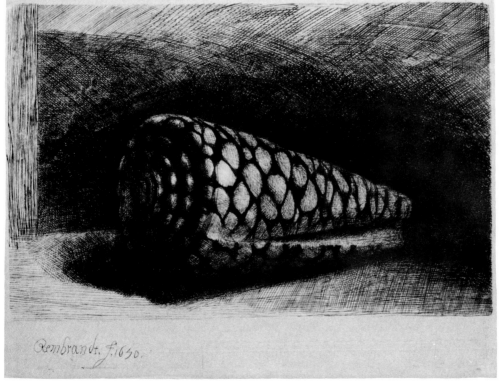

Above left
REMBRANDT HARMENSZ.
VAN RIJN
The sleeping puppy
Etching and drypoint,
39mm by 84mm
£950 ($2,375)

Above right
Portrait of a boy, in profile
Etching, 94mm by 67mm
£4,000 ($10,000)

Centre left
*The bust of an old man with
a fur cap and flowing beard*
Etching, 62mm by 52mm
£2,700 ($6,750)

Below left
The shell (Conus Marmoreus)
Etching and drypoint,
96mm by 133mm
£10,800 ($27,000)

REMBRANDT HARMENSZ. VAN RIJN
Above
The Agony in the Garden
Etching and drypoint, 111mm by 83mm
New York $70,000 (£28,000). 10.V.73

Below
The Goldweigher's Field
Etching and drypoint, 120mm by 320mm
New York $44,000 (£17,600). 10.V.73
Formerly from the collection of H. H. Benedict

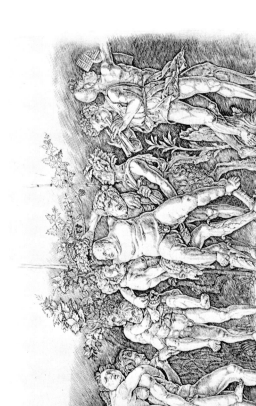

Above ANDREA MANTEGNA
Bacchanale with Silenus
Engraving, 335mm by 461mm
London £8,000 ($20,000). 8.XII.72
From the collection of the late Dr Felix Somary

Above right JACOB VAN RUISDAEL
Three oaks on a mound
Etching and drypoint, 130mm by 151mm
London £3,100 ($7,750). 8.XII.72
From the collection of His Grace the Duke of Portland, KG

Centre GIULIO CAMPAGNOLA
Christ and the Woman of Samaria
Engraving, 132mm by 187mm
London £3,500 ($8,750). 20.III.73
From the collection formed by Richard Bull and his daughter, Miss Elizabeth Bull

Right HANS SEBALD BEHAM
Four horses
Engraving, 120mm by 143mm
London £1,500 ($3,750). 20.III.73
From the collection formed by Richard Bull and his daughter, Miss Elizabeth Bull

JEAN DUVET
The Apocalypse. Satan bound for a thousand years
Engraving, 302mm by 210mm
London £5,800 ($14,500). 20.III.73
From the collection formed by Richard Bull and his daughter,
Miss Elizabeth Bull (1749–1809)

ALBRECHT DÜRER
The Apocalypse. The four horsemen
Woodcut, 392mm by 280mm
London £7,000 ($17,500). 20.III.73
From the collection formed by Richard Bull and his daughter,
Miss Elizabeth Bull (1749–1809)

PAUL REVERE
The Bloody Massacre perpetrated in King Street, Boston, on March 5th, 1770
Hand-coloured engraving, first state, unique impression, 263mm by 227mm
New York $30,000 (£12,000). 18.V.73
From the collection of Ambassador and Mrs William J. Middendorf II

Above
GIOVANNI ANTONIO CANALE
called CANALETTO
An imaginary view of Venice
Etching. One of only six known impressions of this undivided
plate, 297mm by 436mm
London £8,400 ($21,000). 8.XII.72
From the collection of the late Dr Felix Somary

Below
GIOVANNI BATTISTA PIRANESI
View of the interior of the so-called Temple of Neptune at Paestum
Etching, 485mm by 688mm
London £1,700 ($4,250). 8.XII.72
Formerly from the collection of William Bell Scott

GEORGE STUBBS, ARA
A horse frightened by a lion
Mixed method, published
1788, 254mm by 332mm
London £3,000 ($7,500).
12.VII.73
From the collection of
Hubert I. Richmond Esq

GEORGE STUBBS, ARA
A horse attacked by a lion
Mixed method, published
1788, 274mm by 354mm
London £5,600 ($14,000).
12.VII.73
From the collection of
Hubert I. Richmond Esq

GEORGE STUBBS, ARA
Above left
A foxhound on the scent
Mixed method, published
1788, 96mm by 105mm
London £1,050 ($2,625).
31.X.72

Above right
A recumbent lion
Mixed method, 166mm by
212mm
London £3,800 ($9,500).
12.VII.73
From the collection of Lady
Marchant

Below
Two foxhounds in a landscape
Mixed method, published
1788, 190mm by 233mm
London £4,500 ($11,250).
25.IV.73
From the collection of
James Caldwell Esq

Right
J. A. MCNEILL WHISTLER
The piano
Drypoint, 233mm by 157mm
New York $2,700 (£1,080). 11.V.73
From the collection of the late Thérèse Lownes Noble

Below
PAUL-CESAR HELLEU
Croquis lithographique avec portrait avec Mme de Béarn à droite
Lithograph on chine volant, 478mm by 643mm
London £340 ($850). 12.IV.73
From the collection of Mrs A. Finaly

Right
MARC CHAGALL
Selbstbildnis mit Grimasse
Etching with aquatint, signed in pencil, 375mm by 273mm
New York $3,000 (£1,200). 9.11.73
From the collection of Edith G. Halpert of New York

Below left
PABLO PICASSO
Buste de femme au chapeau
Signed in pencil, 1962, 629mm by 530mm
New York $16,500 (£6,600). 11.v.73

Below right
Torse de femme
Aquatint, signed in ink, 1953, 831mm by 472mm
London £2,800 ($7,000). 10.x.72
From the collection of Mr M. F. Feheley of Toronto

Left
FRANK STELLA
Star of Persia I
Lithograph printed in seven
colours, signed and dated in
pencil, published 1967,
660mm by 571mm
Los Angeles $1,200 (£480).
11.XII.72

Below
EDWARD RUSCHA
Standard station
Silkscreen, signed and dated
1966 in pencil, 495mm by
933mm
Los Angeles $1,200 (£480).
27.III.73

Manuscripts and printed books

Oriental manuscripts and miniatures
Medieval manuscripts
Manuscripts of the 16th-20th centuries
Early printed books
English literature
Maps and travel
Coloured plate books and natural history
English illustrated books of the 19th century
French modern illustrated books
Children's books
Music

HUMPHREY REPTON
The original 'Red Book' for
Cobham Hall, Kent, 1790
London £3,400 ($8,500).
28.XI.72
The Red Book contains
autograph suggestions for
improvements to the grounds
of Cobham Hall, illustrated
with ten watercolour and two
sepia drawings. This book,
for one of the most important
estates on which Repton
worked, was hitherto thought
not to have survived.

Oriental manuscripts and miniatures

BY TOBY FALK

The market for oriental miniatures has been altering rapidly over the past year, the change being instigated very largely by the sale in December of part of the Cary Welch Collection. Whereas normally it is the personal preferences of the buyers which are reflected in the results of a sale, this was a case of one man's individual choice changing the buying habits of the market. The trend started by this sale has continued through the season and has resulted in a new price structure, particularly for miniatures of Rajasthani schools. Many of the larger pictures suitable for hanging are now selling for as much as three times their previous prices, and competition for miniatures of the Pahari schools has similarly increased. £5,500 was paid for an illustration from the 'Shangri' *Rāmāyana*, a magnificent example of the Kulu school in an early stage of its development in which strength of colour and boldness of composition combine to achieve an almost expressionist effect. Meanwhile the prices of Mughal paintings have been higher than ever, encouraged by the dispersal of one particularly fine collection in March and July, the record price of £30,000 being paid for a miniature from the emperor Jahāngir's own copy of the *Jahāngir Nāma*, a contemporary biographical account of his reign (1605–28). The painting is by the emperor's favourite artist, Nādir al-Zamān, and depicts Jahāngir's daily appearance at his window in the Red Fort at Agra; on the left of the scene hang the chains of justice, chains of bells which could be jangled by any citizen requiring the emperor's judgement in a dispute. In the same sale two other illustrations from the *Jahāngir Nāma* were sold for £11,000 and £21,000, and a miniature from the *Shāh Jahān Nāma*, a parallel biographical manuscript for the emperor Shāh Jahān (1628–58), fetched £16,000. Speculation on the possible price for a finely-illustrated manuscript of the early Mughal period ended when in the second sale of this collection a copy of Nizāmī's *Khamsa* with thirty-five miniatures painted by the court artists of the emperor Akbar (1556–1605) reached £80,000. The manuscript was slightly handicapped by its postcard size, but the fact that the miniatures bore contemporary attributions to the various artists who worked on the illustrations rendered it an important art-historical document.

Compared to their Indian counterparts Persian miniatures have been in short supply, but a leaf from an unusually large manuscript of the Lives of the Prophets from the Cary Welch collection was sold for £7,000. The interest of this work is enhanced by its comparison with the *Hamza Nāma*, a manuscript of similarly large dimensions which was produced at the Mughal court at about the same time and takes a prominent position among the first products of the Mughal atelier.

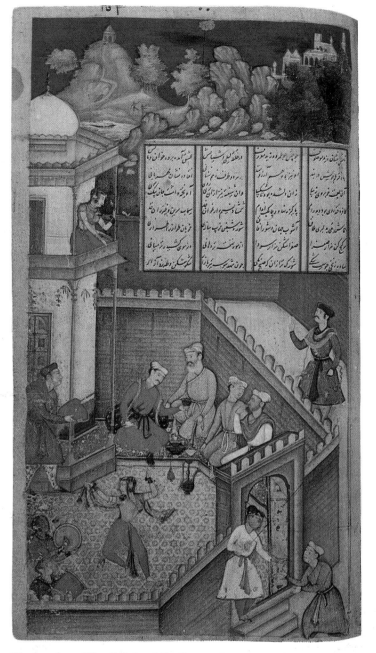

The marriage of Zayd's beloved Zānib to another man
Painted by Basāwan.
One of thirty-five miniatures contained in a manuscript of
Nizāmī's *Khamsa*, Mughal, *circa* 1590–95. 162mm by 101mm
London £80,000 ($200,000). 10.VII.73

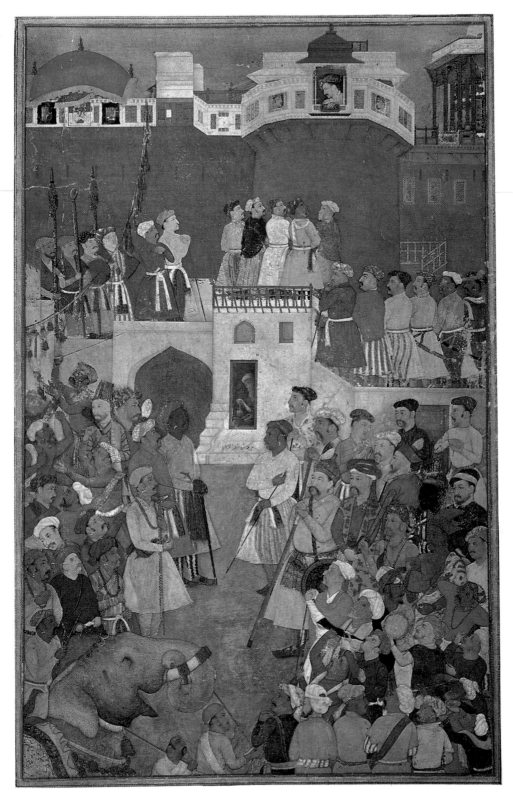

The emperor Jahāngir making his daily appearance at a window of the Red Fort at Agra
Painted by Nādir al-Zamān. Mughal, *circa* 1620. 312mm by 201mm
London £30,000 ($75,000). 26.III.73

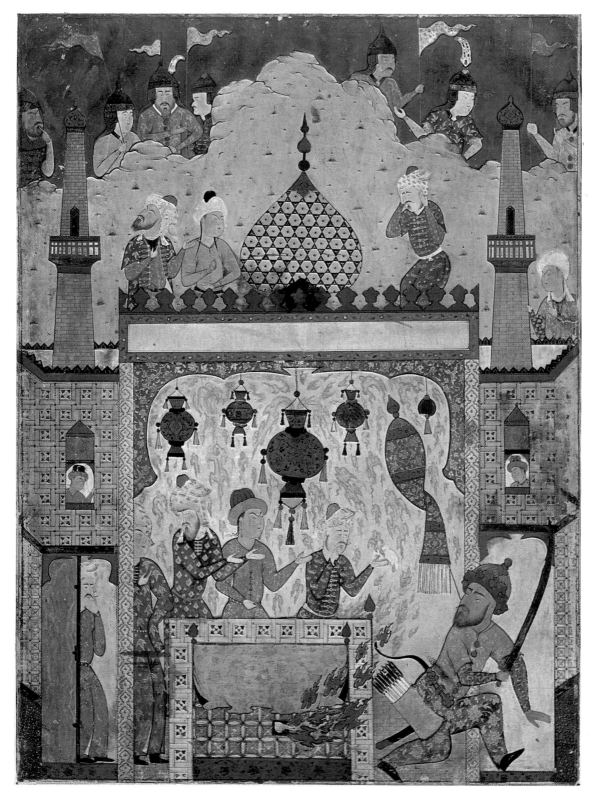

An incident at the tomb of a saint
An illustration from a manuscript of the Lives of the Prophets. Persia, Qazwin or Tabriz,
circa 1560. 595mm by 450mm
London £7,000 ($17,500). 12.XII.72

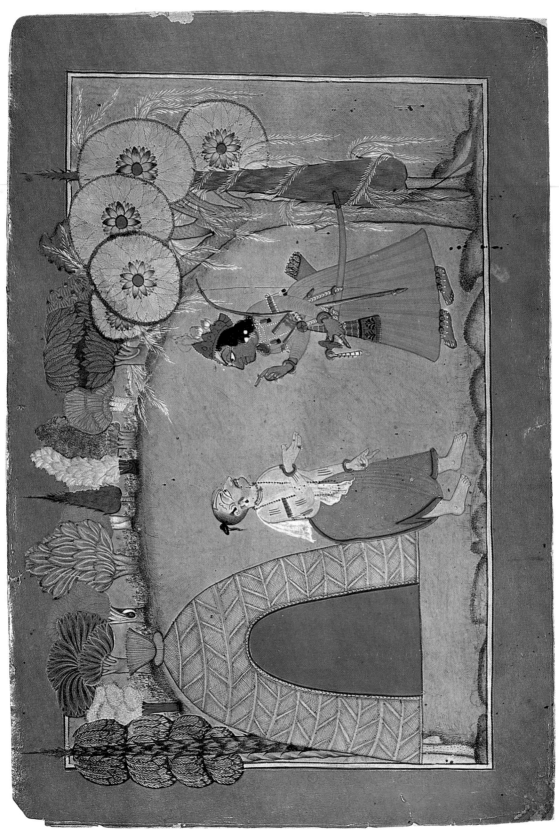

Rama talking with the hermit Bharadvaja outside his dwelling
An illustration from the 'Shangri' *Rāmāyana*. Pahari, Kulu, *circa* 1690. 222mm by 320mm
London £5,500 ($13,750). 27.III.73

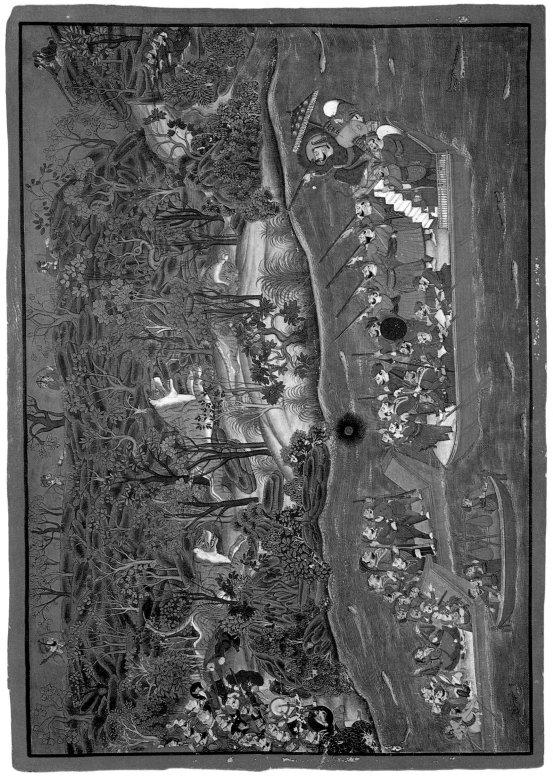

Raja Ram Singh II of Kotah (1828–1866) shooting tigers from a boat
Rajasthan, Kotah, mid-nineteenth century. 487mm by 665mm
London £5,500 ($13,750). 11.VII.73

anoit anon zacharies pieudon
piestres estoit z seruoit au tem
lone la uie loi. Cist zacharias
qui anoit anon elizabel pieude
te uie z estoient eule dui de gran
quirent tant longuement en
ment mes moult estoient bon
te quil nauoient eu onques enfa
apeloient elizabel brehaigne! C
onnons aues oi estoit piestres
tie du temple z tenoit huitisme de
stres z euesques. Il uint au temp
la deuant lautel z aluma leu co
apies fist oroison pour soi z pour
nostie sires oi f car costume est
quil fesoient sacrefices une fois
li euesques pour ceulz de quil
te z laumosne z les saacrefices d
ple que dien leur enuoiast sa gr
z uie pardurable.

Opposite page
La Vie des Saints
Manuscript on vellum with eight miniatures and eighty-eight historiated initials, probably painted in the Parisian atelier of Richard de Verdun, *circa* 1320–30
London £50,000 ($125,000).
21.XI.72
From the collection of the late Sir Thomas Phillipps Bt (1792–1872)

The Old Hall Manuscript
Polyphonic mass settings and motets, written in England *circa* 1410–15, with thirty added compositions *circa* 1415–20 by musicians of the Chapel Royal and others
London £70,000 ($175,000).
9.VII.73
From the collection of St Edmund's College, Old Hall Green, Ware
The manuscript is the largest single source for English music of the period, containing 147 pieces in all, including two written by 'Roy Henry', now thought to be either Henry IV or Henry V.

CONRAD KYESER
Bellifortis
Manuscript illustrated with 195 drawings, [Bohemia or South Germany, *circa* 1405–10]
London £10,000 ($25,000). 21.XI.72
From the collection of the late Sir Thomas Phillipps Bt (1792–1872)
The manuscript is a lavishly illustrated survey of the state of technological knowledge ranging
from equipment for underwater swimming to the chastity belt. The drawing reproduced
illustrates the power of gunpowder

JOSE CARRILLO DE ALBORNOZ, DUKE OF MONTEMAR
The extensive archive of letters and other papers of the Duke of Montemar, relating to the War
of the Polish Succession, in sixty-seven volumes and sixteen folders, 1733–37
London £15,000 ($37,500). 26.VI.73
From the collection of the late Sir Thomas Phillipps Bt (1792–1872)
This archive is of major historical importance for any future research on the war. The
illustration reproduces a pen and wash frontispiece by Pedro Quillacq depicting Fame
celebrating the Duke's victories

JOANNES OLIVA
A complete signed and dated Portolan Atlas containing an added world map and a decorated frontispiece, the four portolan maps decorated with coloured drawings of the principal cities flying the standards of the ruling power, and similar drawings of the principal potentates,
Messina, 1582
London £7,000 ($17,500). 11.XII.72

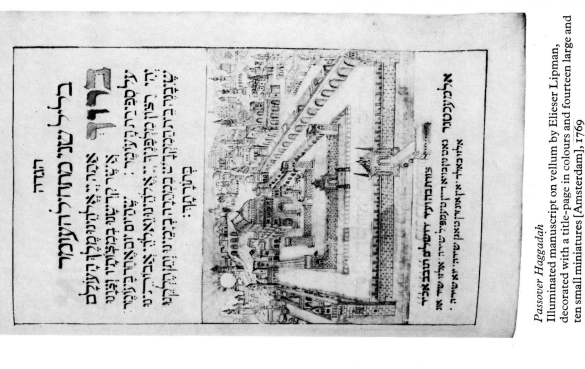

Passover Haggadah
Illuminated manuscript on vellum by Elieser Lipman,
decorated with a title-page in colours and fourteen large and
ten small miniatures [Amsterdam], 1769
London £1,600 ($4,000). 9.VII.73

The Toulongeon Hours
Illuminated manuscript on vellum, decorated with twenty
large miniatures with full illuminated borders, ten large
historiated initials, and full borders on the calendar pages,
each incorporating two rectangular miniatures [Southern
Netherlands, *circa* 1481]
London £12,800 ($32,000). 11.XII.72

JOHN MAVROGÓRDATO
Manuscript commonplace book in demotic Greek, containing long dramatic poems, histories, and dramas, together with verses by the compiler and other minor texts [Constantinople, *circa* 1676–80]
London £3,400 ($8,500) 25.VI.73
From the collection of the late Sir Thomas Phillipps Bt (1792–1872)

JOHN DARKER
A Geometricall Extraction for all affected to the Mathematickes
Manuscript illustrated with numerous diagrams and seven fine drawings,
Levington, 1648
London £900 ($2,250). 14.III.73

NAPOLEON I
An important autograph letter to Josephine de Beauharnais
London £4,200 ($10,500) 3.VII.73
This is the longest of the three known letters from Napoleon to Josephine
before their marriage. In it he declares his love for her after a quarrel the
previous evening

MARTIN LUTHER
Autograph letter to Johann Walther, Cantor to the Elector of Saxony, 1526
London £5,000 ($12,500) 3.VII.73
In the letter Luther promises help to Walther, who is concerned at the
Elector's decision to disband his choir. Walther, a friend and colleague of
Luther's, was one of the earliest composers of the Lutheran Church

ALBERT EINSTEIN
An important collection of autograph notes and drafts of letters, [circa 1950–54]
New York $12,000 (£4,800). 28.XI.72
The notes cover various ideas and elaborations on Einstein's earlier work, particularly his search for the link between the laws of gravitation and electromagnetism

GEORGE WASHINGTON
A long letter to William Livingston, Governor of New Jersey, 1783
New York $27,500 (£11,000). 8.V.73
The letter, 22½ pages long, is one of thirteen copies sent to the governors of the States by Washington on his retirement, giving advice for the future of his country

T. S. ELIOT

The original typescript of *The Love Song of J. Alfred Prufrock*, signed by the author

New York $13,000 (£5,200). 31.x.72

From the collection of the late Urling S. Iselin

The typescript was given by Eliot to Conrad Aiken in 1913 to take to London, but the poem remained unpublished until 1915, when it appeared in the magazine *Poetry*, printed in Chicago. Apart from school and university magazine contributions, this was Eliot's first appearance in print

D. H. LAWRENCE

A series of 121 autograph letters and fifty-one autograph postcards written by Lawrence to Catherine Carswell with some other relating material, 1914–29

New York $6,500 (£2,600). 20.II.73

From the collection of the late Urling S. Iselin

Many of the letters and cards in this important collection are unpublished. Catherine Carswell was a close friend and biographer of Lawrence

Above

PHILIP FRENEAU and HUGH HENRY BRACKENBRIDGE

Manuscript of *Father Bombo's Pilgrimage to Mecca*

New York $22,000 (£8,800). 12.XII.72

This is the only known complete manuscript of the first American novel, originally written in 1770. This copy was written out in 1772 by John Blair Smith, a fellow member of the Whig Society

Below

D. H. LAWRENCE

Autograph manuscript of the novel *Mr. Noon*, 1920–21

New York $17,000 (£6,800). 31.X.72

From the collection of the late Urling S. Iselin

The first seven chapters were printed in *A Modern Lover*. The remaining ten chapters are unpublished

Above CYRIL CONNOLLY
Autograph manuscript of *The Unquiet Grave*
New York $5,000 (£2,000). 20.11.73. From the collection of the late Urling S. Iselin
This is the author's original working draft, which differs widely from the final version
published anonymously in 1944

Below GEORGE BERNARD SHAW
Cashel Byron's Profession, 1886
First edition, with extensive revisions by the author for the new edition published in 1889.
London £1,300 ($3,250). 5.XII.72

Biblia Sacra Latina Vulgata
Two vol, with over 100 initials supplied by hand, printed in Mainz by
Petrus Schoeffer, 1472
London, Chancery Lane, £2,600 ($6,500). 11.1.73
From the collection of the Law Society

ANTONIUS FLORENTINUS
Chronicon
Three vol., first edition, with four large illuminated initials, printed in
Nuremberg by Anton Koberger, 1484
New York $2,250 (£900). 27.11.73

Mirouer hiftorial de france.

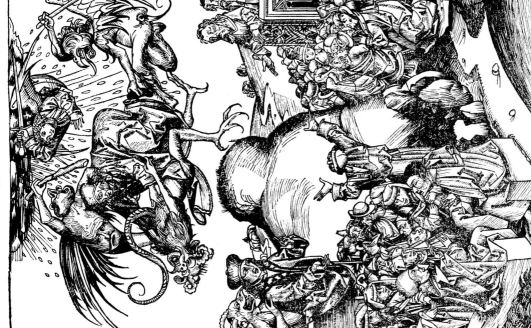

Clodomir⁹ oc/
cis par Gūde/
mar.

Prez loccaiſion de ſainct Sigiſmund/de ſa femme/z
enfans/faicte par Clodomir roy Dorleans/Gun
demar qui eſtoit eſchappe d la bataille/ recouura le
royaulme de Bourgoigne/ mais Clotildis Dou
lant du tout exterminer et exſtaindre ſa lignee de
Gundebauld ſon oncle. Incita de rechief Clodo
mirus daſſaillir ledit Gundemar/ lequel a linſtāce de
ſa mere/aſſēbla la plᵉ groſſe armee qʾil peult/z entra ou royaulme de
Bourgoigne. Cōtre lequel Dint Gundemar aucques teſte puiſſance
quʾil peuſt aſſembler/z fut la bataille au territoire de Dienois/en Dng
lieu qʾ ſapelle Biſozõt. Mais en fin ſes Bourguignōs tourneret en deſ
côfiture/aucũe leur roy Gundemar/leſ̃ fut pourſuiuy troꝑ ẜemēt pᵒ Clo
domir/et ſe haſtoit ſi fort de pourſuyure ſes énemys/q̃ ſeſloigna de ſes
gēs/ce Doyāt Gundemar ſe Dit aſſaillir/z de fait iloccift/z puis ſe ſaul

ROBERT GAGUIN
Le Mirouer Historial de France
Woodcut illustrations, sixteenth century morocco binding, Paris, 1516
London, Chancery Lane £1,200 ($3,000). 9.II.73

Septima etas mūdi

HARMANN SCHEDEL
Liber Chronicarum, the 'Nuremberg Chronicle'
First edition, illustrated with over 2,500 woodcuts, printed in Nuremberg
by Anton Koberger, 1493
London, Chancery Lane £2,600 ($6,500). 23.XI.72
From the collection of Christ's College, Aberdeen

THE
SCHOLEMASTER.

Or plaine and perfite way of tea-
chyng children, to vnderſtand, write, and
ſpeake, the Latin tong, but ſpecially purpoſed
for the priuate bryngyng vp of youth in Ientle-
men and Noble mens houſes, and commodious
alſo for all ſuch, as haue forgot the Latin
tonge, and would, by themſelues, with-
out a Scholemaſter, in ſhort tyme,
and with ſmall paines, recouer à
ſufficient habilitie, to vnder-
ſtand , write , and
ſpeake Latin.

¶ By Roger Aſcham.

An. 1570.

AT LONDON.

Printed by Iohn Daye, dwelling
ouer Alderſgate.

¶ Cum Gratia & Priuilegio Regiæ Maieſtatis,
per Decennium.

ROGER ASCHAM
The Scholemaster, first edition, 1570
London £1,900 ($4,750). 23.x.72
Another copy, bound with two other works, from the collection of
Manchester College, Oxford, was sold for £2,700 ($6,750). 2.IV.73

THE MOST
EXCELLENT
And Lamentable Tragedie
of Romeo and
Juliet.

As it hath been ſundry times publikely Acted
by the Kings Majeſties Servants
at the Globe.

Written by W. Shake-ſpeare.

Newly corrected, augmented, and amended.

LONDON,
Printed by R. Young for John Smethwicke, and are to be ſold at
his Shop in St. Dunſtans Church-yard in Fleetſtreet,
under the Dyall. 1637.

WILLIAM SHAKESPEARE
Romeo and Juliet
Fifth quarto edition, 1637
London £2,300 ($5,750). 23.x.72

W. H. AUDEN

POEMS

Price, 50 Cents

MAGGIE

A Girl of the Streets

(A STORY OF NEW YORK)

By

JOHNSTON SMITH

Copyrighted

Above
W. H. AUDEN
Poems, first edition [Privately Printed by Stephen Spender], 1928
New York $8,500 (£3,400). 20.II.73
From the collection of the late Urling S. Iselin
The author's rare first book, of which probably thirty or less were issued.
This copy is inscribed by both Auden and Spender, and has a letter from
Spender describing the printing of the book

Left
STEPHEN CRANE
Maggie : a Girl of the Streets
First edition, New York, [Privately Printed, 1893]
New York $3,500 (£1,400). 20.II.73
The author's rare first book, in which he used the pseudonym Johnson
Smith. This copy was given by him to his brother, who financed the
printing

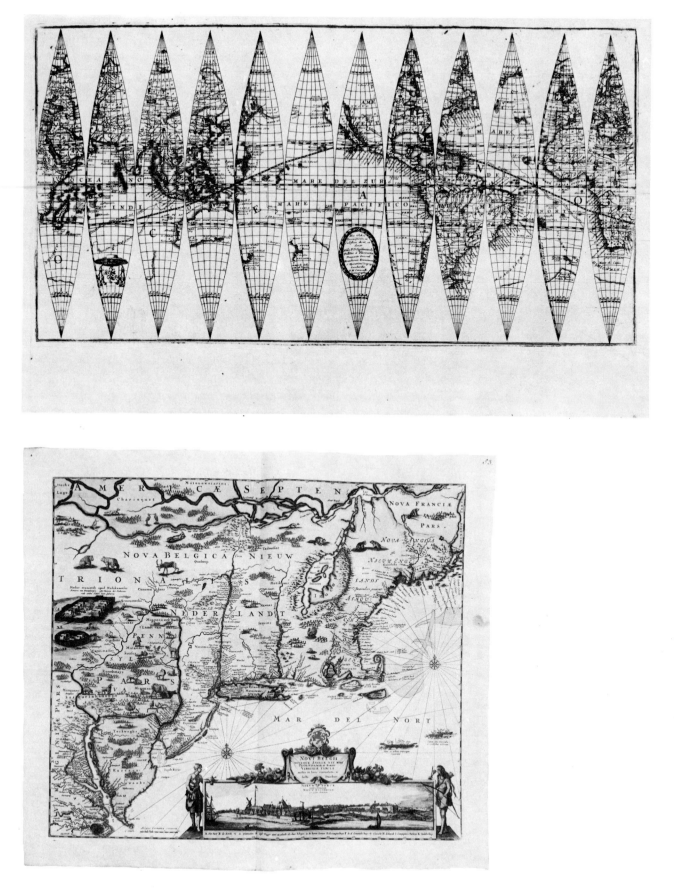

Opposite page, above
VINCENZO MARIA CORONELLI
Globbi Diversi
134 engraved plates, the majority with maps arranged in
sections on gores, Venice, 1691–99
London £11,000 ($27,500). 20.XI.72

Below
Atlas containing a collection of 605 engraved maps by Valk,
Vischer, and others, all but eight fully hand-coloured, in
ten vol., Amsterdam [*circa* 1700–50]
London £17,000 ($42,500). 20.XI.72
From the collection of the Honorable Society of King's Inn's,
Dublin

Right
EDWARD S. CURTIS
The North American Indian
Twenty volumes and twenty portfolios, containing over
3,000 plates, 1907–30
New York $26,000 (£10,400). 14.XI.72

Below
JAMES O. LEWIS
The Aboriginal Port Folio, seventy-eight coloured lithographs,
Philadelphia, 1835
New York $3,850 (£1,540). 14.XI.72
From the collection of Cranbrook Academy of Art

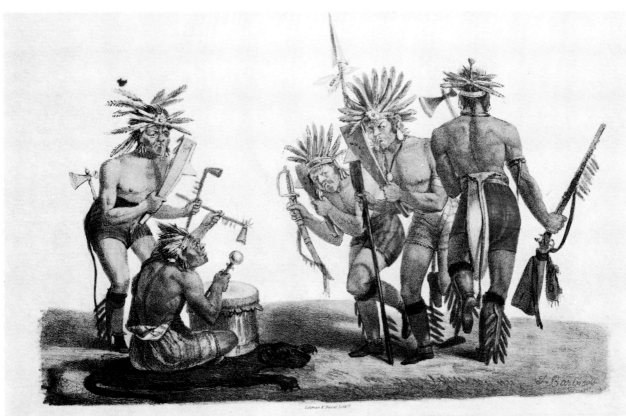

THE PIPE DANCE and THE TOMAHAWK DANCE
of the Chippeway tribe.

WILLIAM DANIELL
*Six Views of the Metropolis of
the British Empire*
Engraved title and six coloured
aquatints, 1805
London, Chancery Lane,
£3,200 ($8,000). 3.V.73
From the collection of
A. R. Martin Esq, FSA

HENRY ALKEN
*The National Sports of Great
Britain*
First edition, first issue,
coloured frontispiece and fifty
coloured aquatints, 1821
New York $3,750 (£1,500).
10.X.72

Above
SAMUEL DANIELL
African Scenery and Animals,
bound with *A Picturesque
Illustration of the Scenery,
Animals, and Native
Inhabitants of Ceylon*
42 coloured aquatints, 1804
and 1808
London £2,800 ($7,000).
6.XI.72
From the collection of Baron
Charles de Selys Longchamps

Below
JOHN GOULD
The Birds of Great Britain
5 vol., 367 coloured plates,
[1862]–1873
New York $9,000 (£3,600).
10.X.72

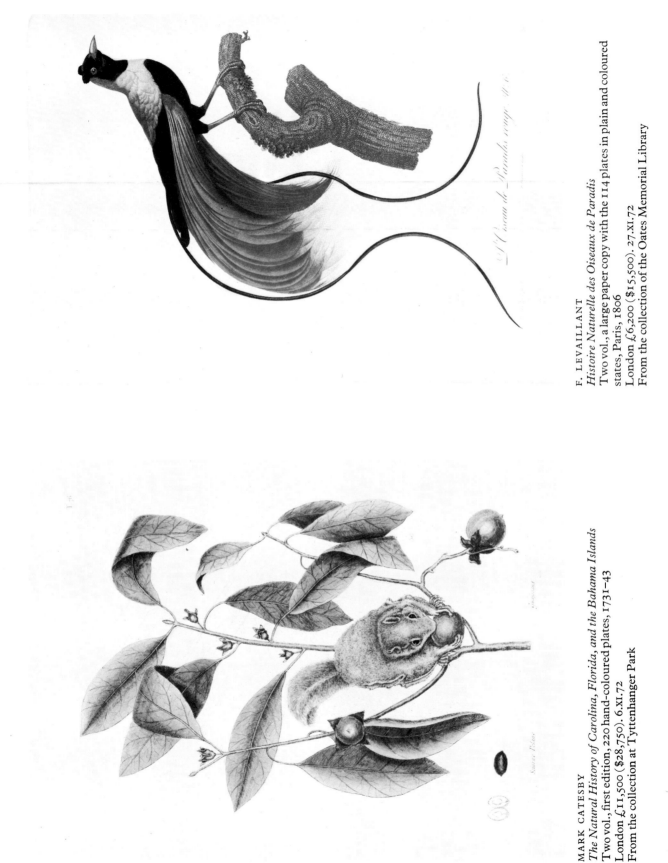

F. LEVAILLANT
Histoire Naturelle des Oiseaux de Paradis
Two vol., a large paper copy with the 114 plates in plain and coloured
states, Paris, 1806
London £6,200 ($15,500). 27.XI.72
From the collection of the Oates Memorial Library

MARK CATESBY
The Natural History of Carolina, Florida, and the Bahama Islands
Two vol., first edition, 220 hand-coloured plates, 1731–43
London £11,500 ($28,750). 6.XI.72
From the collection at Tyttenhanger Park

GEOFFREY CHAUCER
Works
Eighty-seven wood-cut illustrations after Burne-Jones, title, borders, and initials by William Morris, in the Doves pigskin binding, Kelmscott Press, 1896
London £4,000 ($10,000). 19.VI.73

Above
SAMUEL CALVERT *A Memoir of Edward Calvert*
Two engravings and six wood-engravings by Edward Calvert, 1893
London £1,100 ($2,750). 19.VI.73
From the collection of E. Knollys Esq

Below
VIRGIL *Eclogues*
Fourteen illustrations by Samuel Palmer including five etched plates, 1883
London £350 ($875). 18.VI.73
From the collection of W. W. Smithson Esq

A
Little BOOK
FOR
Little Children.

WHEREIN
Are set down several
Directions for Little
Children;

And several remarkable
Stories both Ancient and
Modern of Little
Children,

Divers whereof are of those
who are lately de-
ceased.

LONDON,
Printed for *Joseph Cranford*, at
the *Castle* and *Lion* in *Pauls*
Church-yard, 1 6 6 0.

Above
Silver Hornbook with printed alphabets [late seventeenth
century]
London £1,000 ($2,500). 21.11.73
From the collection of E. H. Letchworth Esq

THOMAS WHITE
*A Manuel for Parents, to which is added A Little Book for
Little Children*, 1660
London £500 ($1,250). 19.11 73
This appears to be the hitherto unrecorded first edition

CHARLES PERRAULT
Histoires ou Contes du Tems Passé
Engraved frontispiece and eight illustrations, Amsterdam,
1721
New York $1,800 (£720). 5.VI.73
An apparently unrecorded edition of the Mother Goose tales

Right
SARAH CATHERINE MARTIN
Old Mother Hubbard, with the continuation and sequel
Three vol., in one, engraved throughout, 1805–6
London £360 ($900). 19.11.73
From the collection of Miss M. D. English

The
COMIC ADVENTURES
of
OLD MOTHER HUBBARD
and
HER DOG.

*Publish'd June 1-1805, by J Harris, Successor to E Newbery, Corner of S: Pauls
Church Yard*

Above

WOLFGANG AMADEUS MOZART
One leaf from the autograph manuscript of *Rondo in A major for Piano and Orchestra*,
[Vienna, 1782]
London £2,600 ($6,500) 27.II.73
From the collection of Dennis Holland Esq

Below

LUDWIG VAN BEETHOVEN
The eight-page autograph manuscript of *Rondo a Capriccio*
New York $57,500 (£23,000) 20.III.73

Antiquities, Nepalese, Tibetan, Indian, African & primitive art

An Egyptian bronze figure of a cat, Saite period, 11 in
London £4,400 ($11,000).
9.VII.73

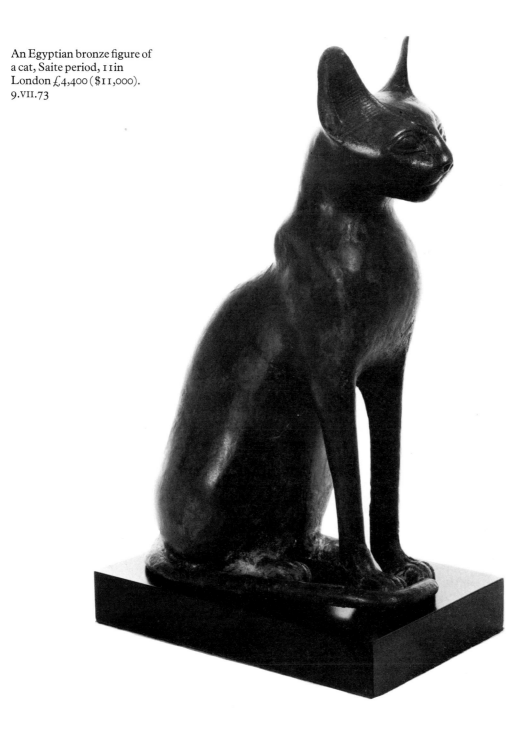

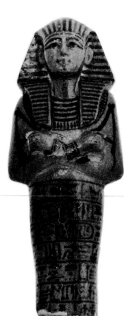

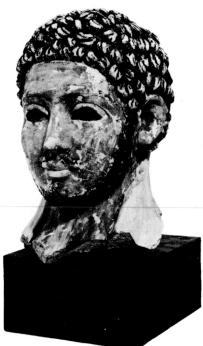

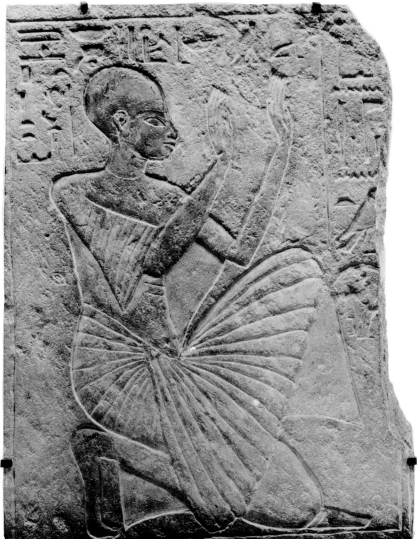

Above left
A large brilliant blue-glazed faience Royal ushabti figure of Seti I, New Kingdom, 9in
London £2,800 ($7,000).
4.XII.72
From the collection of The Rt. Hon. The Earl of Belmore

Above right
A Romano-Egyptian painted stucco portrait head of a man, probably from the Fayum, first century AD, 10½in
London £1,200 ($3,000).
9.VII.73
Formerly from the Ernest Brummer collection, sold in these rooms on 16th November 1964 £950

Left
An Egyptian limestone architrave fragment with a male figure kneeling and a hieroglyphic inscription across the top and down the sides with the owner's name and title 'Setembah, Prophet of Harendotes' (Horus-the-Avenger), nineteenth dynasty, 18¼in by 13¾in
London £1,900 ($4,750).
4.XII.72
From the collection of Mr Jan Mitchell of New York

Right
An over life-size marble male figure with the head of Marcus Aurelius, *circa* second century AD, 7ft 3in
£6,000 ($15,000)
The figure was found by Gavin Hamilton in 1772 at Tor Colombara and was sold to Lord Shelburne for £300

Far right
A Roman marble figure, called Paris, Hadrianic/early Antonine period, 5ft 6in
£6,800 ($17,000)
The figure was found by Gavin Hamilton in 1769 in Hadrian's Villa

Below
A Roman marble frieze from the front of a sarcophagus depicting the Muses, *circa* third century AD, 1ft 10in by 7ft £4,400 ($11,000)
The frieze comes from the sepulchres contiguous to the Appian Way near Rome. It was purchased by Lord Shelburne from Thomas Jenkins in 1771

The sculptures illustrated on this page were sold in London on 4th December 1972 and came from the celebrated collection of ancient marble sculpture formerly at Lansdowne House and Bowood, the property of the Most Hon. the Marquess of Lansdowne, PC. The collection was chiefly formed by William Fitzmaurice, second Earl of Shelburne and first Marquess of Lansdowne, in the second half of the eighteenth century

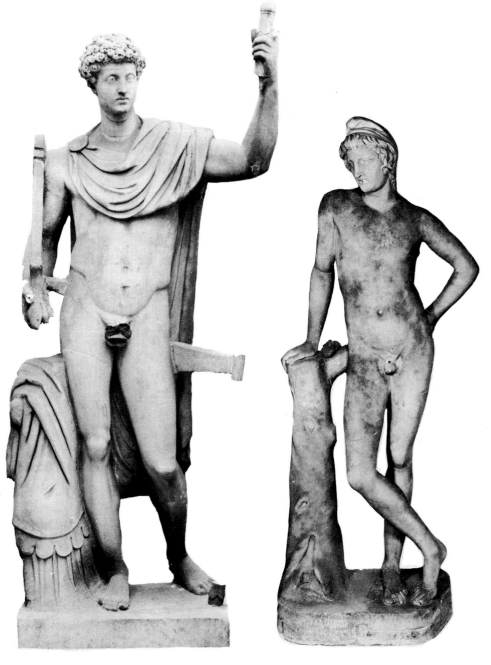

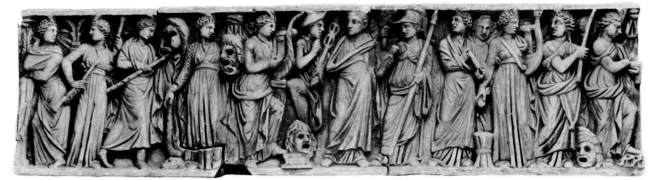

Left
An Egyptian wooden coffin of Tarutu, a lady singer in the
Temple of Amun, in three cases; the box coffin, the second
coffin and the innermost coffin (illustrated). Found at Tekhneh,
Upper Egypt, in 1901, twentieth/twenty-sixth dynasty,
circa 1126–525 BC
New York $28,000 (£11,200). 4.v.73

Right above
Egyptian bronze and wooden figure of an Ibis, probably
thirtieth dynasty, *circa* 378–341 BC, length 19¾in
New York $6,500 (£2,600). 1.XII.72

Below
Egyptian wooden funerary boat found at Bershal, Upper
Egypt in 1901, eleventh/twelfth dynasty, *circa* 2134–1785 BC,
length 49½in
New York $8,250 (£3,300). 4.v.73

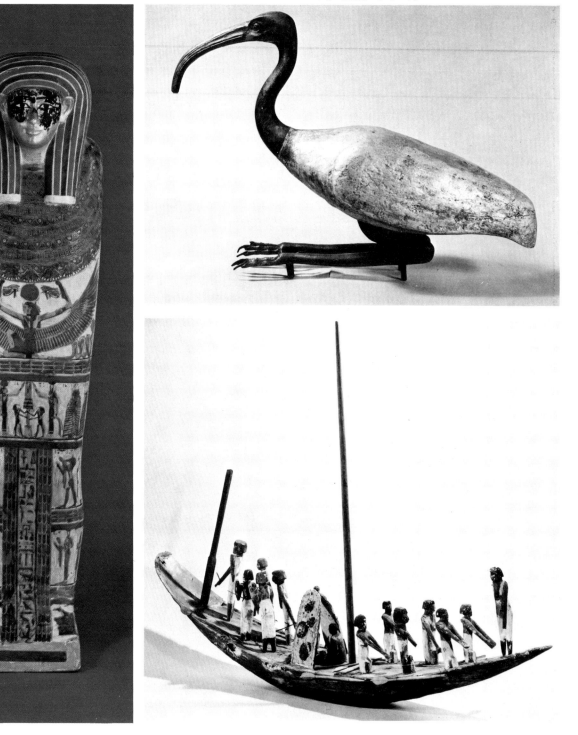

Right
A Roman marble bust of a victorious
youth, *circa* second century AD, 29in
London £6,000 ($15,000). 4.XII.72
From the collection of The Most Hon.
The Marquess of Lansdowne, PC
Found by Gavin Hamilton in 1769 in
Hadrian's Villa. Bought in 1771 by
Lord Shelburne for £75

Below A large fragment from a Roman
stone and glass mosaic, *circa* second
century AD, North Africa, 57¾in by 33¾in
New York $16,500 (£6,600). 4.V.73

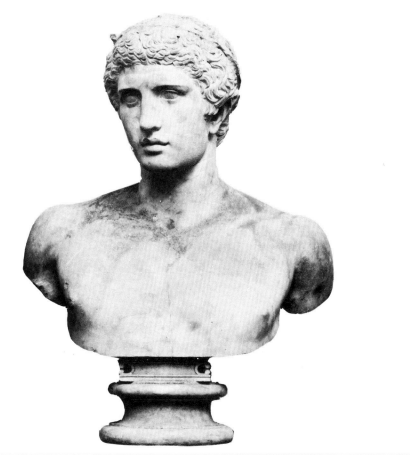

Left below

A Dedalic terracotta head of a woman, the face with Archaic features, *circa* seventh century BC, 5½in
London £1,200 ($3,000). 9.VII.73

A Roman twin-handled silver cup decorated in repoussé, *circa* first century AD
London £2,600 ($6,500). 9.VII.73

A Mycenaean pottery stemmed cup, *circa* 1400–1100 BC, 6⅞in
London £2,600 ($6,500). 9.VII.73

Centre

An Etruscan bronze Thymiaterion (incense stand), fourth century BC, 18in
London £1,250 ($3,125). 4.XII.72

Right below

An Anatolian pottery figure of a woman, *circa* first half of the sixth millennium BC, possibly from Hacilar, length 3 5/16 in
New York $11,000 (£4,400). 1.XII.72

An Attic black-figure pottery hydria from the *Leagros Group*, *circa* 510 BC, 16⅞in
London £2,800 ($7,000). 9.VII.73

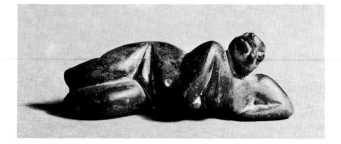

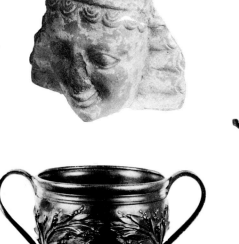

Right
A Sino-Tibetan copper-gilt figure of the
Dharmapala Hayagriva, standing in
pratyalidhasana, eighteenth century,
23½in
London £3,000 ($7,500). 10.VII.73

Right below
A Nepalese pata depicting a Mandala of
the Universe, nineteenth century,
27in by 44in
London £1,000 ($2,500). 10.VII.73

Below
A Sino-Mongolian gilt-metal khatvanga,
the handle incised with the words *Given
by Yung-lo*, fifteenth century, 17½in
London £5,800 ($14,500). 10.VII.73

Yung-lo (1403–1425), the second Ming
Emperor, had two Lamaist Teachers.
One was the Karmapa Hierarch Debzhin
Shegspa (1384–1415) whose chief
monastery was at Tsurphu. He also had
a monastery at Karma Gün in Eastern
Tibet and he returned there from China
in 1409 bringing with him the presents
that the Emperor gave him. The
khatvanga is said to come from Tsurphu,
this fact and the inscription make it
probable that it was indeed one of the
presents the Emperor gave his teacher

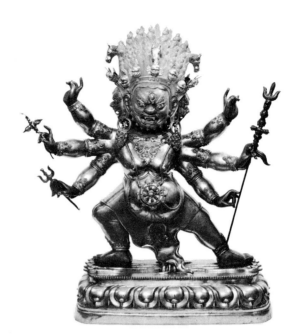

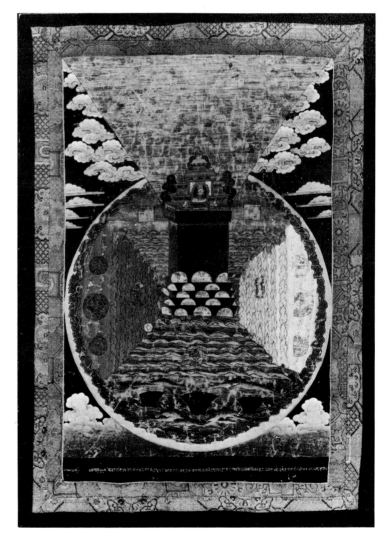

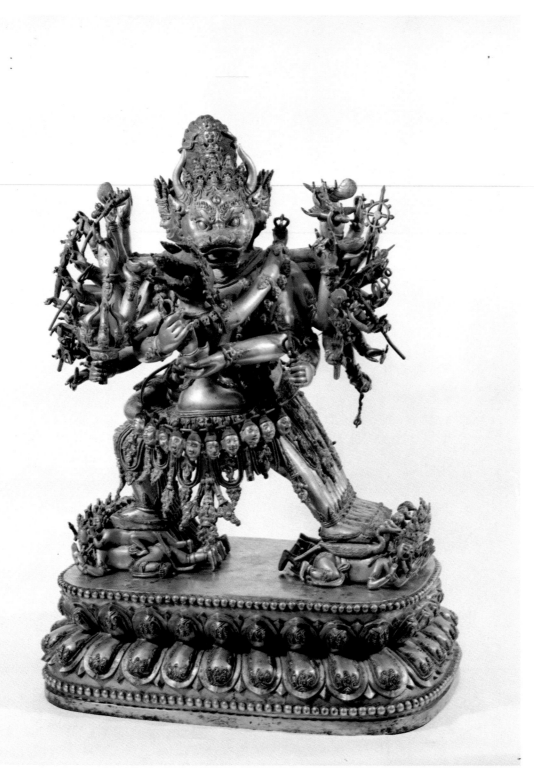

Opposite page

A Sino-Tibetan gilt-bronze figure of the Dharmapala Yamantaka in the form of Vajrabhairava with his bull's head finely sculpted, with nine heads, thirty-four arms and eighteen legs, wearing *dharmapala* garments and ornaments and standing in *pratyalidhasana*, eighteenth century, height and width 22½in
London £13,000 ($32,500). 10.VII.73

A Rarotonga carved wood standing figure of a male god, Cook Islands, Central Polynesia, 22¾in
London £44,000 ($110,000). 5.XII.72
From the collection of D. L. Armitage and G. L. Armitage whose great-grandfather, Mr Elijah Armitage, brought the figure back to England in 1836. Mr Elijah Armitage was a member of the London Missionary Society and was appointed by them as an artisan to Tahiti. He arrived there on 25th September 1821. In 1823 he went to Moorea and on 14th September 1833 he went to Rarotonga, arriving there on 14th October. (Rarotonga was discovered in 1823). He there instructed the people in the manufacture of cotton. Early in 1835 he left Rarotonga and returned to Moorea. At the end of October he sailed for Tahiti with his wife and family and proceeded to England arriving there on 2nd March 1836. His connections with the London Missionary Society then ceased and he returned to Manchester. The only other known free-standing Rarotonga figure of this type is in the British Museum

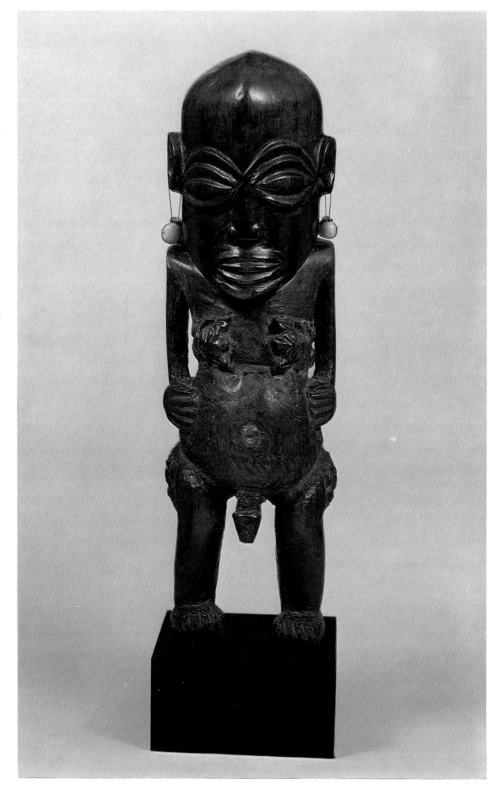

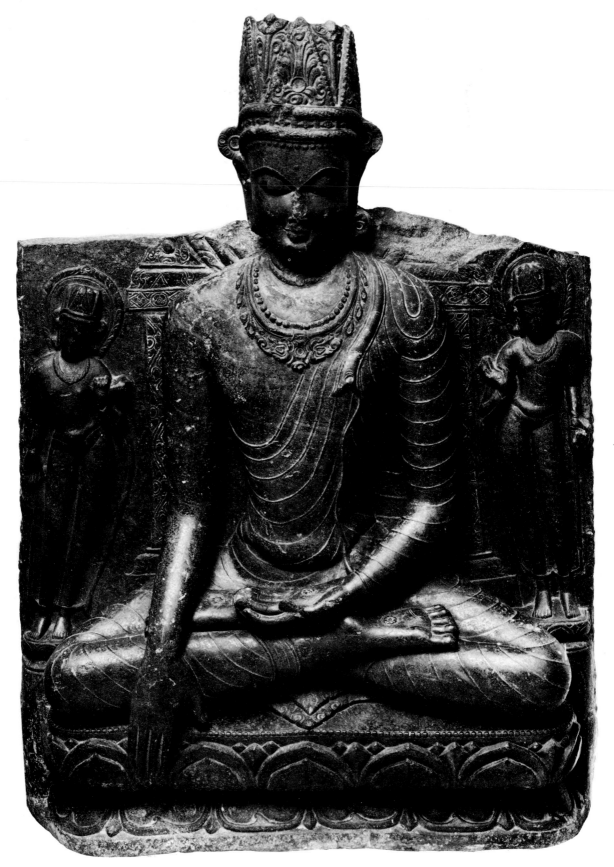

Opposite page
A Pala dark grey chlorite
stele carved with the figure
of the crowned Buddha in
relief, the features of the face
downcast, seated in
padmasana, Bihar or Bengal,
circa eleventh century,
42¾in by 30in
London £7,800 ($19,500).
10.VII.73
Formerly on loan to the
Brooklyn Museum, New
York (1968–1973)

A Benin bronze male head
for the Royal ancestor altars,
Nigeria, 10½in
London £21,000 ($52,500).
10.VII.73
Formerly from the collection
of Miss M. D. Tufnell, sold in
these rooms, 25th June 1968,
£8,000

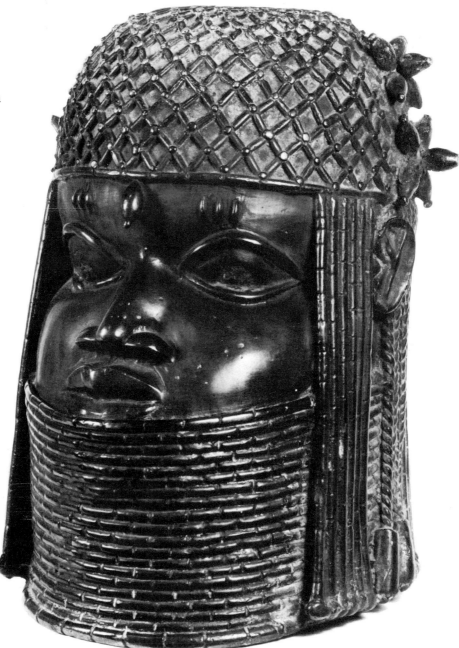

Left
A Baule wood male figure, Ivory Coast, 15in
London £3,800 ($9,500). 10.VII.73
From the Edward G. Robinson Collection

Below
A Maori carved wood feather box, the cover decorated with
two tiki-like figures, New Zealand, 19in by 6½in
London £5,000 ($12,500). 10.VII.73

Centre
A large Fang wood female reliquary figure (*bieri*), Gabon, 23½in
London £12,000 ($30,000). 10.VII.73
From the Edward G. Robinson Collection

Right
A Bakongo wood male fetish figure, Congo, 44½in
London £17,000 ($42,500). 26.III.73
From the collection of Mrs J. Ollers

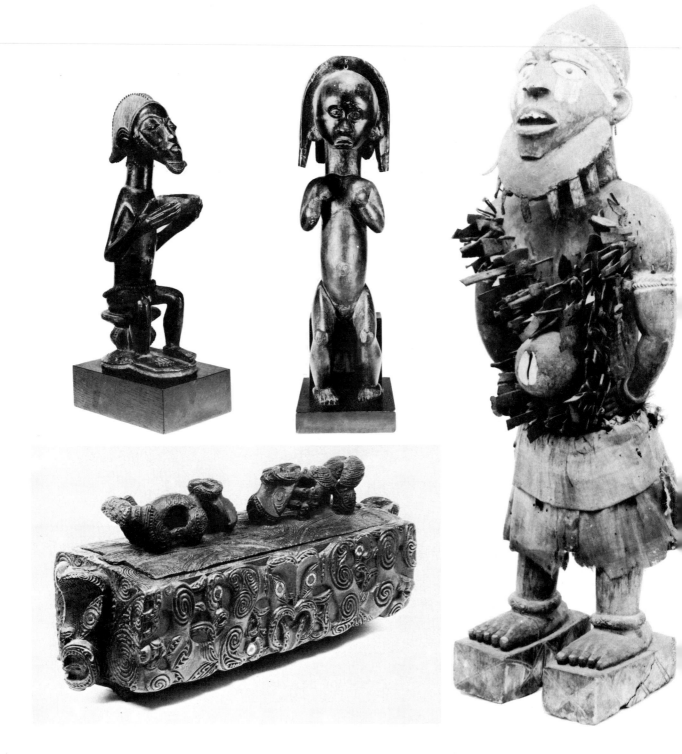

Right
A Pacific North-West Coast ivory finial
from a knife handle, in the form of a bear's
head, with abalone shell inlay, 3¼in
London £1,900 ($4,750). 10.VII.73

Centre
A Pacific North-West Coast carved wood
female mask, 9⅜in
London £4,800 ($12,000). 26.III.73
From the collection of Mrs J. Ollers

Below right
A small Bakongo carved wood male fetish
figure, Congo, 7¼in
London £2,400 ($6,000). 26.III.73
From the collection of Mrs J. Ollers

Below left
A Bena Lulua carved wood figure of a
man, Congo, 10⅛in
London £2,100 ($5,250). 26.III.73
From the collection of Mrs J. Ollers

Far right
An Easter Island carved wood ceremonial
paddle (*tappa*), 31in
London £4,600 ($11,500). 26.III.73
From the collection of Mrs J. Ollers

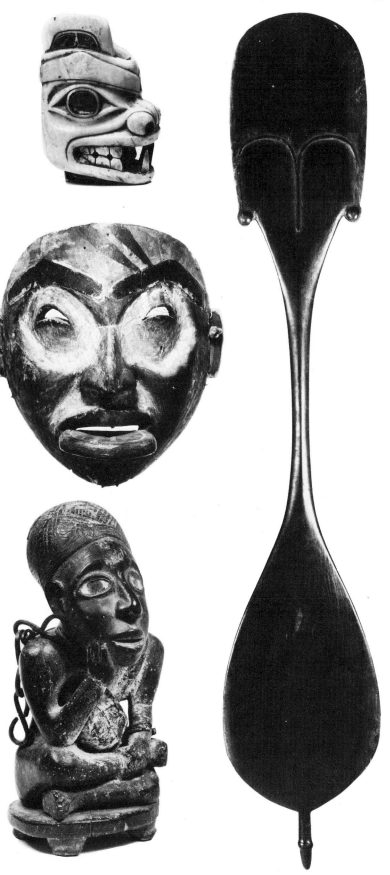

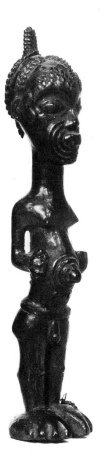

Right
An American Indian wooden
ball-headed club, North
Eastern Region, length 23in
New York $4,000 (£1,600):
20.X.72

Far right
An early Canadian Cree
buckskin pouch, second half
of the eighteenth century,
height 13in
London £900 ($2,250).
5.XII.72

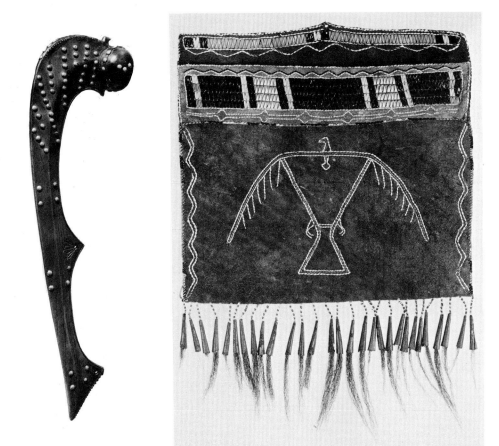

An American Indian woollen
blanket woven in black, blue,
yellow and cream with panels
of various totemic devices,
53in by 67in
New York $6,500 (£2,600).
20.III.73

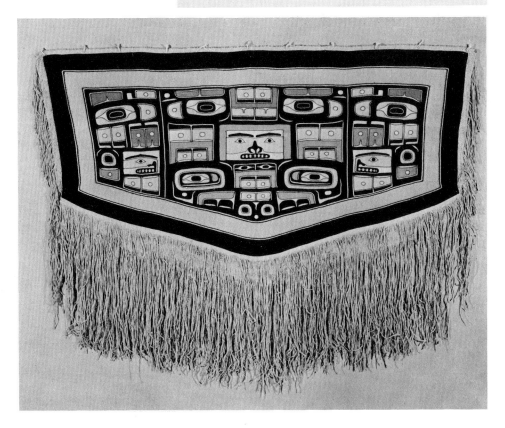

Works of Art

Medieval
Renaissance
Seventeenth, eighteenth and
nineteenth century
Icons and Russian
Objects of vertu
and miniatures

A South German carved
ivory group of a sleeping
infant with his head
supported on a skull, early
seventeenth century, length
8¾in
London £5,200 ($13,000).
9.IV.73

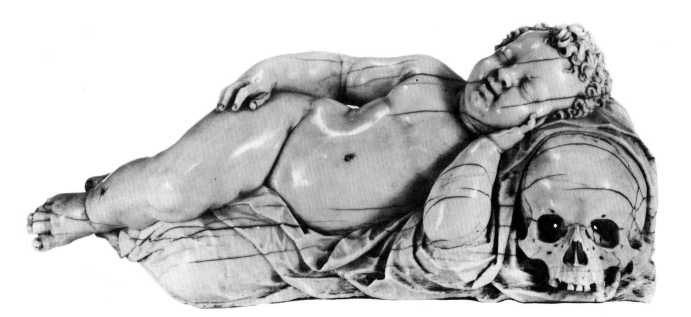

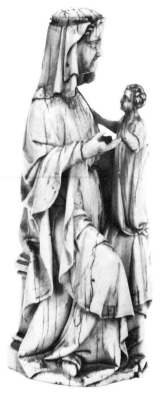

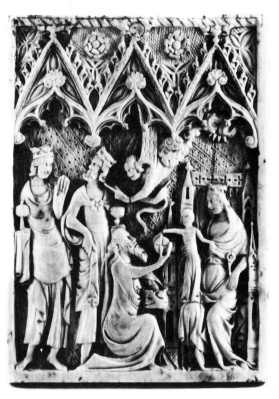

Far left
A French Gothic ivory group
of the Virgin and Child, early
fourteenth century, height
5¼in
London £6,000 ($15,000).
2.VII.73
From the collection of Dr K.
Stavenhagen

Left
A Rhenish Gothic carved
ivory panel of the Adoration
of the Kings, mid-fourteenth
century, height 4in, width
2⅞in
London £2,700 ($6,750).
16.XI.72

Below
A German Gothic ivory
diptych carved with scenes
from the life of Christ.
Probably from Cologne, first
half of the fourteenth century,
height 6½in, width when open
9¾in
London £8,000 ($20,000).
9.IV.73

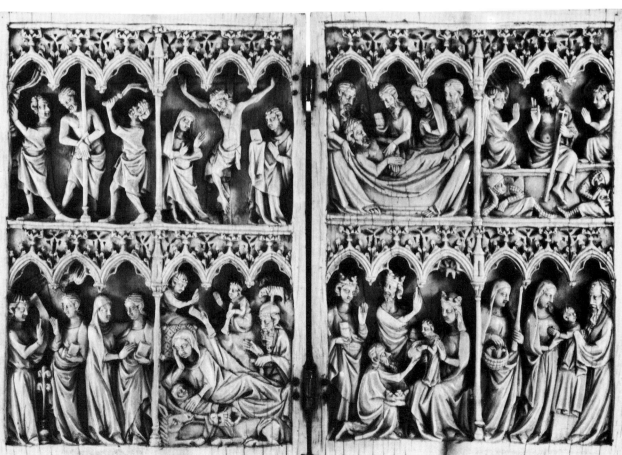

This season has offered us some fine examples of sculpture of both the Gothic and Renaissance periods.

Most notable of the early pieces was a large early fourteenth-century ivory diptych carved in relief with scenes from the life of Christ arranged one below the other in two leaves in much the same way as a contemporary illuminated psalter (£8,000). These diptyches were inspired by Byzantine consular leaves in ivory which were given by a consul to the highest officials in the land; carved on the exterior with a portrait of the man himself, they were engraved inside with his name and that of preceding consuls. Later they were converted for ecclesiastical use. Another single panel from the Cologne district made £2,700. Both these reliefs were set within a framework of arches, crockets and pinnacles inspired by contemporary cathedral architecture. A third French ivory group in the round of the Virgin and Child with traces of original gilt decoration on the hem of her robe and a niche for a relic completes the picture (£6,000). A large Venetian fifteenth-century marble relief of the same subject still retaining the elegant V-forms in the folds of the drapery as in the French ivory group. We know that from the end of the thirteenth century French Gothic art came to be known in Italy through the importation of illuminated manuscripts, as well as ivories and miniatures, though this style began to take on a more human quality under the influence of Giotto.

A small and fine North Italian early sixteenth-century gilt-bronze figure of Venus sold at Parke-Bernet ($29,000) takes us into the Renaissance period with its direct inspiration from the antique, even down to the insertion of silver eyes. The taste for things classical in this period led to the production of many copies of Greek and Roman antiquities and especially small bronzes. Towards the end of the sixteenth century the Renaissance reached its height and developed into the Mannerist phase; one particularly good example of this period was sold in London: the Pietà group attributed by Planiscig to Giovanni da Bologna in 1928, with its typical thin gold lacquer and fine modelling, especially in the limbs, fingers and toes (£12,500).

Three fine South German wood carvings must be mentioned: a group of the Virgin and Child attributed to Daniel Mauch (£9,800) and a relief of St Catherine (£9,600), both in limewood, the most usual material for this region, with their long curling tresses of hair and the boxlike folds of their robes showed the lingerings of Gothic style in the early sixteenth century. Also of this date, *circa* 1520, was an attractive figure of St Florian (£6,400) with the rather sweet expression of the Swabian sculpture and complete with original bucket and water to pour on his burning building. St Florian is, of course, the patron saint of firemen. From Flanders an unusual kneeling figure of a knight, from a tomb, made £8,500. We can date this piece fairly accurately to about 1520 from the type of helmet and sword which rest beside him.

The outstanding bronzes and works of art sold at Sotheby's Belgravia this season, with the notable exception of the Westmacott marble of 'Mercury and Vulcan' (£2,900), have been from the period 1870 to 1915, which was dominated by artists and designers of the Arts and Crafts Movement. Among them was Ernest Gimson, described by Pevsner as 'the greatest English artist-craftsman', who gathered around himself in Gloucestershire a group of superb craftsmen including Alfred Bucknell, who executed from Gimson's design a fine pair of polished steel firedogs (£700).

The 'New Sculpture' movement was also dominated by sculptors with craft sympathies. In the vanguard of the movement was Frederic Leighton (later Lord Leighton) whose 'Sluggard' of 1886 was perhaps one of the most successful bronzes of the period. The majority of 'New Sculpture' bronzes were produced by the highly

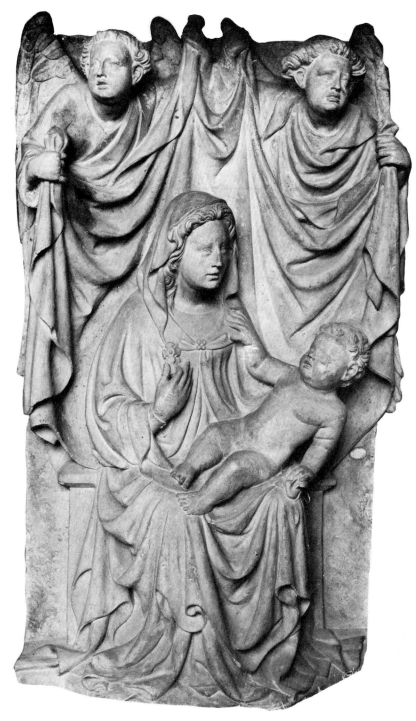

personal lost wax process, Albert Toft's 'Hagar' (£340) being a typical example,
but the 'Sluggard' was, in fact, produced in relatively large numbers by commercial
founders and prices vary according to the quality of the casts; examples at Belgravia
this season secured between £300 for a cast sold on 14th March and £620 for another
sold on 4th July.

A French stone figure of St
Barbara attributed to Jacques
Juliot of Troyes, dated 1524,
2ft 10½in
London £10,000 ($25,000)
16.XI.72
Formerly in the Brummer
Collection in New York

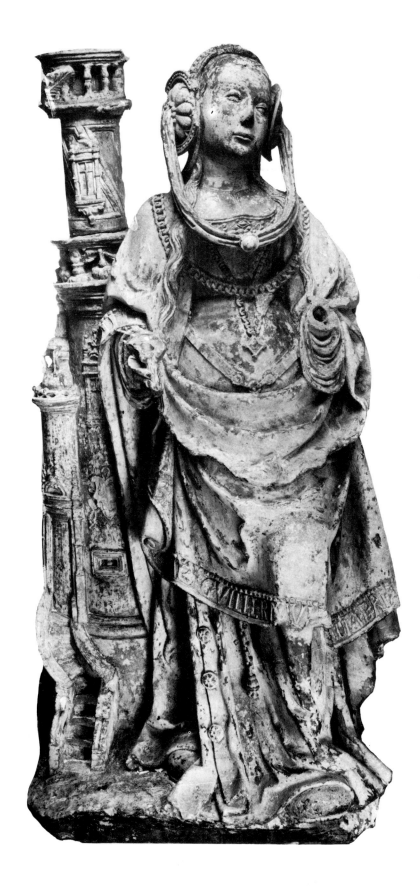

A Flemish carved limestone
figure of a kneeling knight,
circa 1520, height 1ft 6in
London £8,500 ($21,250)
2.VII.73
From the collection of the Rt
Hon Lord Derwent

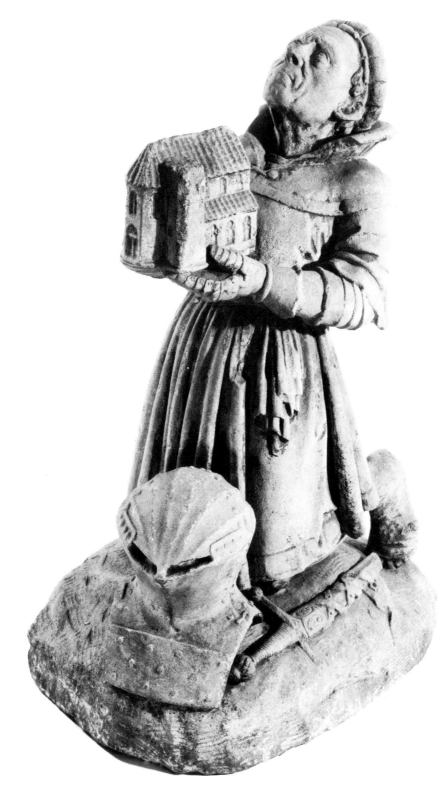

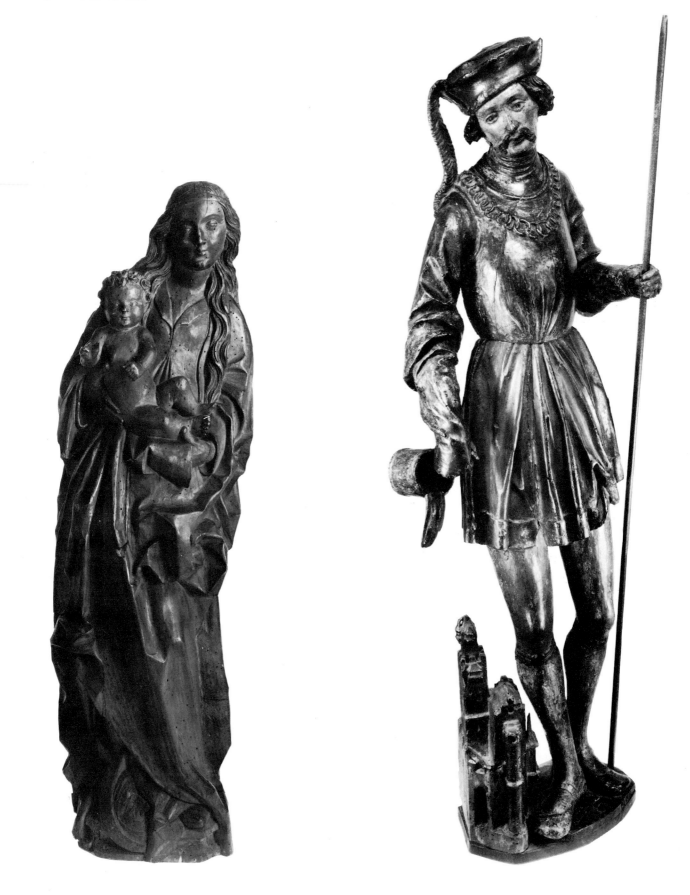

Opposite page
Far left
A carved limewood group of the Virgin and Child attributed to
Daniel Mauch, *circa* 1500, height 2ft 5½in
London £9,800 ($24,500). 16.XI.72

Left
A South German polychrome figure of St Florian, Swabian,
early sixteenth century, height 3ft 6½in
London £6,400 ($16,000). 2.VII.73

Right
A South German carved and polychromed limewood relief of
St Catherine, *circa* 1500, height 3ft 4½in
London £9,600 ($24,000). 16.XI.72

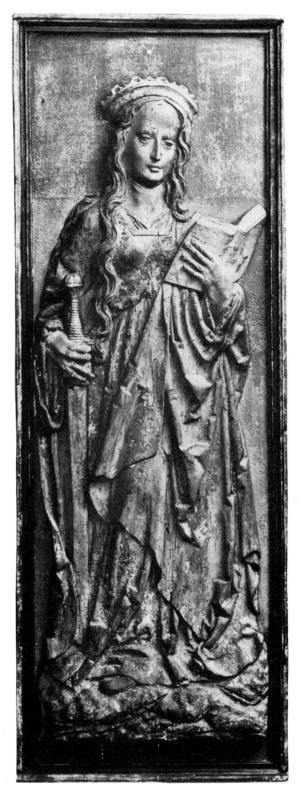

A French Gothic silver parcel-gilt angel reliquary modelled in the round. Maker's mark *BRUKL* in Gothic black letter, late fifteenth century, height 9in
London £3,800 ($9,500). 16.XI.72

A North Italian gilt-bronze figure of Venus after the antique, early sixteenth century, height 7¼in
New York $29,000 (£11,600). 23.III.73

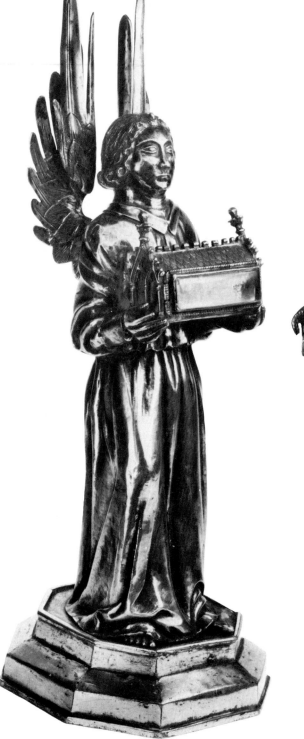

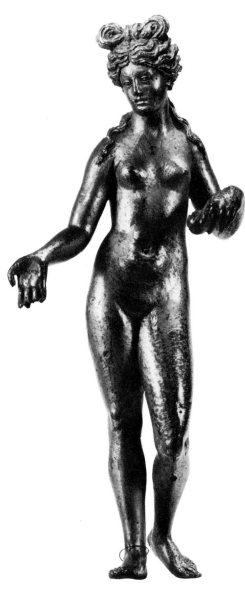

A Florentine bronze group of the Pietà attributed to Giovanni
da Bologna, second half of the sixteenth century, 12in
London £12,500 ($31,250). 2.VII.73
Formerly in the collection of Carl von Weinberg in Frankfurt

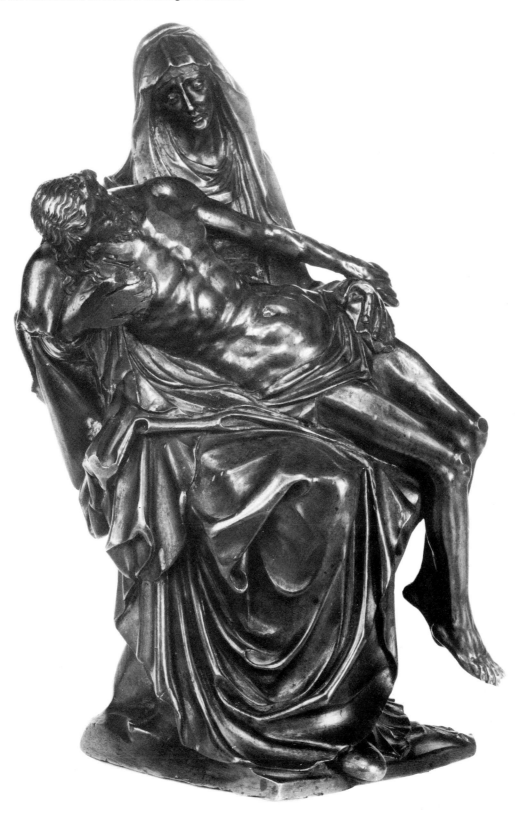

Right
An English oval ivory portrait medallion of Queen Anne by
David Le Marchand, signed *D. L. M.*, early eighteenth
century, 5in
London £2,800 ($7,000). 2.VII.73
From the collection of the Rt Hon the Earl Beauchamp

Below
A set of twelve bronze busts of the Roman emperors, French
or Italian, second half of the seventeenth century, height 11½in
London £9,000 ($22,500). 9.IV.73

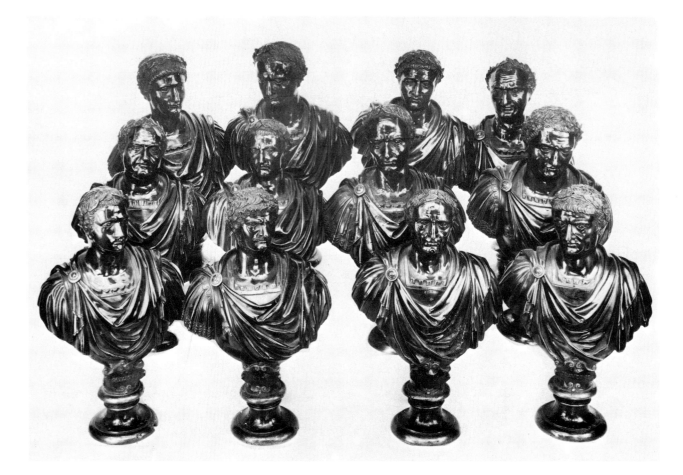

Right
A bronze group of St George and the dragon, probably
Austrian or South German, *circa* 1720, height 1ft 1½in
New York $10,000 (£4,000). 23.III.73

Below
A bronze equestrian group by Francesco Fanelli, first half of
the seventeenth century, length 8in
London, £1,850 ($4,625). 9.IV.73
From the collection of the late Sir Harrison Oulsnam

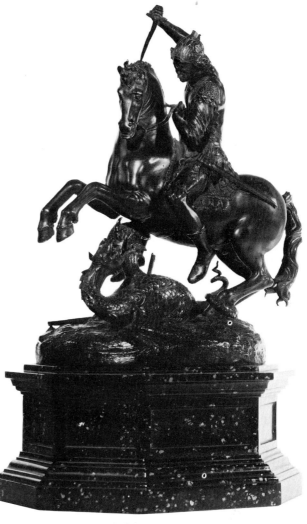

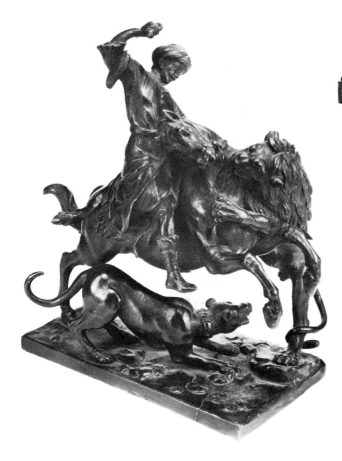

Right
A bronze figure of 'The Sluggard' after F. L. Leighton, 1890, height 1ft 8½in
London £440 ($1,100). 1.XI.72

Centre
A bronze figure of 'Hagar' by Albert Toft. Signed and dated 29.3.98, height 1ft 5in
London £340 ($850). 22.XI.72

Below
A white marble relief of Mercury and Vulcan by Richard Westmacott. Signed and dated 1837, height 2ft 8in, length 5ft
London £2,900 ($7,250). 6.VI.73
From the collection of the Most Hon the Marquis of Lansdowne PC, DL

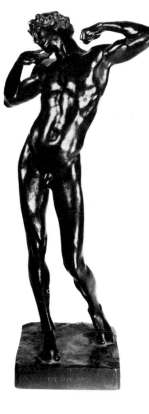

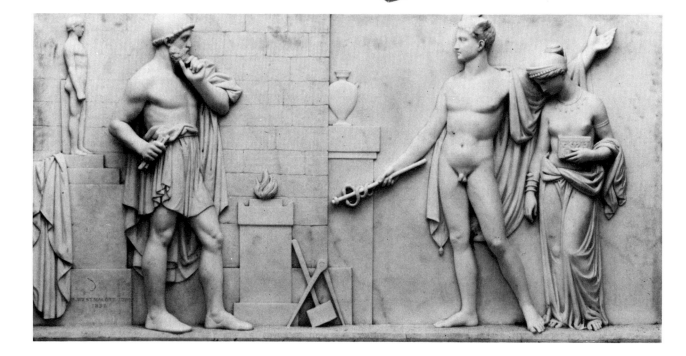

A pair of polished steel firedogs designed by Ernest Gimson
and made by Alfred Bucknell, together with a cast-iron box
basket by Netherton, *circa* 1910, height of firedogs 2ft 4in,
width of basket 2ft 3½in
London £700 ($1,750). 20.XII.72

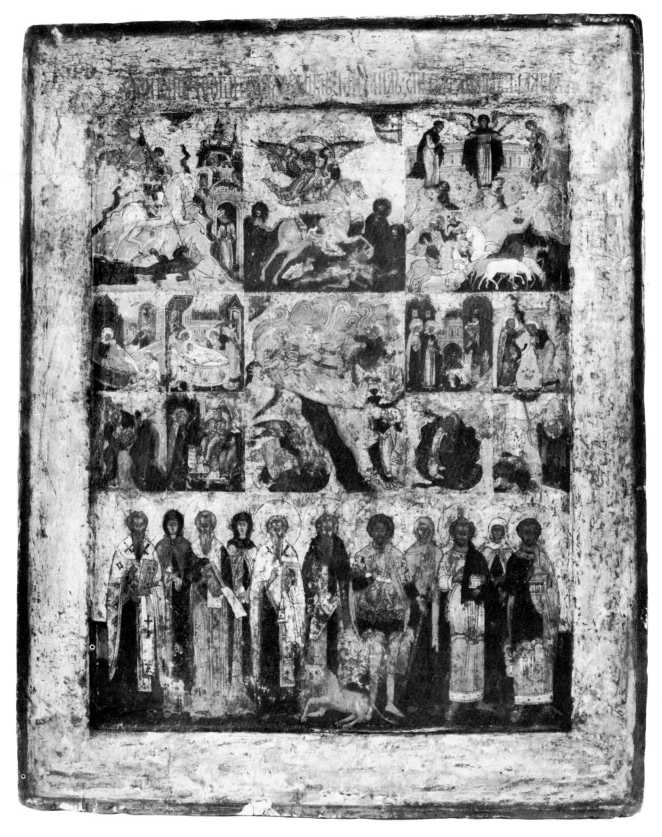

Opposite page
A Russian composite icon centred by the fiery Ascension of the prophet Elijah flanked by eight scenes from his life, the top row with scenes including St George slaying the dragon, the bottom row with eleven saints. Central Russian, *circa* 1600, 24in by 19½in.
London £4,000 ($10,000). 30.x.72
From the collection of H. J. N. Fentiman Esq, OBE, MM, FCIS

Right
A set of three icons, the central one with Christ Emmanuel shown full face shoulder high, above it the archangel Gabriel and below the archangel Michael, both shown shoulder high. Moscow School, early seventeenth century, 13½in by 11½in
London £2,400 ($6,000). 5.xII.72

Below
An early Greek icon of St Paraskeva and St Antonios, both shown full length, the former holding a crucifix, the latter a staff. Probably Macedonian, sixteenth century, 9½in by 7½in.
London £1,550 ($3,875). 17.iv.73

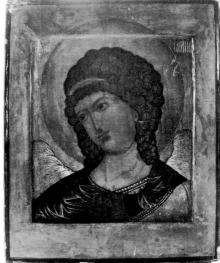

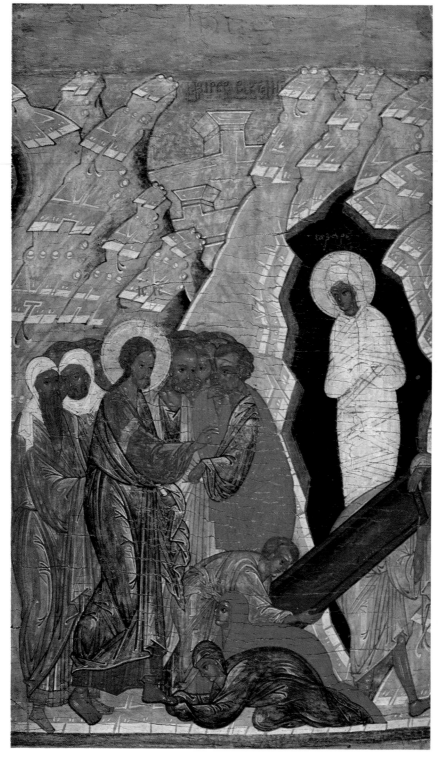

A Russian icon depicting the raising of Lazarus, the major portion of a larger icon that has been cut on both sides. Novgorod School, second half of fifteenth century, 22in by 12½in. New York $28,000 (£11,200). 1.v.73 The composition of this icon is based on the description of the last miracle performed by Christ before his crucifixion according to *John* XI: 1–46; this subject is fairly rare, but the composition and the brilliant colouring are typical of the Novgorod School

Opposite page
An icon of St Catherine, the martyr saint, shown half length full face, wearing a crown and jewelled cape and holding a cross, set into a later panel, Novgorod School, fifteenth century, 17½in by 15in. London £4,200 ($10,500). 19.11.73

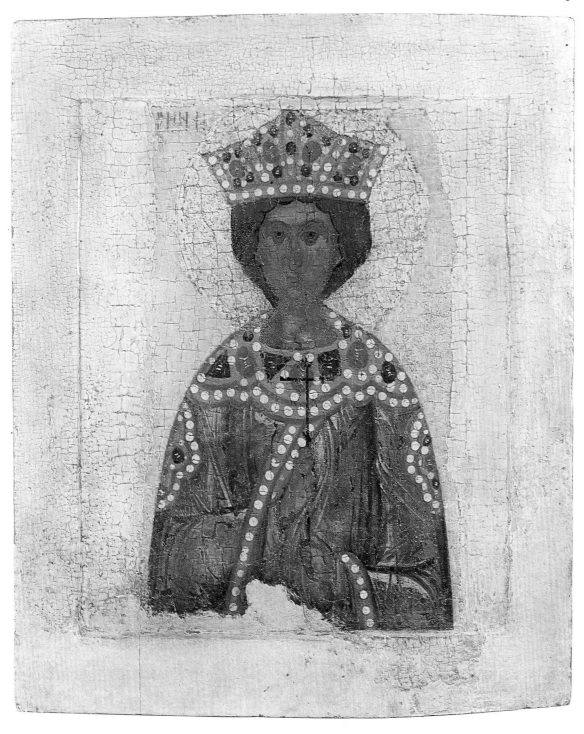

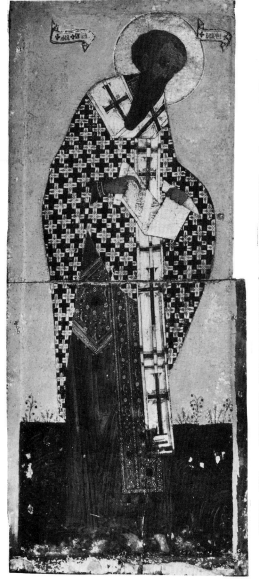

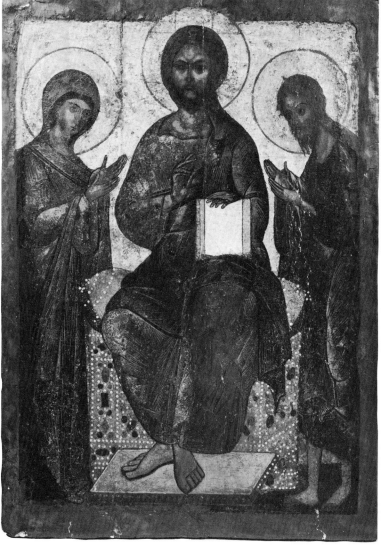

Above

A large North Russian icon of St Basil of Cesarae, shown full length and holding an open scroll in his hands, from the Tchin row of an iconostas. Late seventeenth century, but painted in an earlier tradition, 52½in by 22½in
London £3,000 ($7,500). 30.X.72

Right

A large Russian icon of the Deisis, with Christ depicted seated on a throne, flanked by the Virgin and St John the Baptist, both full length. Northern School, late fifteenth to early sixteenth century, 50½in by 35½in
New York $16,500 (£6,600). 30.XI.72
From the collection of the late Hon. and Mrs John C. Wiley of Washington, DC

Opposite page

A large icon of the Mother of God of Tichvin, the Virgin shown half length holding the Infant Christ with her left arm, painted in the seventeenth-century tradition, with a silver-gilt riza embellished with pastes and blue enamel inscription plaques. Maker's mark *S.A.,* dated St Petersburg 1834, 35in by 26½in
London £3,500 ($8,750). 30.X.72

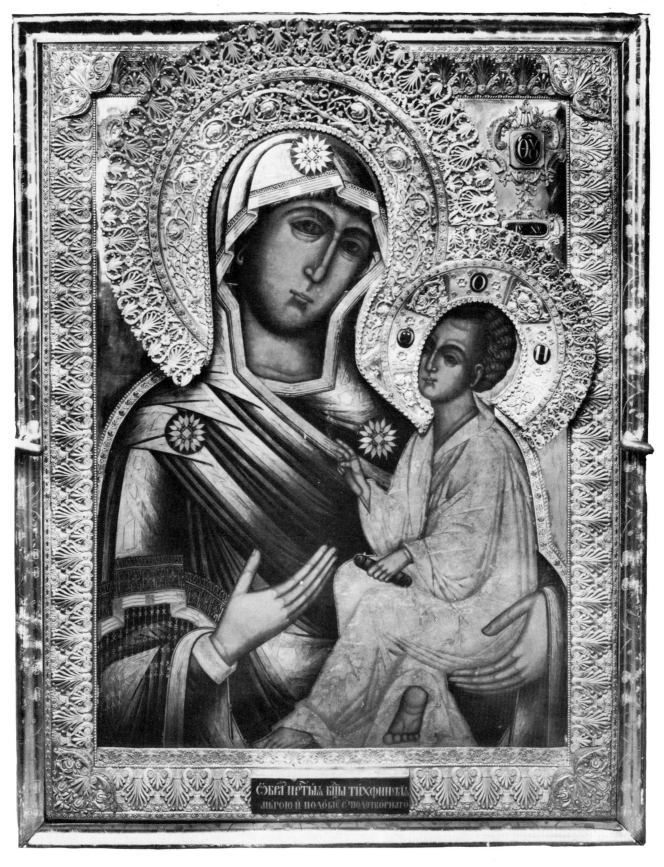

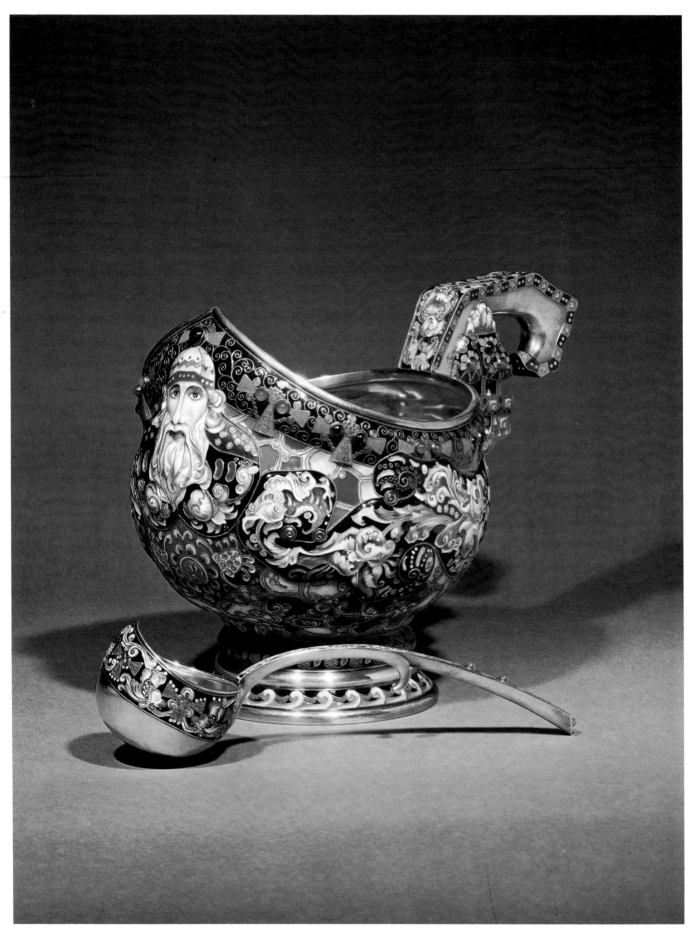

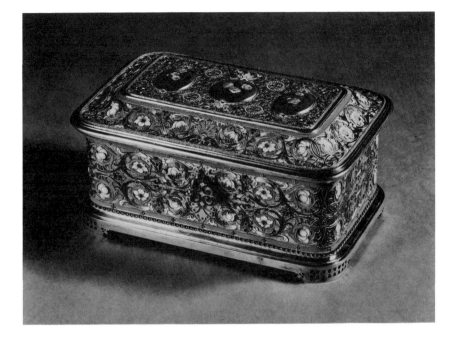

Above
A Russian gilded-silver and shaded enamel casket by Maria Adler, Moscow, 1877, height 4¾in, width 9¼in
New York $8,250 (£3,300). 30.XI.72

Below
A Russian cloisonné enamel two-handled bowl, the exterior decorated with leaf-shaped panels of scrolling acanthus foliage, by Ovtchinnikov, 20½in
London £4,100 ($10,250). 4.XII.72

Opposite page
A Fabergé gilded-silver and shaded enamel punch bowl and ladle. Workmaster Feodor Ruckert, Moscow, *circa* 1900, height of bowl 11¼in, length 16½in, length of ladle 12½in
New York $21,000 (£8,400). 30.XI.72

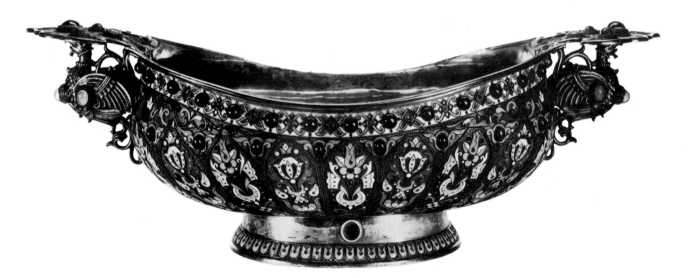

A Fabergé silver flatware service, all 235 items with beaded
decoration, some gilt, bearing the monogram *S.E.*
Workmaster Julius Rappaport, St Petersburg, *circa* 1900
New York $36,000 (£14,400). 30.XI.72

A bronze group of a Cossack warrior and horses by Eugene
Lanceray, signed and dated 1874, with the inscription of the
Chopin foundry, length 16in
London £1,000 ($2,500). 4.XII.72

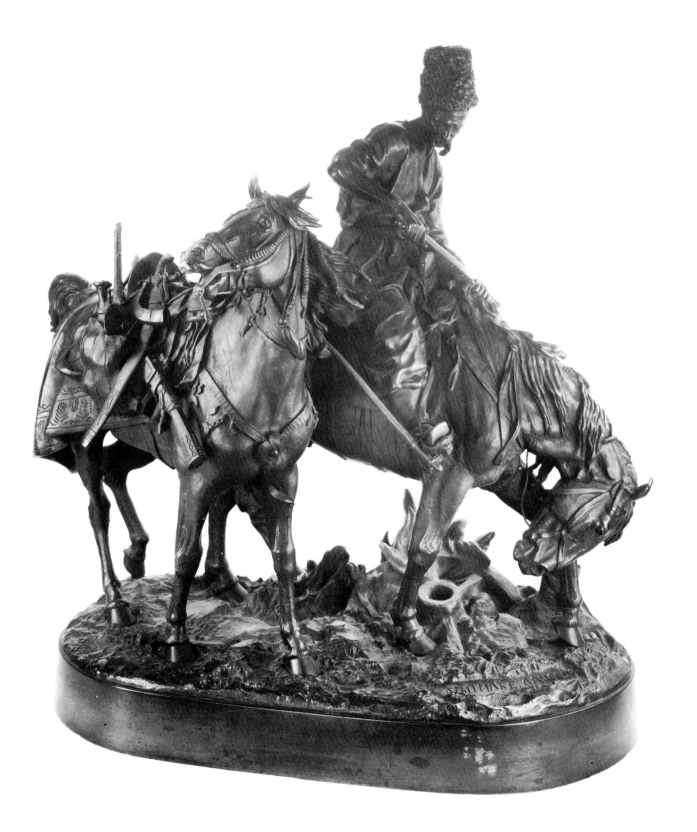

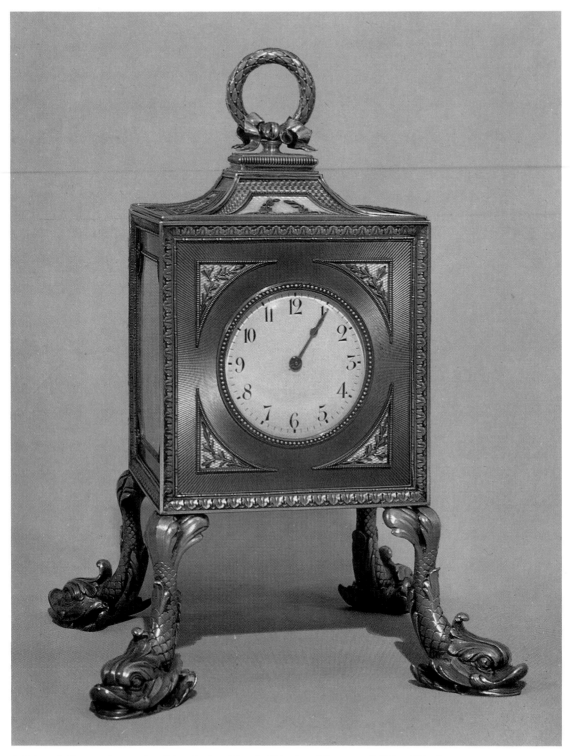

A Fabergé silver and enamel striking clock, with cuboid body, white enamel dial and black
Arabic numerals, in fitted case. Workmaster Karl Gustav Hjalmar Armfelt, height 8½in
London £9,000 ($22,500). 25.VI.73
From the collection of C. G. G. Wainman Esq

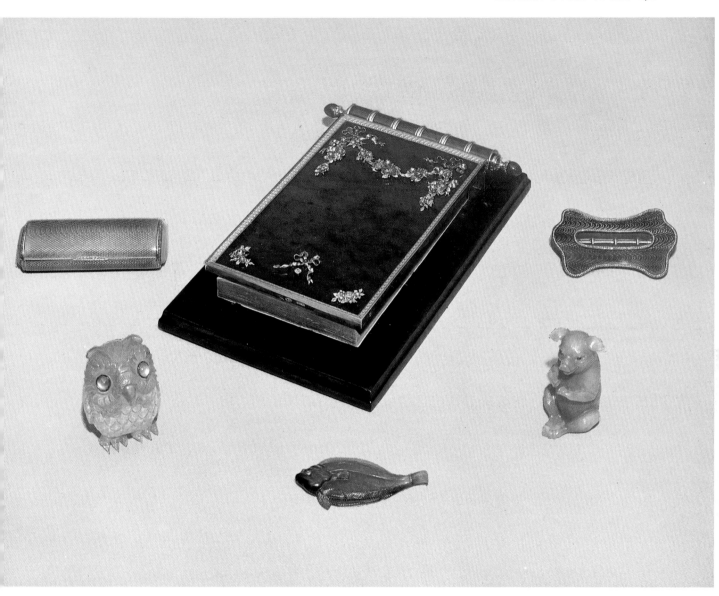

A Fabergé gold and enamel lady's cigarette case
Workmaster Michael Perchin, 3¼in £1,350 ($3,375)

A Fabergé rock crystal short-eared owlet with star sapphire eyes, 2in £3,600 ($9,000)

A Fabergé writing tablet, the hinged nephrite cover applied with multicoloured gold garlands
and swags of flowers. Workmaster Henrik Wigström, 8in £3,900 ($9,750)

A Fabergé smoky quartz fish, 2½in £1,550 ($3,875)

A Fabergé gold and enamel buckle
Workmaster Michael Perchin, 2¾in £750 ($1,875)

A Fabergé hardstone piglet, carved from almost opaque agate, 2⅛in £5,200 ($13,000)

The objects illustrated on this page were sold in London on 26th February 1973, from the
collection of Mrs R. H. R. Palmer

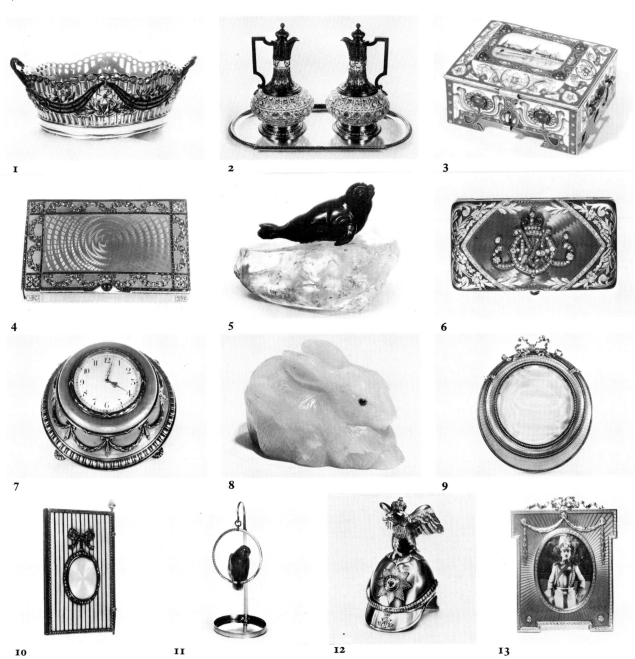

1 2 3

4 5 6

7 8 9

10 11 12 13

1. One of a pair of Gardner baskets decorated with the Collar of the Order of St George. G mark in underglaze blue, 10½in. £880 ($2,200) 4.XII.72. 2. One of pair of Fabergé claret ewers on tray. Ewers 10in, tray 17¾in. £2,500 ($6,250) 4.XII.72. 3. Fabergé gilded-silver and enamel casket, workmaster Feodor Ruckert, Moscow, c. 1900, height 1¾in, width 4in. $4,000 (£1,600) 1.V.73. 4. Russian gold and enamel cigarette case. £2,700 ($6,750) 26.II.73; 5. Fabergé hardstone sea lion resting on slab of rock crystal, 5in. £1,550 ($3,875) 25.VI.73. 6. Russian jewelled, gold and translucent enamel card case belonging to Empress Maria Feodorovna by court goldsmith Bolin, St Petersburg, last quarter of nineteenth century. Length 3¼in, width 1⅞in. $3,400 (£1,360) 30.XI.72. 7. Fabergé silver and enamel table clock, workmaster Henrik Wigström, 4¼in. £1,400 ($3,500). 4.XII.72. 8. Fabergé agate figure of a rabbit, St Petersburg. c. 1900, height 2⅜in, length 4⅜in. $6,000 (£2,400) 1.V.73. 9. Fabergé enamel photograph frame, workmaster Michael Perchin, 5in. £2,100 ($5,250) 4.XII.72. 10. Fabergé gold and enamel aide-mémoire, workmaster Michael Perchin, 2¾in. £1,600 ($4,000) 25.VI.73. 11. Fabergé hardstone parrot on perch, workmaster Henrik Wigström, 5⅛in. £3,900 ($9,750) 25.VI.73. 12. Fabergé miniature silver helmet as worn by the Imperial Horseguards, workmaster August Holmström, 3¾in. £900 ($2,250) 26.II.73. 13. Fabergé silver-gilt and enamel miniature frame, workmaster Michael Perchin, 4¼in. £1,300 ($3,250) 25.VI.73

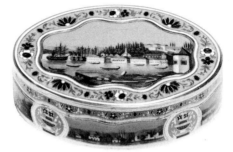

Above
A Dresden gold and hardstone snuff box by Johann Christian Neuber, *circa* 1770, 2½in
London £1,150 ($2,870). 26.III.73
From the collection of The Rt Hon Lord Dormer

Centre
A Dutch silver box, the centre engraved with *The Finding of Moses,* the base engraved with a rose, seventeenth century, 2⅜in
London £1,100 ($2,750). 4.VI.73
From the collection of the Rt Hon The Earl Beauchamp

Below
A Swiss four-colour gold snuff box, the lid decorated with a shepherd standing by his flock with a farm in the background, eighteenth century, 2¾in
London £1,200 ($3,000). 4.VI.73

Above
A Jaipur sweetmeat box, the slightly domed lid centred with a cluster of rose-cut diamonds against a green enamel background, eighteenth century, 4⅓in
London £1,150 ($2,870). 18.XII.72
From the collection of Darius Talyarken Esq

Centre
A Swiss gold and enamel snuff box decorated with Turkish harbour views on an apple green ground, *circa* 1810, 3¼in
New York $3,000 (£1,200). 8.XII.72

Below
A Danish three-colour gold and enamel snuff box by Fredrik Fabricius, Copenhagen, *circa* 1780, 3in
New York $6,750 (£2,700). 2.V.73

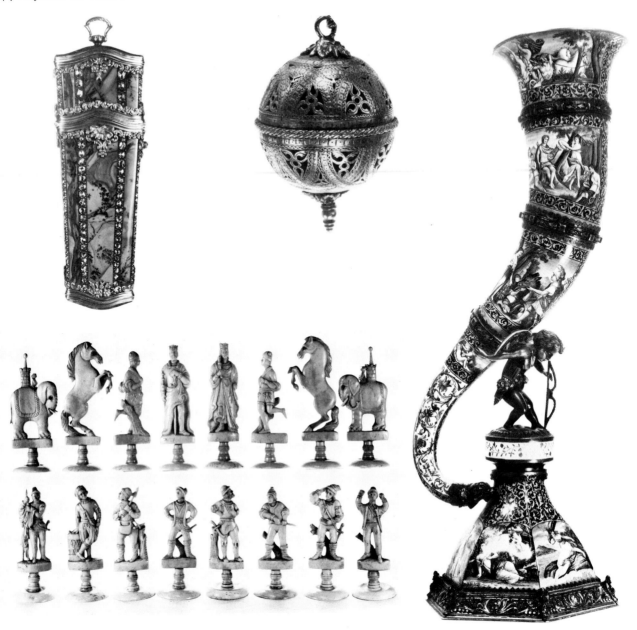

Above left
A George II gold and jewelled étui, the lid and sides set with panels of brown jasper, the interior complete with gold, ivory and steel fittings, the top applied with a diamond and gold loop, mid-eighteenth century, 4½in
London £1,550 ($3,875). 4.VI.73
From the collection of Baroness van Dedem

Below left
An Austrian carved ivory chess set, the main pieces carved as European monarchs in ceremonial robes, the bishops as running peasants in *lederhosen*, the knights as rearing horses, the castles as elephants supporting towers and the pawns as mercenaries, late eighteenth century, kings 3¾in, pawns 3¼in
London £1,100 ($2,750). 5.II.73

Above centre
A German silver-gilt pomander, the two parts pierced and engraved with geometric Gothic panels and trefoil tracery, *circa* 1550, 2¾in
London £720 ($1,800). 4.VI.73
From the collection of the Rt Hon The Earl Beauchamp

Right
A Viennese cornucopia painted with mythological scenes and supported on the back of a winged silver cherub, mid-nineteenth century, 15in
London £1,100 ($2,750). 4.VI.73

A Louis XV gold and enamel tabatière by Jean Formey, the lid decorated *en plein* after Teniers with a peasant offering a tankard of ale to a timid girl with three men in the background playing cards, within a chased rococo frame adorned with blue *basse-taille* shells and green and blue *basse-taille* garlands, the ends painted with still life interiors, the base after Quentin Massys showing an interior with two money-counters. Paris 1756, Farmer General Eloy Brichard, 2¾in London £16,000 ($40,000). 18.XII.72
From the collection of Mrs E. N. Seymour

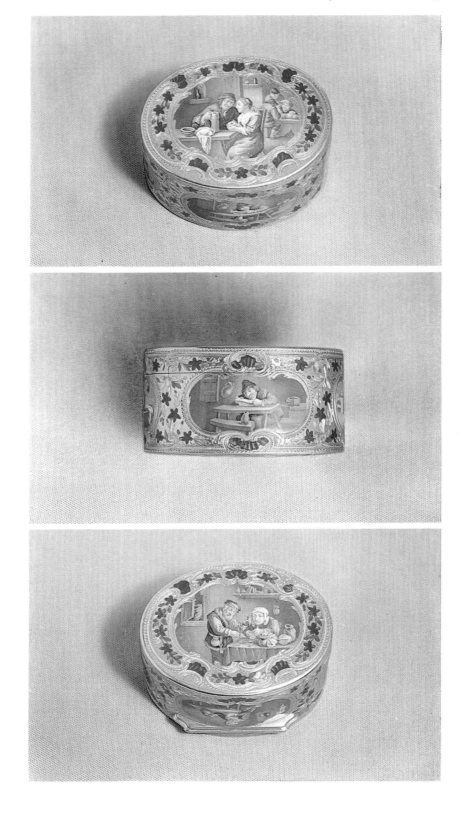

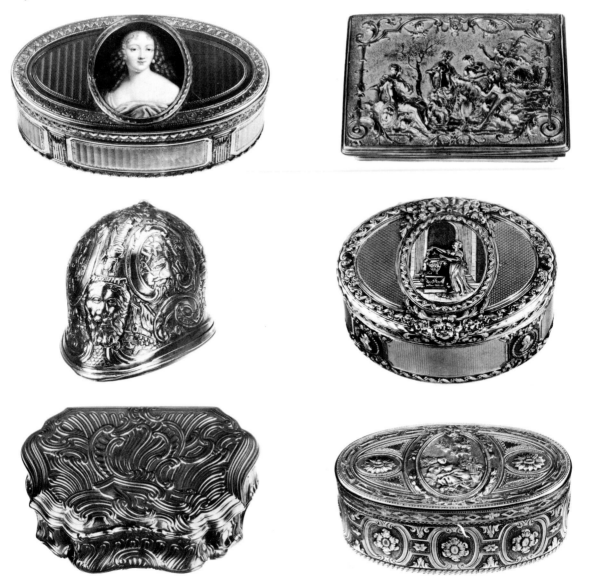

Above
A Louis XVI gold oval snuff box inset with an enamel minia-ture of a lady by Petitot, Paris 1775, Farmer General Julien Alaterre, $3\frac{1}{2}$in
London £1,600 ($4,000). 26.III.73

Centre
A Louis XV silver helmet-shaped bonbonnière chased with battle scenes enclosed by C-scrolls and other martial subjects, Paris, *circa* 1738, Farmer General Hubert Louvet, $3\frac{1}{8}$in
London £1,400 ($3,500). 4.VI.73
From the collection of the Rt Hon The Earl Beauchamp

Below
A Louis XV gold snuff box decorated with rococo scrolls and rocaille ornament, Paris, *circa* 1750, $3\frac{3}{4}$in
London £1,400 ($3,500). 4.VI.73

Above
A George II gold snuff box, the lid chiselled with a scene of Paris presenting the apple to Aphrodite, *circa* 1730, 3in
London £1,050 ($2,625). 26.III.73

Centre
A Louis XV four-colour chased gold snuff box, with an oval medallion depicting a goddess adorning an altar. Maker's mark *FS* (apparently unrecorded), provincial workshop, *circa* 1765, $3\frac{1}{2}$in
London £1,500 ($3,750). 18.XII.72
From the collection of Count W. J. H. van Limburg Stirum

Below
A Louis XV three-colour chased gold snuff box, the lid centred with a medallion of a shepherdess, by Jean-François Defer, Paris 1767, $3\frac{3}{4}$in
London £3,100 ($7,750). 4.VI.73

Top left
A miniature of Frederick the Great by Ernst-August Abel.
Rectangular, 3in
London £1,100 ($2,750). 27.XI.72
From the collection of Mr Allen H. Johness Jnr

Top right
A miniature of the Hon John Douglas by John Smart. Signed
and dated 1779, oval, 1½in
London £1,150 ($2,875). 26.III.73
From the collection of J. S. F. Cooke Esq, CBE, DL

Above left
A miniature of a Chinese boy by William Wood. Signed on the
reverse *No. 5727*, oval, 3⅛in
London £2,300 ($5,750). 16.VII.73
From the collection of Mrs Ruth Muncer

Above centre
A miniature of Queen Elizabeth I by Nicholas Hilliard.
Oval, 1⅞in (the face with restoration)
London £1,400 ($3,500). 4.VI.73

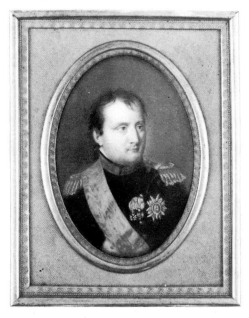

Above right
An oil miniature of Thomas, 8th Earl of Pembroke, by
Francizek Smiadecki. On copper, oval, 3in
London £1,000 ($2,500). 27.XI.72
From the collection of Mr Allen Johness Jnr

Left
A miniature of Napoleon by Jean Baptiste Duchesne. Signed
and dated 1811, oval, 2½in
London £800 ($2,000). 26.III.73

A miniature of Charles II by John Hoskins. Oval 3⅛in London £6,000 ($15,000). 27.XI.72

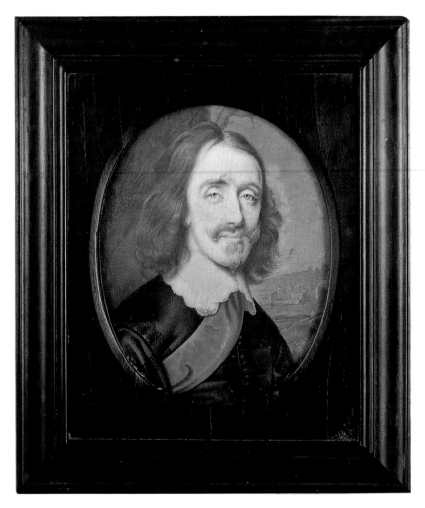

Miniatures

Many new collectors have been attending sales last season, and prices have risen steadily throughout the year, with marked enthusiasm for signed and fully documented works by minor artists of the seventeenth and eighteenth centuries. The higher figures paid for miniatures by well-known artists no longer surprise, proved by the sale of a miniature showing a young Chinese boy-servant, which realised £2,300 in July to a private collector. Previous works by this artist have been sold in the £300–£500 region, but the unusual subject made this particular portrait most desirable.

The season started with an important sale on the 27th November, and it was evident from the number of buyers that the high prices paid at the close of the last season were

A miniature of the Rt Hon. Charles, Earl Cornwallis KG by John Smart. Signed and dated 1794 I, oval, 3in London £4,400 ($11,000). 27.XI.72
From the collection of E.B.H. Travers Esq

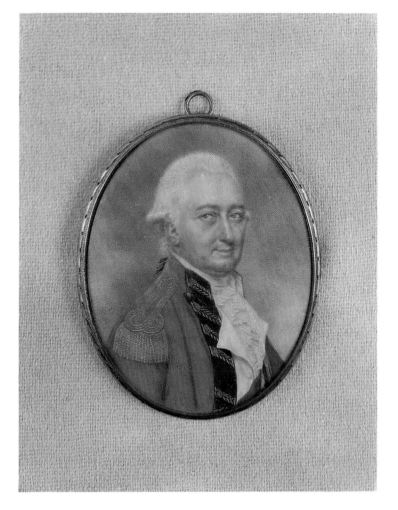

going to continue throughout the year. A portrait of Charles I by John Hoskins realised £6,000, and the same sale produced a new record for works by John Smart when a fine miniature of Earl Cornwallis realised £4,400. The sale totalled £53,554.

A previously underrated corner of the market has been seventeenth- and eighteenth-century miniature portraits on copper, which have gradually begun to climb. These portraits have always been very difficult to authenticate, due to the fact that the artists who worked in this medium rarely signed.

The silhouette market too has expanded steadily, and new records for two leading eighteenth century silhouette artists were established in June, £380 for a portrait of a lady by Mrs Beetham, and £360 for another silhouette of a lady by Walter Jordan.

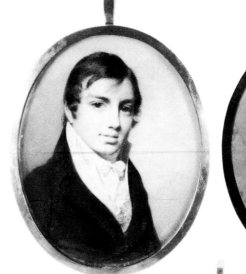

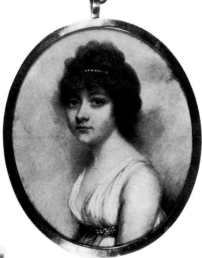

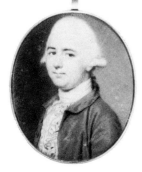

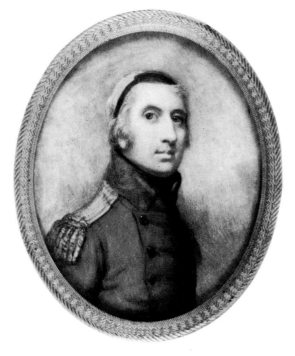

Above left
A miniature of a girl by François Dumont. Diameter 2½in
London £900 ($2,250). 27.XI.72
From the collection of Mr Allen Johness Jnr

Above centre
A miniature of a gentleman wearing a black jacket by George
Engleheart. Signed with initial, oval, 3¾in
London £760 ($1,900). 26.III.73
From the collection of Mrs D. Y. Sillars

Above right
A miniature of Lady Theresa Strangways by Andrew Plimer.
Oval, 3in
London £700 ($1,750). 27.XI.72
From the collection of Mr Allen H. Johness Jnr

Centre
A miniature of a gentleman by John Smart. Signed and dated
1771, oval, 1¾in
London £1,900 ($4,750). 4.VI.73

Right
A miniature of General Sir Charles Craufurd by Richard
Cosway. Signed and dated 1800 in full on reverse, oval, 3in
London £1,050 ($2,625). 27.XI.72
From the collection of Miss Heather Craufurd

Silver and metalwork

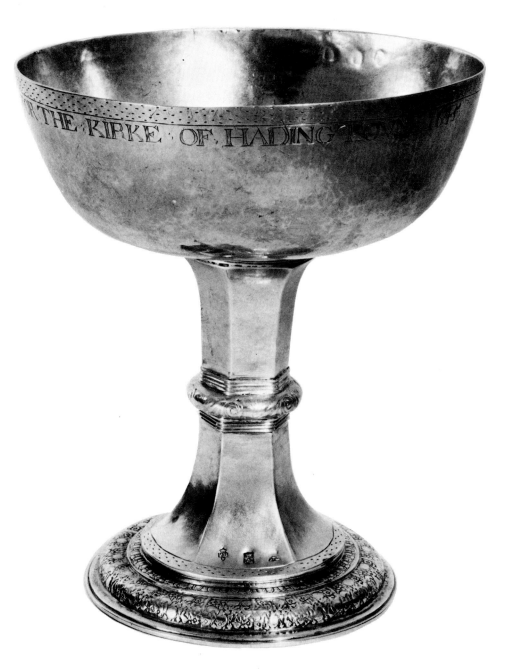

One of four Charles I
Scottish communion cups,
the shallow circular bowls
engraved at the lip with a
band of 'hit-and-miss' work
and the words *For the Kirke
of Hadingtoune 1645* below.
Fully marked on feet and
bowls by Patrick Borthwick,
Deacon Adam Lamb,
Edinburgh *circa* 1645.
Height 9⅛in
London £41,000 ($102,500).
30.XI.72
From the collection of the
Kirk Session, St Mary,
Haddington

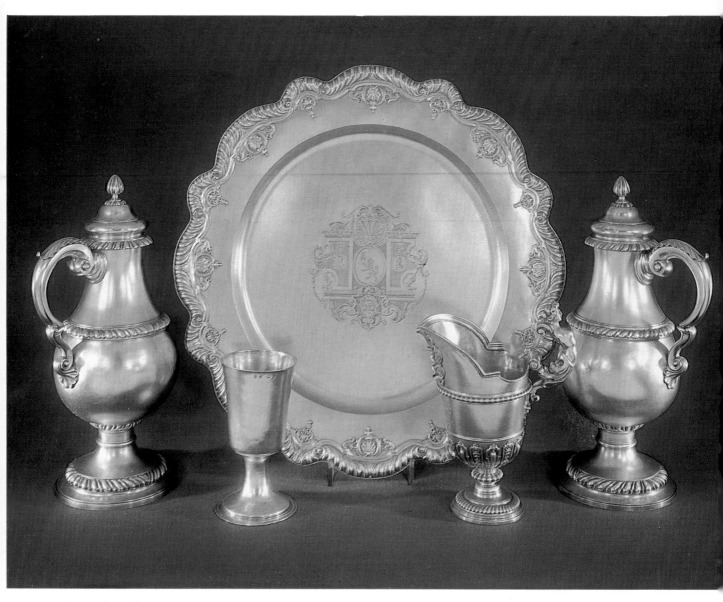

From left to right

A pair of George II massive silver-gilt flagons, with leaf-capped double-scroll handles.
Marked on bases and covers by John Hugh le Sage, London 1746. Height 20½in
London £14,000 ($35,000). 17.v.73

One of three Commonwealth silver-gilt wine cups on simple spreading trumpet foot.
Maker's mark *R.S.*, London 1649. Height 9¼in
London £10,500 ($26,250). 17.v.73

A George I silver-gilt sideboard dish and ewer, the dish engraved with contemporary armorials
within an architectural cartouche, the helmet-shaped ewer engraved with identical armorials.
Both dish and ewer marked by Lewis Mettayer, London 1720. Diameter of dish 27¼in,
height of ewer 13¼in
London £26,000 ($65,000). 17.v.73
The Arms are those of Pocock
From the collection of St Martin-in-the-Fields

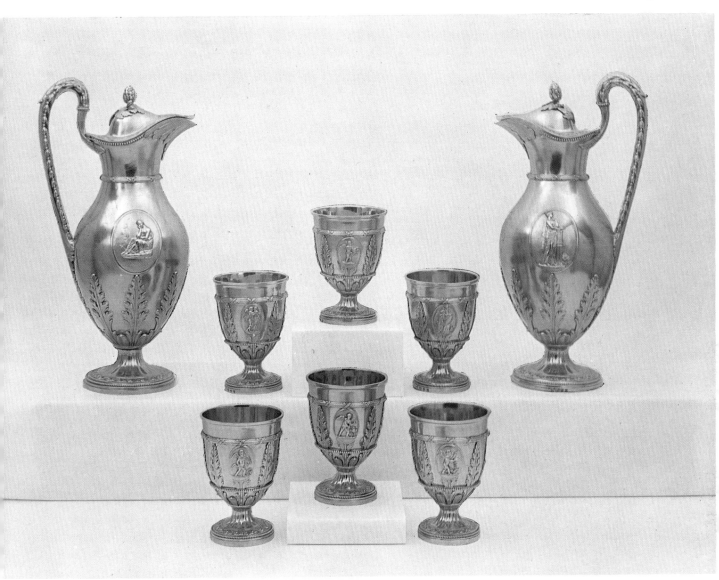

A pair of George III silver-gilt ewers with six goblets en suite, by Andrew Fogelberg and
Stephen Gilbert, London 1780. Height of ewers 15¼in, height of goblets 5¼in
London £12,000 ($30,000). 30.XI.72

The Arms are those of FitzMaurice impaling O'Brien.

Andrew Fogelberg and Stephen Gilbert were in partnership from 1780–93. Fogelberg is
presumed to have come to this country from Sweden about 1770 and has been identified as
Anders Fogelberg. Not a great deal is known about Stephen Gilbert, apprenticed to Edward
Wakelin for a term of seven years, he was made a Freeman of the Goldsmiths Company in
1764. He went into partnership with Fogelberg in 1780. The source of the medallions on
silver produced by Andrew Fogelberg's workshop has always been thought to be James Tassie,
a modeller and reproducer of antique gems. It is interesting to note that most of the
medallions on these ewers and goblets were also reproduced in paste by Wedgwood and
Bentley who were supplied with casts by Flaxman and Hackwood, amongst others, as well as
Tassie.

It seems probable that where modellers have produced identical medallions, there is a common
source. This is most likely to be catalogues of drawings of ancient themes. Andrew Fogelberg,
who worked so close to James Tassie, was therefore either supplied with casts by him or had
access to his source books.

The buoyancy generally experienced by the art market has been matched by silver values both in England and the United States. There has been an almost total recovery in prices after the fall which occurred in 1969–70 (the first since the war). Ordinary domestic silver is now fetching virtually the same as at the former peak in 1969. Rare collectors' items and small pieces are certainly fetching more, as is Victorian silver.

Outstanding examples are still at a premium and as in certain previous years, the decision of some churches to sell silver which they rarely, or never, used, provided some of the more remarkable lots sold this season. St Martin-in-the-Fields, 'London's Parish Church', felt that they could more usefully employ the capital locked up in a most interesting group of secular and communion plate and this fetched over £70,000 on the 17th of May in a sale totalling £263,586. Apart from the three fine communion cups of 1649 (£10,500) perhaps the most notable lot was a secular sideboard ewer and dish, by Lewis Mettayer, 1720, given to the church by a certain Mrs Pocock in remembrance of her husband in 1732. This realised £26,000, and Mrs Pocock added two very large, specially commissioned flagons in 1746 (£14,000).

In Scotland the Kirk Session of St Mary's, Haddington, reached a similar decision to complete the restoration of their beautiful church. Their set of four large cups, by Patrick Borthwick, Edinburgh, *circa* 1645, fetched £41,000 on the 30th November, a high price for ecclesiastical silver. In the same sale, which reached a total of £201,000, a notable group of silver-gilt in neo-classical taste consisting of a pair of ewers and six goblets brought £15,000. Their condition was pristine, the gilding original and the applied medallions perhaps inspired by James Tassie. The sale of the 17th May also contained an Elizabeth I bell salt, 1597 (£13,000), a fine specimen of a rare type, and a pair of soup tureens, by Paul de Lamerie, 1749, not typically exuberant examples of his work, made £21,000.

The increasing dearth of good foreign silver, returning so often to its country of origin and to permanent collections, is high-lighted when a superlative piece appears, exemplified in New York by the German tankard, Hamburg 1650, sold on May 22nd for $15,000 and the equally finely engraved eighteenth-century Dutch tobacco box in the sale of June 21st in London which fetched £5,800.

After two full seasons, something should be said about the Victorian Belgravia saleroom, and Sotheby Parke-Bernet in Los Angeles. Sales at Belgravia have doubled in two years; the fact that much Victorian design is quite exceptional is emphasised by the price paid for a tea and coffee set made by Joseph Angell in 1850 for the Great Exhibition the following year, now in a permanent collection in London. Belgravia catalogues are intended to form a permanent record, and the research and detail contained in them should stimulate appreciation of the fine craftsmanship which prevailed throughout much of the Victorian era.

Los Angeles also generated silver sales of a higher standard than ever before, notably the sale on 30th April and 1st May, which contained one of only four copies of the silver-gilt Achilles Shield, modelled by Flaxman, 660 ounces in weight, by Philip Rundell, 1821, which sold for $40,000 in a sale of nearly 200 lots totalling $246,720. Several pieces by Paul Storr and Hester Bateman in the same sale brought high prices and the higher standard and larger quantity of pieces sold both in New York and Los Angeles during the season under review was most encouraging.

Below
A George I Irish punch bowl engraved with contemporary armorials within a baroque cartouche. Maker's mark indistinct, possibly *P.R.* in gothic script below a crown, perhaps for Peter Racine, Dublin 1725. Diameter 11in
London £11,000 ($27,500). 30.XI.72
From the collection of the Quenby Estate Company

Below left
A James I tapering cylindrical tankard, the S-scroll handle terminating in a shield, the base later crested. Maker's mark *R.B.* in a shaped shield, London 1619. Height 6¼in
London £7,200 ($18,000). 30.XI.72

Right
A Charles I silver-gilt flagon, the moulded thumbpiece pierced with a heart motif. Maker's mark *R.S.* between mullets on base and cover, London 1634. Height 18¼in
London £4,000 ($10,000). 17.V.72
This flagon was the only piece recovered after the theft of all St Martin's plate in 1649
From the collection of St Martin-in-the-Fields

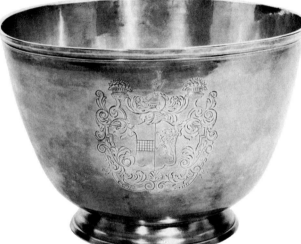

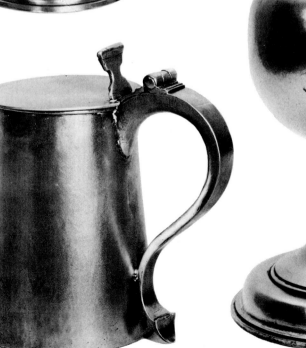

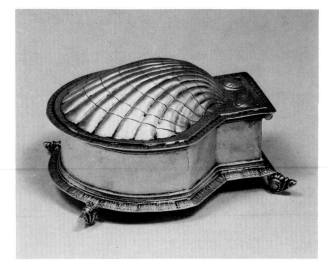

A James I shell-shaped spice box, the base raised on supports modelled and chased as snails. Maker's mark *T.I.*, with star below, London 1613. Length 6⅜in overall
New York $16,000 (£6,400). 27.IV.73
From the collection of Albert Emanuel II of Palm Beach, Florida

Right
An Elizabeth I silver-gilt bell salt chased with foliage and flowerheads with reeded and egg motif borders, both sections pricked with the initials *I.S.V.* Maker's mark *H.D.* conjoined, London 1597. Height 9½in
London £13,000 ($32,500). 17.V.73
From the collection of Mrs A. Caruthers

Below
A William III cup and cover engraved with contemporary armorials. Marked on body and cover by John Boddington, London 1699. Height 8in
London £6,500 ($16,250). 17.V.73
From the collection of Rosamond, Lady Langham MBE

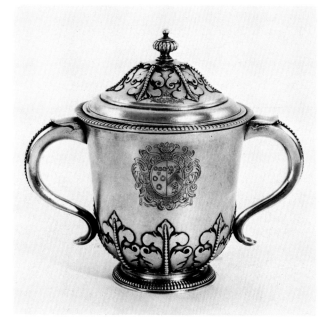

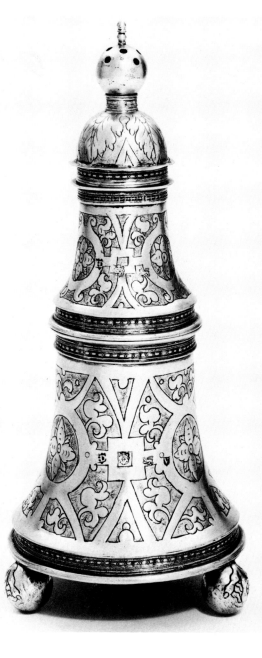

An eighteenth-century
Dutch oval tobacco box,
both lid and base finely
engraved with mythological
scenes and acanthus border.
Maker's mark indecipher-
able, Rotterdam, apparently
1736. Width 4½in
London £5,800 ($14,500).
21.VI.73
It is likely that the engraving
was executed outside
Rotterdam; the technique is
similar to that of Dilles Van
Oye of Gouda

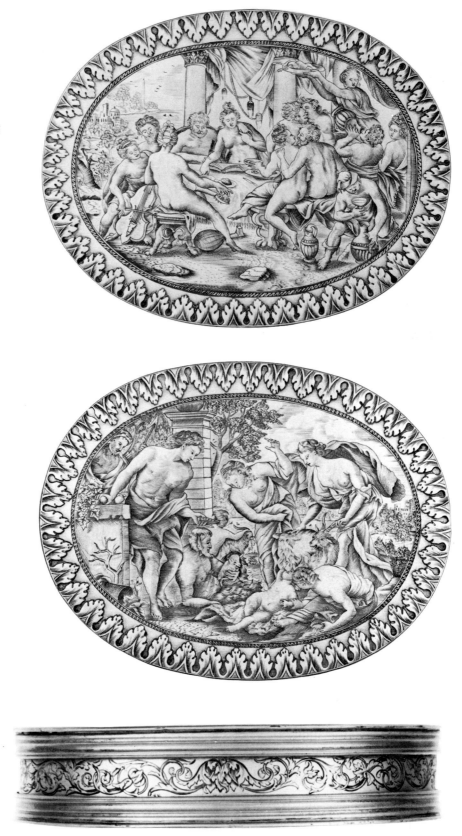

Opposite page

Above
One of a pair of George II soup tureens and covers by Paul de Lamerie, shaped oval bodies engraved with contemporary coats-of-arms within rococo cartouches. Marked on bases and covers, London 1749. Width over handles 17½in
London £21,000 ($52,000). 17.v.73
The Arms are those of Trinity College, Dublin

Below
A German eighteenth-century soup tureen and cover, each piece engraved with the Arms of Ford between a crest and motto *circa* 1830. By Johann Christian Neuss, Augsburg 1771–73. Width over handles 15¾in
London £3,800 ($9,500). 17.v.73
From the collection of John Ford Esq

Right
One of a pair of George III tripod candelabra for three or four lights by Benjamin Smith, Scott & Smith, London 1806–08, the heraldic finials by Paul Storr, London *circa* 1807.
Height 28½in
New York $12,000 (£4,800). 27.iv.73

Below left
A George IV soup tureen and cover by Paul Storr, engraved with royal armorials and an inscription, twin dolphins finial, on four similar dolphin supports. Fully marked, London 1824. Diameter over handles 15½in
London £4,600 ($11,500). 17.v.73

Below right
One of a pair of George III silver wine coolers by Paul Storr. Engraved with the Latin signature of Rundell, Bridge & Rundell and fully marked, London 1813.
Height 11⅛in
Los Angeles $17,000 (£6,800). 1.v.73

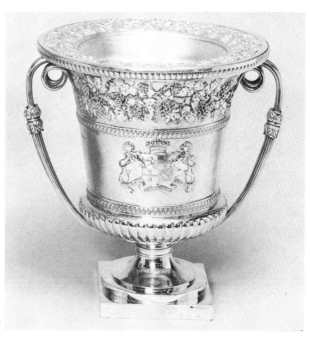

Right
A George I covered jug, the body engraved with contemporary armorials. Marked on body and cover by Joseph Ward, London 1714. Height 10in
London £4,500 ($11,250). 14.XII.72
The Arms are those of Powell
From the collection of Mrs A. Taylor

A George I Irish octafoil salver, the centre engraved with a contemporary coat-of-arms, by Thomas Slade. Dublin 1725.
Diameter 12¾in
London £3,000 ($7,500). 30.XI.72
From the collection of Mrs E. A. King

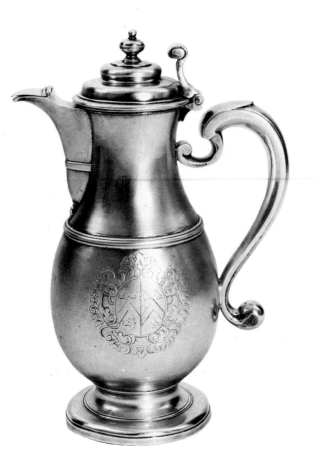

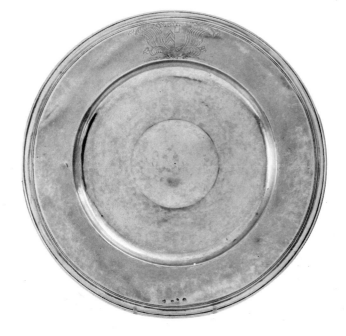

Right
An American silver porringer by Tobias Stoutenburgh.
Struck twice with maker's mark, New York *circa* 1730.
Diameter 5¼in
New York $3,500 (£1,400). 28.III.73

Below right
An American sauceboat engraved beneath the lip with the
name *Hays*, by Paul Revere Jr, Boston *circa* 1790. Length 8in
New York $26,000 (£10,400). 17.X.72

An American silver creamer by Myer Myers, New York *circa*
1760. Height 5⅜in
New York $3,800 (£1,520). 28.III.73
From the collection of the late Norman Norell of New York

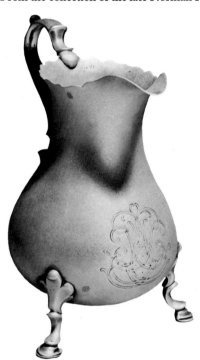

Opposite page far left
One of a pair of George II serving dishes by Paul de Lamerie,
London 1746. Diameter 14¼in
New York $11,000 (£4,400). 15.IX.72
The Arms of those of Anson
From the collection of Mrs Seward Webb Pulitzer

Left
A Charles II sideboard dish engraved with contemporary
armorials (those of Corbet impaling Boothby). Maker's mark
C.K. above pellets, London 1675. Diameter 19½in
London £3,600 ($9,000). 30.XI.72
From the collection of the Quenby Estate Company

Right
One of a pair of early George II silver-gilt bowls and covers,
engraved with the contemporary Arms of Curzon with
Assheton in pretence. Fully marked on bases and covers by
Simon Pantin Snr, London, 1727. Width over handles 7¼in
London £6,500 ($16,250). 17.V.73

Below right
One of a pair of George IV sauceboats with liners, the fluted
bodies supported by dolphins. Marked on bases and liners by
Robert Garrard, London 1824. Height 8¾in
London £2,700 ($6,750). 30.XI.72
From the collection of the late Mrs Mabel Grace Camelinat

Below
A Charles I caudle cup and cover, the body and lid chased
with bands of flowerheads and quatrefoil leafage, the rim of
the cover pricked with the initials *A.H.* Maker's mark on base
and cover *E.S.* in a dotted circle, London 1646. Height 4½in
London £4,400 ($11,000). 17.V.73

Below left
A George I square waiter by Paul de Lamerie, on four bracket
supports, London 1725. 6in square
London £2,500 ($6,250). 30.XI.72
From the collection of the Hon. Mrs Stockdale

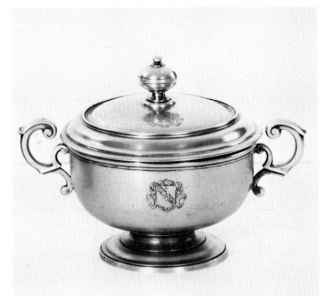

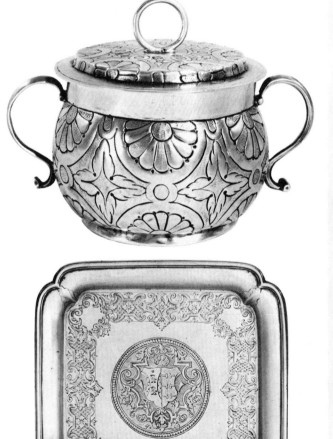

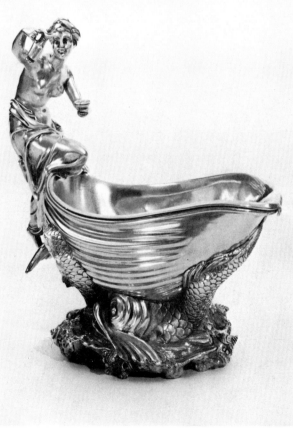

Right

A Swiss oval box, the slip-on cover repoussé and chased with two lovers reclining in a landscape. Maker's mark *E.G.O.*, Schaffhausen *circa* 1700. Length 5½in
New York $4,750 (£1,900). 27.IV.73

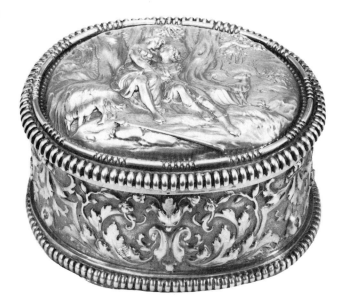

Below right

A German parcel-gilt tankard engraved with oval cartouches enclosing figures of women and men, in the style of Abraham Bosse. Maker's mark *H.L.* conjoined, Hamburg *circa* 1650. Height 9 in
New York $15,000 (£6,000). 22.V.73

Below left

A Dutch parcel-gilt beaker, the lower part of the body engraved with strapwork enclosing portraits of Roman emperors. Amsterdam 1585. Height 3⅝in
New York $5,250 (£2,100). 27.IV.73
From the collection of Baroness von Wrangell

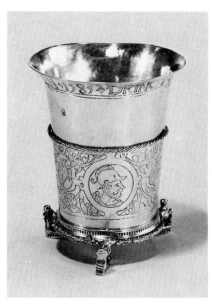

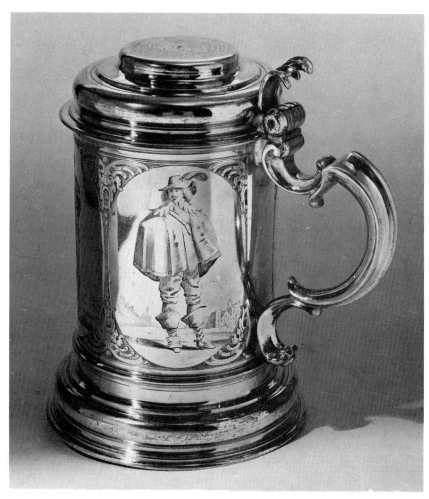

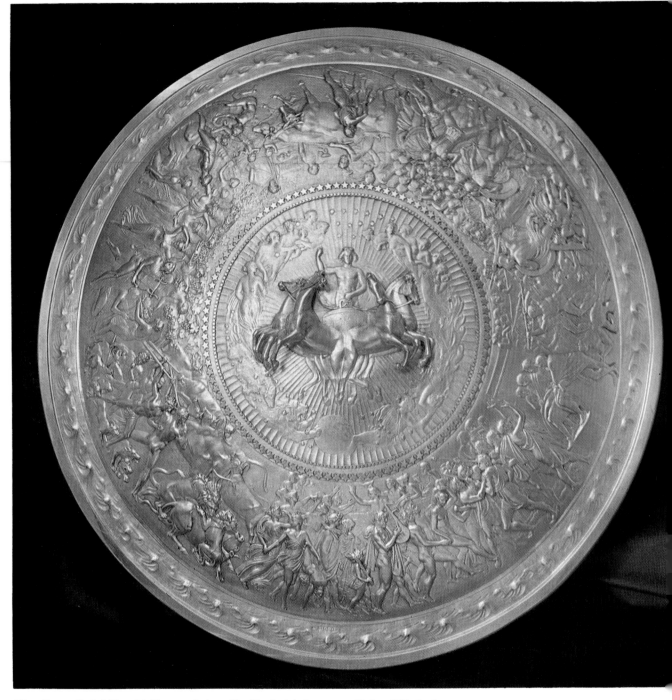

The silver-gilt Achilles shield commissioned by Frederick Augustus, Duke of York, the outer
rim chased with waves typifying the River Ocean of mythology. The main part of the design, the
second band, describes the history of two cities, one at siege, the other in peace – an analogy of
the Trojan Wars. In the centre appears the Sun Chariot driven by Apollo, surrounded by
Orion's Belt, the Seven Sisters, Venus and Leo. Designed and modelled by John Flaxman RA.
Maker's mark *Philip Rundell*, for Rundell, Bridge & Rundell, London 1821, diameter 36in
Los Angeles $40,000 (£16,000). 30.IV.73

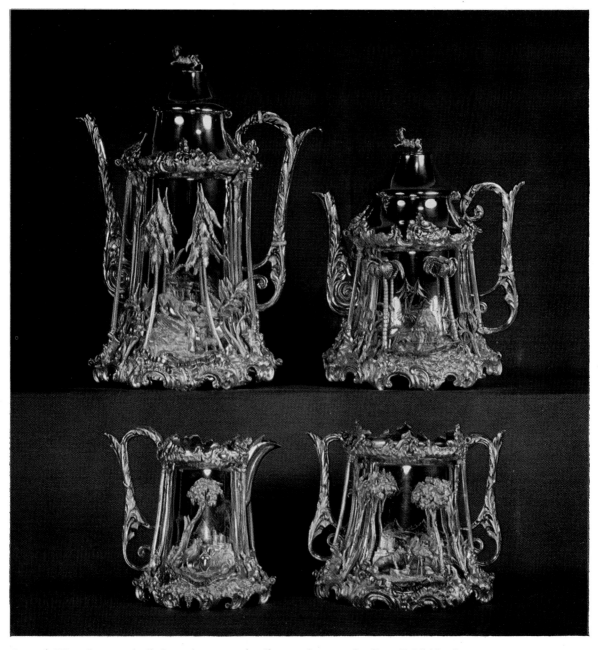

An early Victorian parcel-gilt four-piece tea and coffee set, shown at the Great Exhibition in
1851 and illustrating Aesop's fables modelled in high relief of frosted silver.
All fully marked by Joseph Angell, London 1850, the finial to the coffee pot by Hunt & Roskell,
circa 1880, heights: coffee pot 10in, teapot 8in, sugar basin 5in, milk jug 4¾in
London £3,800 ($9,500). 29.III.73
From the collection of Mrs Eileen A. M. Brown whose grandfather, Benjamin Bridgeman,
acquired the set in about 1890, possibly from Messrs Hunt & Roskell of New Bond Street

Right
One of a group of four Victorian table candlesticks modelled by G. A. Carter to represent Night (*illustrated*), Dawn, Knowledge and Genius. All by Hunt & Roskell, the undersides engraved *Hunt & Roskell, late Storr & Mortimer,* together with the artist's initials *G.A.C.* or *G.A.C. Sc,* London 1885–89, heights 10½in, 11¼in, 11¼in and 11¼in
London £1,650 ($4,125). 26.X.72

Below
A Victorian figure of a drowsy nymph after L. Morel Ladeuil
by Elkington & Co., Birmingham 1893, height 9¾in
London £125 ($312.50). 1.III.73
The figure is the 'Goddess of Sleep', originally modelled by Ladeuil for his table 'Sleep', which was shown by Elkington & Co. at the International Exhibition of 1862; the table was bought by the City of Birmingham as a marriage gift for the Prince and Princess of Wales

Below
A William IV fish slice by Paul Storr, the shaped blade pierced with scrolls and mullets bordering a scene in low relief depicting a ferocious whale preparing to devour four fishes, further decorated with weed and rococo slime, the handle cast and chased as a scaly dolphin. Marked *Paul Storr,* for Storr & Mortimer, London 1831, length 13¾in
London £420 ($1,050). 26.X.72
From the collection of S. R. Houfe Esq

Far right A Victorian owl mustard pot with feather-textured body and large brown boot-button eyes. Fully marked *E. C. Brown*, London 1873, height 3in
London £165 ($412.50). 3.V.73
From the collection of Mrs A. Graham

Right An early Victorian cigar case engraved with armorials within a ground filled with foliate scrolls and twirls. Maker's mark *A.G.W.*, Edinburgh 1840, height 5in
London £220 ($550). 29.III.73

Below right One of a pair of candelabra by Omar Ramsden, each for three lights, the stems capped with waved spheres supporting kneeling winged cherubs, their right hands raised, their left holding hearts. London 1936, height 16in
London £1,300 ($3,250). 19.IV.73

Below An early Victorian coffee pot by Paul Storr decorated with wide bands of anthemions and acanthus leafage over areas of matting. Marked on base, handle and cover, *Paul Storr*, for Storr & Mortimer, London 1838, the acorn and oak leaf finial by John S. Hunt, *circa* 1845, height 9in
London £310 ($775). 21.XII.72

A Charles II broad-rimmed
commemorative charger, the
'well' engraved all over in
wriggled-work with the royal
arms and motto, the reverse
engraved in script with the
owner's names, *Robert and
Mary Shell*, *circa* 1662,
diameter 21¾in, width of rim
4¼in
London £5,800 ($114,500)
25.VII.73

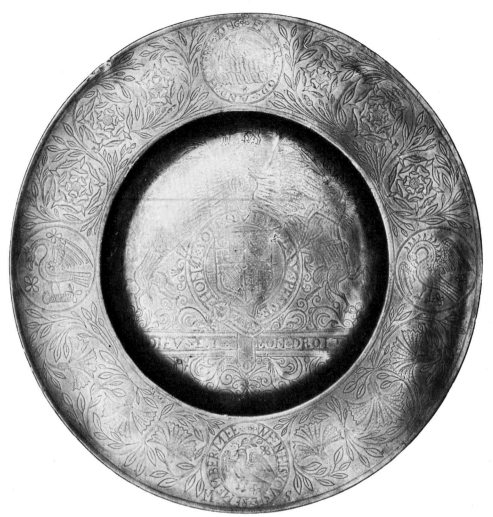

A pair of Charles I flagons on
spreading ovolo-moulded
bases. Stamped with the
mark of the pre-touchplate
pewterer *E.G.*, *circa* 1635,
9in to lip, 11⅛in overall
London £820 ($2,050)
27.X.72

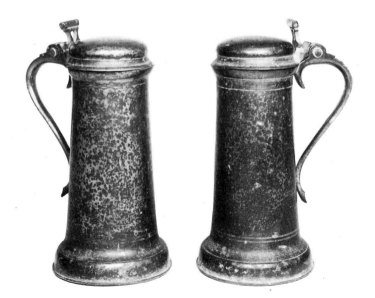

Greek and Roman coins from The Metropolitan Museum of Art of New York

BY T. G. EDEN

Aureus of Saturninus,
circa 280 AD
Zurich, Swiss Francs 210,000
(£24,000; $60,000). 10.XI.72

Tetradrachm of Amphipolis,
circa 460 BC
Zurich, Swiss Francs 145,000
(£18,125; $45,312). 4.IV.73

All enlarged

This past season has seen two highly important sales of ancient coins, as a result of The Metropolitan Museum of Art's decision to sell a large portion of its collection of coins by auction. Zurich was chosen as the venue for both sales, and the final total of 11,538,900 Swiss Francs (£1,354,737) included many record auction prices.

The first sale in November contained the Museum's collection of Roman gold coins. The most important pieces in this section had been bequeathed to the Metropolitan Museum in 1899 by Joseph H. Durkee, an American diplomat based in Paris in the 1890s, who had only collected ancient coins of the finest quality, many of which had been bought at the great coin sales held in that decade by Feuardent in Paris and Sotheby's in London. The sale of this first part of The Metropolitan Museum's collection must be considered as one of the most important auctions of Roman gold coins to be held this century, comparing very favourably in quality with the famous collections of Ponton d'Amécourt, de Quelen and Montagu sold at the end of last century. Although prices were therefore expected to be high, the results, in fact, far exceeded pre-sale estimates and the total of 8,177,800 Swiss Francs (£934,600) was a record in itself for any coin sale. The highest price of 210,000 Swiss Francs (£24,000) was paid for an aureus of the Emperor Saturninus; only one other aureus is known to exist for this little known third-century usurper and the sum paid for the Metropolitan specimen represents an auction record price for a Roman coin. Other notable prices included 205,000 Swiss Francs (£23,428) for an aureus of Marius and 170,000 Swiss Francs (£19,428) for an aureus of Laelianus, again both somewhat obscure emperors whose reigns lasted for short periods and whose coins are therefore of the greatest rarity.

The second sale, held in April, contained the major portion of the famous John Ward collection of Greek coins, which was formed at the end of the last century to illustrate his well-known book, 'Greek Coins and their Parent Cities'. Although, in comparison to the Roman coins, these pieces were not of the same impeccable quality, it must nevertheless be stressed that the public sale of any collection of Greek coins so complete as this was an event of the greatest importance to the numismatic world. Again the top price of the sale created a new record, this being 145,000 Swiss Francs (£18,125) for an exceptionally fine tetradrachm of Amphipolis in Macedonia. Struck in the first half of the fourth century BC and portraying a magnificent facing head of Apollo of pure classical style, these tetradrachms are considered by many numismatists to be the most sought after of Greek coins. This second part of the Metropolitan's collection realised 3,361,100 Swiss Francs (£420,137), still a formidable sum for a coin sale and one which demonstrates the continuing strength of the market for good ancient coins.

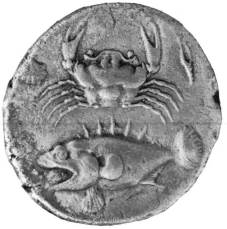
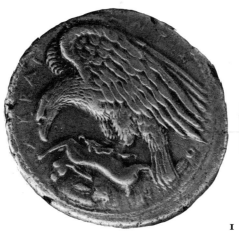

1. SICILY, AGRIGENTUM, Tetradrachm, *circa* 413 BC, Swiss Francs 39,000 (£4,875; $12,187)

I

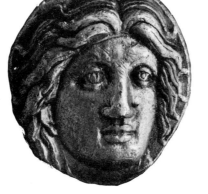
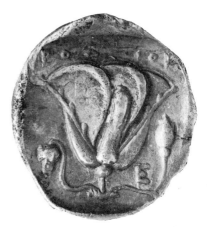

2. CARIA, RHODES, Tetradrachm, *circa* 350 BC, Swiss Francs 8,500 (£1,063; $2,657)

2

3. THRACE, AINOS, Tetradrachm, *circa* 400 BC, Swiss Francs 65,000 (£8,125; $20,312)

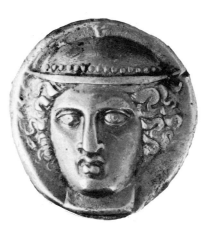
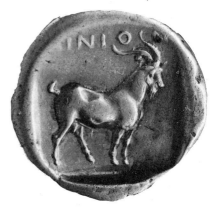

3

Greek coins from the collection of The Metropolitan Museum of Art (John Ward Collection), sold in Zurich on 4th–5th April 1973
All enlargements

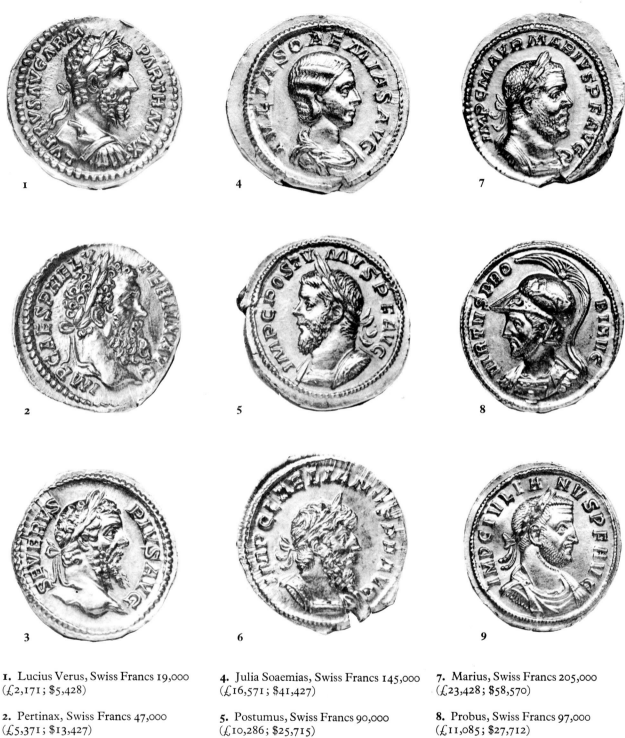

1. Lucius Verus, Swiss Francs 19,000 (£2,171; $5,428)

2. Pertinax, Swiss Francs 47,000 (£5,371; $13,427)

3. Septimius Severus, Swiss Francs 42,000 (£4,800; $12,000)

4. Julia Soaemias, Swiss Francs 145,000 (£16,571; $41,427)

5. Postumus, Swiss Francs 90,000 (£10,286; $25,715)

6. Laelianus, Swiss Francs 170,000 (£19,428; $48,570)

7. Marius, Swiss Francs 205,000 (£23,428; $58,570)

8. Probus, Swiss Francs 97,000 (£11,085; $27,712)

9. Julianus, Swiss Francs 70,000 (£8,000; $20,000)

Roman Aurei from the collection of The Metropolitan Museum of Art, sold in Zurich on 10th November 1972

All enlargements

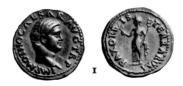

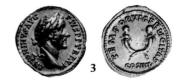

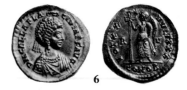

1. Otho £2,900 ($7,250)
4. Julia Domna £3,500 ($8,750)

2. Sabina £3,000 ($7,500)
5. Carinus £5,200 ($13,000)

3. Antoninus Pius £1,300 ($3,250)
6. Galla Placidia £2,300 ($5,750)

Roman Aurei from the collection of Dr A. R. Hands, sold in London on 6th June 1973

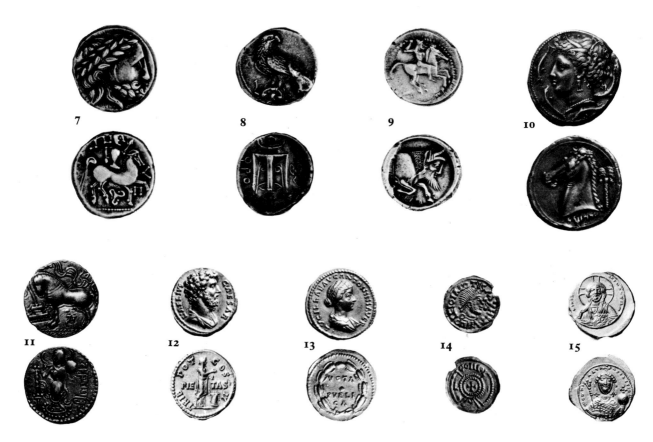

7. CELTIC HUNGARIAN, Tetradrachm £250 ($625). 7.II.73

8. CROTON, Stater £280 ($700). 7.II.73

9. GELA, Didrachm £300 ($750). 7.II.73

10. SICULO-PUNIC, Tetradrachm £620 ($1,550). 26.VII.73

11. INDIA, Samudragupta, Stater £130 ($325). 4.V.73

12. ROME, Aelius, Aureus £2,900 ($7,250). 6.VI.73

13. ROME, Lucilla, Aureus £2,900 ($7,250). 6.VI.73

14. SUEBIAN, Uncertain ruler, Tremissis £800 ($2,000). 6.VI.73

15. BYZANTINE, Constantine IX, Tetarteron £230 ($575). 30.III.73

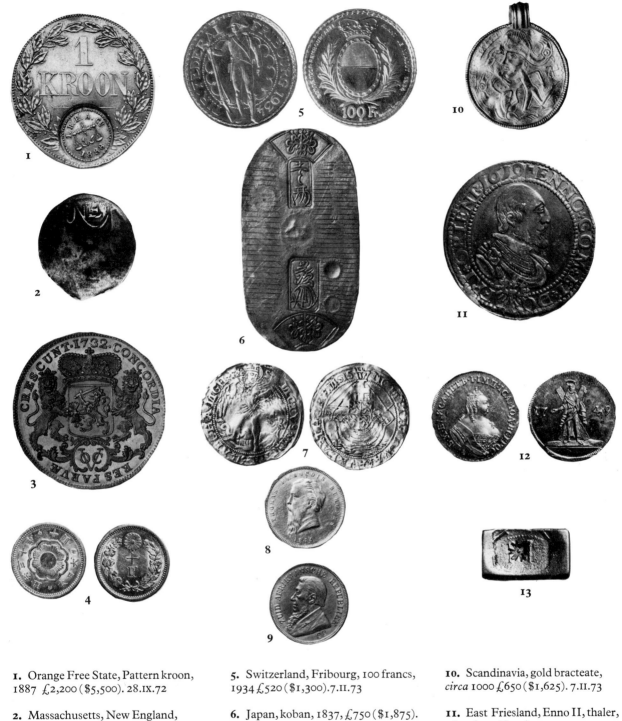

1. Orange Free State, Pattern kroon, 1887 £2,200 ($5,500). 28.IX.72

2. Massachusetts, New England, shilling, 1652 £2,800 ($7,000). 28.IX.72

3. Netherlands East India Company, gold ducatoon, 1732 £1,800 ($4,500). 24.XI.72

4. Japan, 10 yen, 1897 £460 ($1,150). 30.III.73

5. Switzerland, Fribourg, 100 francs, 1934 £520 ($1,300). 7.II.73

6. Japan, koban, 1837, £750 ($1,875). 4.V.73

7. Flanders, Thorn, angel, 1557–77 £300 ($750). 30.III.73

8. South Africa, Burgers pond, 1874 £2,500 ($6,250). 6.VII.73

9. South Africa, Kruger pond, over-stamped 99 £2,300 ($5,750). 6.VII.73

10. Scandinavia, gold bracteate, circa 1000 £650 ($1,625). 7.II.73

11. East Friesland, Enno II, thaler, 1619 £290 ($725). 4.V.73

12. Russia, Elizabeth, 2 ducats, 1749 £1,500 ($3,750). 6.VII.73

13. Mozambique, Mary II, 2½ maticaes, 1834–53 £520 ($1,300). 6.VI.73

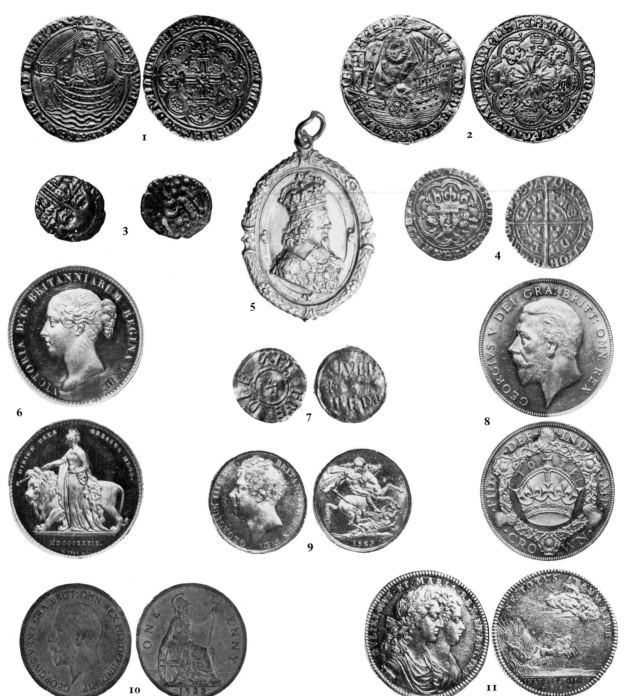

1. Edward III, London noble (1361–69) £170 ($425). 28.IX.72

2. Elizabeth I, ryal of 15/- (1583–84) £3,200 ($8,000). 30.III.73

3. ANCIENT BRITISH, 'Cheriton' stater £520 ($1,300). 30.III.73

4. Richard III, London groat (1483–85) £80 ($200). 4.V.73

5. Charles I, Declaration of Parliament badge, 1642 £180 ($450). 4.V.73

6. Victoria, Pattern £5, 1839 £2,600 ($6,500). 30.III.73

7. King Alfred, silver penny (887–89) £115 ($287.50). 4.V.73

8. George V, crown, 1934 £340 ($850). 30.III.73

9. George IV, £2 piece, 1823 £310 ($775). 30.III.73

10. George V, penny, 1933, only eight specimens known £7,000 ($17,500). 24.XI.72

11. William and Mary, gold Coronation medal, 1689 £280 ($700). 30.III.73

Orders, medals and decorations

BY M. R. NAXTON

The two specialised sales of war medals, orders and decorations held this season both contained many fine pieces for the collector but that held on 27th June was of particular significance, in that it included items seldom offered for public auction or even made available for examination. The Royal Order of Victoria and Albert (illustrated on p 306) and the diamond breast star of the Most Excellent Order of the British Empire, originally the property of Her late Royal Highness, the Princess Royal, both fell into this category and each realised over £4,000, exceptional prices for British orders, although a similar record price of £1,600 was set in the January sale for the insignia of the Most Exalted Order of the Star of India (K.C.S.I.). Campaign medals of every type continue to rise in price, especially to the Navy, and whilst the Hong Kong Plague medal in gold (see left) proved the most fascinating research piece of the year, the most historic of the many groups sold was probably that awarded to Colonel M. B. Robinson, Town Commandant, Kimberley (besieged 1899–1900, during the Boer War). Gallantry awards also arouse the greatest interest and whilst the V.C. group to Colonel J. C. C. Daunt (see below) was the highest price of the year at £2,300, both sales have contained medals to all manner of men for great bravery and self-sacrifice in the many theatres of war since the Crimea.

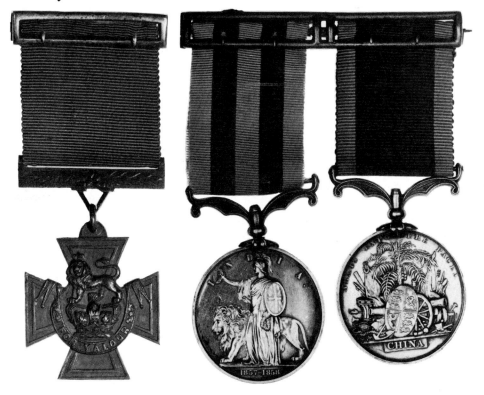

A Victoria Cross group for the Indian Mutiny awarded to Colonel J. C. C. Daunt £2,300 ($5,750). 27.VI.73

The Royal Order of Victoria and Albert

This Royal Family Order, the personal gift of Queen Victoria, was instituted on 10th February 1862 as an award of merit for services to the Queen and her household. Although extended in March, 1880, the number of recipients was always strictly limited and the insignia of the order had never previously been offered for public auction in this country.

Badge of the third class, post-1880.
London £4,200 ($10,500).
27.VI.73

Clocks, watches &
scientific instruments

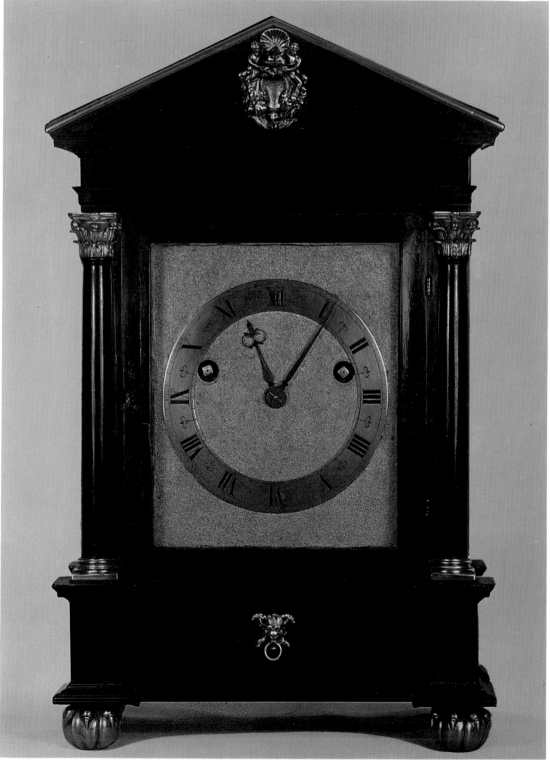

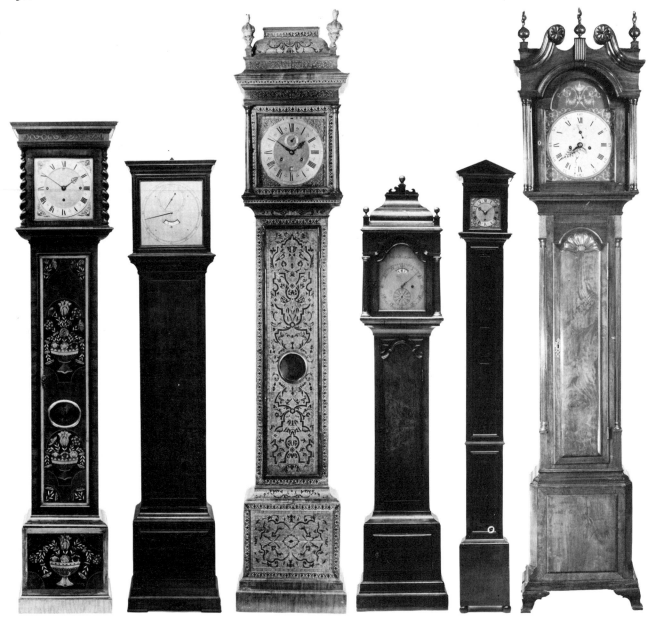

From left to right
An early olivewood and floral marquetry *grande sonnerie* long-case clock, signed *Joseph Knibb Londini fecit, circa* 1690, height 6ft 5½in London £14,000 ($35,000). 19.III.73

A mahogany month regulator by John Shelton, stamped SHELTON twice on the back cock, height 6ft
London £12,000 ($30,000). 19.III.73
John Shelton was apprenticed in 1711 and Free of the Clock-makers' Company in 1720; his regulators played a prominent part in the astronomical observations of the 1760s and 1770s, and accompanied Captain Cook on his voyages of exploration

One of a pair Queen Anne marquetry longcase clocks by Nicholas Lambert, height 8ft 3in
London £4,400 ($11,000). 19.III.73

A George II burr-walnut month regulator by John Ellicott, height 5ft 9in London £11,000 ($27,500). 16.X.72

A small and early ebonised longcase timepiece by Samuel Knibb, height 5ft 11in. London £9,000 ($22,500). 16.X.72

A Chippendale mahogany block-and-shell-carved longcase clock attributed to the Goddard-Townsend Family, Newport, Rhode Island, *circa* 1775, height 8ft 2in
New York $25,000 (£10,000). 21.X.72
From the Lansdell K. Christie Collection

Page 307
An early veneered ebony table clock by Edward East, signed on the backplate, *circa* 1665, height 1ft 5in
London £19,000 ($47,500). 23.VII.73
Formerly in the collection of the late H. Alan Lloyd

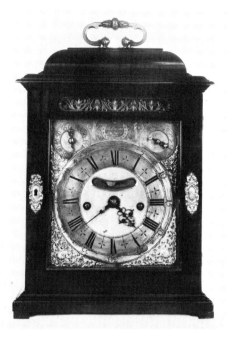

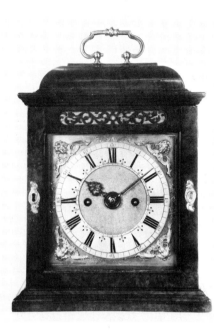

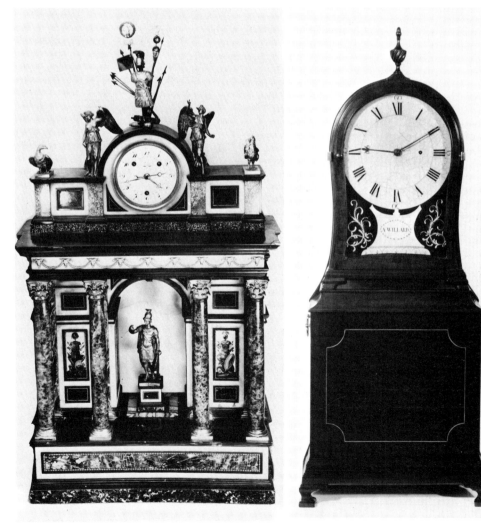

Far left
A veneered ebony quarter-repeating bracket clock, signed *Tho Tompion Londini Fecit*, the dial, front plate and backplate all numbered 367. Height 1ft 2¾in
London £15,500 ($38,750). 16.X.72
From the collection of H. T. Koppen Esq

Left
A small burr-walnut bracket clock by Joseph Knibb, signed on the dial and the backplate, *circa* 1690, height 12in
London £14,000 ($35,000). 19.III.73

Below far left
A Napoleonic mantel clock, the dial inscribed *Breguet à Paris*, the Italian case in semi-precious stones and various marbles and in the form of a triumphal arch, signed *Giacomo Raffaelli fece anno 1804*, height 3ft, width 1ft 7½in
London £12,500 ($31,250). 15.VI.73
From the collection of A. Gifford-Scott, Esq
This clock was said to have been given to Napoleon I by the City of Rome on his entry into the city and as a Coronation present

Left
A federal mahogany double-cased shelf clock by Aaron Willard, Grafton, Massachusetts, *circa* 1780, height 31½in
New York $12,500 (£5,000). 21.X.72
From the Lansdell K. Christie Collection

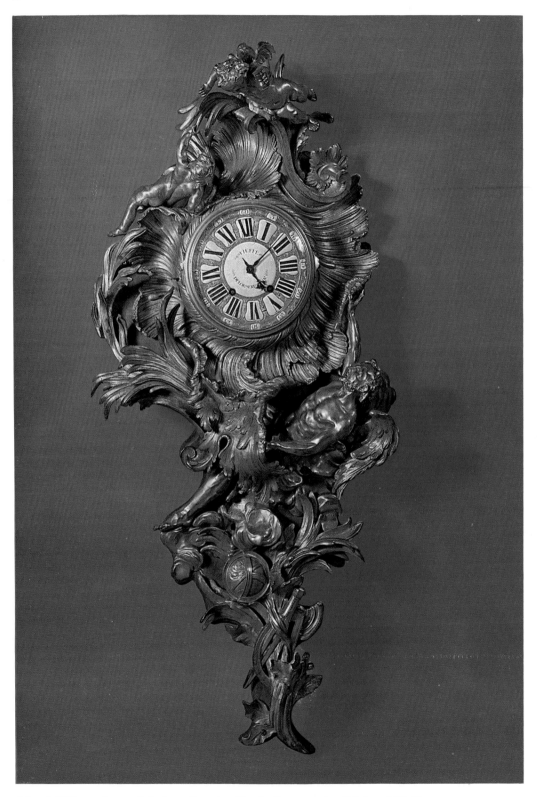

A Louix XV ormolu cartel clock attributed to Charles Cressent, the dial signed *Fieffé
delobservatoir*, contained in an asymmetrical case of vigorous modelling representing Love
triumphing over Time, height 4ft 5in
London £16,000 ($40,000). 24.XI.72
From the collection of Baron Guy de Rothschild

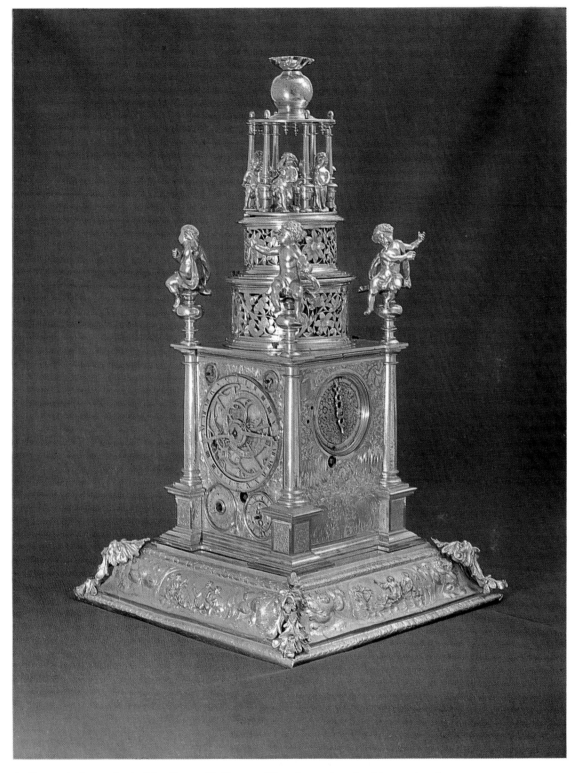

A gilt metal tabernacle clock by Caspar Hoffmann of Augsburg, signed, mid-seventeenth
century, height 500mm
London £9,000 ($22,500). 21.v.73
From the collection of Baron Guy de Rothschild

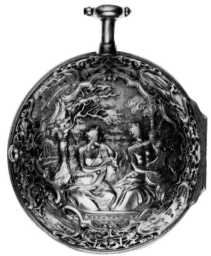

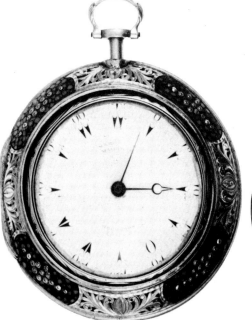

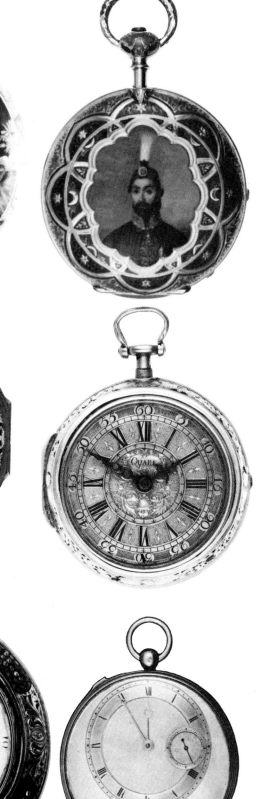

From left to right
Above
A gold and enamel watch case, the early eighteenth-century verge movement signed *A. Hoevenaer Arnhem*, the case with polychrome enamel of the Virgin and Child with John the Baptist and a similar scene on the back, first half of the seventeenth century, diameter 60mm
London £7,200 ($18,000). 21.V.73
A gold and enamel pair cased pocket chronometer by August Courvoisier & Co, and numbered 51394, the outer case with a polychrome enamel portrait miniature of Abdul Hamid, Sultan of Turkey, mid-nineteenth century, diameter 57mm
London £2,500 ($6,250). 23.VII.73

Centre
GEORGE GRAHAM No. 567 A *repoussé* gold pair cased quarter repeating cylinder watch, hallmarked 1727, diameter 55mm
London £3,200 ($8,000). 19.III.73
DANIEL QUARE, LONDON, No. 812
A gold pair cased quarter repeating verge watch, *circa* 1700, diameter 56mm
London £2,200 ($5,500). 22.I.73

Below
A gold triple cased five-minute repeating quarter striking clockwatch for the Turkish market, No. 18653 by Markwick Markham Recordon of London, the dial plate of the movement signed *R. Rippon fecit 1799*, the second case hallmarked 1789, diameter 67mm
London £2,300 ($5,750). 21.V.73
BREGUET No. 4039. A gold half quarter repeating lever watch, sold to the Duke of Berwick on 30th September 1825 for the sum of Fr.5,000, in a red morocco leather box containing a spare glass and with original certificate No. 991, diameter 48mm
London £5,800 ($14,500). 21.V.73

Above
JAMES FERGUSON COLE
A small *grande sonnerie* musical travelling clock, the thirty-
hour movement with cylinder escapement and striking on two
gongs, height 118mm
London £6,500 ($16,250). 21.V.73
Formerly in the collection of the late Sir John Prestige

Right
A gilt metal quarter striking German table clock, *circa* 1600,
height 390mm
London £7,800 ($19,500). 21.V.73
From the collection of Baron Guy de Rothschild

A late sixteenth-century Flemish ivory pocket sun dial in the form of a barrel, length 78mm
London £1,000 ($2,500). 19.III.73

An English silver circular perpetual calendar designed to begin from 1728 and inscribed *George to his esteemed friend Isaac Newton*, 1727, diameter 62mm
London £8,000 ($20,000). 23.VII.73
This instrument was intended as a gift to Isaac Newton although he probably never received it as he died in March 1727
From the collection of the Rt Hon. The Earl Beauchamp

A silver *aide mémoire* by Johann Georg Mettel, containing four ivory leaves, first half of the eighteenth century, 100mm by 52mm
London £800 ($2,000). 23.VII.73
From the collection of the Rt Hon. The Earl Beauchamp

A brass astrolabic ring dial, signed *Narcy à Paris*, circa 1710, diameter 140mm
London £3,400 ($8,500). 22.I.73

A gilt-metal double folding compendium by Christopher Schissler, dated 1575, 59mm by 49mm
London £3,400 ($8,500). 22.I.73

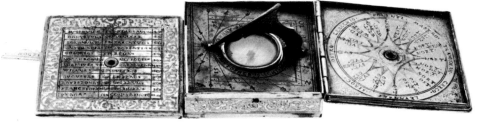

Arms & armour

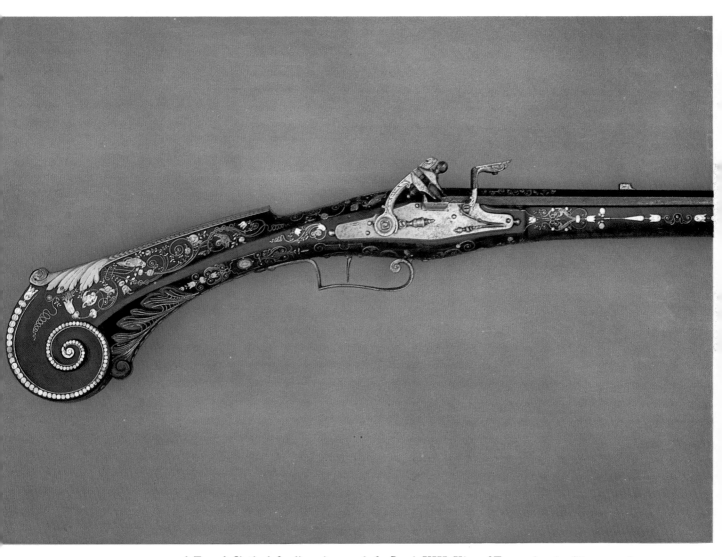

A French flintlock fowling piece made for Louis XIII, King of France, bearing his crowned cypher and the inventory number 134 of his *Cabinet d'Armes*. Stamped on the top of the barrel with the mark of a crossbow between the letters P.B., attributed to Pierre le Bourgeoys of Lisieux. *Circa* 1615. Length 55in. London £125,000 ($312,500). 21.XI.72
From the collection of the late William Goodwin Renwick

The Louis XIII Fowling Piece,* attributed to Pierre le Bourgeoys of Lisieux, circa 1615, from the collection of the late William Goodwin Renwick.

BY DIANA KEITH-NEAL

There can be no greater goal for the collector of antique weapons than to own a piece from the personal collection of Louis XIII of France (1610–1643). The King's love of sport and firearms led him to form his famous *Cabinet d'Armes* which he housed in a remote part of the Palais du Louvre, often retiring there to relax from the strains of regal duty to dismantle and re-assemble the pieces himself. The *Cabinet* comprised not only the weapons belonging to his predecessors on the French throne, particularly Henry IV, but also the finest and technically most advanced firearms made during his lifetime. It is not surprising, therefore, that when one of his flintlock 'birding guns' was offered for sale at auction it attracted unprecedented attention and brought a world record figure of £125,000. (Previous world record for firearms was £60,000 for a pair of pistols from the same collection sold in these rooms in July 1972.)

This gun bears a *Cabinet d'Armes* inventory number 134 stamped on the stock and is one of the three earliest firearms made with an action of 'true' flintlock construction. (The other two are in the State Hermitage Museum, Leningrad and the Musée de l'Armée, Paris.) This method of ignition was to displace the then popular wheel-lock (although not until the middle of the 17th century) and continue in use until the 19th century. Dr Torsten Lenk attributed the introduction of the flintlock to the le Bourgeoys family of Lisieux who made many firearms for Louis XIII. The most famous member of this family was Marin le Bourgeoys, who was granted the privilege of a workshop in the Galeries du Louvre in 1608, and who signed the Hermitage flintlock, which was possibly made for Henry IV and would thus date from before his assassination in 1610. The present gun bears a mark on the barrel which had previously been wrongly recorded as the initials I.B. with a crossbow between, and thereby incorrectly attributed to Marin's brother, Jean, who died in 1615.

When the gun arrived in London the mark proved on examination to be P.B. with a crossbow, and Mr John Hayward was able to re-attribute it to another brother, Pierre le Bourgeoys, about whom very little is known. As the gun has the crowned cypher of Louis XIII inlaid into the stock it must have been made sometime between 1610, when he ascended the throne, aged nine years, and 1627, the year of Pierre le Bourgeoys' death. A date of about 1615 would seem likely, as the light construction of the gun suggests that it was made for a youth rather than a fully grown man.

The fowling piece is an elegant gun with a beautiful scrolling butt of ebonised pearwood. It is described in the *Inventaire Général du Mobilier de la Couronne* of 30.1.1681 as '*un beau fusil de 4 pieds 4 pouces, fait à Lisieux, le canon rond couleur*

* See colour illustration on page 315

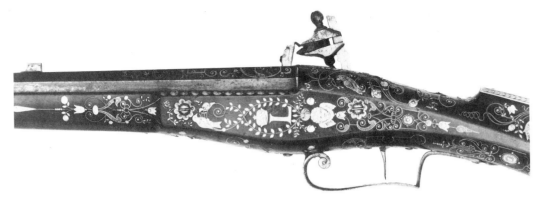

d'eau, ayant une arreste sur le devant et à huit pams sur le derrière, doré de rinceaux en trois endroits, la platine unie ornée de quelques pettites pièces dorées sur un beau bois de poirier noircy . . .' etc.

The blued barrel shows up the gilt scrollwork at the breech, centre point and muzzle. The butt and stock are inlaid with silver and brass sheet and wire depicting lively animals, birds and snails which perch on scrolls and foliage, and enriched with engraved mother of pearl plaques and leaf-shaped brass nailheads. All the steel furniture is etched and gilt with scrollwork, even on the inside of the trigger guard. Apart from the crowned L of Louis XIII on the stock opposite the lock, the most outstanding feature of the decoration is the top of the butt which is sheathed in gilt-bronze overlapping leaves. It is a fowling piece fit for a king whose enthusiasm for firearms began when he was three years of age, and made France an important centre of European weapons industry.

Literature
Lenk, Torsten, *Flintlåset* (English translation by Urquhart and Hayward, London, 1965)
Hayward, J. F., 'Notes on the Cabinet d'Armes of Louis XIII', *The Journal of the Royal Armoury, Livrustkammaren*, Stockholm, 1973, vol. XIII
Ricketts, Howard, 'Louis XIII – an Infant Gun Collector', *The Ivory Hammer*, Sotheby's 1962–63, London
Charles, Jean-Robert, Salle Drouot Catalogue, *Armes Anciennes*, Paris 26.V.1972 which includes notes on the Cabinet d'Armes de Louis XIII

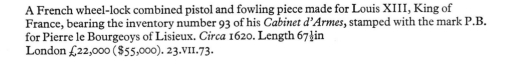

A French wheel-lock combined pistol and fowling piece made for Louis XIII, King of France, bearing the inventory number 93 of his *Cabinet d'Armes*, stamped with the mark P.B. for Pierre le Bourgeoys of Lisieux. *Circa* 1620. Length 67½in
London £22,000 ($55,000). 23.VII.73.

A historic pair of rifled flintlock duelling pistols by Nicholas Noel Boutet, presented by General Gilbert Motier de Lafayette to Simon Bolivar, the Liberator of Colombia, in 1825. Stamped *Boutet* over the breech, the locks signed, one *N. N. Boutet à Versailles* and the other *Manufacture Royale à Versailles*. An oval escutcheon plate inset in the small of each pistol is inscribed *Bolivar*. Paris mark for 1809–15, goldsmith's mark of *N. Boutet*. The case is complete with fittings. Paris *circa* 1820. Length 16¼in, case 17¾in by 12¼in
London £22,000 ($55,000). 19.III.73
From the collection of the late William Goodwin Renwick

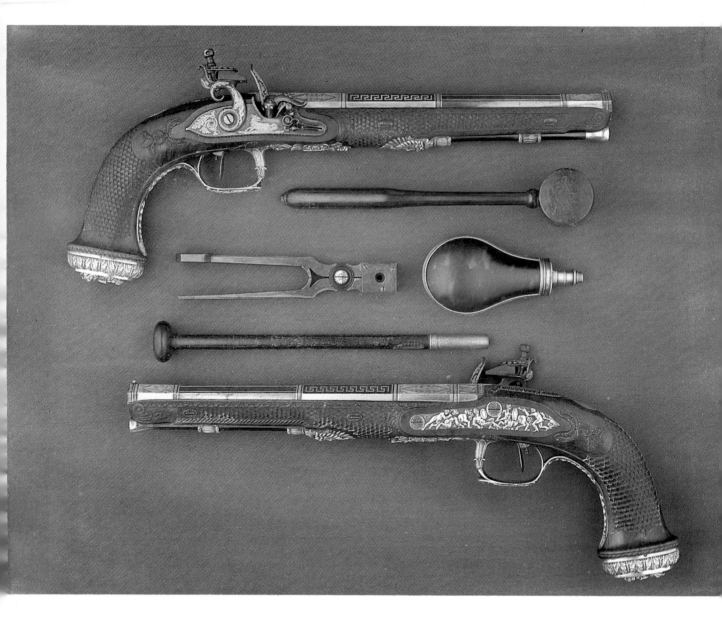

A pair of Italian flintlock holster pistols signed *Lazarino Cominazzo* at the breech, the locks signed inside the plate *Francesco Garato, Brescia,* walnut stocks carved in high relief, steel furniture chiselled and pierced with scrolling foliage inhabited by dragons and monkeys, original ramrods terminating in a monkey supporting a basket. *Circa* 1675. Length 19in. London £6,600 ($16,500). 21.XI.72
From the collection of the late William Goodwin Renwick

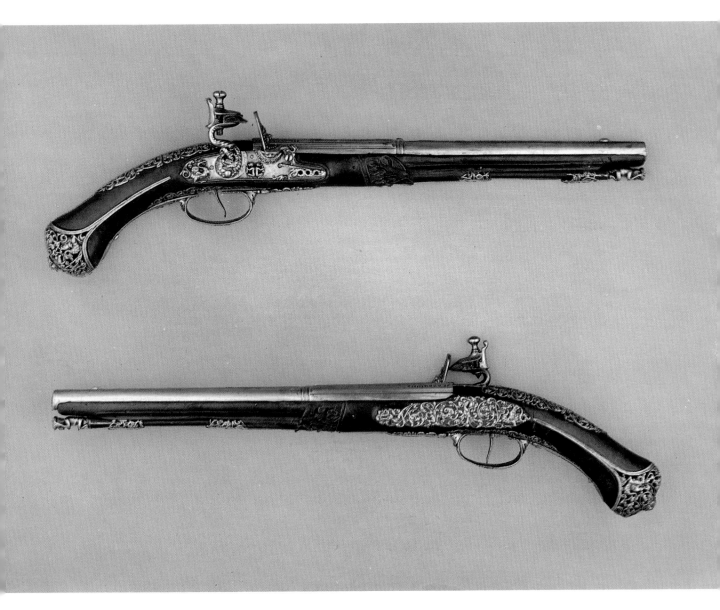

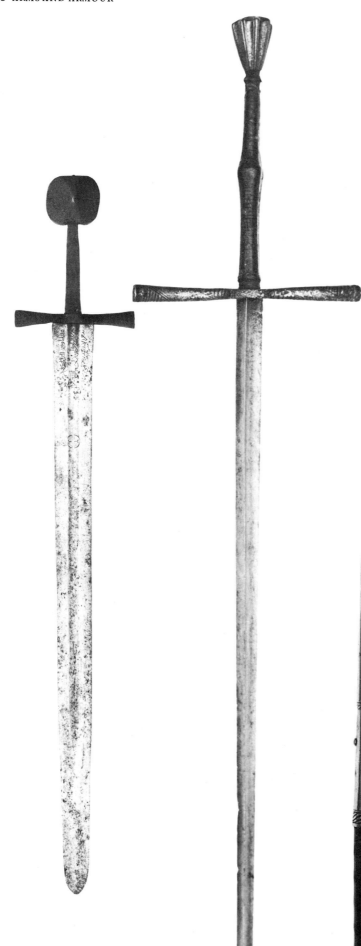

Left
A medieval knightly sword, the broad double-edged blade with central groove, inlaid on one side with a cross within a circle and on the other with the letter S within a circle and inscribed in Arabic characters recording its presentation to *the Arsenal of* (illegible) *by His Excellency Nasir ad-Din Muhammad Ibn Hamud in honour of raids and warfare in the path of God the Exalted.*
Fourteenth century. Length 35½in
London £1,950 ($4,875). 21.V.73
From the collection of the late William Goodwin Renwick

Centre
A German two-handed estoc, the blade of hollow triangular section, original leather-covered waisted grip. *Circa* 1500. 55in
London £1,200 ($3,000). 21.V.73
From the collection of the late William Goodwin Renwick

Below
An executioner's beheading axe, pierced with two cross motifs, the edges pierced and engrailed, a flowerhead stud on the right side. Late sixteenth century.
Length 57in
London £500 ($1,250). 21.V.73
From the collection of the late William Goodwin Renwick

Right
A German late Gothic gauntlet for the left hand, dating from the end of the fifteenth century. Length 13½in London £800 ($2,000). 19.II.73

Below
A late sixteenth century German crossbow, the walnut stock inlaid with engraved horn, the steel bow retaining the original cording, aperture sight 25in; and a steel cranequin, the ratchet wheel pierced and inlaid with brass, 14in. London £1,900 ($4,750). 21.V.73 From the collection of the late William Goodwin Renwick

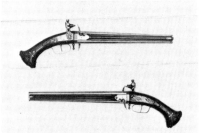

1

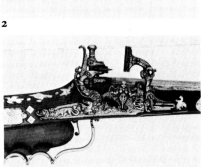

2

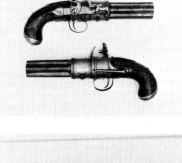
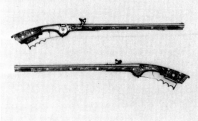

3

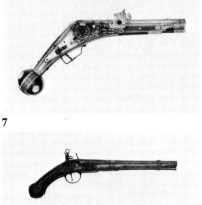

4

5

6

7

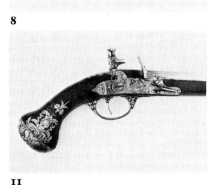

8

9

10

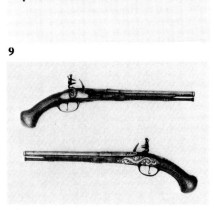

11

12

1. A pair of German flintlock four-barrelled Wender holster pistols, signed *Johann Krach, circa* 1675. 20in. £7,200 ($18,000). 19.III.73. **2.** A Saxon wheel-lock carbine, barrel-smith's mark *N.Z.*, chiseller's mark *H.W.*, *circa* 1575. 36½in. £21,000 ($52,500). 19.III.73. **3.** A pair of Swiss 7 shot flintlock pepperbox revolvers, signed *Mairet Artiste aux Ponts, circa* 1750. 11½in. £10,000 ($25,000). 19.II.73.
4. A pair of French double-barrelled turn-over flintlock holster pistols, signed *J. S. Charlet à Lyon, circa* 1675. 20½in. £6,400 ($16,000). 21.XI.72. **5.** A Russian snaphaunce sporting rifle (detail), *circa* 1625. 53½in. £4,200 ($10,500). 19.III.73. **6.** A pair of Silesian light wheel-lock carbines, Teschen, *circa* 1650. 32½in. £7,000 ($17,500). 21.V.73.
7. A Nuremberg wheel-lock holster pistol (puffer), the lock-smith's mark a spur (Støckel No. 5876), *circa* 1575. 18½in.

£7,000 ($17,500). 21.V.73. **8.** A Saxon wheel-lock rifle, struck with a fleur-de-lys (Støckel No. 5421.1), dated 1593. 45in. £6,600 ($16,500). 21.XI.72. **9.** A German wheel and matchlock musket, stamped with a crowned anchor and the initials *P.L.* (Støckel No. 4852), early 17th century. 64in. £5,600 ($14,000). 21.XI.72. **10.** A pair of Spanish lock holster pistols, signed *Nicolas Bis MD*, Madrid, *circa* 1695. 18½in. £5,800 ($14,500). 19.II.73. **11.** One of a pair of Swiss flint-lock holster pistols, signed *Aubert*, lock plates engraved in the manner of Jean Bérain, *circa* 1660. 22in. £11,000 ($27,500). 19.III.73. **12.** A pair of French holster pistols, signed on the locks *Thurenne à Paris*, bearing the emblems of Louis XIV who probably presented them, *circa* 1670. 19in. £10,500 ($26,250). 18.VI.73.

Musical instruments

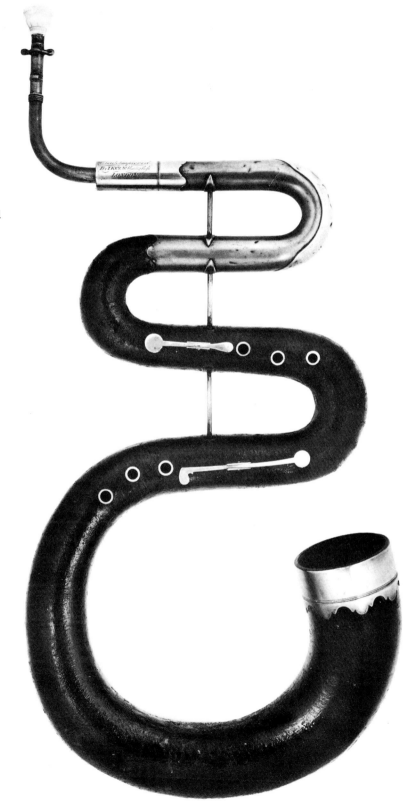

An English serpent by
Thomas Key, London, the
tube of leather-bound wood,
brass and nickel mounts,
four brass keys, ivory-bushed
finger holes, brass crook and
bit with ivory mouthpiece.
Circa 1820. Length of tube
7ft 11½in
London £400 ($1,000).
21.XII.72
From the collection of
William Barrow
of Llandudno

Violins still dominated this season's sales numerically and it was again a violin that brought the highest price. This was the 'Soames' Stradivari which, despite its small size, a critical quarter of an inch less than normal, was sold for £21,000. However the keyboard instruments obtained the other high prices, the instruments belonging to the collection of William Barrow of Llandudno, in particular, providing the major interest in this field. This collection included English spinets by Hitchcock, Keene and Player as well as a two-manual harpsichord by Jacob Kirckman dated 1767 (£6,000). A very attractively cased late eighteenth-century grand pianoforte by Longman and Broderip from the same collection brought £3,000 and underlined the ever growing interest in early pianos.

A two-keyed flute, which had formerly belonged to Frederick the Great of Prussia, set a new auction record for woodwind instruments (£5,800). The King was an accomplished flautist; he was taught the instrument by Quantz and employed C. P. E. Bach as his court harpsichordist.

Opposite page
A violin by Antonio Stradivari bearing its original label *Antonius Stradivarius Cremonenfis faciebat anno* 1684. Length of back 13¾in London £21,000 ($52,500). 24.V.73
From the collection of Mrs Helen Ware Cappel

Below
A two-keyed ebony flute after Johann Joachim Quantz, formerly the property of King Frederick II of Prussia. *Circa* 1750. Length with longest and shortest joints 26 $\frac{11}{16}$ in and 25 $\frac{9}{16}$ in respectively
London £5,800 ($14,500). 21.XII.72

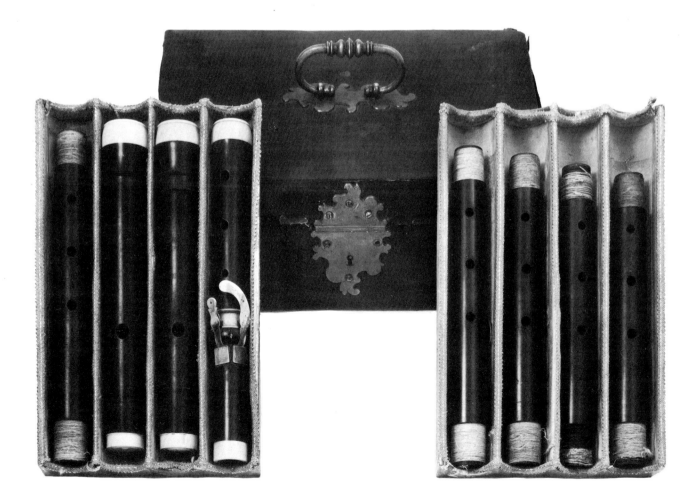

An English spinet by John Player, inscribed on the nameboard *Johannes Player, Londini fecit*, the walnut case raised on oak trestle stand. *Circa* 1660. Length 5ft 1½in
London £3,000 ($7,500).
21.XII.72
From the collection of William Barrow of Llandudno

A two-manual harpsichord by Jacob Kirckman inscribed on a boxwood plaque on the nameboard *Jacobus Kirckman Londini fecit* 1767 in a mahogany case with fruitwood stringing. Length 7ft 9in
London £6,000 ($15,000).
21.XII.72
From the collection of William Barrow of Llandudno

Sotheby's at Quenby

Last October Sotheby's went to Quenby Hall. The three-day sale comprised the contents of the Hall and over a thousand lots from attics to cellars which were offered in a large adjoining marquee. The late Sir Harold Nutting had moved to Quenby in 1924 and several of the pictures and some of the furniture were bought by him at a previous sale of the contents held then. The two sales provided some interesing contrasts, although the apparent appreciation must always be considered in the light of the ever-decreasing value of money over the last fifty years. A large pastoral landscape in the style of Albrecht Cuyp sold in 1924 for 3 guineas was now sold for £520; a portrait of a lady attributed to Cornelius Johnson rose from 34 guineas to £780, and another portrait from the Circle of Hans Eworth was now sold for £1,350 against 8 guineas previously. The rise in furniture prices was less pronounced and an early seventeenth century dining table was now sold for £850 against 120 guineas, but

P. TILLEMANS
A view of Quenby Hall from the Park
40in by 50in
Quenby Hall £4,800
($12,000). 24.X.72

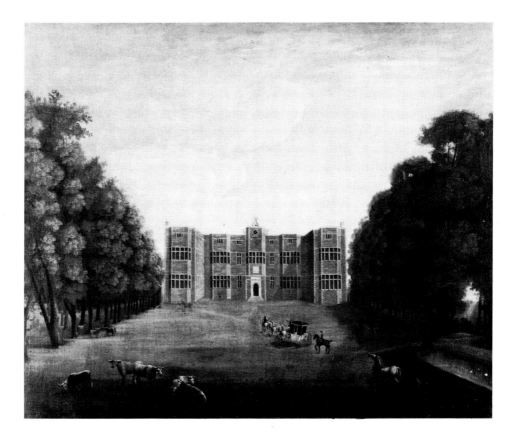

it must be remembered that oak and walnut furniture of this period was much in demand at that time.

Apart from the furniture and paintings which Sir Harold Nutting bought at the previous Quenby sale, many of which have now in their turn been bought by the new owner and thus remain part of Quenby, the greatest enthusiasm was aroused by the sporting pictures. A set of four attractive fox hunting scenes attributed to Dalby of York sold for £8,200 but the contemporary sporting pictures provoked equally spirited bidding. These pictures of the Quorn and the Meynell, both of which at one time had Sir Harold Nutting for Master, were naturally of great local interest. A bodycolour by Francis Algernon Stewart of *The Quorn running hard* sold for £600; a pair of slight pencil sketches of *A Meet of the Quorn* by Lionel Edwards were sold for £320; a bodycolour by the same artist of *Sir Harold Nutting with the Meynell breaking cover* was sold for £1,700 and an oil of *The Quorn at Billesden* with hounds in full cry made £2,100.

The total for the three days was £192,232, including something over £1,400 for copper kitchen ware; this recalled the successful sale at Stobo Castle the previous April of a copper batterie de cuisine for £460.

Possibly the most fascinating item in the whole sale was an early *View of Quenby* in the manner of Pieter Tillemans which fetched £4,800. This was remarkable not only as an early landscape portrait showing a rather stylised view of the Hall with cattle and horses and a coach-and-six in the park, but also as showing how little Quenby has changed since George Ashby built it some 350 years ago.

LIONEL EDWARDS
The Quorn at Billesden
Signed and inscribed,
28in by 36in
Quenby Hall £2,100
($5,250). 24.X.72

French furniture in the salerooms, the early period 1660-1830

BY SIR FRANCIS WATSON

French furniture of the 'great' period, that is to say furniture made in Paris between the reign of Louis XIV and the Revolution, certainly came to England almost from the beginning. From Evelyn's descriptions we know that the magnificent silver furnishings of the Duchess of Portsmouth's apartments in the Palace of Whitehall must have been made at the Gobelins manufactory like the silver furniture at Versailles. Louis XIV himself is even said (by a somewhat doubtful tradition) to have given certain of the splendid early Boulle cabinets at Drumlanrig to the Duke of Monmouth. The Duke of Montagu, too, almost certainly brought back furniture from Paris when he was ambassador at the Court of Versailles. But none of this, if it remains amongst the other furniture in the collection of the Duke of Buccleuch, can be identified with any real probability today. The earliest surviving piece of French furniture known certainly to have come to England at about this period appears to be a Boulle writing-table at Erthig in Denbighshire, which is mentioned in an inventory of 1726.

Soon after this, French furniture began to come over here in considerable quantities. Indeed, Parisian products and Parisian manners were so fashionable by the mid-1730s that an Anti-Gallican Society[1] was founded to combat the growing taste for things French in the interest of English commerce. Nevertheless, there is an abundance of evidence that French furniture continued to be purchased and brought home by English visitors to Paris throughout the eighteenth century. An interesting survival of this taste reappeared in the London salerooms recently, when a Louis XV writing table signed B.V.R.B. was sold by Christie's on 23rd March 1972 for the remarkable price of 24,000 guineas. This table actually appears in a drawing by the English architect John Vardy, now in the possession of the Royal Institute of British Architects. The drawing can be dated to about 1745, and bears an inscription *J. Vardy delin. at Mr. Arundales*. It was a descendant of this last named gentleman who sold the table in 1972, though the *cartonnier en suite* shown in Vardy's drawing is no longer with it.

This English fashion for buying contemporary French furniture reached its peak in the decade preceding the French Revolution, when a considerable part of the furnishings of Carlton House were purchased from Paris by the Prince of Wales through the intermediary of the fashionable *marchand-mercier*, Daguerre, who shortly afterwards found it worth while to set up a branch of his Parisian establishment *A la Couronne d'Or* in London.

[1] See, on this point, the article by David Sanctuary Howard, p. 425ff

Throughout this period French furniture seems to have enjoyed little favour in the English salerooms; and when it appeared at all, the catalogue descriptions are usually too brief or too indefinite to permit any sort of identification. It certainly enjoyed no plus-value as an antique. In France the situation was entirely different. Furniture is frequently described in detail in eighteenth-century Parisian sale catalogues. The names of certain prestigious makers are even sometimes mentioned and appear to have added to the market value of the pieces as they do today. In the last twenty-five years before 1789, furniture made by André-Charles Boulle was especially prized in Paris. Thus at the duc d'Aumont's sale in 1782 two magnificent Boulle cabinets received 36 lines of detailed description in the catalogue, and were purchased by the duc de Villequier for the considerable sum of 2,451 *livres*. Two other Boulle cabinets in the same sale, inlaid with marble mosaic panels in the manner of Florentine *pietre commesse* were bought on behalf of Louis XVI for the much higher sum of 5,708 *livres*. How highly such furniture was admired may be judged by the auctioneer's encomium which precedes the section of the catalogue devoted to furniture of the Louis XIV period:

> '*Le genre des Meubles qui coopérent au parfait accord de la précieuse Collection de ce Cabinet*' he writes, '*forme encore une partie très-importante par l'art et la richesse de leur ensemble; les Amateurs en jugeront par les ouvrages qui la composent, tant en marquetrie qu'en pierres de rapport et en tables de marbres rares, sur des pieds du goût le plus recherché qui se soit vu.*'

This was a relatively new turn of taste. Only thirty years earlier, on 3rd February 1751, a remarkable sale by auction had been held at the Louvre in which some of the most magnificent pieces created for Louis XIV and earlier sovereigns were disposed of by the officials of the *Garde-Meuble*, under the authority of Louis XV, both of whom quite clearly regarded such things as old-fashioned and of little interest. Lot 1 in this sale was '*Un Cabinet de bois de Cèdre*' mounted with an effigy of Henri IV, and ornamented with the Royal arms of France. The King was represented on horseback in the central niche. This piece of furniture can be traced back as far as 1603, when it appears in an inventory of the contents of the Louvre. It appears, again as item 1, in the section devoted to *Cabinets, Tables et Guéridons* of the inventory drawn up for Louis XIV by Gédéon du Metz from 1673 onwards:

> 1 – *Un cabinet de bois de cèdre, orné par devant de huit colonnes de mesme bois, avec leurs bases et chapiteaux, aussy de bois doré, d'ordre corinthe, au milieu d'une niche dans laquelle est le Roy Henry 4 à cheval qui foule au pied ses ennemys, et sur l'attique quatre figures, deux trophées et les armes du Roy sous-teniies par deux anges, le tout de bronze doré; avec son pied de mesme bois, hault de 6 pieds 8 pouces, large de 4 pieds ½ sur 18 pouces de profondeur.*

This historic cabinet was purchased at the 1751 sale on behalf of Mme de Pompadour by her favourite *marchand-mercier*, Lazare Duvaux, for the extremely modest sum of 51 *livres*, little more than three times the charge (15 *livres*) for delivering the cabinet to her Château de Bellevue, half way between Paris and Versailles.

Doubtless some of the pieces in this sale were old and dilapidated, and M Verlet has suggested that Mme de Pompadour may have purchased the Henri IV '*buffet tout de bois de cèdre*' in order to use the precious, sweet-smelling wood (still cheap at the price of 51 *livres*) to cut up to make small boxes, of which she possessed a number. However all the fine furniture in this sale cannot have been in bad condition. Lots 372 and 373 were a pair of cabinets 'inlaid with mosaics of marble, bearing

Louis XIV's cipher, by Cucci' (Fig 1). These two magnificent cabinets, perhaps the finest pieces of Louis XIV furniture to survive, are to be seen today at Alnwick, having been bought for £2,000 in 1824 by the third Duke of Northumberland from the well-known dealer in French furniture, Baldock of Stanway Yard. They had originally been delivered to Versailles by Cucci in November 1683 at a cost of 16,000 *livres*.

Another pair of magnificent Louis XIV cabinets embellished with twisted columns of lapis lazuli (possibly the same as the ones pictured in the famous tapestry of Louis XIV's visit to the Gobelins on 15th October 1667) were likewise sold for a modest price on this occasion, but reappeared as lot 312 in the duc d'Aumont's sale mentioned above when they were sold for the considerable sum of 2,451 *livres*.

Fig 1
Cabinet (one of a pair) made by Domenico Cucci for Louis XIV's bedchamber and sold at Versailles on 3rd February 1751. Bought by the third duke of Northumberland in 1824 for £2,000 (Duke of Northumberland, Alnwick Castle).

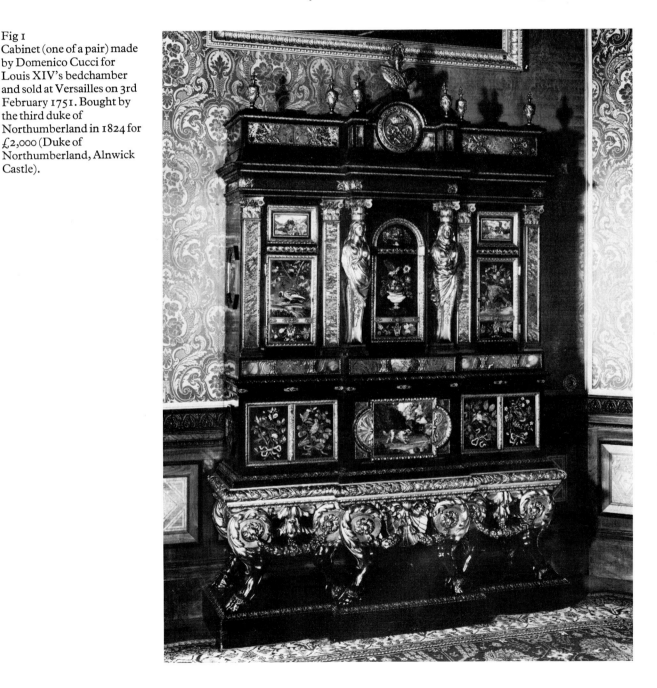

Today it seems strange that such monumental baroque pieces should have been regarded, as the auctioneers Julliot and Paillet emphasise in the passage quoted above, as the ideal accompaniment for the relatively small-sized works in the extreme neo-classic style by Pierre Gouthière, of whom the duc d'Aumont was the principal patron. Of the numerous pieces by this great craftsman included in the same sale, it is perhaps worth singling out the celebrated perfume-burner now in the Wallace Collection (Fig 2), which appears as lot 25. In addition to a lengthy description it was illustrated (Fig 3), for the catalogue of the d'Aumont sale was one of the earliest to be fairly fully illustrated and included 29 line engravings, one of which even showed a detail of a table referred to below, as well as depicting the whole piece. The perfume-burner was purchased on behalf of Marie-Antoinette by the dealer Le Brun, husband of the more famous Mme Vigée, the portrait painter, for 12,000 *livres* in spite of its small size (it is only 19 in. high). Even higher prices were achieved at this famous sale. A pair of porphyry-topped tables also by Gouthière reached the astronomical price of 23,999 *livres* 19 *sous*, and were again purchased for the Queen.

Other craftsmen whose names occasionally appear in eighteenth-century sale catalogues are Cressent, the Caffiéri, Oeben, Riesener and a certain 'Bernard', described as a '*habile artiste*' who is almost certainly to be identified as Bernard II van Risenburgh, the *ébéniste* who used the signature B.V.R.B., and whose work is so greatly admired today. Thus in the catalogue of the posthumous sale of the effects of the painter François Boucher in 1771, we find lot 1006 was '*Un vuide poche fait par Bernard, il est de bois de rose & amaranthe, le dessus à fleurs de bois de violette, entouré d'un quart de rond, chûte, sabots & ornemens de bronze doré*'. It is interesting that Boucher painted no less than three portraits of his great patron Mme de Pompadour with just such a small table, recognisably by van Risenburgh, at her side. Indeed, there is reason to believe these tables were actually known as *tables à la Pompadour* by the art trade of the period, and the one included in the sale may have been used as a studio property in the portraits of the Marquise. Later on in the same sale, we find two lots (1022 and 1023) comprising a pair of three-branch candelabra '*dans le goût antique*', and a pair of similar candlesticks, both of them described as '*par M. Caffieri*'. Presumably this is Philippe Caffieri rather than his more celebrated father Jacques, who worked almost exclusively in the rococo style. Nevertheless the candelabra attained a price of 441 *livres*, the highest price reached by any single furnishing piece in Boucher's sale.

The happy situation outlined above was brought to an abrupt end by the Revolution. The drying up of patronage, and the consequent fall in prices, ruined many *ébénistes*. Riesener, who had probably made as large a fortune out of furniture-making as any eighteenth-century cabinet-maker apart from Roentgen, clearly regarded the Revolution as a temporary affair. He purchased back at low prices, in sales of furniture seized from the French crown or from *emigrés*, many pieces he had created, hoping to sell them profitably when the political climate became easier once again. In this aim he was woefully disappointed. When he attempted to dispose of them by public auction in 1793 and again in 1797, the result was a lamentable failure. No one in France any longer wanted furniture associated with *ci-devant* royalty.

Nevertheless if the Revolution killed the sale of French furniture in France it promoted an entire series of auction sales of French furniture on an unprecedented scale at home, and led to many further sales abroad. On 10th June 1793 the *Convention* passed a law entitled: 'Law relating to the sale of the furniture of the

Fig 2
Perfume Burner of jasper mounted in gilt bronze made by
Pierre Gouthière for the duc d'Aumont probably at a price of
1500 *livres*. At d'Aumont sale in 1782 it was bought on behalf
of Marie-Antoinette for 12,000 *livres*. Subsequently it appeared
in the Fournier sale in Paris in 1831, and was sold for 1200
francs. Finally it was bought by Lord Hertford for 31,900
francs at the prince de Beauvau sale in 1865 (Wallace
Collection).

Fig 3
Engraved illustration from d'Aumont sale catalogue of 1782
showing lot 25, the perfume burner illustrated in Fig 2.

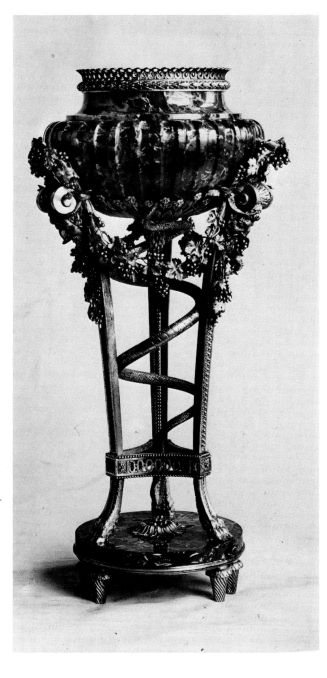

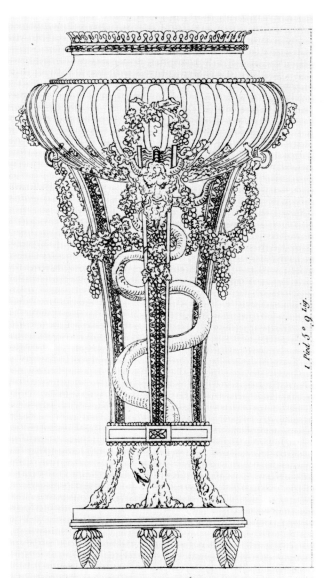

Trépied de Bronze doré d'or mat: la Coupe et le
Socle sont de Jaspe fleuri rouge.

Garde-Meuble National and the former civil list', the effect of which was to disperse by auction nearly all the contents of the great royal palaces of France so that 'the sumptuous furniture of the last tyrants of France' might be 'put to the service of the defence of liberty and the growth of national prosperity'. Some idea of the scale of these sales may be obtained from their length alone. The sale of the contents of Versailles lasted for almost a year, from 25th August 1793 to 11th August 1794, with breaks only on the *décadis*, the revolutionary equivalent of Sunday, which took place only every tenth day. The sales, which were 'by the candle', continued daily from early morning until the evening. At the other royal châteaux sales were of equal or almost equal length, and were held concurrently with the Versailles sale:

Compiègne: 20th May 1795 – 19th October 1795

Fig 4
Notice of the opening of the sale of the contents of the Petit Trianon on 25th August 1793.

VENTE
DE
MEUBLES ET EFFETS
DE LA CI - DEVANT REINE,
PROVENANT DU PETIT TRIANON,
EN VERTU DE LA LOI DU DIX JUIN DERNIER.

Le Dimanche 25 Août 1793, l'an deuxième de la République une & indivisible, 10 heures du matin, & 4 heures de relevée, & jours suivans.

SAVOIR:

Tous les matins. **B**Atterie & ustensiles de cuisine & d'office, ferrailles & meubles communs. *Tous les soirs.* Meubles de suite, consistans en Lits avec leurs housses de différentes étoffes; armoires, secrétaires, commodes, tables, consoles, partie à dessus de marbre; feux, chaises longues, fauteuils, canapés, banquettes, chaises à tabourets de damas, lampas, velours de soie d'Utrecht, & moquette; faience, verrerie, porcelaine d'office & de table.

Les autres Meubles de toute espèce, & en grande quantité, seront annoncés par de nouvelles affiches.

Cette vente se fera en présence des Représentans du Peuple, & des Commissaires du District, au ci-devant Château de Versailles.

N. B. Les Meubles de la ci-devant Liste civile peuvent être transportés à l'étranger, en exemption de tous droits.

Les Commissaires de la Convention Nationale.
CH. DELACROIX, J. M. MUSSET.

DE L'IMPRIMERIE NATIONALE.

Fontainebleau: 19th June 1794 – 29th October 1794
Marly: 6th October 1793 – 25th November 1793
Saint-Cloud: 29th March 1794 – 5th September 1795

In view of the quality of the goods sold, it may at first seem surprising that the sales were not a commercial success, but the flooding of so vast a quantity of furniture onto the market in so short a period of time was not conducive to producing high prices. In addition, large numbers of important pieces were lotted together in a highly unsophisticated manner. The catalogue descriptions are for the most part brief, and it is often difficult to identify the originals (Fig 4). At the sale at the Petit Trianon we find, for example, lot 205: '*Un secrétaire d'acajou à dessus de marbre*', sold to '*citoyen Riesener*' for 326 *livres*. This was unquestionably a piece he had made himself for the Queen's personal palace, and was one of those he bought back cheaply in the hope of later profit. The price was certainly no more than one-tenth of what the table would have originally cost, and it must be remembered that the currency was no longer that in use in pre-Revolutionary days, but had been greatly devalued since 1789.

A particularly striking item was lot 15,845 (the very number casts light on the scale of the sales) sold in the week 30th June–9th July 1794: '*Item un bureau, une commode et deux encoignures à dessus de marbre griotte d'Italie, le tout en bois de rapports et richement ornés de bronze doré d'or moulu, de l'art. 1678, attendu que ledit article est estimé au dessus de mille livres, les feux ont été allumés conformement à la loi du 10 juin 1793 sur l'enchere de cinq mille livres du C. Trusset, cy . . . 5,000 l.*'

For this modest sum, the fortunate purchaser '*citoyen Trusset*' became possessed of the great commode by Riesener made in 1774 for Louis XVI's bedchamber at Versailles together with the matching corner cupboards (Fig 5) made by the same craftsman in 1779, when the commode was removed to the King's *Arrière Cabinet*. When new they had cost the French crown nearly 19,000 *livres*. All three pieces are now in the Royal Collection at Windsor. In addition the *bureau* mentioned at the opening of the catalogue entry was the magnificent writing table made by Benneman in 1786 for the King's *Cabinet Intérieur* at Versailles. This is now at Waddesdon Manor, and had cost 5,716 *livres* in 1786. Ironically all four pieces had been offered for sale earlier, on 17th June of the same year, when, in spite of the auctioneer's encomium '*C'est faire l'éloge de ces meubles que d'annoncer qu'ils sont faits par Riesner qui n'a rien épargné pour les rendre parfaits*', they failed to find any purchaser at all.

Not only were the sales ill-organised and released far too much on the market at one time, but they were accompanied by every device known to the *mafiosi* of the saleroom. Rings were formed, barracking by the crowds often intimidated purchasers of furniture associated with the hated *Ancien Régime*, and even examples of the mugging of buyers are quoted by contemporaries. It may be supposed, in view of these factors, that little of the furniture from the former Royal collections remained in France. In the early days of the Revolution much of it was bought by Russians. Alexandre Reimers, when describing a visit to Saint Petersburg a few years later in 1805, throws interesting light on this. In his account of calling on Prince Koucheleff-Bezborodko, he writes: '*Le palais Bezborodko est aussi à remarquer par les meubles precieux qui ornaient, sous l'ancienne royauté française, les plus beaux palais. Au début de la Revolution et de la Terreur ces meubles sortirent de France et le prince réussit à les acheter. C'est ainsi qu'on y voit un bureau, des bras de lumière, des figures de bronze pour orner les tables, des vases, des rideaux de soie brodée au tambour et des fauteuils provenant d'un cabinet de la malheureuse Marie-Antoinette au Petit Trianon, un lustre*

magnifique en cristal de roche provenant du duc d'Orléans au Palais-Royal, un meuble précieux et extremement rare, incrusté d'écaille et de cuivre, travail de Charles Boulle.'

A well-known secretaire by Riesener in the Wallace Collection, made in 1783 for Marie-Antoinette's use at Versailles, was acquired from this collection in the 1860s and may well have been amongst the pieces Reimers saw.

However the English were by far the greatest beneficiaries of the Revolutionary sales. Already in the early days of the Revolution the first *emigrés* had been arriving in London with their furniture and other possessions in the hope that they would be able to sell them here to provide themselves with the wherewithal to live. As early as April 1790 we find Sir Gilbert Eliot (the future Lord Minto) writing from London to his wife in Scotland: 'the quantity of French goods of all sorts, particularly

Fig 5
One of a pair of corner-cupboards made by J.-H. Riesener in 1779 for the *Arrière Cabinet* of Louis XVI at Versailles at a cost of 11,608 *livres* for the two. It was sold with its companion, a commode for Louis XVI's bedchamber and a *bureau plât* by Benneman from the King's *Cabinet Intérieur* in early July 1794 for 5,000 *livres* to a certain '*citoyen Trusset*'. In 1825 the first three pieces were bought for George IV at the Watson Taylor sale for £107 (Windsor Castle reproduced by Gracious Permission of H. M. the Queen).

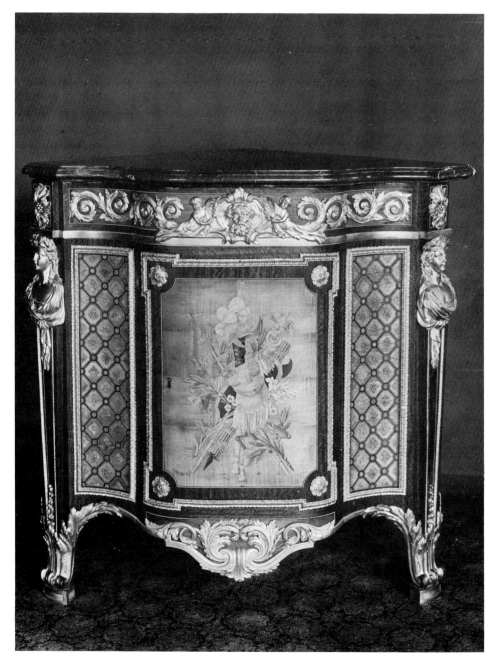

ornamental furniture and jewels, has sunk the price of these things here'. A few years later the same writer described a vast assemblage of Sèvres porcelain and French furniture, including 'six great Paris clocks, ormolu and bronze, all immense in size and superb in decoration as the fashion now is' which he had seen shown at the house of a certain 'Caulfield'. These were the years when the Prince of Wales and his boon companion Lord Yarmouth (later the third Marquess of Hertford) were haunting the London salerooms and antique dealers' shops together, and laying the foundations of the extraordinarily rich assemblages of French eighteenth-century decorative art to be seen in the Wallace Collection and at Windsor and Buckingham Palace today. And on an only slightly smaller scale, many other wealthy Englishmen were doing the same.

The impact of the Revolutionary sales became fairly quickly apparent in the London auction rooms. As early as March 1791, the Parisian *marchand-mercier* Daguerre held a large sale of French furniture at Christie's, probably his own stock which he was unable to dispose of in Paris owing to the political situation. The mere title pages of the auction sales of the period, far more flowery than those of today, provide evidence of what was happening. To take a few examples at random, the title page of the catalogue of the sale held by H. Phillips which began on 31st March 1798, was headed: 'Parisian Elegancies from the PALACE of Versailles . . . SUPERBE FURNITURE, Musical & Mechanical Clocks in Or-Moulu, Bronze, MARBLE & BISCUIT . . .' and much more to the same effect. A further sale described in almost similar terms was held a month later on 28th April. On 17th February 1800, the same auctioneer burst into elaborate tautology, offering: 'A MAGNIFICENT ASSEMBLAGE of the most superbe & Elegant Assemblage of Articles ever imported into this country . . . the greater Part whereof have been recently imported from PARIS via Hamburgh except a few ELEGANT GEMS, undoubtedly removed from the Residence of the late QUEEN of FRANCE's Chateau St Cloud . . .' (Fig 6) a sale which was continued for a second period of seven days on 26th February. Many of the items are described as 'formerly in the possession of the late KING of FRANCE' or 'from the chamber of Louis XV' etc. An example of the last, a commode of red Boulle marquetry, is certainly given an incorrect provenance, though it may very likely have been a Royal piece; Boulle furniture was never to Louis XV's taste, and at no time were there any Boulle pieces in the *chambre du Roi* during his reign. Nevertheless, Harry Phillips's boasts were by no means empty. Lot 251 of the sale held on 31st March 1798 was described at length: 'A MAGNIFICENT and superlatively ELEGANT CLOCK and BAROMETER, truly UNIQUE, of indispensable utility, mounted on BRONZE EAGLES characterestically (*sic*) modelled, and sumptuous or-moulu cases, enriched by figures, of APOLLO and ASTRONOMY, supported by plynths, composed of the most beautiful woods, decorated by choice OR-MOULU devices, terminated by pedestals, embellished by two remarkable fine BRONZE BAS RELIEFS. The Clock by ROBIN, the Barometer by MASSY, mechanists to the late KING and QUEEN of France, and made by special order for those distinguished personages, at an expence of upwards of ONE THOUSAND POUNDS STERLING' (Fig 7).

These are unquestionably the magnificent clock and barometer today at Southill in the possession of Mr Samuel Whitbread (Fig 8), which had been included in a list of clocks at Versailles owned by Marie-Antoinette, drawn up shortly before the Revolution by Robin himself, *horloger de la Reine*. They had already appeared in November 1793 in the sale of the contents of Versailles as '*4150. Deux guennes* (i.e.

gaines) *en racine d'acajou avec pendule et thermomètre ornées d'aigles en bronze antique*' when they were sold to a certain '*Citoyen Berton Cadet*' for the relatively large sum of 7,899 *livres*.

By the very way in which they were dispersed, many of the works of art sold from the former French royal palaces tended to gravitate into the hands of antique dealers rather than into the salerooms. Some of the finest things came here through the foreign agents of the *Commission des Subsistances*, who took payment for essential commodities such as saltpetre and wood for ships' masts, of which the young Republic was in short supply, in '*objets de luxe*' from the former Royal collections rather than in devalued *assignats*. Certain important sculptures and French furnishings at both the Wallace Collection and at Windsor Castle can be traced back into

A

CATALOGUE

OF

A MAGNIFICENT ASSEMBLAGE

OF THE MOST

SUPERBE & ELEGANT

Assemblage of Articles,

EVER IMPORTED INTO THIS COUNTRY,

And which are domestically useful and elegantly ornamental,

EITHER FOR

The Palace, the Mansion, or the Chateau,

Are designed with superior Taste in the several Branches of their

MANUFACTURE,

And finished and executed in the best Stile of Workmanship;

The greater Part whereof have been recently imported from

Paris via Hamburgh,

Except a few ELEGANT GEMS, undoubtedly removed

from the Residence of the late

QUEEN OF FRANCE's *Chateau St. Cloud;*

This Miscellaneous Assemblage of Elegancies comprises

FRENCH PORCELANE	MIRRORS
MUSICAL AND MECHANICAL CLOCKS	CHANDELIERS
IN OR-MOLU AND BRONZE	LUSTRES
CANDELABRAS IN DITTO	GLASS WARE
GIRANDOLES IN DITTO	FURNITURE
TRIPODS IN DITTO	SILVER FILLIGREE PLATE
CASSOLETS IN DITTO	VALUABLE JEWELLERY
ESSENCE URNS IN DITTO	BOOKS
BISCUIT GROUPS	AND
LARGE FRENCH GLASSES	MISCELLANIES

Which

WILL BE SOLD BY AUCTION,

BY MR. H. PHILLIPS,

At his Great Room, New Bond Street,

On Monday, February 17, 1800, and seven following Days,

Sunday excepted, at Half-past Twelve o'Clock.

May be Viewed by CATALOGUES ONLY, to be had as above, at One Shilling each.

(22)

248 A *magnificent* DEJUNE, *square plateaux, with black and gold border, enriched by arabesque designs,* containing tea pot, sugar bason, ewer, and 2 cups and stands

249 An elegant FRENCH CLOCK, supported between statuary pillars on an enriched pedestal, chastely decorated by or-moulu, and glass shade

250 *An elegant* LADIES' SHEFFENIER and SECRETAIRE, formed of beautiful wood, tastefully mounted with OR-MOULU, China shelf, inclosure, and a variety of drawers

251 *A* MAGNIFICENT *and superlatively* ELEGANT CLOCK and BAROMETER, *truly* UNIQUE, *of indispensable utility, mounted on* BRONZE EAGLES *characteristically modelled, and sumptuous or-moulu cases, enriched by figures, of* APOLLO *and* ASTRONOMY, *supported by plinths, composed of the most beautiful woods, decorated by choice* OR-MOULU *devices, terminated by pedestals, embellished by two remarkable fine* BRONZE BAS RELIEFS. The Clock by ROBIN, the Barometer by MASSY, mechanists to the late KING and QUEEN of France, and made by special order for those distinguished personages, at an expence of upwards of ONE THOUSAND POUNDS STERLING.

SEVE PORCELANE.

252 Two dozen of flat, and 2 dozen of deep plates of the scarce SEVE porcelane, coloured in a choice selection of flowers, and rich blue and gold bandeaux

Fig 6
Title page of catalogue of sale held at H. Phillips' auction rooms on 17th February 1800 mentioning items coming from the Revolutionary sales of French Royal furniture.

Fig 7
Page from catalogue of sale held at H. Phillips' rooms on 31st March 1798 showing lot 251 (see Fig 8)

the hands of a '*M Chapeaurouge*', the agent of the *Commission* at Hamburg. It seems highly probable that it was he who consigned the objects included in the two sales of objects 'imported from Paris via Hamburgh' mentioned above.

The flow of these things on to the London art market increased rather than diminished after Waterloo as the newly impoverished Napoleonic aristocracy were forced in their turn to divest themselves of many of their possessions. Lord Yarmouth approached the problem in an even more direct way. Not long after the declaration of peace he hurried to Paris. On his return journey he found it necessary to hire a large yacht to cross the Channel. Nothing less would provide sufficient space for the furniture and objects of art he had acquired. These he divided, on getting back to London, with the Prince Regent, who thus acquired, amongst other

Fig 8
The clock and barometer described on the page of the sale catalogue illustrated in Fig 7. Both belonged to Marie-Antoinette and were sold with other furniture from Versailles in November 1793 for 7,899 *livres* (Mr S. Whitbread, Southill)

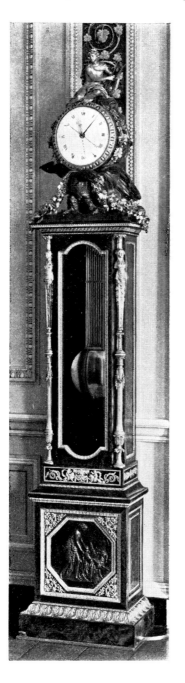
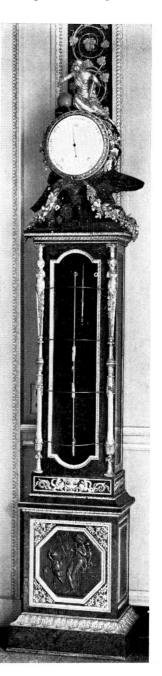

items, a series of fine Boulle cabinets still at Buckingham Palace. But Lord Yarmouth also continued to buy French furniture in London, both on his own behalf and on that of his friend the Regent. In the same year as he visited Paris, he purchased at Phillips's auction rooms on 15th June 'lot 467. A CLOCK of NOBLE design, mounted on a PEDESTAL and PLYNTH, decorated in the *old style*, by or-molu masques and other devices, and four BRONZE FIGURES, finely modelled, from the *Palace of Versailles*.' For this he paid £262.10.0. In spite of the brevity of the description it can be recognised from the drawing of it done by Jutsham in his pictorial inventory. After being given a place of honour on the Grand Staircase at Carlton House, it was removed to Buckingham Palace where it is today. When originally acquired it still possessed the original movement by J. B. Farine but in 1828 this was replaced by a modern one by Vulliamy, who did the same with so many of the fine French clocks in the Royal Collection.

This particular sale is notable as being one of the first in London in which Empire furniture appears. Lot 571, for example, comprised 'The Pair of CONSOLES, *en suite* with the preceding (a commode of yew wood by Daguerre and Lignereux) designed by JACOB, Son-in-law and Successor to Lignereux, formed of selected specimens of *yew tree*, and supported by WINGED CHIMERAS, in bronze and BRONZE D'ORE and correspondingly embellished, surmounted by two MATCHLESS SLABS of ORIENTAL ALABASTER.' They fetched £362.5.0, the highest price of the sale.

Empire furniture soon began to appear here in considerable quantities. Sale catalogues describing their wares as 'A Magnificent Consignment of Parisian Furniture, Bronzes, Sévres Porcelain, Lustres etc.' (Phillips, 30th May ff, 1818) or 'A Splendid Consignment of Parisian Furniture, Bronzes, Sévres Porcelain &c. &c' now differ from the earlier ones quoted, by including a number of such pieces as well as those dating from the eighteenth century. And this continued at least as late as 1830.

By this time not all the French furniture appearing in the salerooms came direct from Paris. The English had now been collecting it avidly for nearly a quarter of a century, and some of the finest pieces offered at auction came immediately from English rather than French sources. William Beckford, one of the greatest and most impassioned of English collectors, had been quite unable to resist the temptation to take advantage of the unusual opportunities for acquiring works of art of all sorts arising from the situation in France in the early years of the Revolution. He actually spent some months in Paris in 1791–92, and was again there in 1793. During this second visit, he found himself trapped by the Terror. His situation was a delicate one. As an enemy alien he was liable to be imprisoned by the French, and as an English MP he was in danger of being regarded as a traitor at home for lingering on in a country with which England was at war, especially as he had been engaged in unofficial political negotiations as well as purchasing works of art. For a time he was compelled to disguise himself as an assistant in the shop of a bookseller, Merigot, an arrangement organised by the more famous bookseller Chardin, with whom Beckford had many dealings in pre-Revolutionary days. Later Beckford was to express his gratitude to Chardin (who also obtained an exit visa for him) by settling a life annuity on the French bookseller.

Unfortunately we have very few details, except by inference, about what Beckford actually bought at this time. He certainly entered into negotiations for the acquisition of the remarkable collections of oriental lacquer assembled by Mme de Pompadour

and later acquired by the duc de Bouillon. When the Fonthill sale took place in 1823, it included a great deal of this as well as large quantities of the finest French furniture. The high spot was the *bureau à cylindre*, probably made by Riesener for Louis XV's queen, Marie Lesczinska, to give her father, King Stanislas Lesczinski of Poland, one of the most renowned of all pieces of French eighteenth-century furniture; it is now in the Wallace Collection. It sold in 1823 for £179.11.0.

One of the difficulties with the Fonthill sale is that the devious owner arranged to buy in and retain a number of the finest things for himself. Amongst these was a pair of Boulle *armoires* coming from the d'Aumont collection and now in the Louvre. These were apparently sold for £509.5.0 but reappeared again in 1882 at the Hamilton Palace sale when they fetched £12,075 (a sign of changing taste), for much of Beckford's collection descended to his daughter, the Duchess of Hamilton. Amongst the French furniture at Fonthill was a black and gold lacquer commode made by Riesener for Marie-Antoinette's *Cabinet Intérieur* at Saint-Cloud, apparently in 1787, at a cost of 12,000 *livres* with its matching secretaire etc. At Fonthill the commode attained a price of £57.15.0, but this may not have been a 'real' price, for it too reappeared at Hamilton Palace. By the time of the 1882 sale it was *en suite* with the companion secretaire (untraceable at Fonthill) and both were purchased by Cornelius Vanderbilt, the pair fetching the enormous price of £18,900. The two are now in the Metropolitan Museum, New York. A third secretaire-cabinet, of much the same character but not apparently *en suite*, appeared at Hamilton Palace also, and quite recently reappeared at a Sotheby auction (sale of 26th November 1971, lot 71; price £72,000). This, too, almost certainly came from the French Crown. All three pieces are amongst the richest ever made by Riesener. The same claim might be made for an upright secretaire, signed by Riesener in the marquetry and likewise dated 1790, and a matching commode similarly dated 1791, both made for Marie-Antoinette, which appeared at Hamilton Palace. The former sold for £4,620 in 1882, and the latter for £4,305. Both are now in the Frick Collection, New York, whilst a small writing table, apparently *en suite* with them and, in addition, bearing the brand of the *Garde Meuble* of the Petit Trianon, was sold at the same sale for £6,300 and is now at Waddesdon Manor. Although not all of the component parts of these groups of furniture can be traced back to Beckford with certainty, items from each group can be shown to have been in his possession. It seems therefore rather more than possible that they are amongst the acquisitions he made at the Revolutionary sales in 1793.

However the problems presented by the Beckford/Hamilton French furniture are too numerous and too complex to be dwelt on further here. There was only one other English private collector of French furniture at this period who is worthy to rank with the three so far discussed, the Prince Regent, Lord Yarmouth, and Beckford. This is George Watson Taylor. This gentleman was born about 1770, the son of a Jamaican merchant, George Watson. He was described by a contemporary as 'a regular independent man worth about £1,500 a year, and happy' up to the age of forty-five. In 1815, however, his wife inherited from her brother an estate which was said to have made them 'the richest commoners in England'. They immediately embarked on a course of the greatest extravagance, commensurate with such a reputation. Within a few years Watson Taylor (who had now added his wife's surname to his own) was in financial difficulties. In 1825 he was forced to sell the contents of his London house in Cavendish Square at Christie's sale (sale of 28th May). In 1832 he failed with liabilities amounting to just short of half a million

pounds. The contents of his country house, Erlestoke, near Devizes in Wiltshire, had to come under the hammer also. The crash was partly due to the drop in value of West Indian property (which also affected Beckford's collecting), but there is no doubt that Watson Taylor's difficulties were precipitated by extreme prodigality. The finest of Watson Taylor's French furniture had been in his house at Cavendish Square. George IV made extensive purchases at the sale in 1825, using as his agent the dealer Fogg, 'the china man', as he was called, whose emporium was at No. 16 Warwick Street, Golden Square. The King's purchases included lot 76, a jewel cabinet made by Riesener for the comtesse de Provence, perhaps the finest single piece of Louis XVI furniture in existence, and now at Windsor Castle. It was exhibited at the Queen's Gallery a year or two ago. For this Fogg paid £420. Lots 58 and 59 were the commode made by Riesener for Louis XVI's bedchamber at Versailles in 1774, and the two corner cupboards made by the same *ébéniste* to match it when it was removed to the king's *Arrière Cabinet* in the same palace five years later. The commode cost George IV 56 guineas, whilst he bought the corner cupboards at £48.6.0 the pair. High as these prices were by the standards prevailing at that day, it is interesting to compare them with the original price Louis XVI had paid for them: over 7,000 *livres* for the commode, nearly 12,000 *livres* for the *encoignures*. All three pieces were included in the single lot purchased for 5,000 *livres* at the Versailles sale by '*citoyen Trusset*' mentioned earlier on in this article.

Another important piece bought on the King's behalf at the Watson Taylor sale was lot 49, a particularly elegant small roll-top desk by Riesener, of which the compiler of the catalogue wrote: 'it formerly belonged to Louis XVI'. Although in the absence of an inventory mark it is impossible to check this statement, it belongs to a group of such *bureaux à cylindre*, a number of which were certainly made for the French Crown. Two, made for Mme Adélaïde, the King's aunt, and the King's brother, the comte de Provence, respectively, are at Waddesdon Manor today. A third, made for the comtesse de Provence in 1773, is in the Calouste Gulbenkian museum at Lisbon. Fogg bought the Buckingham Palace example for George IV for £106.2.0.

George IV made a number of other purchases at this Watson Taylor sale, including four magnificent candelabra of monumental size, forming lots 77, 78, 79, and 80. The gilt bronze branches and stands were embellished with four large groups of patinated bronze by Desjardins, and representing the Seasons. For these, which were inscribed as 'coming from the palace of Versailles', Fogg paid the exceptional sum of 885 guineas. Even so the King did not by any means purchase all the finest French furniture owned by Watson Taylor. Lot 23, for instance, was 'A Library Table, composed of Tulip and Tamarind wood, inlaid in Lozenge fashion in panels bordered with or-moulu. The angles are strengthened with Dolphins and Foliage in massive taste; the top of the Table is strongly brass-bound, and covered with crimson velvet, 5 feet long by 2 feet 7 wide.' This was bought by a certain 'Lockhart' (probably a dealer) for £29.18.6. It is almost certainly the particularly elegant late Louis XV table today in the possession of the Earl of Rosebery, and which it has been suggested, may have been made for the Dauphin, son of Louis XV. It, like the *bureaux à cylindre* just mentioned, falls into a well defined group of tables made for the French Crown, one of which, recently acquired by the Victoria and Albert Museum, bears the brand of the Château of Versailles.

The contents of Erlestoke Mansion, sold by George Robins on 9th July–1st August 1832, were luxurious but included fewer outstanding pieces of fine French furniture

than the Watson Taylors' London house. One item, however, is worth mentioning here. Lot 22 on the twelfth day, was modestly described as 'A very unique Milan steel and or-molu dejeune table, of singular form and beauty, the top exhibiting a beautiful specimen of petrified oak, with inlaid border, tripod pedestal ornamented with shells, ram's heads, and serpentine wreath of flowers, on triangular Satyr feet.' This was, in fact, one of the famous tables of petrified wood which had been in Marie-Antoinette's collection of curiosities at the Petit Trianon, and which raised a storm in the *Commission des Arts* when it was discovered that the commissioners had paid 12,200 *livres* for them to a dealer. The commissioners were destituted and the tables included in the Revolutionary sales. The petrified wood top of the Erlestoke table bore the brand of Charles I in whose natural history collection it had once been. This had been purchased for Mazarin by a 'Mr Kinnerly' at the Commonwealth sale for the modest sum of ten shillings. Later it gravitated into the possession of the Empress Maria Theresa of Austria, whose brand it also bears. After having it mounted in metal in the extreme Louis XVI style, the Empress presented it to her daughter on the occasion of her marriage to the heir to the throne of France. Baldock bought it for £115 at Erlestoke. Subsequently it spent just short of a century in an English private collection before being bought by an American, whose heirs recently presented the Musée de Versailles with this truly historic piece of furniture which bore the brand marks of three sovereign rulers of three different countries.

The Watson Taylor sales mark a watershed in the history of French eighteenth-century furniture in the salerooms in England. Although sales of 'furniture imported from Paris' continued in the London salerooms down to 1830 and later, the contents were generally inferior to those mentioned earlier on. It was only exceptionally that a high price was obtained, for example when a secretaire inset with Sèvres porcelain plaques at Lord Gwydir's sale (20th May 1829, lot 106) fetched a price of £215.5.0, or when a well-known Sèvres-mounted cartonnier surmounted by a clock, by Julien Le Roy, which is now in the Wallace Collection, was purchased by Fogg for £154.7.0 in the same sale. The Watson Taylor sales seem therefore a suitable moment to bring this brief outline of the early history of French eighteenth-century furniture in the salerooms to an end. The more regular appearance of Empire furniture at auction, and the high prices it often commanded, are a pointer to a new orientation of fashion. The year 1830 seems to have inaugurated a new cycle of taste for such things, a phase which reached its culminating point with the Hamilton Palace sale of 1882, when a further cycle began, leading to the great sales before the 1914–18 war, and after the 1939–45 war.

Some tentative conclusions emerge from a study of the auctions with which this article has been concerned. Firstly, it is interesting to observe that all the techniques of the modern auction sale catalogue: detailed descriptions, illustrations (even of details), stress on the names of the famous makers, were used by the Parisian auctioneers of the eighteenth century, something that vanished entirely during most of the nineteenth century, both here and in France. Then in the eighteenth century (at any rate in the latter years before the Revolution) there was a tendency for old pieces of fine quality to show a considerable increase in value over the original cost, as they do today. The vast quantities arriving on the market in the last decade of the century depressed prices, not only in France but in England, where the best collector's market then was, and it was not until well beyond the period covered by this article that really high prices resumed. Further it may be remarked that the arrival of such large quantities of fine French furniture on the English market in the first

two decades of the nineteenth century unquestionably had a striking influence on English taste in interior decoration. The introduction to *'Modern Furniture from Designs by A. Pugin, J. Stafford of Bath & others'* which appeared in 1823, and enjoyed considerable success (it was later re-issued in *Ackerman's Repository* as 'Fashionable Furniture') declared 'the taste for French furniture is carried to such an extent that most elegantly furnished mansions . . . are fitted up in the French style'. The writer is clearly alluding to the bastard 'Louis XIV style' as it was called (it was in fact a curious mixture of *Régence* and Louis XV motifs) used for the decoration of, for example, the Grand Reception Room at Windsor Castle, and certain rooms at Lancaster House, Belvoir Castle, etc. That such a florid style should have been adopted is curious, for the greater part of the furniture arriving here from France was in the Louis XVI style, this being naturally what the French were mostly using in their houses in the immediately pre-Revolutionary period. A great deal of Boulle furniture also appears in the London sales mentioned, and bears witness to the French taste for this monumental furniture during the Louis XVI period, which has already been remarked. Although much of that sold may, in fact, have been of Louis XVI rather than Louis XIV date (it is, of course, impossible to tell from the catalogue descriptions), it no doubt influenced the style of interior decoration described in 'Fashionable Furniture', and laid the foundations for the love of Boulle furniture so characteristic of mid-nineteenth-century Victorian taste in England and in France under the Second Empire.

Another interesting point to emerge is that almost all the furniture mentioned here is *ébénisterie*. French chairs seldom seem to have impressed the English like French cabinet work. The prices that sets of chairs fetched were rarely high, though at the Duke of Leeds' sale of 11–14th June 1800, £430.10.0 was paid for a suite of twenty-three pieces, together with curtains, pelmets, etc.; a few other examples could be quoted, but they are rare. Even today England is much less rich in fine French chairs than in fine French cabinet work. Partly, no doubt, the sparsity of chairs in these sales may reflect the fact that they were more fragile and therefore more difficult to transport from overseas. But the impression remains that the English preferred their own chairs to French ones, but found French commodes more attractive than English chests of drawers.

The unprecedented situation described here, arising from the sale of the possessions of the French Crown and of noble *emigrés* in the years following the Revolution, ensured that by 1830 England was far richer in fine French eighteenth-century *ébénisterie* (especially that of the Louis XVI period) than any other country in the world, including France itself. Although much of this has gone abroad to the United States and elsewhere in recent years, the Wallace Collection, the Rothschild Collection at Waddesdon Manor, the Jones Collection at the Victoria and Albert Museum, and the collections of the English Crown remain unrivalled anywhere, and there is still a great deal of fine French furniture in private houses in this country.

Furniture, decorations, carpets and tapestries

Left
A Chippendale carved mahogany pole screen made for Governor Joseph Wanton, attributed to the Goddard-Townsend family of Newport, Rhode Island, *circa* 1770–80, height 4ft 7in
New York $26,000 (£10,400).
21.X.73
From the Lansdell K. Christie Collection

Right
A Chippendale mahogany corner chair made for John Brown, attributed to John Goddard
Newport, Rhode Island, *circa* 1760
New York $85,000 (£34,000).
21.X.72
From the Lansdell K. Christie Collection

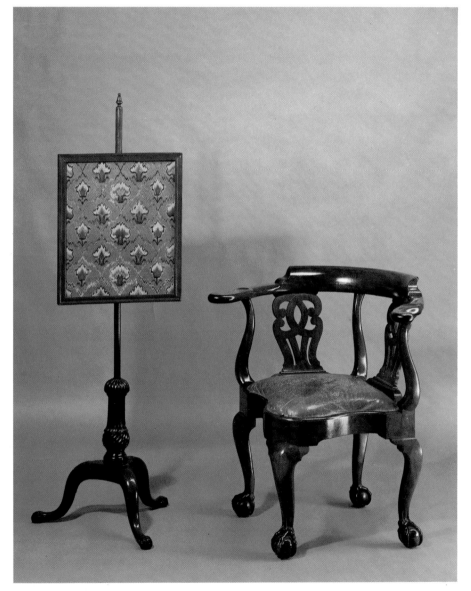

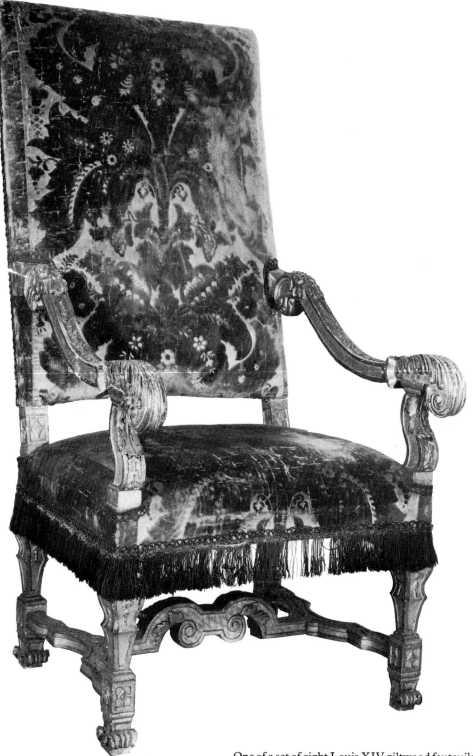

One of a set of eight Louis XIV giltwood fauteuils with stuffed
rectangular backs, formerly at Kimbolton Castle,
Huntingdonshire
London £10,500 ($26,250). 15.VI.73
From the collection of His Grace the
Duke of Manchester OBE

The three world record prices achieved in the field of furniture this season demonstrate the twin virtues of provenance and correct identification. On June 15th in London £190,000 was paid for a table and a pair of matching torchères. This, the highest price ever recorded for any lot in a furniture sale, must have been substantially affected by the discovery, while the catalogue was already in production, of two maker's marks and two town marks of Augsburg for the years 1714–1716 on silver scrollwork on the base of the table. The maker proved to be the little known *silber kistler* Jeremias Jakob Aberell (1680–1716). On the day of the discovery the possibility still remained that the pieces were from Dresden, an argument supported by the fascinating chinoiserie inlay of the table top (see the end papers of this book) but refuted by the style of the silver and silver-gilt mounts with which all three pieces are richly adorned. The identification of Aberell led at once to an equally exciting discovery that he was connected by marriage to the family of Heinrich Eichler (1637-1719), the leading exponent of furniture in the boulle technique then working in Augsburg. The identification of the silver maker and the Augsburg town mark played a substantial part in justifying such a remarkable price at the auction. It is interesting to learn that when they were last sold in London in the 1950s they were described as French.

The two remaining record prices both came for American furniture on 21st October in New York at the sale of the Lansdell K. Christie Collection. They demonstrate, as did many other results in this sale, the peculiar importance of provenance in the collecting of American furniture. The John Brown Chippendale mahogany corner chair which brought $85,000 had written on the slip seat *Brown* which referred without doubt to John Brown (1736–1803) of Providence, Rhode Island. It formed one of a pair thought to have been made by John Goddard of Newport, Rhode Island, *circa* 1760, and while it closely follows a pattern found in English chair making of the 1740s, it shows Goddard's highly developed sense of the flowing line in chair design. From Newport, Rhode Island, came the block-and-shell kneehole desk attributed to Edmund Townsend, but described as a Goddard-Townsend piece ($120,000). With the closely allied shell-carved block front chest, Lot 80 in the same sale and only $10,000 cheaper, it can rightly be claimed as one of the most distinguished American pieces; features derived from English furniture of the second quarter of the eighteenth century are adapted and improved by the remarkable personality and craftsmanship of the finest Newport makers.

Surveying the whole furniture market of the past season it is impossible to ignore the continual upward trend in prices of all periods and all qualities. In Florence, Los Angeles, New York and London new records were set in almost every class of furniture, and the further specialisation in the catalogues of Sotheby's Belgravia, for its second year, produced several quite unexpected results. The £3,000 paid for an Indian ivory chair of the mid-nineteenth century was, with the obvious exception of John Brown's chair mentioned above, one of the highest prices for any chair in the salerooms this year.

One of a pair of William and Mary armchairs in black-painted walnut, covered in Genoese cut velvet, from a set of state furniture at Kimbolton Castle, Huntingdonshire, probably acquired by the 4th Earl of Manchester, later the 1st Duke. *Circa* 1685
London £1,500 ($3,750). 18.V.73
From the collection of His Grace the Duke of Manchester OBE

Right

A William and Mary burr-walnut bureau cabinet in three parts, mounted throughout in engraved gilt metal, the corner mounts to the doors, handles, escutcheons and internal bolts also engraved. Height 7ft 5in, width 3ft 7in, depth 2ft
London £10,000 ($25,000). 8.XII.72
From the collection of Mrs K. E. Metcalfe

Below left

A North-Italian walnut bureau cabinet, the upper part with an exaggerated swan-neck cresting above a pair of cupboard doors enclosing shelves, the surface of both parts veneered in various walnuts with elaborate scroll patterns. Probably Venetian, height 8ft 5in, width 4ft 5in
London £6,000 ($15,000). 26.I.73

Below centre

An early eighteenth-century Roman bureau secretaire of root walnut in three parts, the upper part with a pair of arched mirror-glass doors and carved cresting, the centre section with sloping front enclosing three drawers, the lower part with four shaped drawers. Height 8ft 8in, width 4ft 1½in
Florence Lire 15,000,000 (£10,000; $25,000). 23.V.73
From the collection of Comte Francesco Castelbarco Albani

Below right

A Queen Anne double-domed burr-walnut bureau cabinet, the upper part with two moulded ogee domes above the cupboard doors. Height 7ft 10in, width 3ft 4in
London £9,500 ($23,750). 20.X.72

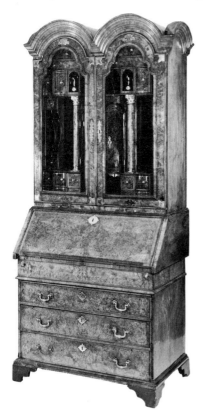

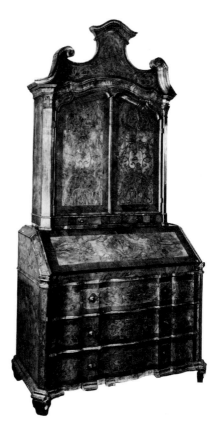

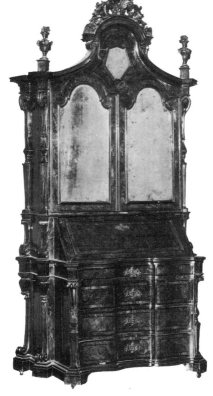

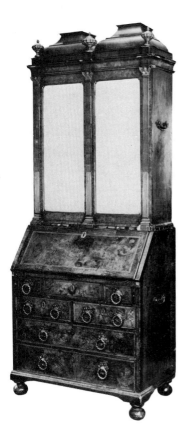

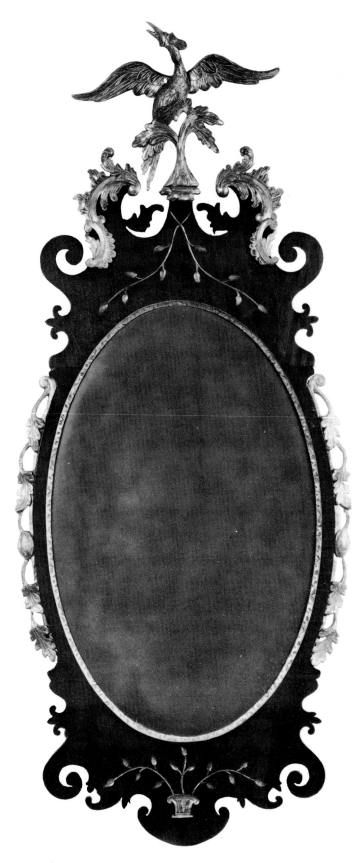

A Chippendale mahogany and parcel-gilt wall mirror, probably made in New York, *circa* 1770. Height 4ft 4in, width 1ft 10¼in
New York $11,000 (£4,400). 21.X.72
From the Lansdell K. Christie Collection

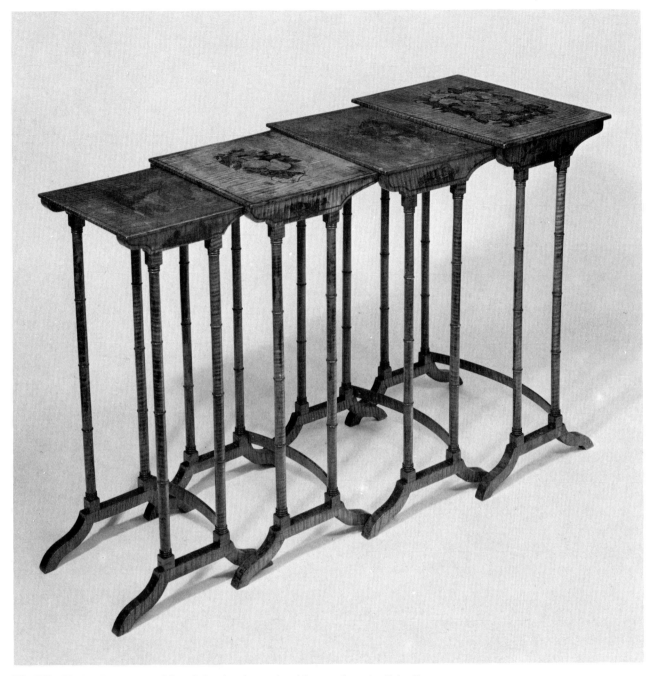

The Elias Hasket Derby nest of four federal curly maple tables, attributed to John Seymour,
painted by John Penniman, Boston, Massachusetts, *circa* 1800. Heights 28in to 29in
New York $16,000 (£6,400). 21.X.72
From the Lansdell K. Christie Collection

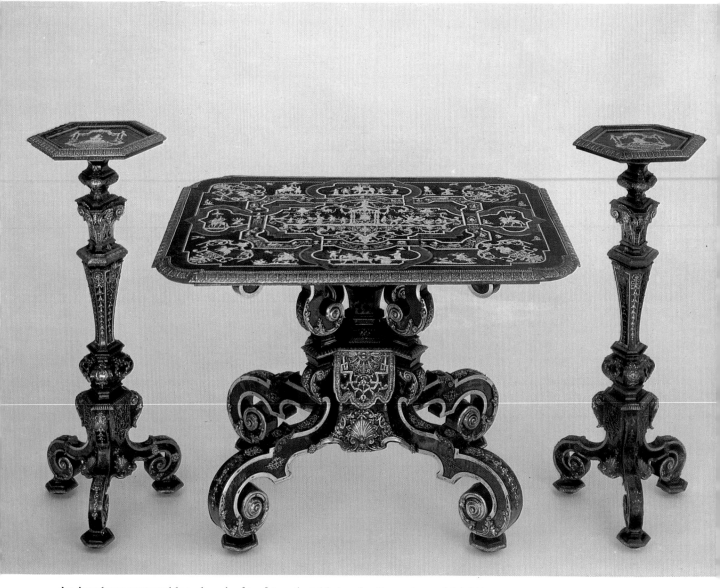

An Augsburg centre table and a pair of *torchères*, the table (*see detail on endpapers*) inlaid in engraved silver with a variety of imaginative chinoiseries on a dark brown tortoiseshell ground, the scenes divided by interlaced strapwork in red and brown tortoiseshell within borders of green and natural ivory and including a large number of engraved silver figures, birds and beasts from the four Continents, among them a rhinoceros after Dürer; the *torchères* with hexagonal tops matching the table and the elegant stems triangular in form, waisted and with balusters of conforming shape standing on S-scroll feet.

Two mounts on table with the Augsburg silver mark 1714/1715 and the maker's stamp *I.I.A.*, *circa* 1715; table: height 2ft 7in, width 3ft 5in, depth 2ft 6½in; *torchères*: height 3ft 4in, width 1ft 1¾in

London £190,000 ($475,000). 15.VI.73

Formerly in the collection of the Earls of Malmesbury

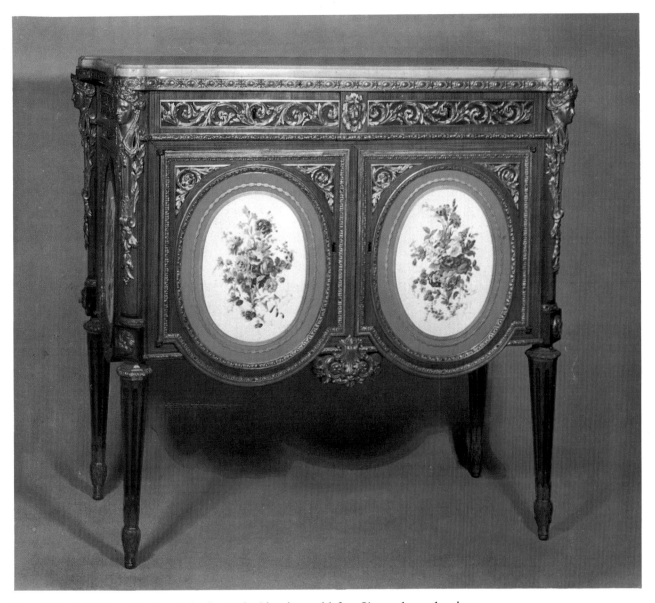

A small Louis XVI ormolu-mounted tulipwood cabinet inset with four Sèvres plaques bearing
the date letters for 1774 and 1775 and painted by Levé and Méreaud, with a white marble top
and a chiselled border of cabochons and florettes. Stamped *M. Carlin JME*, height 2ft 9in,
width 2ft 11½in, depth 1ft 5¾in
London £130,000 ($325,000). 24.XI.72
From the collection of Baron Guy de Rothschild

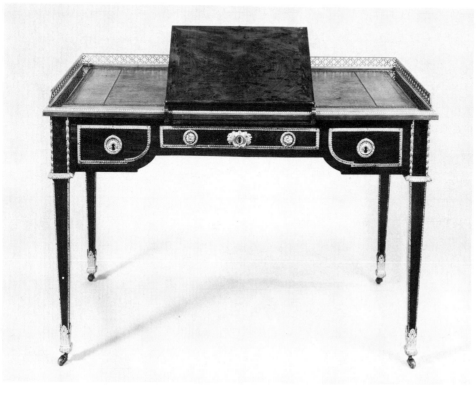

A Louis XV tulipwood and kingwood *secrétaire en pente,* the back and sides of slightly *bombé* form, the whole veneered *à quatre faces* with asymmetrical scrollwork, flowerheads and anthemions, partly in olivewood. Stamped *E. H. B.,* height 2ft 11in, width 3ft 3in, depth 1ft 11in London £10,000 ($25,000). 24.XI.72

A Louis XVI ormolu-mounted mahogany *petit bureau plât* by J. H. Riesener, the underside bearing the *marque au feu* of Windsor Castle. Signed, last quarter of the eighteenth century, height 2ft 7¼in, width 3ft 9in New York $140,000 (56,000). 9.XII.72
From the collection of Mr and Mrs Deane Johnson of Bel Air, California

Right
One of a pair of Chippendale mahogany side chairs made for
George Washington, each bearing a brass plate inscribed
'Owned by George Washington when President of the United
States'. Philadelphia, 1780–85
New York $29,000 (£11,600). 21.x.72
From the Lansdell K. Christie Collection

Below left
A Chippendale carved mahogany armchair, the outward-
flaring canted back with fluted stiles and a cupid's-bow crest
rail carved with tassels. Philadelphia, 1760–70
New York $15,000 (£6,000). 27.I.73
Formerly in the collection of Andrew Varick Stout of New
York City

Below right
A Queen Anne walnut wing armchair on cabriole legs
ornamented with C-scrolls. Newport, Rhode Island, 1740–60
New York $21,000 (£8,400). 21.x.72
From the Lansdell K. Christie Collection

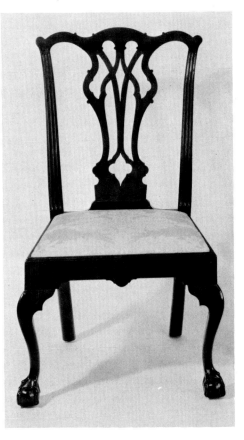

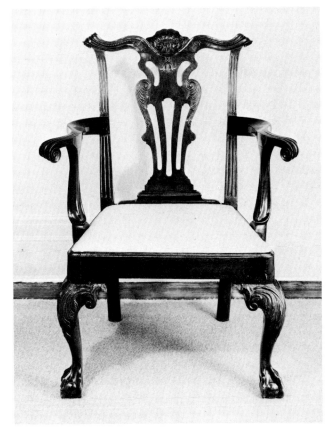

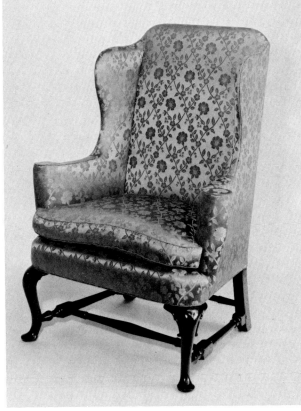

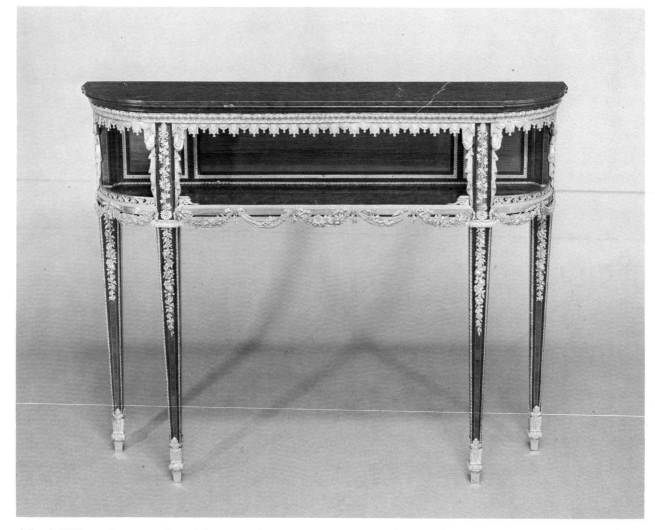

A Louis XVI ormolu-mounted purpleheart and kingwood console by J. H. Riesener, from the Chateau of Versailles. Signed, last quarter of the eighteenth century, height 2ft 10in, width 3ft 7⅝in
New York $400,000 (£160,000). 9.XII.72
This piece was delivered during the most flourishing period of Riesener's career, when he was *ébéniste ordinaire du Roi*. It was made for Marie Antoinette's *Cabinet-Intérieur* at Versailles, which she had completely transformed in 1783.

Opposite page below
Left A Louis XVI Sèvres porcelain-mounted, tulipwood and walnut marquetry *serviteur fidèle*. Signed *M. CARLIN, JME*, the Sèvres plaque bearing the date mark X for the year 1775 and the painter's mark for Méreaud Jeune (1756–1779). Height 3ft 2¾in, width 15½in $65,000 (£26,000).

Centre A Louis XV-XVI circular green-stained sycamore and hollywood *table à écrire* by Roger Vandercruse, *dit* Lacroix, stamped *R.V.L.C., JME,* third quarter of the eighteenth century. Height 2ft 5½in, diameter 15in $40,000 (£16,000)

Right A Louis XVI Sèvres porcelain-mounted, green-stained sycamore and hollywood marquetry serviteur fidèle. Signed *M. CARLIN,* The Sèvres plaque bearing the mark x for the year 1775 and the painter's mark for Méreaud jeune (1756–1779). Height 3ft 0½in, width 1ft 1½in $38,000 (£15,200)
The objects illustrated above and the opposite page below, were sold in New York on 9th December 1972 and came from the collection of Mr andMrs Deane Johnson of Bel Air, California

A pair of early eighteenth-century Arita cockerels mounted as table candelabra in Louis XV ormolu, each with three asymmetrical scrolling branches with leaves supporting brightly painted Mennecy flowers, height 1ft 2½in, width 11¾in London £20,000 ($50,000). 15.VI.73

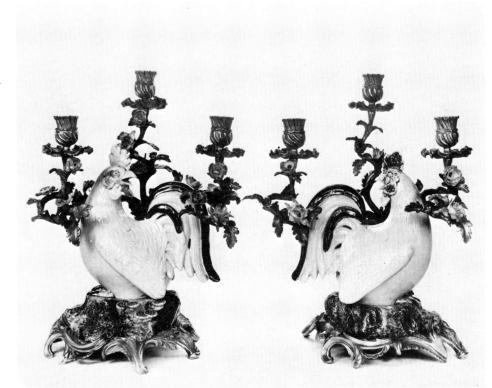

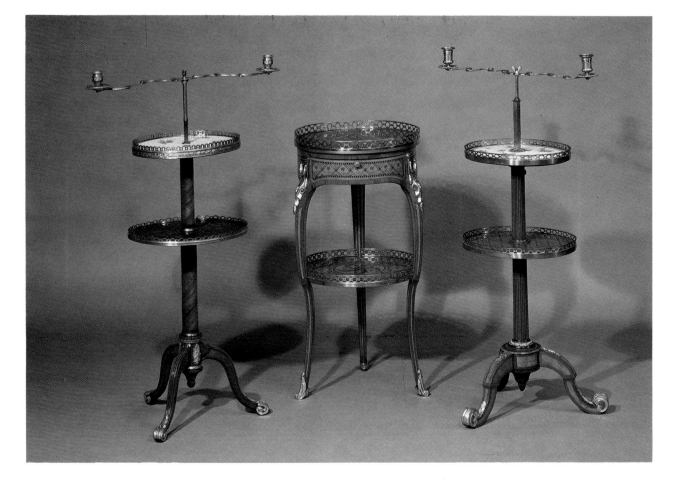

A Chippendale carved mahogany five-legged games table, one leg swinging out as a gate support and revealing an original secret drawer. New York, 1760–80, height 2ft 3½in, length 2ft 10in
Los Angeles $37,000 (£14,800). 25.VI.73
Formerly in the collection of the late Miss Mary Buel Varick of Santa Barbara, California

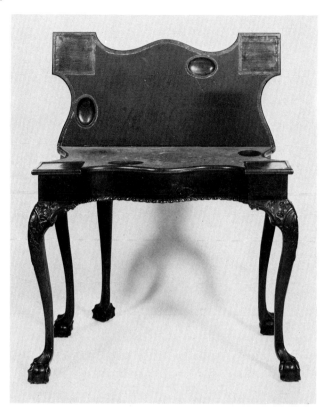

A Federal inlaid mahogany tambour writing desk, attributed to John and Thomas Seymour of Boston. Massachusetts, *circa* 1790, height 3ft 5¾in, width 3ft 1½in
New York $41,000 (£16,400). 27.I.73

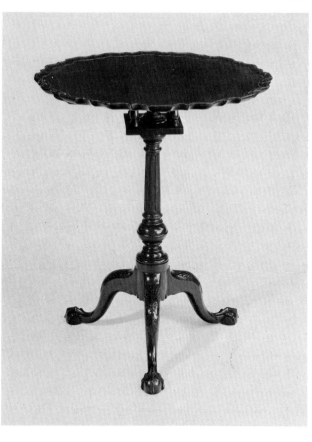

Above
The Hancock family Queen Anne walnut drop-leaf tea table.
Massachusetts, *circa* 1740, height 2ft 3¼in, length 2ft 5in
New York $17,000 (£6,800). 21.X.72
From the Lansdell K. Christie Collection

Above right
A Chippendale carved mahogany piecrust tilt-top table.
Philadelphia, *circa* 1760, height 2ft 3¾in, diameter 2ft ½in
New York $24,000 (£9,600). 21.X.72
From the Lansdell K. Christie Collection

Right
A Chippendale curly maple cellarette, the bottle case on a
stand ending in Marlborough feet. Philadelphia, 1760–80,
height 2ft 9in, width 1ft 7¼in
New York $10,500 (£6,200). 14.IV.73
Formerly in the collection of the late Mrs J. Amory Haskell

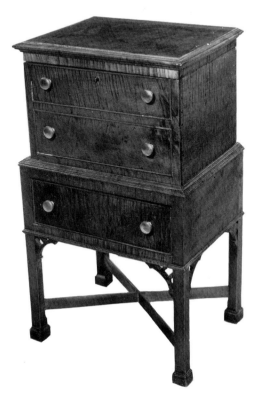

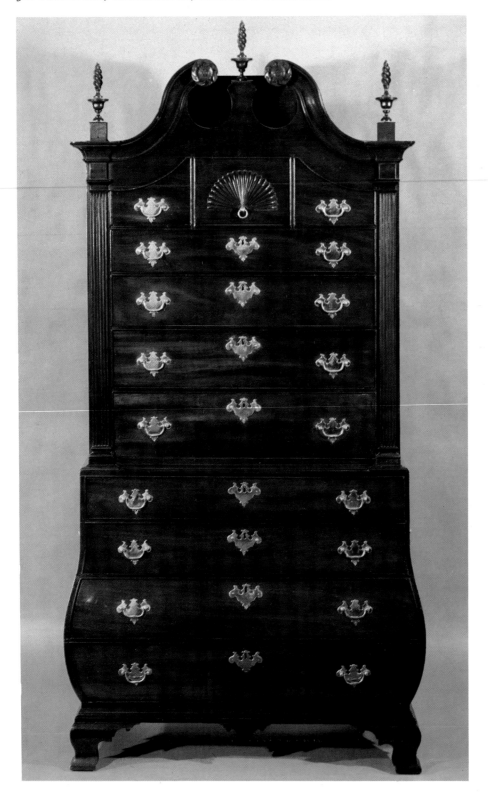

Left
A Chippendale mahogany
bombé chest-on-chest.
Boston, Massachusetts,
1760–80, height 7ft 9in,
width 3ft 10in
New York $47,500 (£19,000).
21.X.72
From the Lansdell K.
Christie Collection

Opposite page above
A Goddard-Townsend
Cuban mahogany block-and-
shell-carved kneehole desk,
possibly by Edmund
Townsend of Newport,
Rhode Island, 1760–80,
height 2ft 9in, length 3ft 0½in
New York $120,000
(£48,000). 21.X.72
From the Lansdell K.
Christie Collection

Opposite page below
A Chippendale mahogany
shell-carved block-front
chest of drawers, attributed
to the Goddard-Townsend
family of Newport, Rhode
Island, *circa* 1750, height
2ft 9½in, length 3ft 2in
New York $110,000
(£44,000). 21.X.72
From the Landsell K.
Christie Collection.

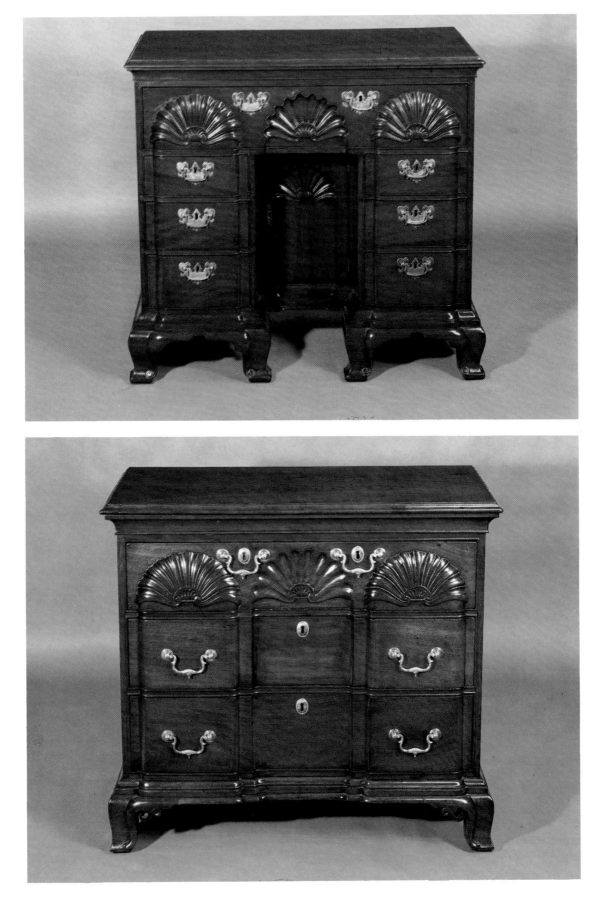

1

2

3

4

5

6

7

8

9

10

11

12

13

14

1. Late eighteenth-century *verre églomisé* picture of Westerkerk, Amsterdam, by Zeuner, signed, 1782, 1ft 10in by 2ft 5in. £7,500 ($18,750). 15.VI.73. 2. Late seventeenth-century table runner, possibly Hungarian. 15ft 11in by 2ft 1in. £1,250 ($3,125). 26.I.73. 3. One of pair of late eighteenth-century Chinese mirror paintings, each 21in by 28in, the contemporary Swedish frames 28in by 35in. £6,500 ($16,250). 20.X.72. 4. Regency footstool, 1ft 5in by 1ft 1in. £500 ($1,250). 9.II.73. 5. Sixteenth-century small painted oak coffer, probably Swiss. Width 1ft 1in. £420 ($1,050). 13.IV.73. 6. Florentine brass and iron X-frame stool, mid-sixteenth century 2ft 9in by 2ft 2in. $4,100 (£1,640). 24.III.73. 7. One of pair of carved Régence walnut doors, probably from an armoire, 5ft 10in by 1ft 10in. £360 ($900). 26.I.73. 8. Oak panel depicting Hope with dove and anchor, probably English, first quarter seventeenth century. 11¾in by 9½in. £50 ($125). 13.IV.73. 9. One of four Louis XIV carved oak panels depicting the four continents, 5ft 6in by 5ft 11½in. $7,000 (£2,800). 13.III.73. 10. James II beechwood child's high chair. £300 ($750). 27.X.72. 11. One of pair of Regency cut-glass and gilt-metal chandeliers of 24 lights each, 6ft 5in by 4ft. £6,500 ($16,250). 30.III.73. 12. George III painted wooden doll. Third quarter eighteenth century, height 19in. £1,000 ($2,500). 15.XII.72. 13. One of pair of late George II lead jardinières, dated 1757, diameter 1ft 8in. £1,300 ($3,250). 18.V.73. 14. One of pair of George III clear and blue glass and ormolu candelabra. Height 2ft 7in. £1,500 ($3,750). 8.XII.72

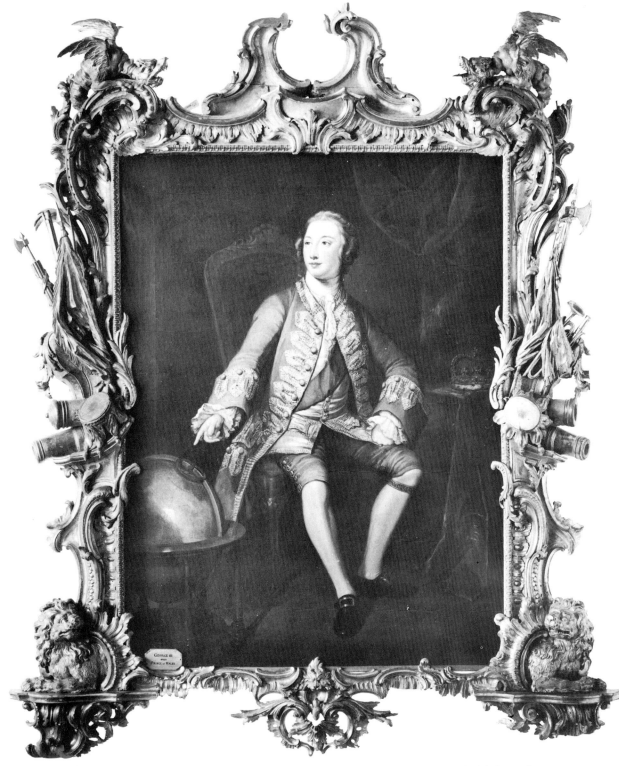

A George II giltwood picture frame attributed to Thomas Chippendale, carved with C-scrolls, flame motifs and acanthus leaves, surmounted by winged dragons, the sides carved with martial trophies, the base with a pair of lions and scrolled feet, the apron centred by a grotesque mask and an acanthus cartouche, containing a contemporary portrait of George III when Prince of Wales after G. Knapton. Height 7ft 1in, width 6ft 1in
London £3,600 ($9,000). 20.X.72

One of a pair of Japanese lacquer plaques in Louis XV oval ormolu frames, the *lac burgauté*
panels on copper and decorated on a black ground with *nashiji* gold vases standing on trellised
rectangular tables. Height 1ft 3¾in, width 11½in
London £11,000 ($27,500). 24.XI.72
From the collection of Baron Guy de Rothschild, formerly in the collection of Madame
Alexandrine de Rothschild; previously sold in these rooms on 18th May, 1967 for £6,800 ($17,240)

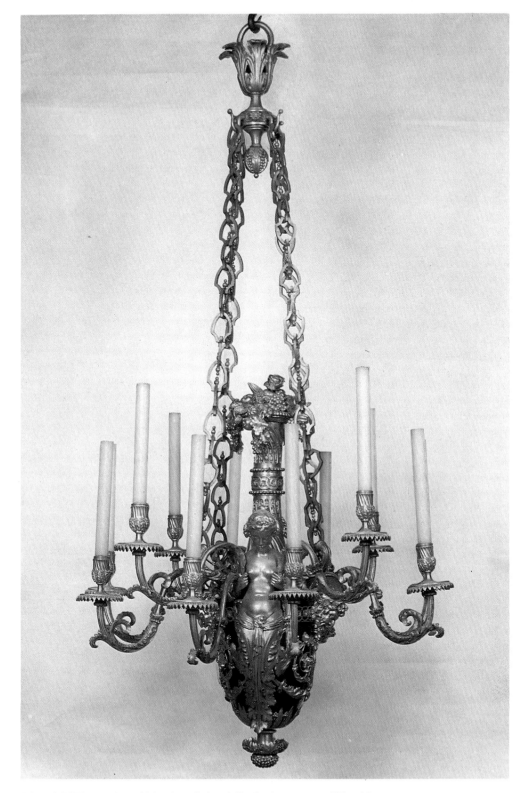

A Louis XVI ormolu and blued steel chandelier in the manner of Feuchères
Diameter 2ft 4½in
London £38,000 ($95,000). 24.XI.72
From the collection of Baron Guy de Rothschild, formerly in the Chefdebien Collection, Paris

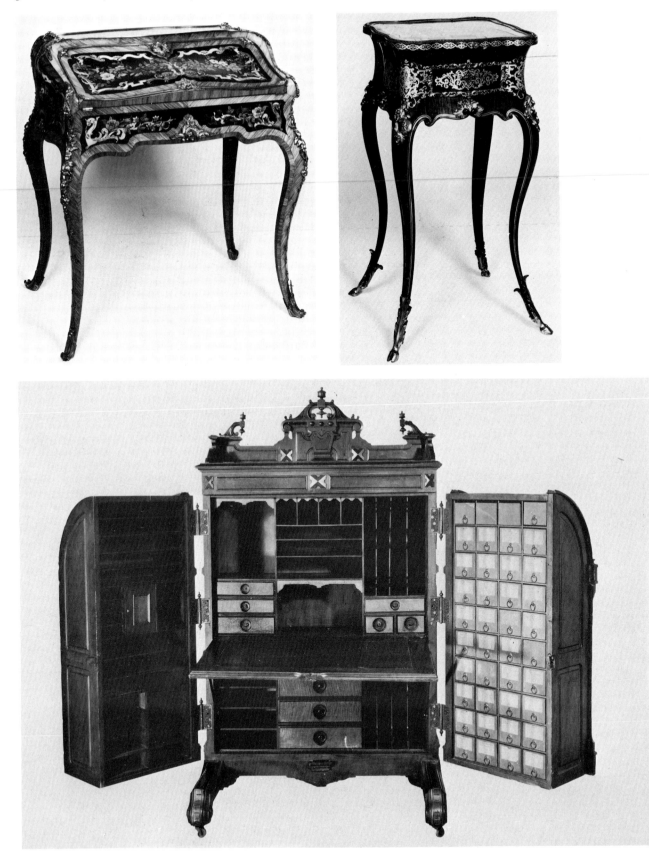

Opposite page far left
A kingwood marquetry *bureau de dame,* raised high on cabriole legs and with gilt-bronze mouldings and floral mounts, mid-nineteenth century, English,
height 2ft 11in, width 2ft 9in
London £1,550 ($3,875).
6.VI.73

Left
An amber- and silver-mounted mahogany occasional table, the serpentine top inset with crazy-patterned amber pieces within a lapis enamel border, late nineteenth century, probably English,
height 2ft 7in, width 1ft 5in
London £2,300 ($5,750).
6.VI.73
According to family records, this table was previously in the possession of Queen Alexandra

Opposite page below
A mahogany Wooton's Patent Secretary. Indianapolis, Indiana, *circa* 1876, height 6ft 3in, width 3ft 7½in closed and 7ft 6in open.
New York $4,900 (£1,960).
19.V.73

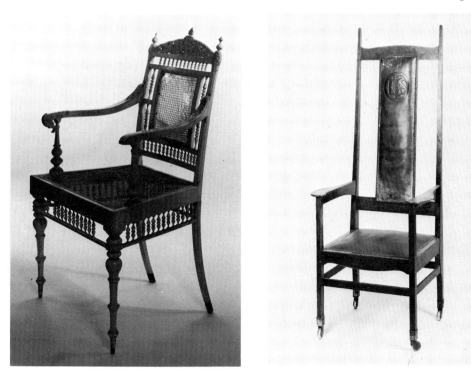

Above left
An ivory chair with pierced leaf-scrolled top-rail and caned back with baluster panels.
Indian, late nineteenth century
London £3,000 ($7,500). 6.VI.73

Above right
One of a pair of oak armchairs designed by C. F. A. Voysey. Stamped with the monogram *ESIC*.
English, 1900–10
London £420 ($1,050). 6.VI.73

Below
A parcel-gilt settee, design attributed to A. W. N. Pugin, labelled *Windsor Castle Catalogue 1904.*
English, 1820–30, length 6ft 6in
London £2,500 ($6,250). 1.XI.72

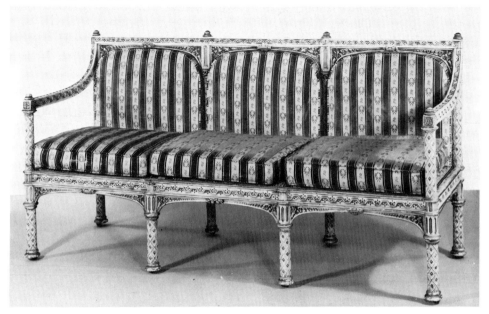

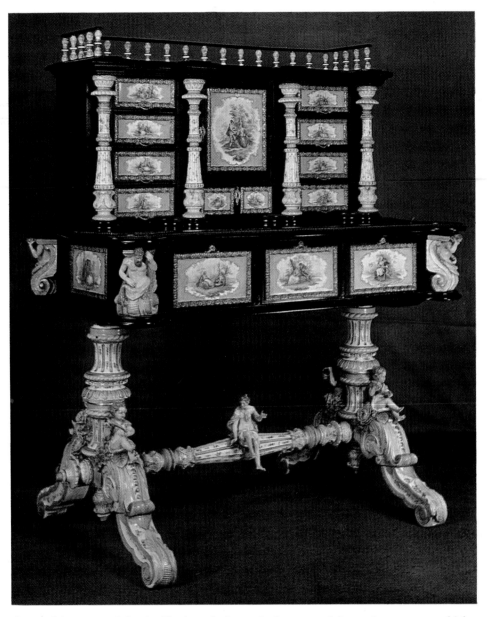

A porcelain-mounted ebonised *bonheur-du-jour*, raised on a porcelain trestle support on which sit cherubs and nymphs. German, *circa* 1860, height 4ft 4in, width 3ft 8in
London £6,800 ($17,000). 14.III.73

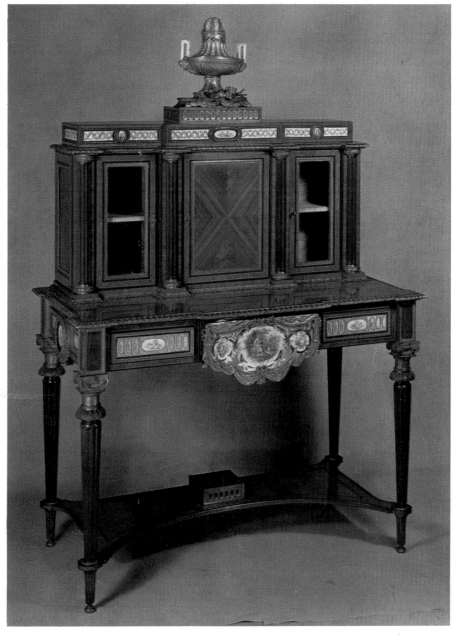

A porcelain-mounted kingwood and purpleheart *bonheur-du-jour*. French, third quarter of the nineteenth century, width 3ft 11½in, height 5ft 10in
London £3,200 ($8,000). 6.VI.73

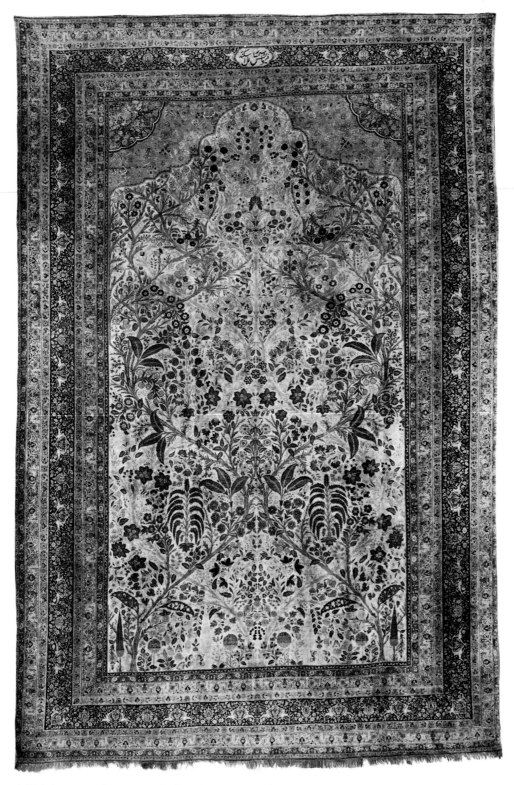

A Tabriz carpet of prayer rug design, the white field filled with flowering trees, entwined branches forming an ogee trellis, enclosed by a lotus and flower border with an inscription medallion and eight subsidiary floral borders, 14ft 2in by 9ft 11in
London £4,400 ($11,000). 9.11.73

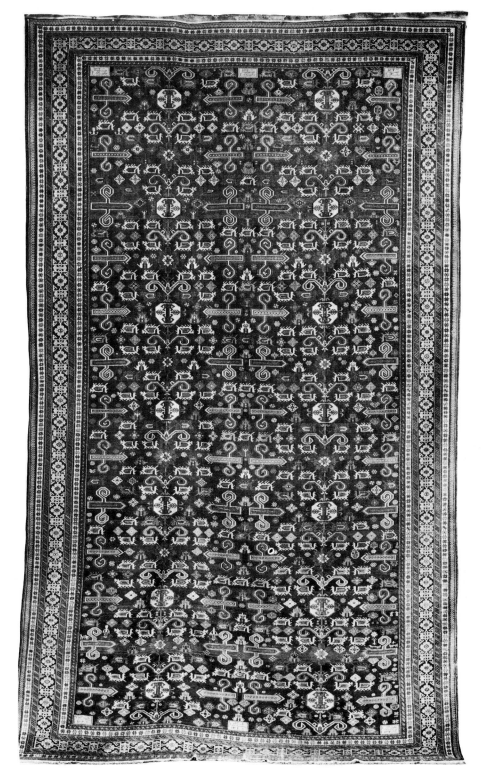

A Shirvan carpet with three inscription medallions at each end of the field, dated 1907, enclosed by a blue and white Kufic letter border and six geometrical guard stripes, 15ft 6in by 9ft 6in
London £3,500 ($8,750). 18.v.73

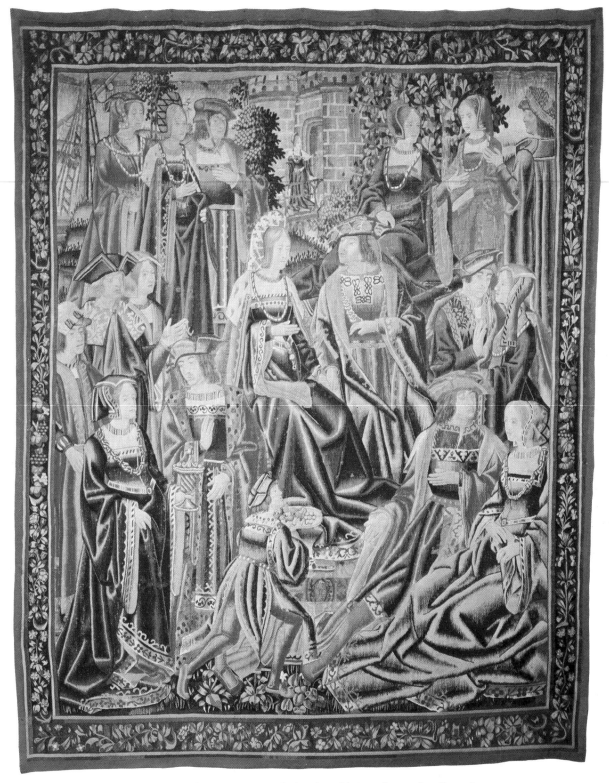

A Brussels tapestry depicting a scene from a Romance, the border with a continuous banding of
flowering branches and fruiting vines. *Circa* 1515, height 11ft, width 8ft 10in
New York $20,000 (£8,000). 11.XI.72

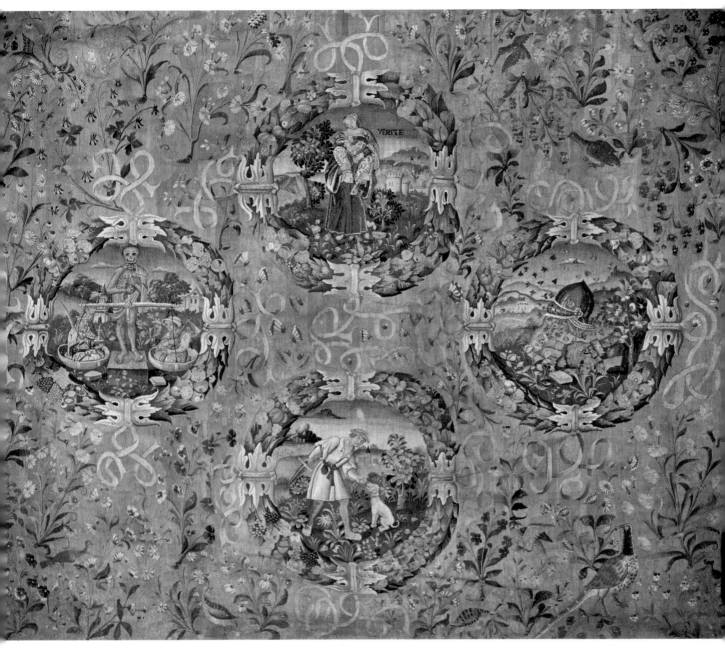

A Flemish allegorical tapestry with a *mille-fleurs* ground. *Circa* 1525, height 9ft 10in, width
11ft 9in
New York $25,000 (£10,000). 11.XI.72
The cartoons for this tapestry have been attributed to Antoine Fierret.
From the collection of the late Muriel Rockefeller McCormick Hubbard

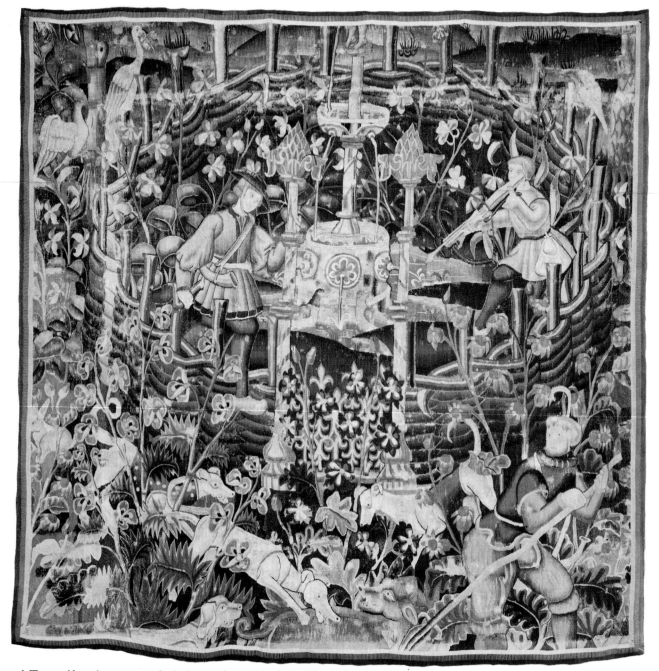

A Tournai hunting tapestry depicting two huntsmen, one with a crossbow, and numerous dogs attacking a wounded beast being speared by another huntsman. *Circa* 1525, height 8ft 2in, width 8ft 6in. New York $20,000 (£8,000). 11.XI.72
From the collection of the late Muriel Rockefeller McCormick Hubbard

Opposite page
Above
An early eighteenth-century Lille Teniers tapestry by G. Werniers, depicting a scene of rustic revelry. Weaver's mark and a *fleur-de-lis* on a red shell and the factory mark, height
11ft 6in, width 15ft 8in. London £7,000 ($17,500). 15.VI.73
Formerly in the collection of the Duke of Aremburg

Below
A Burgundian Gothic marriage tapestry, probably derived from a medieval Romance. First quarter of the sixteenth century, height 7ft 6in, width 11ft 7in
London £8,500 ($21,250). 24.XI.72

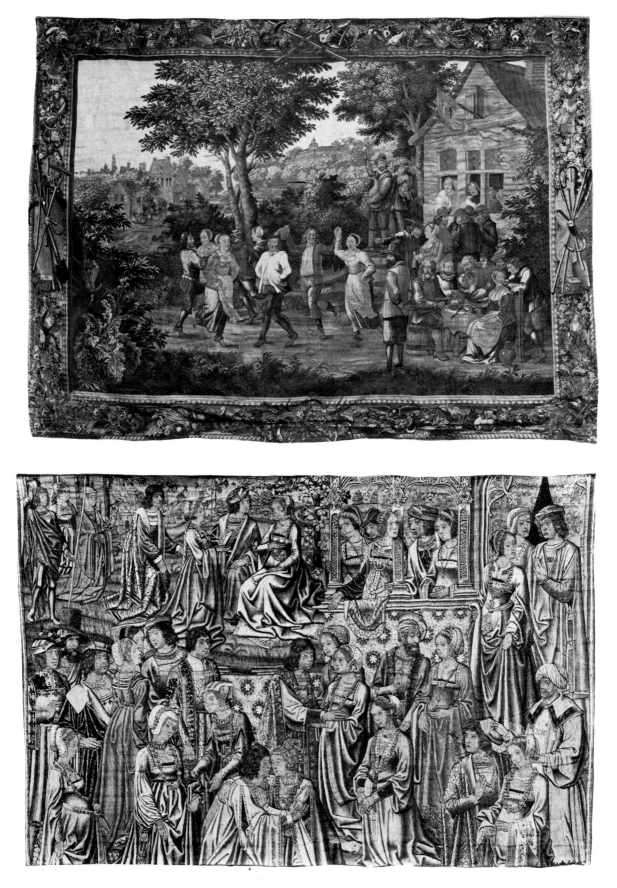

An English tapestry entitled 'Love and the Pilgrim', designed by Sir Edward Burne-Jones.
Merton Abbey monogram, dated 1910, height 5ft 3in, width 8ft 8in
London £4,500 ($11,250). 14.III.73
This tapestry, formerly in the collection of Stanley Baldwin, MP, was one of the two examples
woven from this design

Art Nouveau
and Art Deco

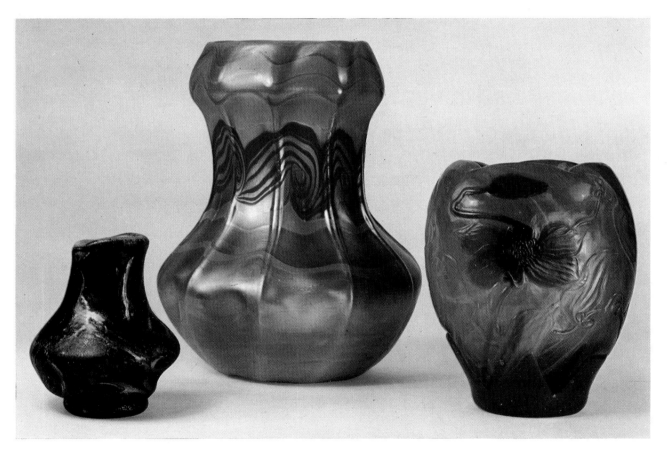

Left A free form Tiffany lava vase, the base engraved *R* 1837, *LCT*. Height 3¾in
London £1,000 ($2,500). 22.VI.73

Centre A Tiffany gold and red lustre vase, the base engraved 07805 and with original paper
label, *circa* 1900. Height 7⅞in London £920 ($2,300). 22.VI.73

Right A wheel-carved inlaid free form glass vase by Emile Gallé, the body finely engraved in
'style nouille'; with the script *Emile Gallé*; his initials and the Croix de Lorraine within a shield,
circa 1900. Height 5¼in London £2,300 ($5,750). 22.VI.73

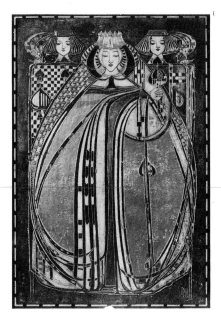

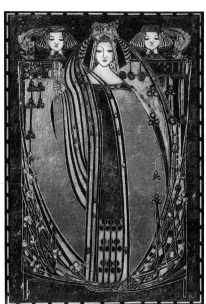

Above

MARGARET MACDONALD

The Four Queens A set of four painted and gilt gesso panels depicting the queens of hearts, diamonds, spades and clubs, within stylised decoration in typical Glasgow style, each mono-grammed *MMM* and dated 1909, 22½in by 15¾in
London £8,000 ($20,000). 16.XI.72
These panels were executed for the cardroom at Hous'hill. They were exhibited at the Charles Rennie Mackintosh – Margaret Macdonald Mackintosh Memorial Exhibition at the McLellan Galleries, Glasgow 1933

Left The Queen of Spades *Right* The Queen of Clubs

Below

CHARLES RENNIE MACKINTOSH

A pair of high back armchairs, in dark stained oak, decorated on the back with four square inlays of mother-of-pearl. *Circa* 1905–10. Height 51¼in
London £4,200 ($10,500). 28.III.73
These chairs were commissioned by Miss Cranston, for whom Mackintosh designed the Willow Tea Rooms in Glasgow; they were conceived as part of the decorative scheme for Hous'hill, as were the gesso panels illustrated above.

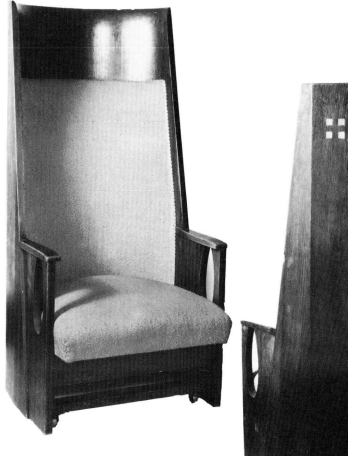

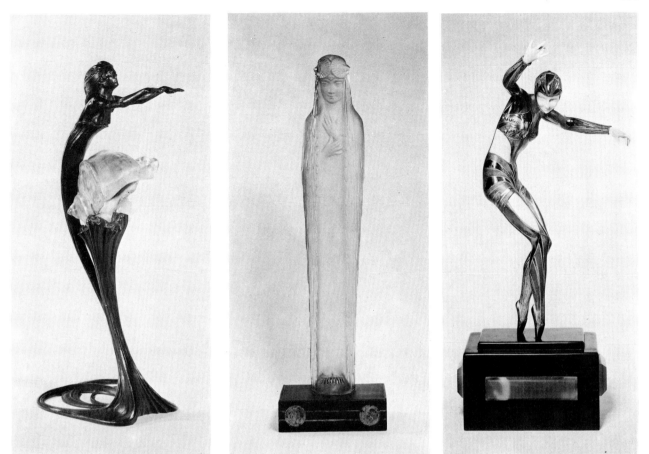

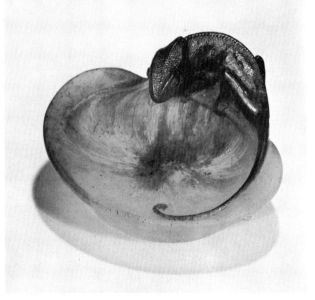

Above left

GUSTAV GURSCHNER

A bronze and shell lamp, signed *Gurschner* 8.99, executed in
1899. Height 21¼in. New York $1,700 (£680). 29.III.73

Above centre

RENE LALIQUE

The ice maiden

One of a series of four maidens designed by Lalique depicting
the four seasons. Signed. *Circa* 1930. Height 30½in
New York $1,300 (£520). 15.XII.72

Above right

D. H. CHIPARUS

A bronze and ivory figure of a dancing girl. *Circa* 1920.
Height 19½in. New York $1,600 (£640). 15.XII.72

Below right

A. WALTER

A pâte-de-verre dish modelled in full relief as a black and
green spotted chameleon. Signed *A. Walter, Nancy, Berge Sc.*
Circa 1910. Diameter 6½in. New York $1,300 (£520). 29.III.73

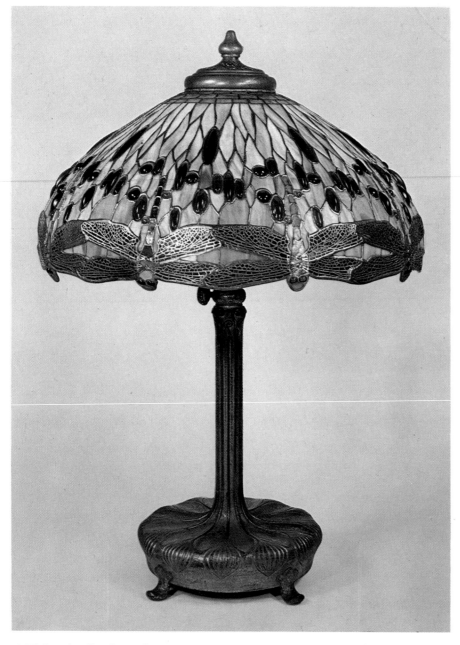

A Tiffany Studios dragonfly lamp, the base marked on the underside *Tiffany Studios New York* 367. *Circa* 1900. Height 31in, diameter of shade 23in
London £5,200 ($13,000). 22.VI.73

Glass and paperweights

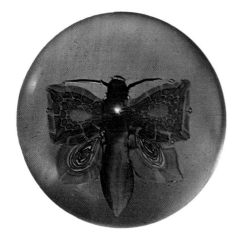

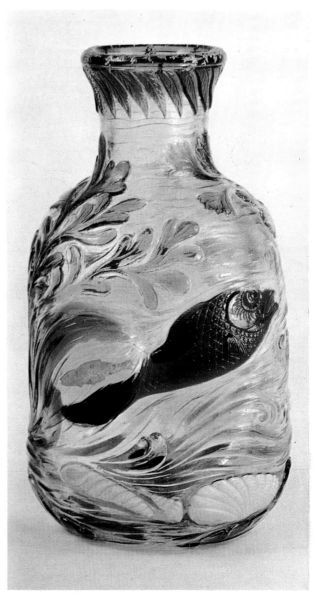

A Clichy butterfly weight containing a large insect with a plump orange and yellow body, $4\frac{5}{8}$in
London £1,900 ($4,750). 16.IV.73
This appears to be the only recorded example of a Clichy butterfly

A six-coloured Webb cameo-glass vase, the clear glass etched with flowing waves and decorated with scattered overlay carved in relief with fronds of seaweed and a red fish. Marked *Webb, circa* 1880, $6\frac{1}{4}$in
London £2,400 ($6,000). 14.XII.72
This vase was probably executed by Daniel and Lionel Pearce, who concentrated mainly on Chinese-influenced designs

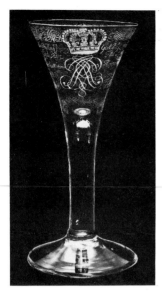

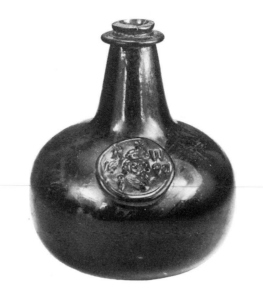

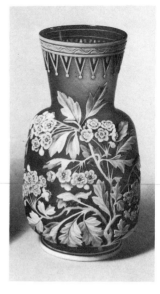

Above
The 'Perry' Amen glass with drawn-trumpet bowl and conical foot, etched in diamond point with a crown and the cypher *JR* and intertwined with the figure 8, alluding to King James VIII of Scotland, with the word *AMEN* beneath and verses of the Jacobite version of the national anthem, 6¼in
London £2,700 ($6,750). 16.x.72

Above centre
An early sealed wine bottle of green glass, the shoulder applied with a circular seal of a crowned bust portrait flanked by the cipher *RW*. Dated 1690, 5¼in. London £320 ($800). 11.XII.72
The initials are those of Richard Walker of the King's Head Tavern, Oxford

Above right
A Webb-type cameo glass vase, the body decorated with apple blossom and leaves on one side and raspberries on the other, in blue and white on a light ochre ground. Height 6⅝in
New York $2,200 (£880). 9.XI.72

Below left
A Jacobite wine glass engraved with the badge of the Society of Sea Serjeants, a star with a dolphin in the centre, 6⅝in
London £1,850 ($4,625). 12.II.73
From the collection of T. W. Naylor Esq
Formerly in the collection of the late Lt-Col Claude Beddington

Below centre
A Ravenscroft crizzled decanter jug, 9½in
London £3,400 ($8,500). 14.v.73

Below right
One of a pair of Dutch-engraved and inscribed 'lottery' goblets. Newcastle, mid-eighteenth century, 8in
London £1,500 ($3,750). 16.x.72
Lotteries at this date were a normal method of selling the wares of the lesser German porcelain factories
From the collection of J. D. Fox Esq

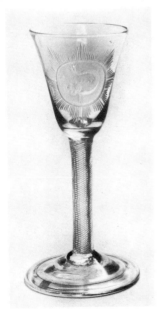

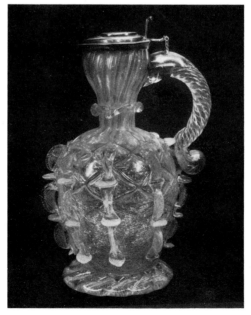

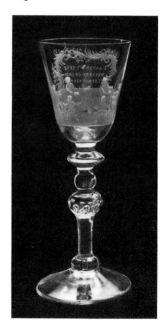

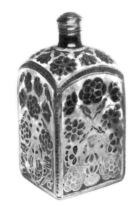

Above
One of a set of six Indian travelling spirit flasks contained in a shagreen canteen applied in silver with the monogram *GR* and a crown, each decanter enamelled with roses, lotus and other stylised flowers. Mughal, *circa* 1770, height 5¾in (one broken)
London £1,400 ($3,500). 12.11.73
The monogram and crown suggest that the set may have been a gift to George III from the East India Company

Above centre
A *Transparent-Malerei* footed beaker by C. von Scheidt, one side painted with an architectural scene with figures in the foreground, the subject being the Josephsplatz in Vienna. Signed *C.v.S.* and dated 1813, height 5in
New York $1,550 (£620). 24.X.72

Above right
A blown three-mould sugar bowl and cover of deep amethyst glass. Midwestern, *circa* 1815–30, height 6⅜in, diameter 4¼in
New York $4,000 (£1,600). 16.XI.72

Centre left
A Nuremberg wheel-engraved beaker attributed to Paulus Eder, with two coats of arms and other decoration on one side, the reverse with a madonna lily set in a landscape, late seventeenth century, 4¾in
London £1,700 ($4,250). 12.11.73
From the collection of W. W. Winkworth Esq

Centre right
An early seventeenth-century enamelled tankard, the body naïvely enamelled with birds inhabiting red scrollwork and stylised green leaves. Probably Bohemian, dated 1601, 5⅛in
London £450 ($1,125). 14.V.73

Below left
A Central German *Passglass*, the body enamelled in colour with bust portraits of a man and his wife plus appropriate trite verses in white enamel. Dated 1716, 9⅜in
London £800 ($2,000). 12.11.73
From the collection of the Most Hon the Marquess of Lansdowne PC

Below right
A Netherlands diamond-engraved goblet engraved in the manner of Mooleyser, 7⅞in
London £1,250 ($3,125). 12.11.73

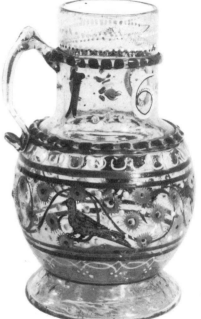

A St Louis encased pink overlay weight enclosing an upright bouquet, 3⅛in
London £5,600 ($14,000). 16.IV.73

A St Louis green overlay relief lizard weight, the reptile originally gilt all over, 3½in
London £4,800 ($12,000). 16.IV.73
From the collection of Mrs G. J. Brunström

Natural history

Left
A large celestite geode, broken open on two sides to show the transparent light-blue crystals, most free standing and up to about 1½in long. Madagascar, height 14in by 13in by 10in
London £500 ($1,250). 27.XI.72

Below left
A nodule split open to show both sides of the well-preserved fossil fish *Aspidorhyncus comptoni*, showing the gaping jaws, scales and most of the fins
Another specimen of the fossil fish, this one large and curved, with well-preserved head regions, scales and fins
Both specimens from the Lower Cretaceous period (approximately 100 million years old), Santana formation, Chapada do Araripe, Ceara Province, Brazil, the lengths 20½in and 22in respectively
London £65 ($162.50) and £105 ($262.50). 27.XI.72

Below
An egg of the sauroped dinosaur, generally called *Hypselosaurus priscus*, almost complete but fractured all over.
From the Upper Cretaceous (approximately 70 million years old), Montagne Saint-Victoire, Aix-en-Provence, France, length 8in, height 6in
London £260 ($650). 27.XI.72

"Don't admire anything. He might give it to you."

Victoriana

BY BEVIS HILLIER

In 1847 an article appeared in *Punch* which predicted, with extraordinary accuracy as well as facetiousness, that homes in 1947 would be full of relics of the Victorian Age:

> The system of decoration is, just now, all of the character of the Middle Age, and our rooms are crowded with Elizabethan ornaments. We may reasonably expect, therefore, that the next age will adopt for its adornments the style which is prevalent at the present period. What the armed knight of our ancestors is to us, the policeman in uniform will be to our posterity.
>
> We can fancy the effect of a room a hundred years hence, decorated with figures clothed in the fantastic garb of the present century. Of course it is only antiquity that gives value to many of those objects which figure in the catalogues of the present period, and are clutched up as bits of *vertu* by the connoisseurs of our own era.

The conceit of having policemen's uniforms around the room instead of romantic suits of armour was unfulfilled, except in the museums of costume; but in other respects the illustration in *Punch*, captioned 'A hundred years hence – A room in the style of the nineteenth century' is uncannily like that depicted by R. Taylor in the *New Yorker Album* of 1942, even down to the domed glass cases and the weapons hung on the walls. However, one girl is saying to the other in Taylor's cartoon: 'Don't admire anything. He might give it to you' – showing that although Victoriana had arrived by the 1940s, it had not yet won general public acceptance (Fig 1). In fact, it is no exaggeration to say that at that time, 'Victoriana' and 'Bad Taste' were just about synonymous in most people's minds.

How did the taste for Victoriana grow? The antipathy for Victorian relics, living and inanimate, was probably at its height after the First World War. Young men felt that the Victorians, with their misplaced jingoism, had landed them in the war; and the anti-Victorian feeling was crystallised by Lytton Strachey (a pacifist) in *Eminent Victorians* (1918), of which Cyril Connolly has said that 'It appeared to the post-war young people like the light at the end of a tunnel.'

Strachey's horror of the Victorians was founded in his childhood, which was spent in a gloomy Victorian house of the kind once described as a 'Nausoleum' – No. 69, Lancaster Gate, of which he wrote:

> It was size gone wrong, size pathological; it was a house afflicted with elephantiasis that one found one had entered, when, having passed through the front door and down the narrow dark passage with its ochre walls and its tessellated floor of

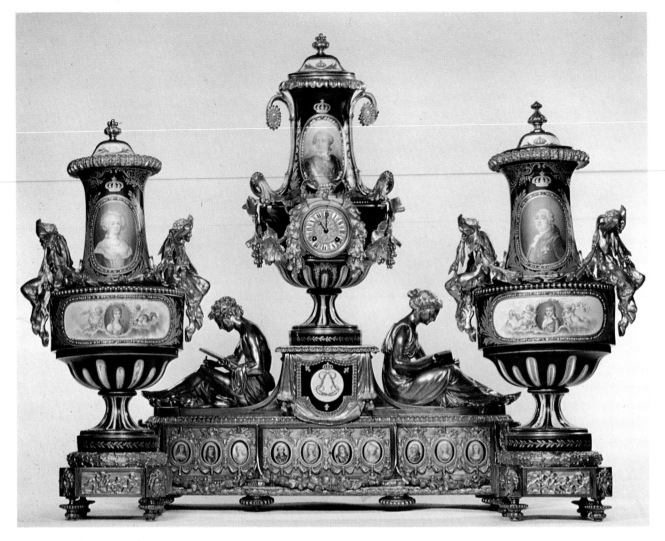

A Sèvres porcelain ormolu-
mounted clock garniture in
Louis XVI style, interlaced *L*'s,
1840–60, the clock 32in, the
vases 25in
London £8,500 ($21,250).
31.V.73

magenta and indigo tiles, one looked upwards and saw the staircase twisting
steeply up its elongated well – spiralling away into a thin infinitude, until far above,
one's surprised vision came upon a dome of pink and white glass, which yet one
judged, with an unerring instinct, was not the top – no, not nearly, nearly the top.

The focal point of Lancaster Gate was the monumental drawing room. Michael
Holroyd has written: 'This great assembly hall, with its lofty eminence, its gigantic
door, its glowing *portière* of pale green silk, its adumbrated sofas, instilled into him an
almost religious awe'. And Strachey himself wrote of the room:

> The same vitality, the same optimism, the same absence of nerves which went into
> the deliberate creation of ten children, built the high, hideous edifice that sheltered
> them. . . . When one entered that vast chamber, when peering through its foggy
> distances, ill-lit by gas-jets, or casting one's eyes wildly towards the infinitely
> distant ceiling overhead, one struggled to traverse its dreadful length, to reach a
> tiny chair or a far-distant fireplace, conscious as one did so that some kind of queer
> life was clustered thick about one . . . then in truth one had come – whether one
> realised it or no – into an extraordinary holy of holies.

Strachey's biographer, Michael Holroyd, leads us down from these mystical heights to tangible Victoriana familiar to the collector:

> If the drawing-room was a temple erected to the enigmatic spirit of Victorianism, its altar was undoubtedly the large, elevated and elaborate mantelpiece, an expanse of painted wood, designed by Halsey Ricardo, with pilasters and cornices and various marble and multicoloured tiles.

Holroyd does not say so, but the mention of Ricardo immediately suggests that the coloured tiles were made by William De Morgan, who went into partnership with Ricardo in 1888.

Ironically, Strachey's *Eminent Victorians*, and his biography of Queen Victoria with its famous virtuoso deathbed scene, helped to stimulate interest in the Victorian age. There is a form of hate very close to love in its passion and its demand to be satisfied; and from Strachey's malevolent portraits of Cardinal Manning and Dr Arnold, and his cruel send-up of Victoria ('To her it mattered nothing that her face turned red in the heat and that her purple pork-pie hat was of last year's fashion . . . she was Queen of England, and was not that enough?') it is obvious that he had ransacked with huge relish the two-volume biographies where he found his raw material, and that he was half-envious of the stability and invincible self-confidence of the High Victorian period. No one could find the great Victorians boring after reading Strachey. Bertrand Russell, his Cambridge friend, recalls in his memoirs: 'I heard him read *Eminent Victorians* before it was published, and I read it again to myself in prison. It caused me to laugh so loud that the officer came round to my cell, saying that I must remember that prison is a place of punishment.'

Strachey, then, kindled an interest in the Victorians; but where do the victory honours lie for awakening an enthusiasm for collectable Victoriana? The first name that springs to mind is that of Sir John Betjeman who, certainly, has done more than anyone, by his quirkish but utterly sympathetic presentment, to popularise Victorian art and architecture. Kenneth Clark paid tribute to Betjeman in the preface to his early book on the Gothic Revival.

But probably the most determined early collector was that militant aesthete, Harold Acton. Evelyn Waugh wrote in his autobiography: 'While Mr Betjeman was still a schoolboy rubbing church brasses, Harold was collecting Victoriana'; and Acton himself has written of his Oxford days:

> Robert Byron's vivacity and pugnacity made him an invaluable ally in our campaign against false prophets. Between us we had collected a varied array of Early Victorian domestic ornaments and, having investigated characteristic examples of that period in the neighbourhood and secured the promise of loans from such amateurs as John Fothergill of Thame, we proposed to hold an Early Victorian exhibition. We intended to bring out an illustrated catalogue, for which Lytton Strachey was to write the introduction. But the Proctors banned our venture without a word of explanation. Perhaps they feared we would exhibit their photographs among the wax bric-à-brac. I explained to one of them the serious-ness behind our purpose. But he was unmoved and vaguely hostile. We sent a letter of strenuous protest to the *Daily Mail*, and various correspondents from London came to see us, but the harm had been done.

Acton and Byron were not easily quelled; other Victorian projects and activities followed:

> Our friends wished to organise a Queen Victoria ballet, in which the talented Martin Harvey was to dance the title-role while I was to assume a red beard and take historical notes in appropriate postures, at one time beneath a Balmoral sofa, in the role of Lytton Strachey. Long-forgotten polkas and quadrilles were to have provided the musical accompaniment, and the scenery was to have been composed of imitation flowers and fruit. . . . To promote our campaign I read papers to the Newman and other societies about the British genre painters, Wilkie, Frith, Augustus Egg and Martineau, and tried to revive an interest in the flesh-tints of Etty and the cataclysms of Martin the Mezzotinter. As imitation is the sincerest form of flattery, it was gratifying to find ocular evidence of our success. By the time I left Oxford, many a room had been brightened with souvenirs of Queen Victoria's heyday.

Osbert Sitwell was another pioneer of the taste for Victoriana. Acton describes his house in Carlyle Square at this time as 'a shrine of eighteenth-century shell furniture, sailing ships of spun glass, humming-birds under globes, petit-point screens, porcelain spaniels, daguerrotype albums and musical boxes combined.' His strong sympathy for Victoriana comes through in his poem 'Mr and Mrs Goodbeare', first published in the 1920s:

> Mr. Goodbeare's parlour was a paradise
> Of polished wood, a haven of joinery,
> A heaven of varnish,
> There were brackets, shelves, shields
> And cupboards, with ferns traced on them
> By his artistry,
> And even wooden vases, turned
> So beautifully, and full of dried, dull grasses,
> Tied with dusty ribbons,
> That rustled suffocatingly
> In the dry wind from under the door.
> Fantastic flights of Mr. Goodbeare's imagination,
> Cricket-bats combined with dragons,
> And improbable bows and loops,
> Framed-in the almost legendary
> Topiary of beard and whisker –
> Tied in True-lover's Knots
> In which Mr. Goodbeare's friends
> Had at one time extravagantly –
> If elegantly – indulged.

So far, the response to Victoriana was 'atmospheric', unscientific – the equivalent, in art appreciation, of Strachey's impressionistic (and often inaccurate) portraits of the Victorians. The next phase is an increasing application to Victorian art and architecture of serious research and explication. Goodhart-Rendel's Slade Lectures at Oxford dealing with Victorian architecture were delivered in 1934 (though they were

Fig 2

not published until 1953). 'That was the start,' Sir Nikolaus Pevsner has written; 'Here positive values were seen as positive values, architect after architect and building after building were succinctly and with brilliant insight analysed and characterised.' Pevsner's own *Pioneers of the Modern Movement* appeared in 1936; Basil Clarke's *Church Builders of the Nineteenth Century* in 1938; Pevsner's *High Victorian Design* in 1951; Henry Russell Hitchcock's *Early Victorian Architecture* in 1954. T. S. R. Boase's paper on the decoration of the Houses of Parliament was read in 1954 and his volume on Victorian Art appeared in 1959; Quentin Bell's work on the Schools of Design appeared in 1963, Winslow Ames's on Prince Albert's taste in 1967, and Andrews's work on the Nazarenes in 1964. The Victorian Society was founded in 1958. The attitude towards 'Victoriana' of the new scientific students of Victorian art was supercilious: in a foreword to a re-issue of John Steegman's *Consort of Taste*, a much-admired pioneer work of 1950, Pevsner has written: 'Admittedly a fashion for Victoriana had set in already before 1950, but this book does nowhere pander to that. It is a serious work throughout. . . .'

At the same time, the 'atmospheric' interest in Victoriana continued. It is seen at its brightest and best in *The Saturday Book*, founded in 1940. After the Second World War, as after the First, there was a craving for the secure and spacious age of Victoria. A new impetus came with the Festival of Britain in 1951, with its echoes of the Great Exhibition of 1851; and the Coronation in 1953, establishing a Queen on the throne of England for the first time since Victoria, produced another welling-up of pro-Victorian feeling. Men of the 1950s, reacting against a decade of regimenta-

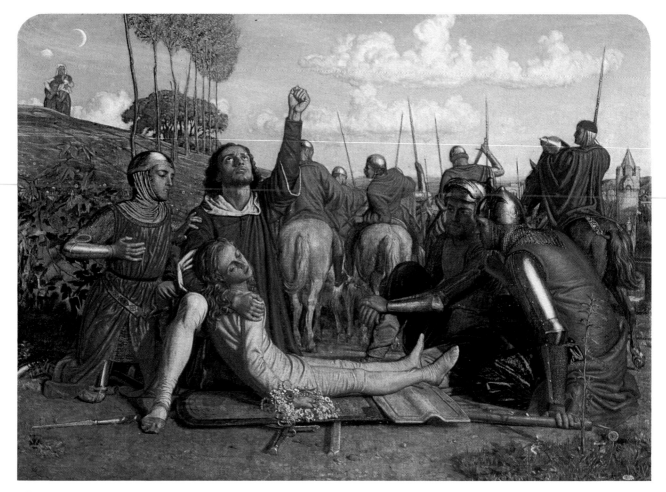

Fig 3
WILLIAM HOLMAN HUNT,
OM, ARSA, RWS
*Rienzi vowing to obtain
justice for the death of his
young brother*
Signed, inscribed *P.R.B* and
dated 1849, 34in by 48in
London £48,000 ($120,000).
27.III.73
From the collection of the
late C. S. Clarke
The subject was taken from
the novel, *Rienzi, the Last of
the Tribunes*, by Bulwer
Lytton

tion, either in war or austerity, liked the eccentric side of the Victorians: you see this clearly in the ballooning escapades of the film *Round the World in Eighty Days* and in the characters portrayed by Alec Guinness in *Kind Hearts and Coronets*. Balloons, penny-farthing bicycles and archaic wheel-chairs became part of the designer's and the window-dresser's armoury of motifs.

But still the trade in Victoriana was largely confined to chi-chi little antique shops, and prices were seldom high. It was only in the 1960s that Victorian antiques (which the Grosvenor House Fair still does not recognise as antiques) began to command prices which made newspaper headlines. The 1960s and early 1970s also saw many additions to scholarship in Victorian art and antiques, both in books and in exhibitions. In architecture, there have been fine works such as Paul Thompson's on Butterfield and Mark Girouard's on the Victorian Country House. In art, superseding the impressionist charm and insight of William Gaunt's 1940s book on the Pre-Raphaelites, there have been excellent books on Victorian painting by Jeremy Maas, Quentin Bell, Graham Reynolds and Christopher Wood; and major exhibitions such as those at the Royal Academy on Millais and Rossetti. In ceramics, Hugh Wakefield's and Geoffrey Godden's contributions have been invaluable, complemented by Desmond Eyles's book on Doulton, the splendid Doulton exhibition held by Richard Dennis, the Christopher Dresser ceramics shown at the Fine Art Society, and Moorcroft Wares at the Victoria and Albert Museum. Also at the V and A,

Fig 4
RICHARD REDGRAVE, RA
The emigrant's last sight of home
Signed and dated 1858,
signed and dated 1859 on the
reverse, 26½in by 38½in
London £17,000 ($42,500).
27.III.73
From the collection of R. N.
Marshall Esq, great grandson
of the artist

Shirley Bury has exhibited important Victorian silver. On textiles Barbara Morris, of the same museum, is a prime authority. The 1960s was also the period of an Art Nouveau revival, in the Mucha and Beardsley exhibitions of the early 1960s and (reinforcing the pioneer work of Pevsner and Tschudi Madsen) the books on Art Nouveau by Amaya, Rheims, Schmutzler, Battersby and others, and a superb exhibition on Charles Rennie Mackintosh which came from Scotland to the Victoria and Albert. Above all, perhaps, must be mentioned the two great Victorian exhibitions of the early 1970s – of Ecclesiastical Art, organised by Shirley Bury at the V and A, and of the collection of Charles and Lavinia Handley-Read at the Royal Academy. Charles Handley-Read did more than anyone to make us take Victorian furniture seriously, and it is a tragedy that his projected book on Burges was never written; Lavinia was an expert on Victorian sculpture, and her work on Alfred Gilbert, published in *The Connoisseur*, is a lasting memorial.

There is really no need for the 'atmospheric' collectors and the scientific ones to be at odds with each other; and in a way, the foundation of Sotheby's, Belgravia in 1971, to specialise in the sale of Victoriana, brings the two factions together. Here the 'atmospheric' collector can browse, inhale the mystical properties of Victorianism, and bid for additions to his antimacassar'd, aspidistra'd rooms. And at the same time the catalogues, copiously illustrated because Belgravia's director, Marcus Linell, long ago realised that catalogues are never properly read, are models of scholarly

Fig 5

WILLIAM DYCE, RA
The manse
On board, 12in by 16in
London £23,000 ($57,500).
10.VII.73
From the collection of Mrs
Margaret H. Rose
Formerly in the collection of
James Dugdale (1927) and
G. S. Rose (*circa* 1930)

record. The turnover in the first season was £1.5 million and the second season reached a final figure of well over £3 million.

There have been some notable paintings sales. On November 28th, 1972, Henry Wallis's *The death of Chatterton* (Fig 2) – a small version of the picture in the Tate brought £18,000. Two pencil sketches of heads by Burne-Jones made £850. A painting by the Pre-Raphaelites' friend Thomas Seddon, *Penelope unravelling her tapestry*, made £3,200, though in poor condition.

One of the best paintings sales was held on the 27th February, when Holman Hunt's *Rienzi* (Fig 3) was sold for £48,000. This painting, whose full title is *Rienzi vowing to obtain justice for the death of his young brother*, was based on Bulwer Lytton's novel *Rienzi, the Last of the Tribunes*. It is important in the history of Pre-Raphaelitism, as it was hung in 1849 with Millais's *Lorenzo and Isabella*, now in the Walker Art Gallery, Liverpool. In the same February sale, Richard Redgrave's *The emigrant's last sight of home* (Fig 4) was sold for £17,000. A sale held on the 10th July contained more important Victorian works amongst which were William Dyce's *The manse* (Fig 5), and Holman Hunt's *Valentine and Sylvia* (Fig 6).

In ceramics, Martin ware and De Morgan ware are among the most sought-after pottery. On the 15th February 1973, a large Martin ware bird was sold for £1,250 (page 478). It is 16½in high; there are only two higher, one of 17in in a private collec-

Fig 6

WILLIAM HOLMAN HUNT,
OM, ARSA, RWS
*Valentine rescuing Sylvia
from Proteus*
On panel, signed and dated
1851, 10in by 13¼in
London £22,000 ($55,000).
10.VII.73

tion, and a 41in owl in the Fitzwilliam Museum. A flaring vase by William De Morgan, 11in high and painted by Fred Passenger with stylised cranes in silver, pale blue, and gold lustre brought £780; and a De Morgan ruby dish with griffinesque beasts snarling at a fish in a river reached £480 (page 478).

The kind of prices commanded by good Art Nouveau nowadays may be represented by the £4,200 paid for two simple high-backed armchairs by Charles Rennie Mackintosh (page 378) (the last previous pair of Mackintosh chairs made £700 in 1970) and by the $24,000 given for a wisteria lamp (Fig 7) at Parke-Bernet on the 29th March (comparing with 1970 prices of between $13,500 and $16,500 for similar lamps).

Silver sales have included a Joseph Angell coffee set of 1850 which fetched £3,800 (page 295). It was one of the prize exhibits in the 1851 Great Exhibition. In Mr Angell's words, each piece of slender spooled form is 'illustrative of . . . fables from Aesop, all modelled in high relief of frosted silver, the whole of the ornamentation made to remove, so that the service may be used plain, each Fable bearing its appropriate moral in a scroll.'

With almost the speed of log-rolling on a Canadian river, an endless selection of good Victorian furniture (much of it mahogany) passes through the Belgravia rooms. Some of it fetches prices well below the prices being asked for contemporary furni-

Fig 7
A Tiffany favrile glass and
bronze wisteria lamp, the
base impressed *Tiffany
Studios, New York*, 26854,
height 27½in
New York $24,000 (£9,600).
29.III.73

DAVID OCTAVIUS HILL
AND ROBERT ADAMSON
A volume of thirty-five
calotypes taken between 1843
and 1848, the prints mounted
one to a page, small folio size,
each print approximately
200mm by 150mm
London £6,000 ($15,000).
24.v.73

ture in London shops; but there is the occasional spectacular piece such as the porcelain-mounted ebonised *bonheur-du-jour*, German, *circa* 1860, which fetched £6,800 in a sale of the 14th March (page 368).

Photographs are another subject in which there is increasing scholarship and collecting interest. Belgravia lost the chance to sell the Royal Academy's Hill and Adamson volumes which went to the National Portrait Gallery; they would probably have fetched about £70,000 if they had come under the hammer. But Belgravia did sell, on the 24th May 1973, an 1843 Fox Talbot photograph of chess players for £720, and a single photograph by Octavius Hill and Robert Adamson, *The Minnow Pool*, for £700.

The art historians have still not fully taken Victoriana to their heart; and perhaps they never will. The latest book on the subject is *The Victorian Treasure-House* by Peter Conrad. The publisher's blurb begins:

It is fifty years since Lytton Strachey taught the polite world to giggle at the Victorians. Now the wheel has come full circle. Their literature and their art, which never lost their strong popular appeal, attract some of the most interesting and original critical minds, among whom Mr. Conrad takes his place with this admirably written and stimulating book.

MYLES BIRKET FOSTER,
RWS
Harvest time
Heightened with bodycolour,
signed with monogram,
20½in by 32¾in
London £5,800 ($14,500).
27.III.73
From the collection of
P. J. Dearden, Esq

Admirably written and stimulating the book indeed is; but on turning to the first page, what do we find? An indictment of Victorian art worthy of Strachey himself:

'A treasure-house of detail', said Henry James of *Middlemarch* – 'but it is an indifferent whole.' The same might be said of the entire Victorian period. Its works of art often seem, like its interiors, containers to be stuffed as full as possible. Its paintings are cluttered with objects, each precisely and conscientiously depicted; its novels expand to take in a miscellany of characters and incidents, delighting in loose ends. Paintings and novels and even poems have a chaotic fullness, a superabundance, which James thought to be their weakness, but which is perhaps their glory. He was offended by the obesity of the Victorian novel: it bulged into those loose baggy shapes which he found so unsightly, but which accord perfectly with the self-satisfied curves, the prosperous embonpoint, of Victorian ornament. . . .

Careless of refinement and selection and of classical notions of beauty and harmonious form, Victorian artists are always perilously close to badness, and their triumphs are almost always flawed – reckless, extravagant, slightly monstrous, their masterpieces, *Modern Painters*, *The Old Curiosity Shop*, *The Ring and the Book*, the pictures of Holman Hunt and the buildings of Butterfield, seem in a rather exhilarating way to have only just saved themselves from calamity. . . . They seem to have had a pact with their genius never to be perfect.

I agree with Conrad's verdict; but of course that may be only because I, too, am a child of my time. It is still too early to judge what the final assessment of Victoriana will be – if in art appreciation any assessment can ever be considered final.

DAVID ROBERTS, RA
The interior of the Church of St Gomar at Lierre in Belgium
Signed, inscribed *Painted at Lierre* and dated *Sept. 20th,* 1949, 45in by 36in
London £8,500 ($21,250). 10.VII.73
From the collection of the Hon Colin Tennant

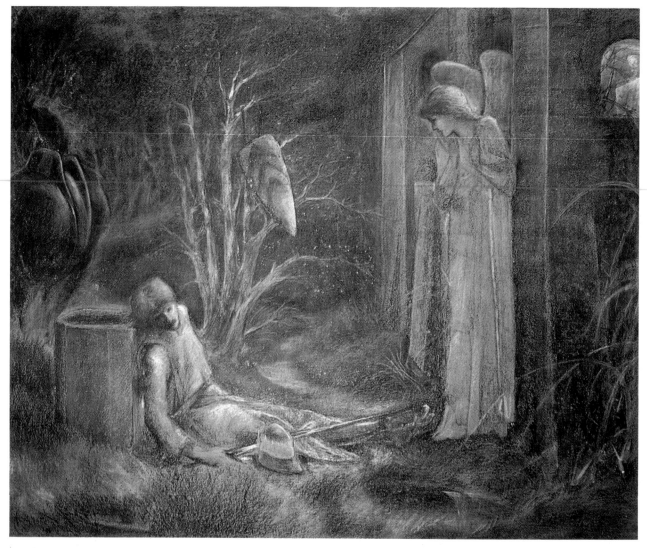

SIR EDWARD COLEY BURNE-JONES, Bt, ARA
The dream of Sir Lancelot
Coloured chalks on brown paper, 39in by 48in
London £5,800 ($14,500). 27.III.73
One of a series of seven designs for tapestries executed by Morris and Co for Stanmore Hall

Chinese ceramics
& works of art

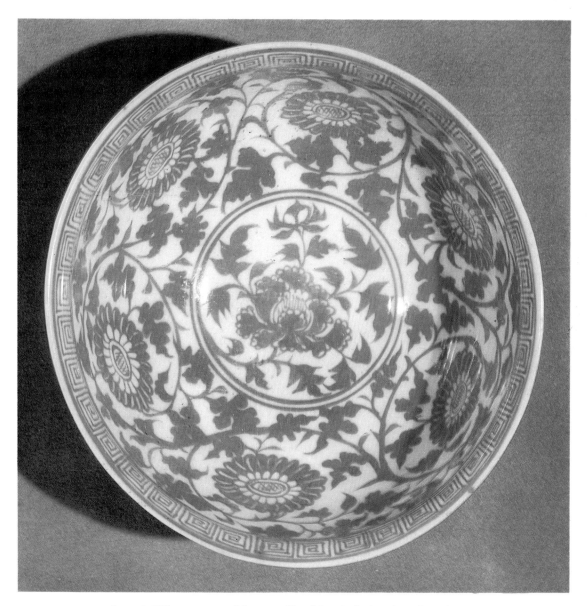

An early Ming copper-red decorated bowl (*wan*), the interior painted in underglaze-red with a peony spray in a central medallion encircled by a continuous chrysanthemum scroll. Late fourteenth century, 8⅛in
London £85,000 ($212,500). 13.III.73

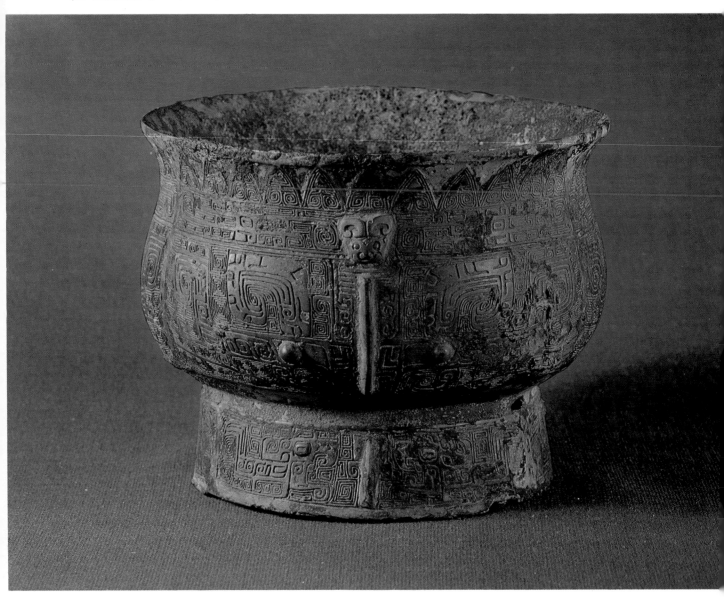

A ritual bronze food vessel (*kuei*), Shang Dynasty, height 5in, width 7in
London £17,000 ($42,500). 14.XI.72

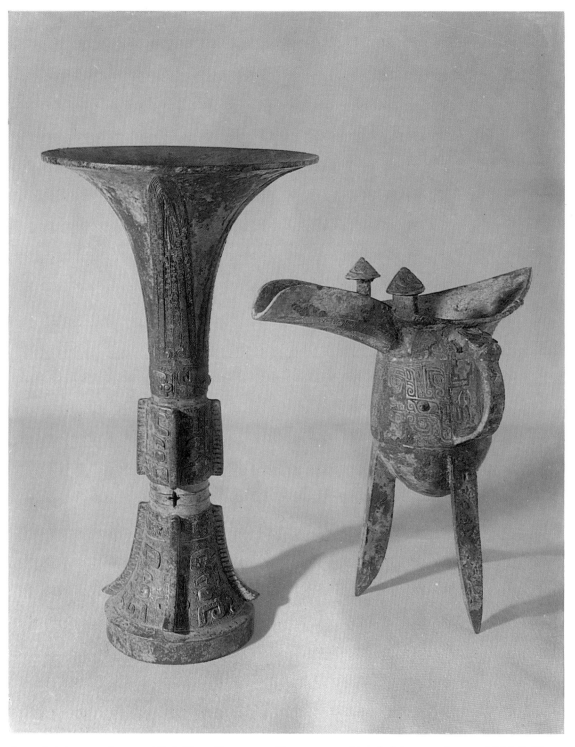

An archaic bronze wine vessel (*ku*), Shang Dynasty, 11¾in
London £24,000 ($60,000). 26.VI.73
Sold by order of the R.E.R. Luff Will Trust

An archaic bronze wine vessel (*chüeh*), Shang
Dynasty, height 8¼in, width 8in
London £12,000 ($30,000). 26.VI.73
Sold by order of the R.E.R. Luff Will Trust

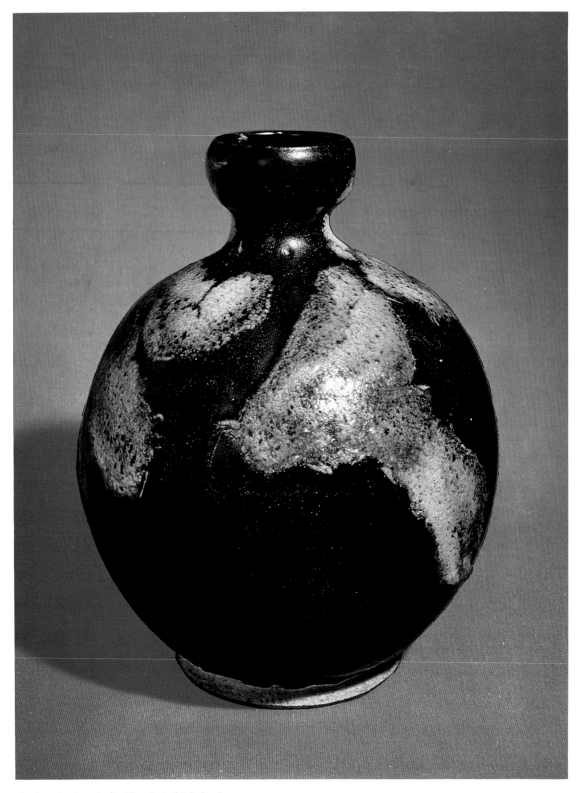

A phosphatic splashed bottle in high fired grey
stoneware, T'ang Dynasty, height 8½in
London £21,000 ($52,500). 13.III.73

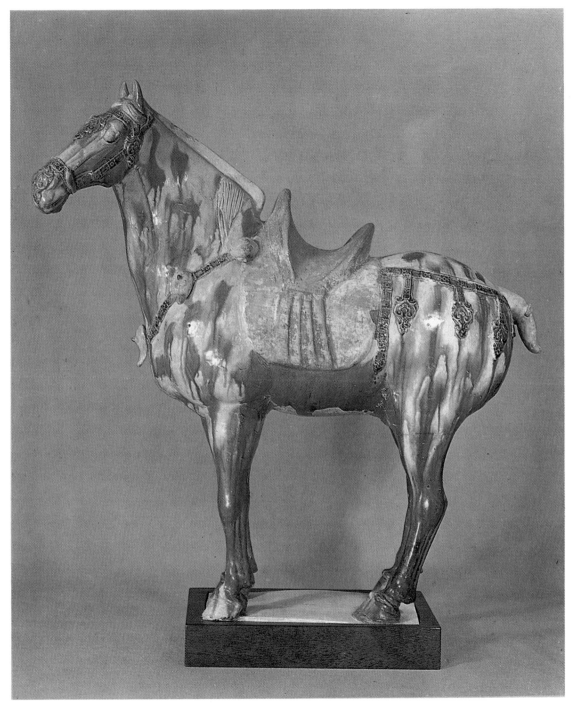

A figure of a harnessed Fereghan horse, T'ang Dynasty, height 22¼in
London £33,000 ($82,500). 26.VI.73

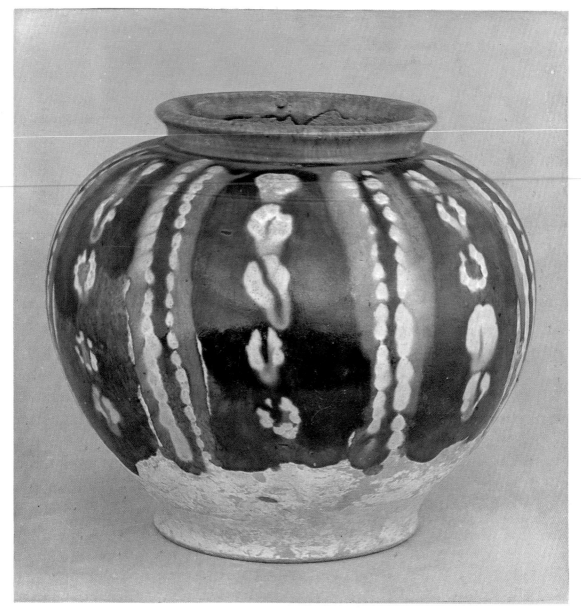

A three-colour pottery jar of ovoid form, T'ang Dynasty, height 7in, width 8in
London £42,000 ($105,000). 26.VI.73
Sold by order of the R.E.R. Luff Will Trust

A blue-glazed pottery jar, T'ang
Dynasty, height 6½in
New York $47,000 (£19,000). 30.V.73
From the collection of Winifred Gray
Whitman MD

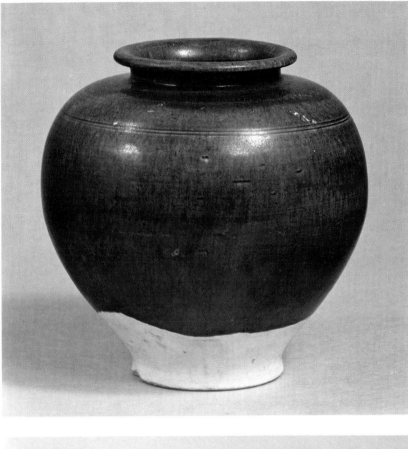

A green-glazed pottery jar and cover,
T'ang Dynasty, height 9¼in
New York $45,000 (£18,000). 30.V.73
From the collection of Winifred Gray
Whitman MD

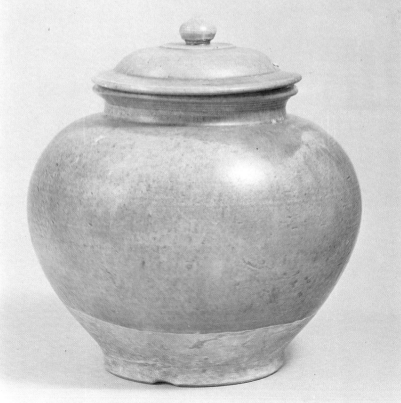

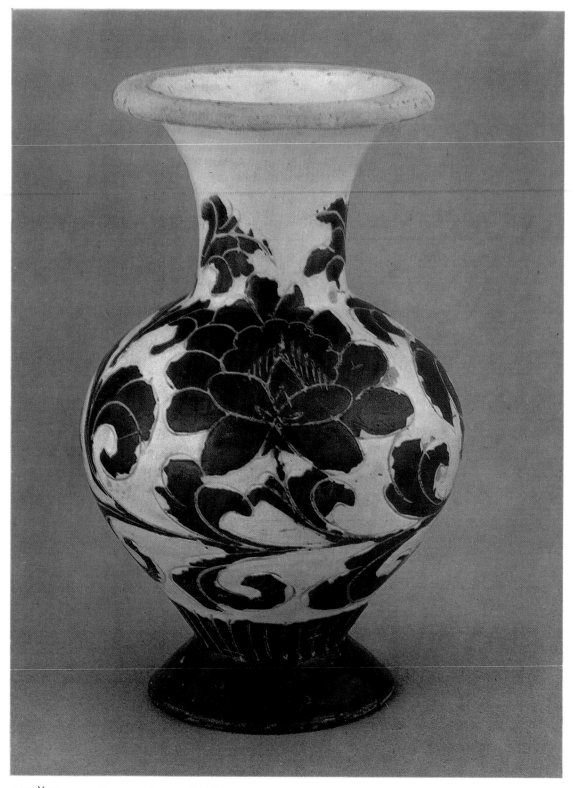

A Tz'ŭ Chou *sgraffiato* vase decorated with two peony sprays in brown glaze applied over a
white slip with incised details and covered with a translucent glaze, Sung Dynasty, 7¾in
London £76,000 ($190,000). 26.VI.73

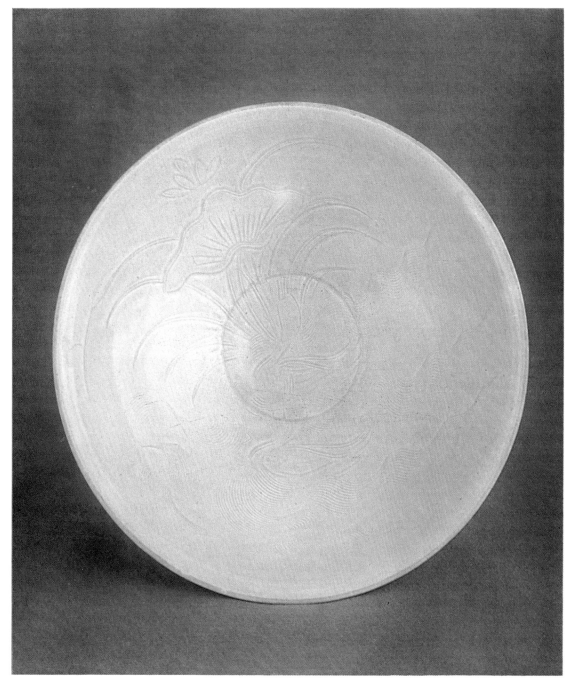

A carved Ting-yao conical bowl, Sung Dynasty, 9¼in
London £32,000 ($80,000). 26.VI.73
Sold by order of the R.E.R. Luff Will Trust

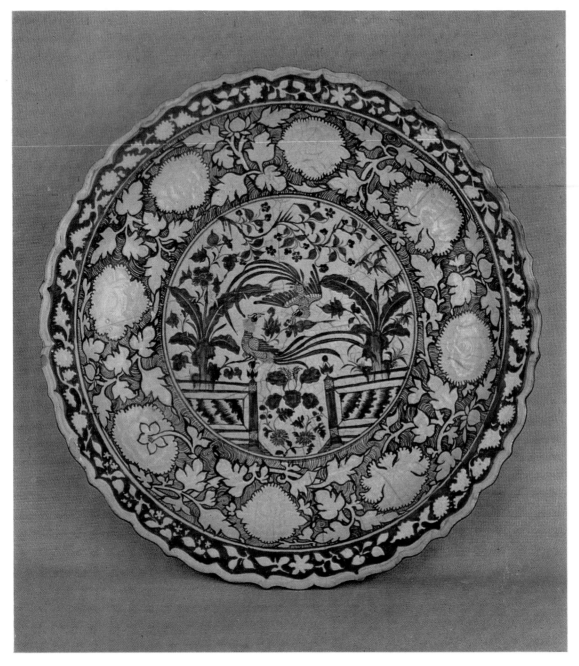

A late Yüan moulded blue and white dish, mid-fourteenth century, 18⅝in
London £31,000 ($77,500). 26.VI.73

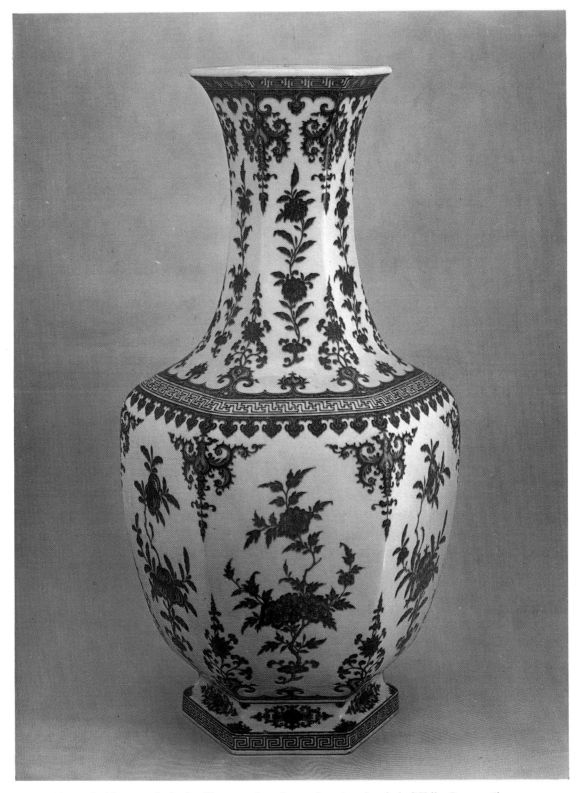

A large blue and white vase, the body of hexagonal section, seal mark and period of Ch'ien Lung, 26in
London £24,000 ($60,000). 26.VI.73

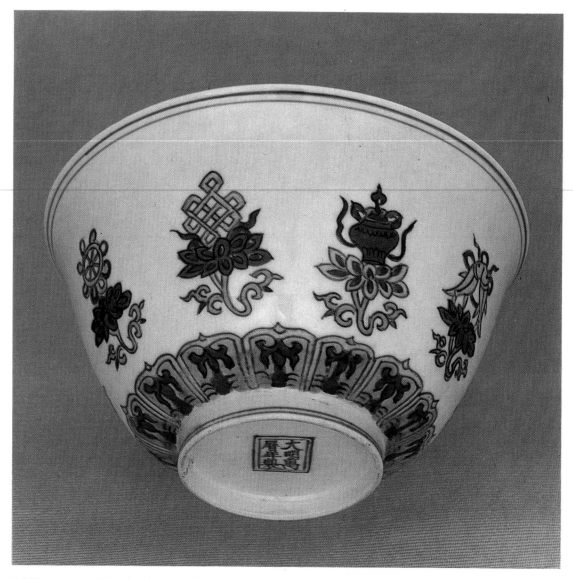

A Ming enamelled bowl, painted on the exterior with the *pa chi-hsiang*, the eight Buddist emblems of good augury, the interior decorated with a small medallion enclosing a *ling chih* fungus spray with red head and multi-coloured leaves within a double line border. Six character mark of Wan Li in underglaze-blue within a double square and of the period, 6½in
London £33,000 ($82,500). 26.VI.73
From the collection of the late Sir John Braithwaite

Opposite page
A blue and white palace bowl, six character mark of Ch'êng Hua within a double circle and of the period, 5¾in
London £130,000 ($325,000). 26.VI.73
Sold by order of the R.E.R. Luff Will Trust

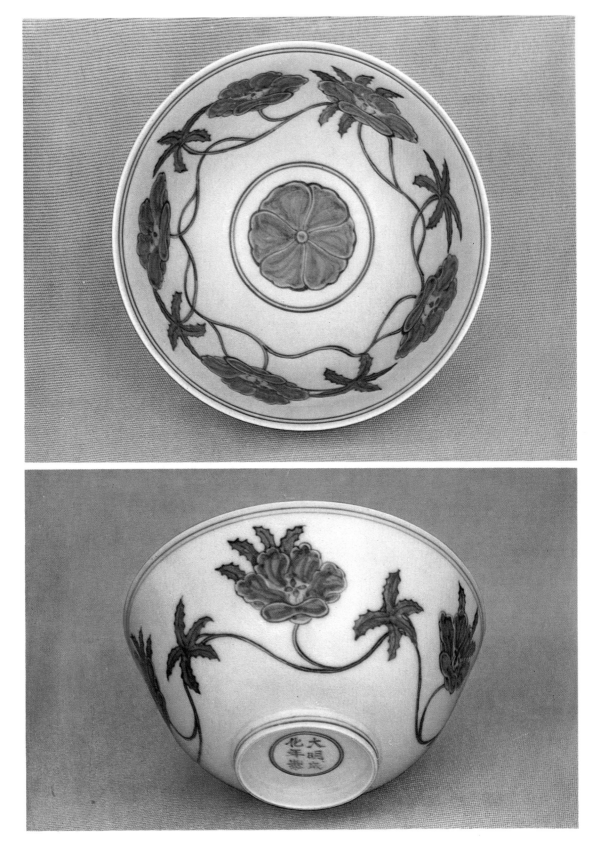

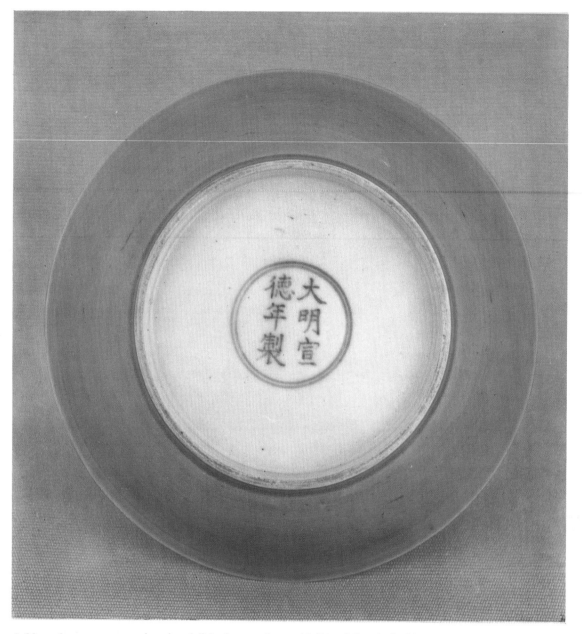

A fifteenth-century turquoise-glazed dish of saucer shape with lipped rim, the inside covered
with a white glaze and moulded in *an hua* with two dragons in pursuit of 'flaming pearls', the
centre faintly engraved with three cloud scrolls. Six character mark of Hsüan Tê within a
double circle and of the period, 5⅞in
London £58,000 ($145,000). 26.VI.73
Formerly in the Parfitt Collection, and sold in these rooms on 8th February 1946 (£150) and
again on 18th June 1968 (£3,800)

A peach-bloom 'amphora' vase, six character mark of K'ang
Hsi written in two columns in underglaze-blue, and of the
period, 6¼in
London £50,000 ($125,000). 26.VI.73
Formerly in the J. Pierpont Morgan Collection

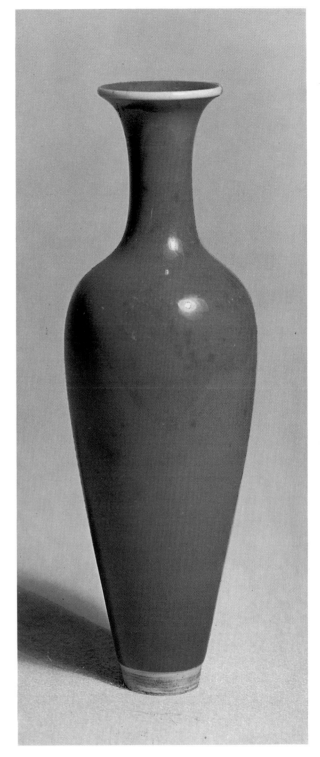

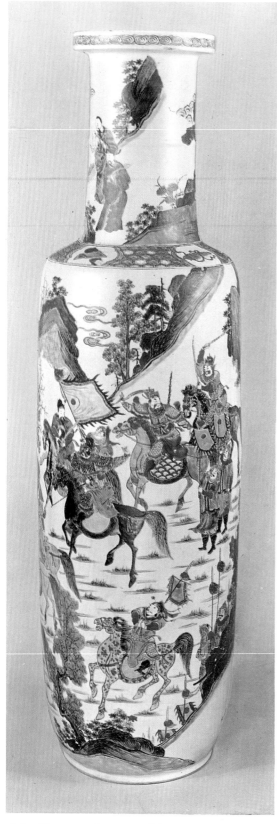

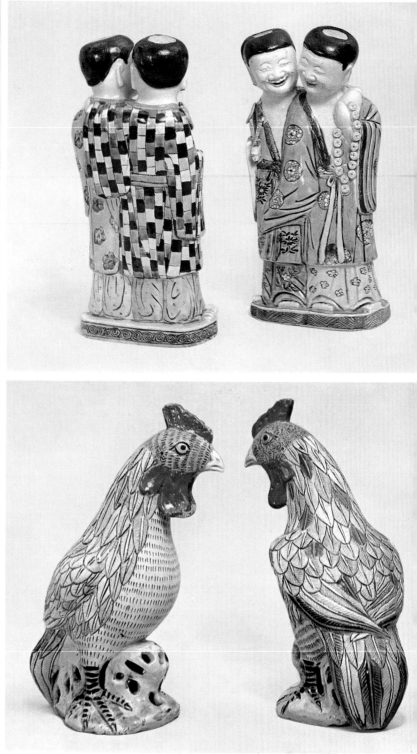

A *famille verte* rouleau vase of elongated form,
K'ang Hsi, 30⅛in
London £7,000 ($17,500). 27.11.73

A pair of biscuit groups of the Ho-ho Erh-hsien, twin spirits of Mirth
and Harmony, K'ang Hsi. 8½in and 8⅜in
London £5,800 ($14,500). 27.11.73
From the collection of Mrs Robert Henriques
Formerly in the collection of the late the Hon. Mrs Nellie Ionides

A pair of biscuit figures of Asil game cocks, K'ang Hsi, 10¼in
London £22,000 ($55,000). 27.11.73
From the collection of Mrs Robert Henriques
Formerly in the collection of the late the Hon. Mrs Nellie Ionides

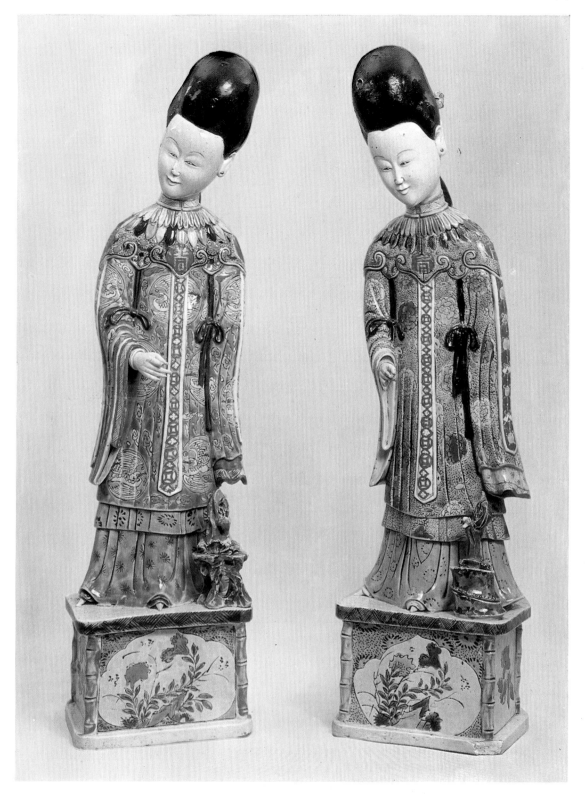

A pair of large biscuit figures of maidens, K'ang Hsi, 18¾in
London £35,000 ($87,500). 27.11.73
From the collection of Mrs Robert Henriques
Formerly in the collection of the late the Hon. Mrs Nellie Ionides

Left
A grey pottery figure of a lady, Han Dynasty, 27in
New York $28,000 (£11,200). 28.IX.72
From the Thomas Barlow Walker Collection

Centre
A green-ground Tz'ŭ Chou vase painted in dark brown with
two peony branches, Sung Dynasty, 10¼in
London £50,000 ($125,000). 14.XI.72

Right
A Korean celadon bottle with underglaze-red decoration,
and inlay in black and white slip
Koryu Dynasty, 13¼in
London £40,000 ($100,000). 13.III.73

Below
A large Honan storage jar painted in iron-brown on the
brown-mottled black glaze, Sung Dynasty, 14in
London £28,000 ($70,000). 14.XI.72

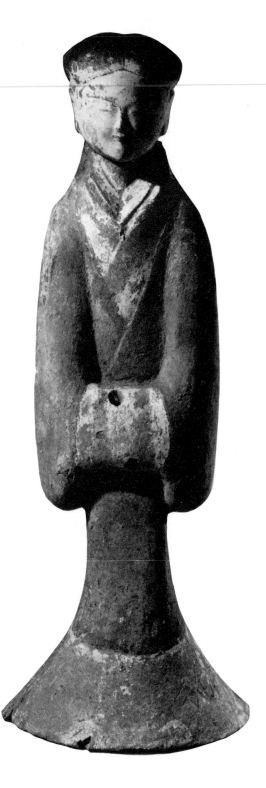

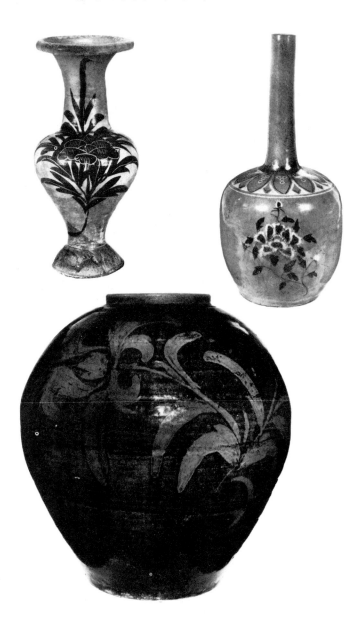

Right
An eighteenth-century white jade covered vase, 11¾in
New York $46,000 (£18,400). 29.V.73
From the collection of the late Harriet Hersey

Far right
An eighteenth-century white jade covered vase, 11½in
New York $40,000 (£16,000). 29.V.73
From the collection of the late Harriet Hersey

Below
A polychrome wood figure of Kuan Yin, Sung Dynasty, 41½in
New York $31,000 (£12,400). 28.IX.72
From the Thomas Barlow Walker Collection

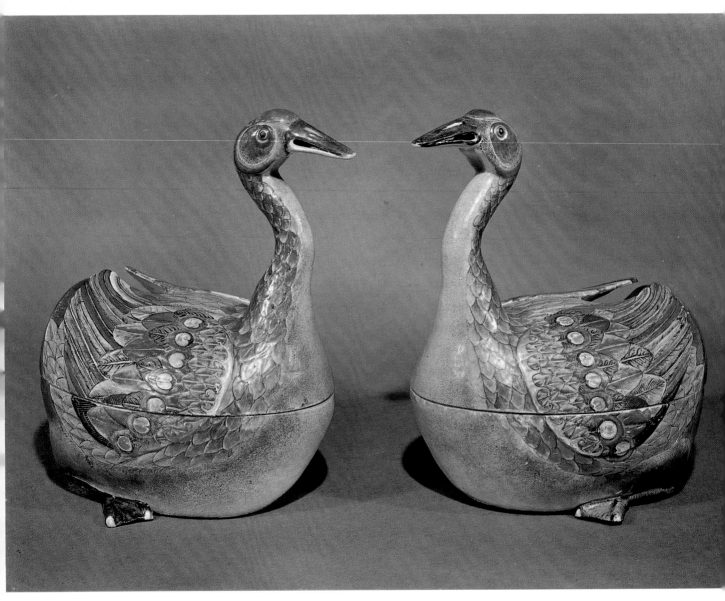

A pair of *Compagnie des Indes* goose tureens and covers, Ch'ien Lung, 15¾in
London £72,000 ($180,000). 3.VII.73

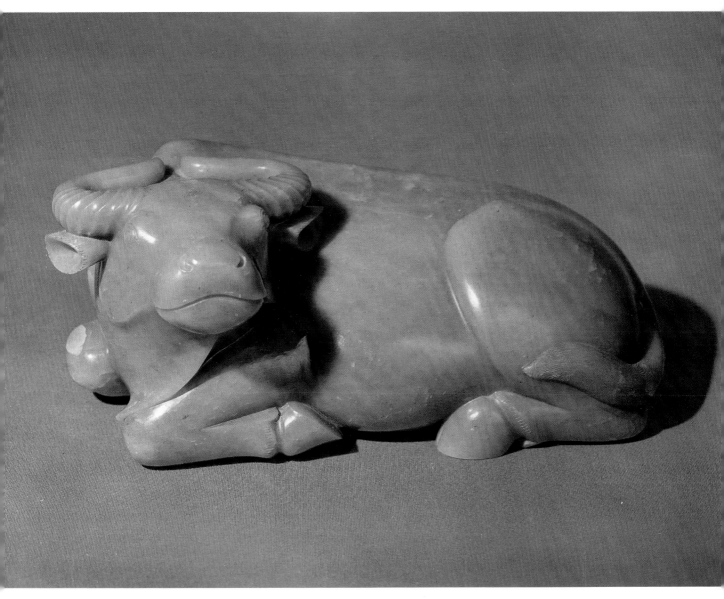

A green jade figure of a water buffalo, Ming Dynasty, length 14in, height 5¾in, weight 36lb 4oz
London £71,000 ($177,500). 15.III.73

Right
A **Ming** dragon bowl painted in underglaze-blue, six character mark of Lung Ch'ing within a double circle and of the period, 9in
London £10,000 ($25,000). 26.VI.73
Sold by order of the R.E.R. Luff Will Trust

Far right
An early fifteenth-century blue and white stemcup, six character mark of Hsüan Tê within a double circle inside the bowl and of the period, height 3½in, width 3⅞in
London £31,000 ($77,500). 13.III.73

Centre
An early Ming blue-ground dish, six character mark of Hsüan Tê in underglaze-blue within a double ring, fifteenth century, 10in
London £15,000 ($37,500). 13.III.73

Below left
An early Ming blue and white dish, early fifteenth century, 14⅝in
London £24,000 ($60,000). 26.VI.73
Sold by order of the R.E.R. Luff Will Trust

Below right
A **Ming** blue and white double-gourd vase, the lower bulb of cube shape. Six-character mark of Chia Ching in a recessed panel on the base and of the period, height 12⅝in, width 5⅞in
London £31,000 ($77,500). 13.III.73

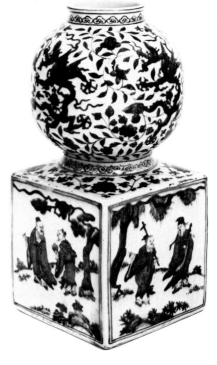

Centre
A Ming stemcup, Ch'êng Hua, diameter 6⅛in, height 4in
London £8,500 ($21,250). 12.XII.72
From the collection of W. W. Winkworth Esq

Top right
A Ming double-gourd vase painted in underglaze-blue and
iron-red on a yellow ground. Six character mark of Chia Ching
and of the period, height 8½in
New York $85,000 (£34,000). 28.IX.72
From the Thomas Barlow Walker Collection

Below left
A Ming fa hua Mei P'ing, the decoration predominantly in
turquoise, with details in aubergine and yellowish green on a
rich dark blue ground, *circa* 1500, 11⅞in
London £28,000 ($70,000). 13.III.73

Below right
A Ming fa hua jar glazed in turquoise, yellow and white on a
blue ground, the interior glazed camellia-leaf green, *circa* 1500
height 14in
New York $26,000 (£12,400). 28.IX.72
From the Thomas Barlow Walker Collection

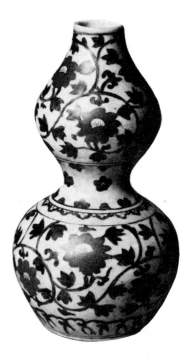

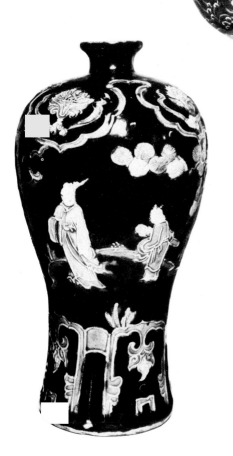

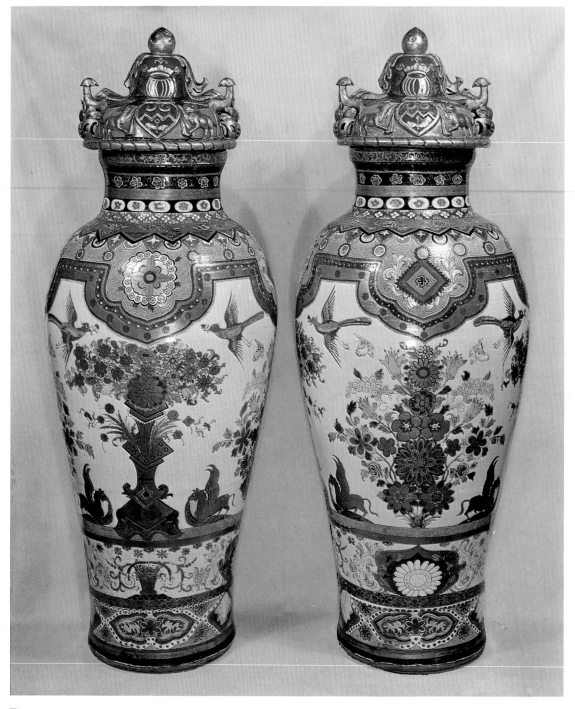

Fig 1
A pair of large armorial vases and covers enamelled in a *famille rose* palette, the covers moulded
with the arms of the Westphalian family of von Jabach, each side with the coat and supporters,
a lion and a griffin, without wings, on a green ground divided by the repeated eagle crest, partly
free-standing. Ch'ien Lung, 54in
London £12,000 ($30,000). 27.II.73
Formerly in the collection of the Duke of Arenberg

Stories in armorial porcelain

BY DAVID SANCTUARY HOWARD

Eighty-five years ago, in 1888, Messrs Sotheby, Wilkinson and Hodge held a sale in Brighton which included armorial porcelain. There were fifty-two lots at the beginning of the catalogue of the effects of the Reverend Charles Walker, entitled:

'*Oriental and European China, painted with Arms.*

This interesting variety of porcelain (hard paste) is often considered by Collectors to be Lowestoft China; but whether painted in England or China it forms a heraldic record of numerous old English County families of the XVIII century.'

An object lesson in the writing of a sales catalogue!

Fifty years ago this year, Putticks sold the collection of Frederick Arthur Crisp – more than one thousand one hundred pieces of porcelain from over four hundred services in three hundred and fifty lots. No wonder the twenty-three tureens averaged £6.30p each (the highest tureen price being for a piece from the Chase service £10.50p), and the eighty-four mugs averaged £4.12p (with again the highest price for Chase, £28.30p).

No doubt also the price was heightened by the belief that this service had been made for Samuel Chase, a signatory of the American Declaration of Independence; who was in fact distantly related but never used these arms, preferring his mother's. The real owner of the service lies buried outside the East window of the church of Much Hadham in Hertfordshire – Sir Richard Chase, a wealthy ironmonger of Gracechurch Street in London.

If we are not all wiser today we should be better informed, for Sotheby and Parke-Bernet catalogues this year have named over a hundred families who bought their porcelain in China including the most valuable of all armorial porcelain, the two great vases with the arms of Jabach, which so rightly had their place at the exhibition 'A Fanfare for Europe' (Fig 1).

Pieces from these services groaned under gourmet creations before the Governor of Bombay (Fig 2), tossed with the Admiral of the East India squadron off Trincomalee (Fig 3), were set before a Duke, a Bishop of Pôrto (Fig 4) and a Prince Bishop of Durham.

A punchbowl heard the noisy Francophobe toasts of the Anti-Gallican Society, a mug listened to the troubles of Lord Elgin (Fig 5), two dishes (Fig 6) had their moment of glory when the Czar of Russia landed at Dover in 1814 after a stormy crossing and was entertained by a Mr Fector, and one dish may have heard many of the sermons of Bishop Hoadley, who in forty years never visited the three great sees to which he had been appointed, but preferred to stay in London.

In January a dish of the de Vassey service in *famille verte*, dated 1702, was a rare collectors piece. In February the Canton enamel centrepiece (Fig 4) made for

Below

Fig 2

An armorial side plate decorated in *famille rose* enamels with
the arms of Bourchier. Ch'ien Lung, 6¼in

London £32 ($80). 31.x.72

This plate is from a service made for Richard Bourchier,
Governor of Bombay from 1750 to 1760, who died in 1770

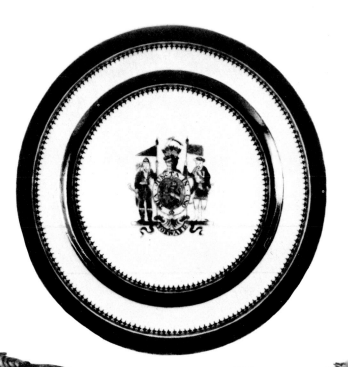

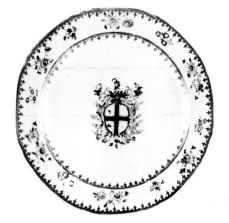

Top right

Fig 3

One of a pair of soup plates decorated in underglaze-blue in the
centre with the arms of Admiral Sir Edward Hughes, encircled
by a ribbon with the motto of the Order of the Bath above the
family motto FORWARD. Ch'ien Lung, 9½in

London £160 ($400). 31.x.72

Admiral Hughes, Commander-in-Chief, East Indies from
1773 to 1783, was present at the capture of Trincomalee in 1781
and died in 1794. William Hickie wrote in his *Memoirs* of the
dinner he had on the Admiral's flagship off Trincomalee.

Centre right

Fig 4

A Canton enamel armorial centrepiece of faceted boat shape
with wavy rim, set with four florette-shaped sockets decorated
in a *famille rose* palette with the arms of Fonseca, the four legs
as caryatids, the heads detachable, with European features.
Early Ch'ien Lung, height 10in, length 17¼in

London £4,600 ($11,500). 27.II.73

From the collection of Lady Henderson

The shape seems to be derived from an English silver épergne
of *circa* 1725–30, when English designs were frequently
adopted in Portugal. The arms are almost certainly those of
José Maria da Fonseca e Evora as Bishop of Pôrto.

Right

Fig 5

An armorial mug decorated with the arms of Nisbet of Dirleton
in Scotland. Ch'ien Lung, 5¾in

London £48 ($120). 28.XI.72

This mug was almost certainly made for William Hamilton
Nisbet whose only child, Mary, married in 1799 Thomas,
seventh Earl of Elgin, who was appointed that year
Ambassador to Constantinople and brought to England the
Elgin marbles.

José Maria da Fonseca e Evona, Bishop of Pôrto from 1739 to 1750, must be one of the most intricate pieces of Canton enamel ever made. It deserves a fine table and candlelight for its four candleholders, good wine and gay company, and may have seen all of these in the last two hundred and thirty years.

The same sale gathered together other rarities. The Dobree plate (Fig 7) was from one of only two known services, made for the two related Guernsey families of Andros and Dobree. The careful customers wrote the tinctures on the drawings of their arms before they were sent to China, and below the rose enamel is still the word 'green', and below the green, the word 'red'. No mention has previously been made of the service, although Andros is recorded in Williamson's 'Book of Famille Rose' after Cosmo Monkhouse's work of 1901. The Grill family of Sweden had at least six armorial services and Dr Roth of Gothenburg tells of a visitor to their estate in 1781 who wrote that 'broken pieces of china from plates, saucers, bowls in blue, red and white, pieces which had been unusually beautiful, now lie on all the paths in the garden', but this dish (Fig 8) survived to be catalogued as

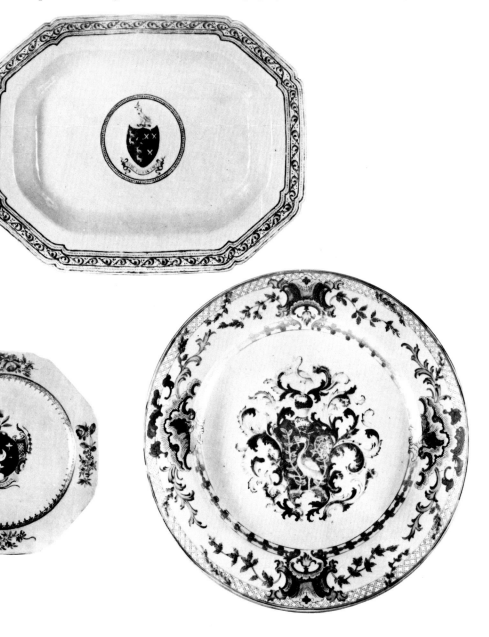

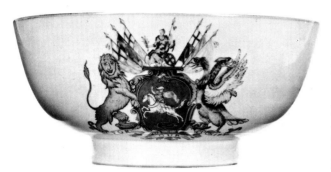

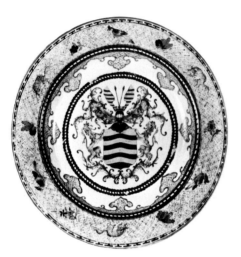

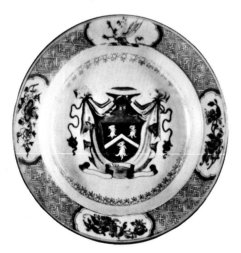

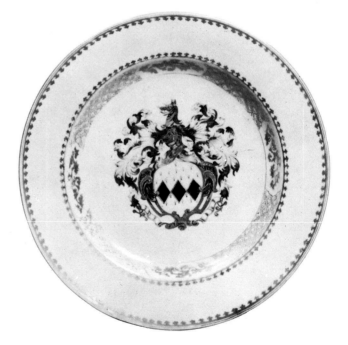

Left
Fig 9
An Anti-Gallican Society punch bowl decorated in *famille rose* enamels with the arms of the Society and the motto FOR OUR COUNTRY, and the crest, Britannia. Ch'ien Lung, 10¼in
London £1,800 ($4,500). 27.11.73

Centre left
Fig 10
An armorial plate painted in a palette of *rouge-de-fer*, yellow enamel, grisaille and gilding, with the arms of Van Hardenbroeck of the Province of Utrecht. Yung Chêng, 8½in
London £1,000 ($2,500). 27.11.73

Below left
Fig 11
One of a pair of *famille rose* soup plates with the arms of Peers, the rim with the crest. Yung Chêng, 8⅜in
London £360 ($900). 15.V.73
The service was made for Charles Peers of Chislehampton Lodge, the second son of Sir Charles Peers, Lord Mayor of London in 1715 and a director of the Hon. East India Company. The invoice for the service is still with the family and the duplicate is in the British Museum and lists 524 pieces for 228 taels (about £76); only three such invoices are known to survive.

Below right
Fig 12
One of a pair of armorial chargers painted with the arms of Pigot. Ch'ien Lung, 11⅝in
New York $550 (£220). 26.1.73

having ' . . . the everted rim with trailing turquoise leafy branches and puce feathery foliage radiating from four large rocaille motifs in yellow, grisaille and gilding'. (Eighty-five years later the catalogue writer's skill is not lost.)

Perhaps the most surprising price of that sale was the £1,800 paid for a 10-inch bowl of the Anti-Gallican Society (Fig 9); a much finer, larger bowl with a plate was sold in May 1954 at the Cecil Higgins sale for £18. The Society was formed in 1745 'to discourage the introduction of French modes and the importation of French commodities', and in 1751 one thousand members attended a divine service at Bow Church in Cheapside, followed by the annual meeting at the Grocers' Hall.

At the same February sale another superb eggshell Yung Chêng plate of the Van Hardenbroeck family of Utrecht sold for £1,000 (Fig 10), and this will be seen to be a very reasonable price in years to come, as were the two Peers plates of the same period and similar design sold on 15th May for £360 (Fig 11). Few services have been better recorded, for the family still possess the invoice of 1731 and a duplicate is in the British Museum.

At Parke-Bernet the Americana weeks of 24th to 27th January and 16th to 19th May were appropriately named as far as a number of lots of armorial porcelain were concerned. The saucer of the Ouchterlony service was painted with an urn with arms and looped handles modelled as maidens and copied exactly from a bookplate of 'Robert Ouchterlony' (British Museum, Franks Collection No. 22472), – part of his family settled in Boston, Massachusetts. The crest of Sinclair beneath an earl's coronet on a pair of coffee cups and saucers disguise a grim struggle for recognition by Captain James Sinclair of the Hon East India Company.

On the death of the 9th Earl of Caithness in 1765, the great nephew of the 8th Earl, Captain Sinclair, claimed the title, but this passed to a distant cousin because of a question of legitimacy. The son of this 10th Earl, Colonel John Sinclair, was wounded at Charlestown in the American War, and on his death in 1789 the title again passed to a distant relative. Only Captain Sinclair's armorial service achieved an earl's Coronet.

In the January Americana sale a large plate of the Pigot service (Fig 12) was a comparatively inexpensive heirloom of this opulent family at $550. George Pigot was Governor of Fort St George, Madras, from 1755–63 and again from 1775–77 after he had been created Baron Pigot of Patshull. He died, probably by violence while in temporary confinement in India in 1777. It was for him that Stubbs painted *A cheetah with two Indian attendants*, sold at Sotheby's in March 1970 for £220,000. This service too has American interest, for his brother Robert, who succeeded to his baronetcy, was gazetted Colonel after the Battle of Bunker Hill.

No armorial service has attracted more interest in the last few years than the Ker-Martin service. In Mr Crisp's sale a fine pair of pierced baskets sold for 9 guineas and a soup tureen and cover for 5½ guineas. In 1956 Sotheby's sold a 48 piece tea service for £800 and in 1968 a 9½ inch plate for £260. It would have surprised (and irritated) Mr Crisp to see another 9½ inch plate reach £950 in October 1972 (Fig 13).

Among the almost unrecognised pieces of armorial porcelain were the Marriott plate (Fig 16) made for Randolph Marriott of the East India Company who, as a civilian, won a gold medal under Clive at Plessey and later retired to England with a comfortable fortune, and a dish of the service made for James Caulfield, Earl Charlemont who was a founder Knight of the Order of St Patrick and had the chain of the Order painted on the rim of his underglaze-blue service (Fig 14).

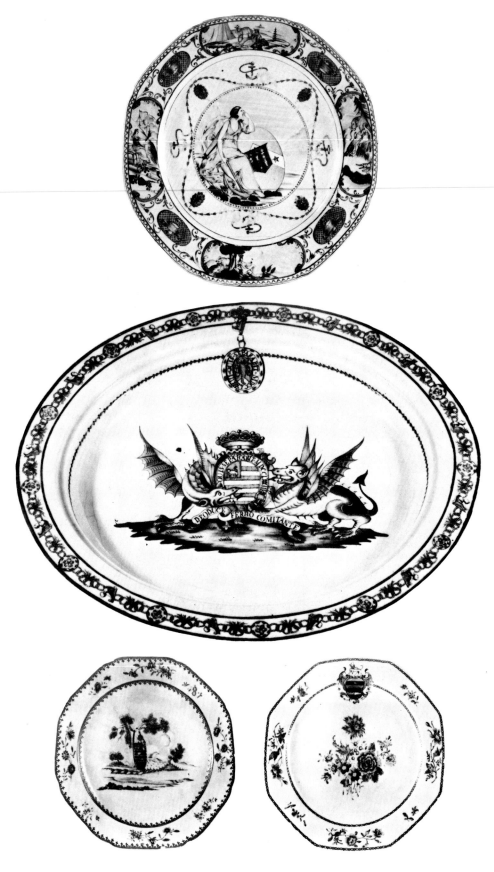

On May 1st however, two of the three lots of armorial porcelain returned home. A large and beautiful enamelled rose-water bowl was bought by Lord Harcourt whose ancestor ordered the service about 1740, and Mrs Wynyard from New Zealand acquired the dish with the arms of Wynyard impaling St Leger, made for Lieut-General William Wynyard who in 1758 married Kitty St Leger and whose grandson was Lieutenant Governor of New Zealand, her husband's ancestor.

On a more wistful note – there is armorial porcelain for all moods – the unusual plate of Clarke of Sandford (Fig 15) is decorated with what is probably a sandy ford, possibly the Sandford on the Thames where Nell Gwynn lived at Sandford Manor still then looking much as it must have been when she lived there.

Undoubtedly the most exciting, as well as the most valuable, sale of the season in armorial porcelain were the Jabach vases, where history was to balance, in a small measure, an account on 27th February. Even at the £12,000 these 54 inch vases were a good investment (Fig 1). At the time of the 'Fanfare for Europe' exhibition earlier in January, it was known only that they had once been in the collection of the Duke of Arenberg and bore a strange mixture of armorial bearings which were in part those of that ducal house. The best that can be said of their date is that they were made early in the reign of the Emperor Ch'ien Lung, and decorated in predominantly Chinese designs of about 1740, but with European griffins added. In the absence of any clear knowledge of their earlier provenance the arms alone could provide any clue.

The style of armorial bearing is earlier than the porcelain and may well be after a seventeenth-century original, while almost all the heraldic tinctures are incorrect so that presumably the original pattern was not in colour. In contrast to the careful painting of much of the decoration, the arms are clumsy and possibly copied from a very small original, for even the proportions and drawing of the two hands issuing from sleeves in the coat of arms make them seem more like eagle's claws (Fig 17) (perhaps this is not too surprising for nineteenth-century reference books were themselves unclear as to how the arms should be described).

But the coat is definitely that of the Westphalian family of Jabach while the supporters, a lion and a griffin without wings, and the coronet, appear to belong to the family of the Duke. Perhaps they were a gift from one family to the other or perhaps another error was made, as had been made on more than one occasion in China, and an earlier design sent out for copying with instructions to change the coat and add the supporters, was misinterpreted so that only the supporters were added while the coat remained the same.

In 1635 Everard Jabach, a German banker from Cologne, moved to Paris and at once found great success in his new country. So much so that in 1642 when Cardinal Richelieu took a leading part in founding La Compagnie des Indes Orientales, M Jabach was invited to become one of its financiers and founder directors.

Although the risk of total loss was always present in East Indian ventures, the profits were very high – frequently more than 100% on a two year voyage – and there is little doubt that M Jabach's involvement was a profitable one. But it was as a collector that he was to make his most spectacular investments in 1651 and 1653.

In England, trade with the East had become spasmodic because of the Civil War, and after King Charles's execution, Parliament decided that the King's collection of paintings and works of art should be sold. This attracted collectors and the agents of European princes in great numbers.

The sales realised £118,000, the equivalent of many millions of pounds today,

and purchasers included the Queen of Sweden, the Archduke Leopold William, and Cardinal Mazarin, while the largest buyer was the Spanish Ambassador in London, followed closely by M Jabach. Among the many paintings he bought were *The Entombment* by Titian, *Christ with the Disciples at Emmaus* by the same artist, and Correggio's *Jupiter and Antiope*. The Jabach collection was later sold to Louis XIV and his purchases are still in the Louvre.

Did Everard Jabach the banker, East India Company director and collector, himself order some vases from China which served as the original for those of the Duke of Arenburg? Was it possible that by accident or design the beautiful Ch'ien Lung vases were made exactly a century after the founding of La Compagnie des Indes Orientales and the vases presented by the banker's descendant to an illustrious client, but with these strangely marshalled arms? History at least must have smiled on 27th February when these works of art, with the arms of Everard Jabach were sold in London, three hundred and twenty years after he was purchasing there himself from the estate of the unfortunate King Charles. *Plus ça change....*

(David Howard is the author of *Chinese Armorial Porcelain* published in 1973 by Faber and Faber.)

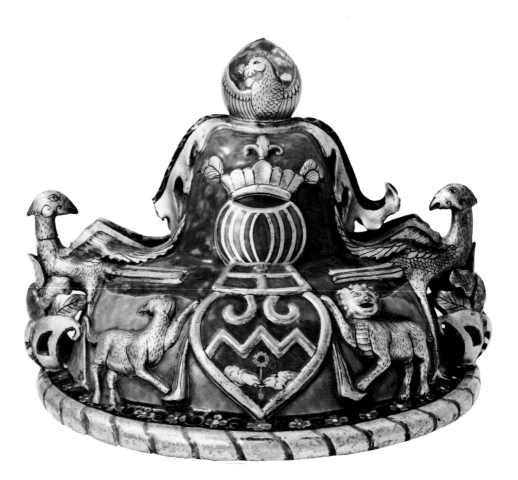

Fig 17
Detail of Fig 1

The Hans Popper Collection of Japanese prints

BY JACK HILLIER

Hans Popper (1904–71) was a man of refined taste with a variety of cultural interests. He was a serious musician to whose views some of the world's virtuosi deferred and he was a student of Western and Oriental art. He collected more particularly European paintings of the nineteenth and twentieth centuries, Chinese bronzes and ceramics, and Japanese prints.

Mr Popper originally visited Japan about twenty-five years ago, at which time he came under the spell of Japanese prints. After an initiation under the friendly guidance of Japanese connoisseurs, his own taste took over. He made his selection both as a scholar and as a collector; his choice was both informed and discerning, and the collection was recognised as one of the most notable to have been formed. Some measure of its importance can be gauged from the fact that seventy-one prints were selected for the 1970 Tokyo exhibition of 'Ukiyo-e Masterpieces in Foreign Collections'. When this collection was dispersed at a memorable sale at Parke-Bernet in October last, predictions made soon after the last war, that the time had passed for forming any considerable collection of Japanese prints, were disproved. On the other hand, it did fulfil another prophecy, made by a prominent dealer at about the same time and pooh-poohed by everybody as salesman's propaganda, that the prints of Utamaro and Sharaku would one day be valued as highly as those of Dürer and Rembrandt.

It would be easier to explain the failure of the first of these predictions if the late Hans Popper had been unique in bringing together so many fine prints at a time of supposed dearth, but great as his achievement was, at least a dozen other comparable collections have been formed since the war in America, in Europe (sadly, not in Britain) and, more recently, in Japan itself. Indeed, the fulfilment of the second prediction was simply the inevitable result of the widespread competition for prints of outstanding quality that had steadily intensified during this period.

The Popper collection followed a model upon which most have been constructed in modern times. The era of vast collections, such as those formed by the great French enthusiasts at the turn of the century, is irrevocably past. That happy band had a seemingly inexhaustible supply of prints to draw on: the Japanese entrepreneurs, like Hayashi and Wakai, scoured the country for the neglected and despised broadsheets for which the foreign barbarian had conceived so inexplicable a passion, and Vever and Haviland, Gillot and Gonse, accumulated prints literally by the thousand, often with the indiscrimination that came from what amounted to an infatuation with every object of Japanese art, and especially of the Japanese print, easily the most collectable.

The 1920s saw the break-up of many of these great hoards. The prints brought to

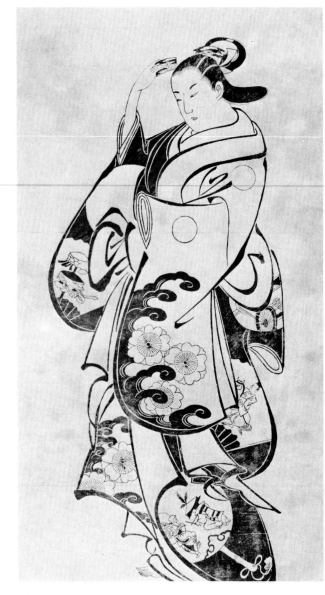

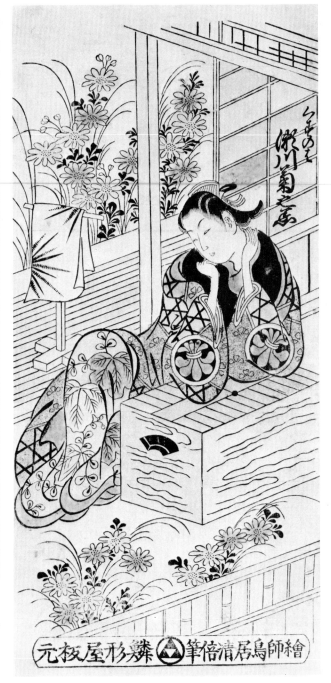

Fig 1

TORII KIYONOBU

Courtesan placing a comb in her hair. Ink print, *circa* 1705.
22in by 12⅝in. $800 (£320)

Fig 2

TORII KIYOMASU II

The actor Segawa Kikunojo as a woman in a play performed
in 1737. Lacquer print, hand coloured. 12½in by 6in. $1,800
(£720)

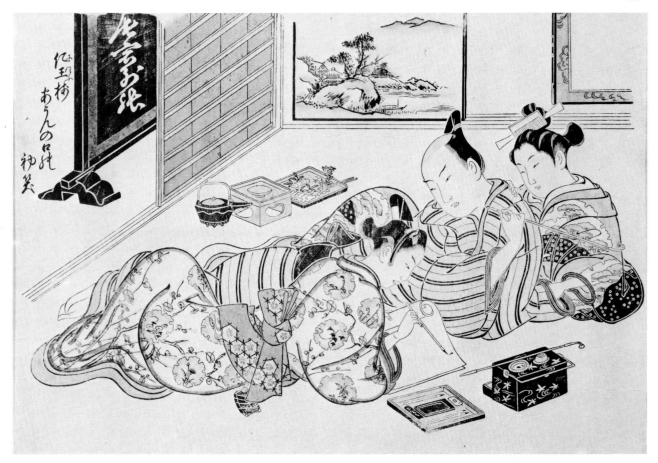

Fig 3
OKUMURA MASANOBU
A young fop writing, watched
by a man and a courtesan.
Ink print, hand coloured,
circa 1720. 9⅝in by 14¼in.
$8,750 (£3,500)

France by Henri Vever were repatriated by the industrialist Matsukata and through his generosity became the basis of the Tokyo National Museum collection; the Haviland collection was sold over a period of years in Paris in a series of sales that furnished the star exhibits of a score of embryo collections throughout the world. Paris, not London or New York, was for a time the centre of Japanese print auctions.

In the days of those pioneer collectors, almost any print had the allure of the exotic, the shock of an alien style in a medium startling in its non-naturalistic use of pattern and colour, and moreover, those princely amateurs could indulge their omnivorous tastes without a care for the taxman, death duties, posterity or the vagaries of the art market: some sought the famous prints, even if that meant accepting inferior impressions, others were obsessed by sheer numbers.

The complete antithesis to such almost random compilations was demonstrated in the collection of the American connoisseur Louis Ledoux. In the Foreword to the first volume (1941) of the splendid catalogue he drew up of his collection, Ledoux wrote: 'The collection of 250 Japanese prints formed by the writer has remained of the same size for more than twenty years because it has been his constant endeavour to improve its artistic quality rather than to increase the number of prints it contained. Whenever one print has been added another has been taken out . . .'. Post-war collectors have generally aimed to emulate Ledoux: the emphasis has been on 'distinction of subject, excellence of impression, excellence of condition, loveliness of colour'. Hans Popper, without the rather selfconscious fastidiousness of Ledoux, and allowing himself rather more latitude, succeeded in compiling a collection of rare distinction.

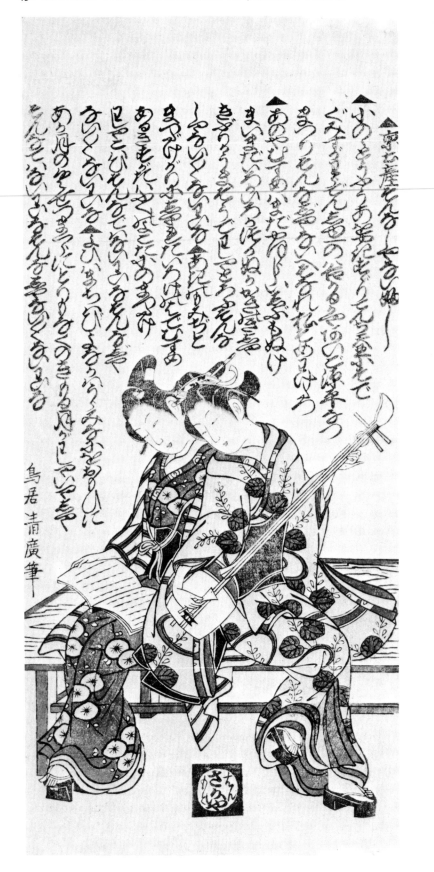

Fig 4
TORII KIYOHIRO
Girl playing a *samisen* and
youth singing the song
'Souvenir of Kyoto' written
above. Colour print, red and
green only, *circa* 1750. 12⅜in
by 5¾in. $3,200 (£1,280)

Opposite page
Fig 5
SUZUKI HARUNOBU
Lovers in the snow. Poly-
chrome print, *circa* 1768.
12¼in by 8¾in. $18,000
(£7,200)

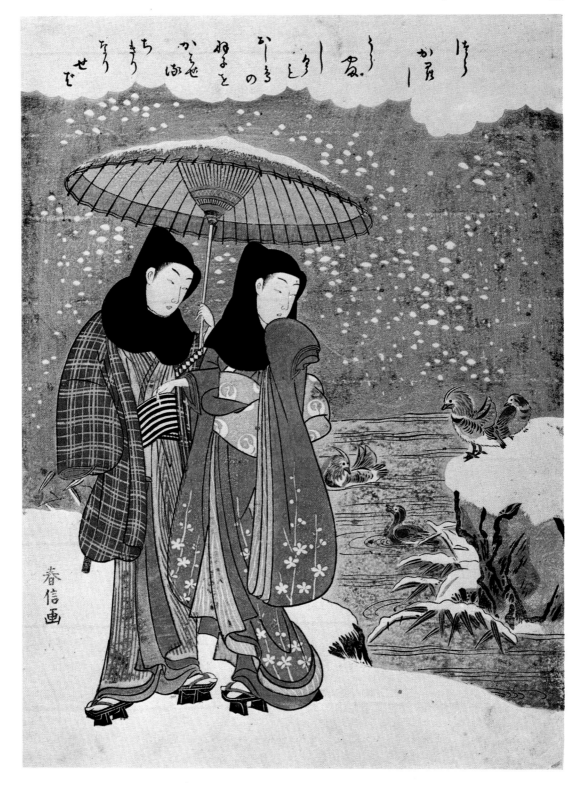

Even Ledoux, restricting himself to 250 prints, could not forbear, if they came his way, to admit disproportionate numbers of rarities, of the prints that other collectors covet most, and moreover, he allowed his own predilection for certain artists and his bias against others to prejudice what might generally be accepted as a representative cross-section, for instance, he had ten prints by Toyokuni but none by Kunimasa. Hans Popper, too, had strong feelings for particular artists and the sale catalogue reveals a passion for Harunobu, Utamaro, Hokusai and Hiroshige. What is more, he brought to his collecting a refined and catholic taste that, given the chance, ensured the acquisition of prints that are among the finest of those artists' works.

Although personal taste must operate, and indeed gives each collection its own *cachet*, the inevitable limitation in numbers tends to make each collection an epitome of the wide range of artists, styles and subjects encompassed by the Ukiyo-e, or 'Floating World' school in Japan, microcosm of an art form bewildering in its vastness and complexity. The Popper collection illustrated all phases of the Ukiyo-e movement. True, the large early prints of majestic figures outlined in massive strokes in black ink only, or hand-coloured, was represented not by the Kaigetsudo print that every collector vainly covets, but by a Kiyonobu, and possibly a 'pirated' print at that, lacking the artist's signature but following another well-known print that *is* signed (Fig 1): it still possesses all the strength and poise habitual to this type of print. The later phases of this so-called Primitive period are perfectly summarised in such prints as the interior with three figures by Okumura Masanobu (Fig 3) and the narrow print of the actor Segawa Kikunojo taking the part of a woman in a Kabuki play (Fig 2). The Masanobu print is, typically enough, from an album of erotic prints, a series of pictures of bedrooms of which this one shows the relatively innocent foreplay to the violent scenes of lovemaking that ensue in the rest of the album. The Kabuki print, by Kiyomasu II, a follower of the school that Kiyonobu founded, is a delightful example of the artistry the Ukiyo-e artists brought to their pictures of current, short-lived, plays. In these three examples, the courtesan by Kiyonobu, the erotic album by Masanobu, and the theatre print by Kiyomasu II, the whole gamut of the subject matter at this period is practically covered. Later, there was more straightforward genre, frequent parody or burlesque transcription of legend and poetry into scenes of everyday life, and later still, the introduction and development of landscape.

Towards the latter part of the Primitive period, colour, previously applied by hand, began to be printed from woodblocks, but for a time, it was confined to two colours only, red and green. The Kiyohiro (Fig 4) shows how the Japanese artists were instinctively able to make a virtue of what might have been thought a limitation, achieving, in this particular case with a backdrop of dancing calligraphy, a beautifully balanced decorative scheme.

In 1765 came the first fully polychrome colour-prints, the true *nishiki-e*, 'brocade prints', and Harunobu more than any other is the artist identified with the earliest work of this kind. Among the Popper prints it is not surprising to find some that had earlier belonged to Ledoux himself, and one of the loveliest is by Haranobu (Fig 5) full of gentle wistfulness and touching poetry exquisitely expressed by his design and the enchanting colour of his collaborator, the printer. The two lovers in the snow are encouraged (as the poem above tells) by the sight of the mandarin ducks, emblems of conjugal fidelity. There were twenty-four other prints by Harunobu in the Popper collection, most of them instinct with the qualities we sense as essentially and uniquely Harunobu, and clear evidence of the perfect *rapport* of the collector

Opposite page
Fig 6
SUZUKI HARUNOBU
Youth breaking off a branch of flowering cherry for a girl, a night piece. Polychrome print, *circa* 1768. 10$\frac{7}{8}$in by 8$\frac{1}{4}$in. $2,200 (£880)

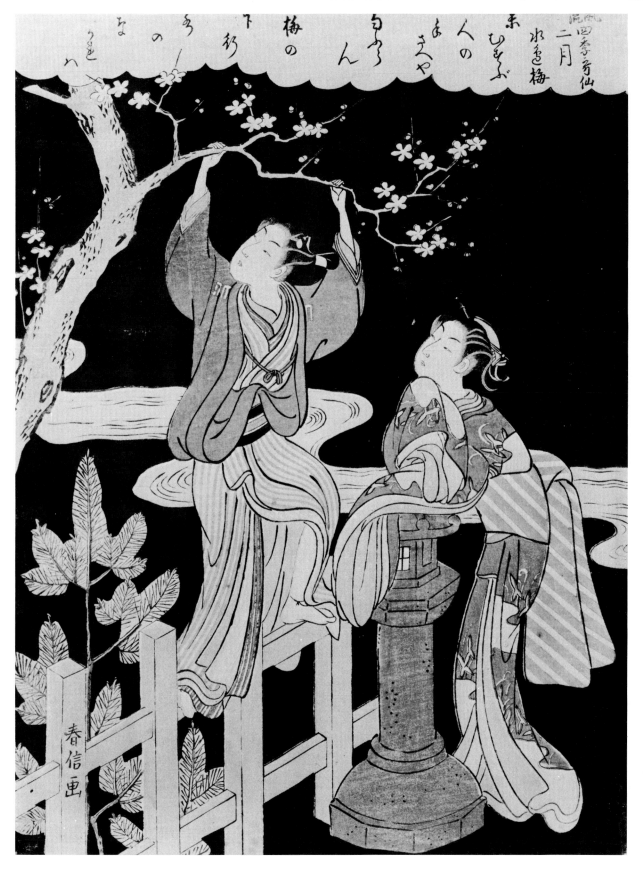

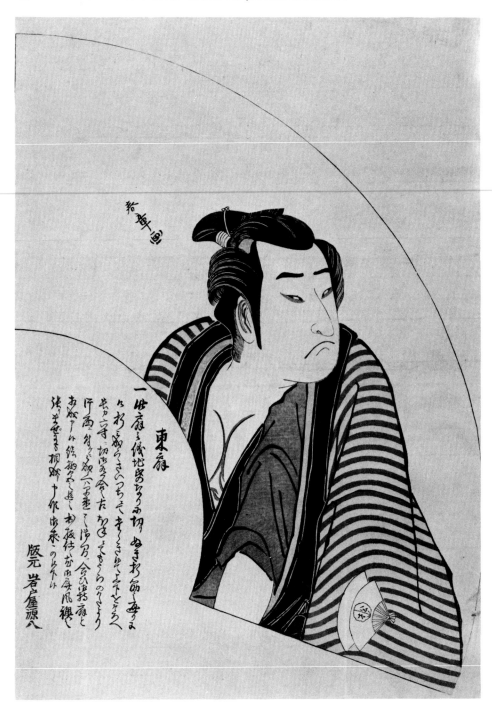

Fig 7
KATSUKAWA SHUNSHO
The actor Onoe Matsusuke.
Polychrome print, *circa* 1785.
18⅛in by 12⅞in. $1,900
(£760)

Opposite page
Fig 8
TOSHUSAI SHARAKU
The actor Otani Hiroji in
character. Polychrome print.
1794. 14in by 9½in.
$17,000 (£6,800)

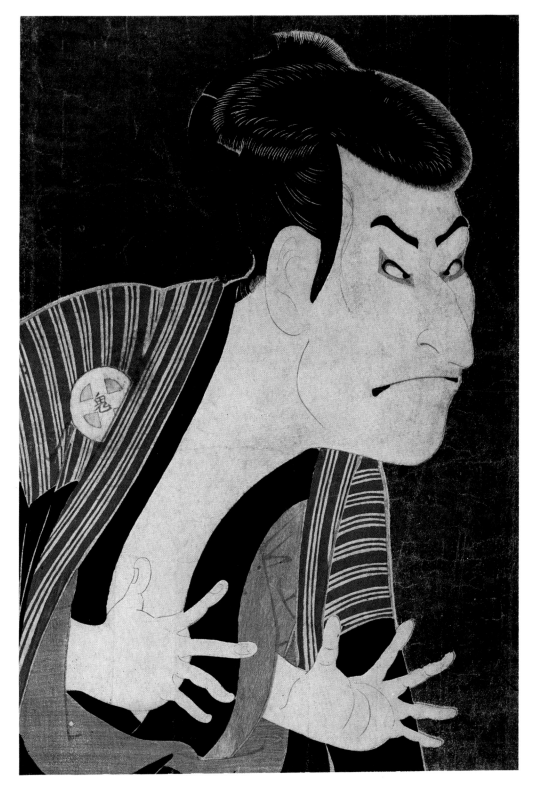

with this artist. The other print illustrated (Fig 6) showing a youth standing on a fence to break a bough of flowering cherry for a girl, is one of a small number where the figures are set against a night sky, whose velvety, impenetrable black is another of the printer's triumphs, with as much appeal as the richest colour.

Harunobu dominated his period in the 1760s, but a new wave of semi-naturalism in the treatment of the human form (at least compared with Harunobu's affectedly *petite* technique) led, through Koryusai and Shigemasa, to Kiyonaga, who imposed his style on every Ukiyo-e artist in the 1780s, and beyond that date. No more characteristic example of his mature work exists than the splendidly designed diptych (Fig 10) universally admired as one of the key masterpieces of the Japanese print. It depicts courtesans entertaining a young man in a room looking out over Shinagawa Bay: it sums up the popular notion (whatever may have been the sober fact) of the luxury, the parade of fashion, and the hedonistic mode of life generally, centred round the 'licensed quarters', which were so glamourised a feature of Edo low life.

From the numerous prints of the Katsukawa school, the most prolific designers in the late eighteenth century of prints of Kabuki plays and players, the exceptional print by Shunsho in the form of a fan has been chosen (Fig 7), displaying as it does the artist's superb sense of design, and also his unfailing capacity to capture the dramatic pose. In the mid-1790s this dramatic intensity was tautened to an extreme pitch in the astonishing creations of the enigmatic Sharaku, four of whose 'large heads', portraits of actors in current roles, were included in the sale. The print illustrated shows Otani Hiroji in the part of a belligerent manservant in a play performed in 1794: the dark mica employed in the background seems to throw up the features of the actor as if caught in the glare of footlights (Fig 8).

The mica ground was a mark of *de luxe*, and apart from Sharaku, the artist who relied most upon its use was Utamaro, another of Hans Popper's great favourites. Indeed, it could be argued that the outstanding prints of the collection were by this artist: certainly the two works illustrated here, the half-length portrait of the waitress Ohisa (Fig 11) and the picture of a girl using a hand-mirror as she applies cosmetic to her neck (a zone far more erogenic to the Japanese than to us) (Fig 12) are among the supreme masterpieces of the Japanese print; and bearing in mind their wonderful state of preservation, the world record price for the first ($37,000) and the next highest for the other, ($25,000) are understandable. Of course, neither of these prints today causes quite the shock that it brought to the amateurs and artists, mainly French, who encountered it in the years of flux in western painting in the second half of the nineteenth century: but who can doubt the influence of such daring design and *mise-en-page* upon such an artist as, say, Toulouse-Lautrec, whose poster of Aristide Bruant, for instance, reveals his debt to the Japanese master, and whose lithograph series *Elles* is to some extent explained by his known familiarity with Utamaro's erotica.

The eighteenth century did not see the end of the figure print, though the later designers never again reached the astonishing achievement of the 'Golden Decade' when not only Utamaro and Sharaku, but Choki, Shuncho, Shunman, Eishi, Eisho, Eiri, Shunko, Shunei, Tokokuni and Kunimasa – all artists of great stature – were at the height of their powers. It was through the genius of Hokusai and Hiroshige (and to a lesser degree, of Kuniyoshi, Eisen and Kunisada), that landscape now came into its own, and the contribution of these artists refutes the denigration of the nineteenth century by those critics who have termed it the period of 'Decadence'. The glorious

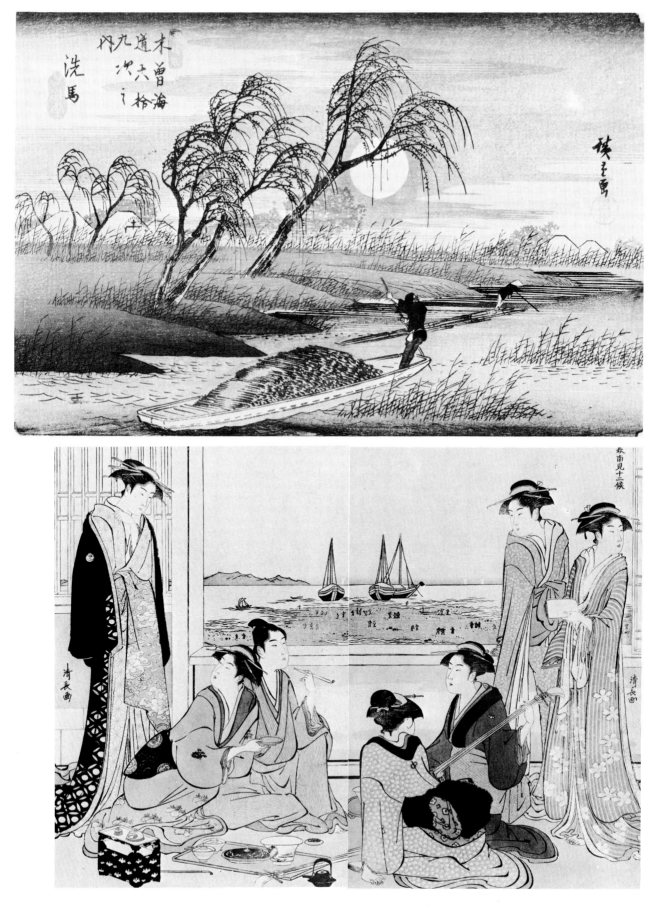

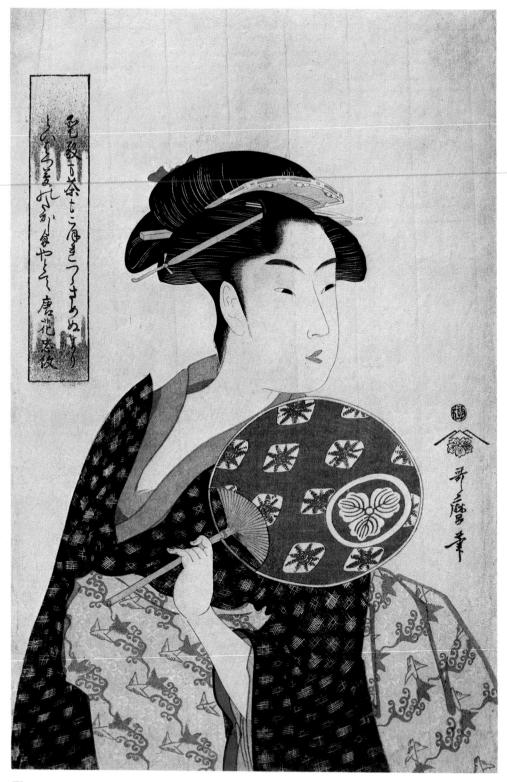

Fig 11

KITAGAWA UTAMARO
The waitress Ohisa. Polychrome print, *circa* 1793. 15in by 10in. $37,000 (£14,800)

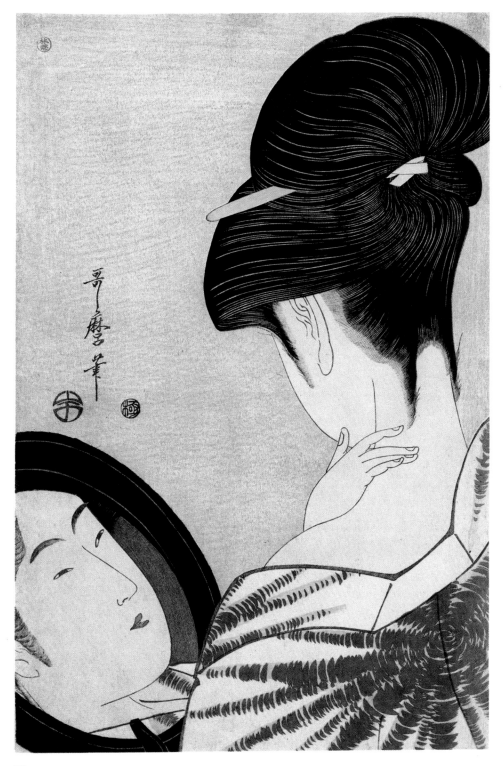

Fig 12

KITAGAWA UTAMARO
Girl making up at a mirror, Polychrome print, *circa* 1796. 14$\frac{7}{8}$in by 9$\frac{7}{8}$in. $25,000 (£10,000)

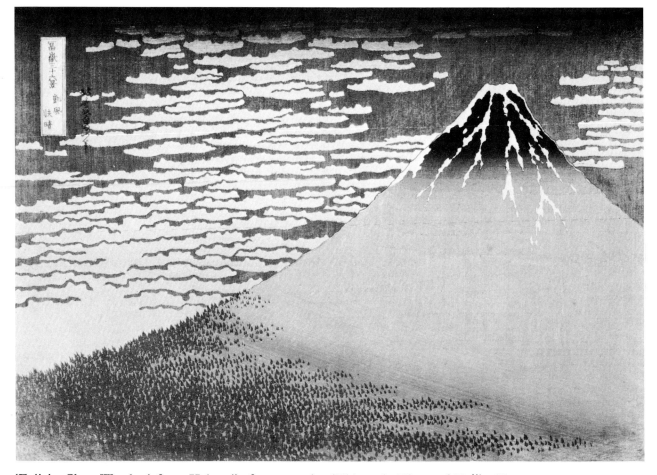

'Fuji in Clear Weather' from Hokusai's famous series 'Thirty-six Views of Fuji' (Fig 13) and Hiroshige's evocative moonlight scene of Seba, one of his set of the posting Stations on the Kisokaido, one of the main highways of Japan at the time (Fig 9), are works that continue to stir us as they did those first westerners to see them. They, and numerous other prints by Hokusai and Hiroshige, have always been irresistible desiderata to every collector, from the very first, down to those fortunate successors who acquired them in the auction sale last October.

Fig 13
KATSUSHIKA HOKUSAI
'South wind and clear sky' (or 'Fuji in clear weather') from the 'Thirty-six Views of Fuji' set, *circa* 1830. 10⅛in by 14½in. $12,500 (£5,000)

Japanese works of art

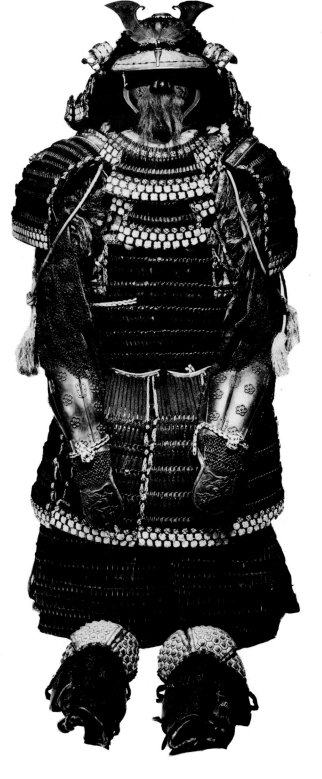

A suit of armour by
Myochin Munechika,
dated 1848
New York $20,000 (£8,000).
31.V.73

An early dated *Satsuma* vase and cover, painted by Seiko, marked in blue *Satsuma mon, Satsu-ma, Sei-ko ga, Bun-ka nen sei* (made in the reign of Bunka, 1804)
London £3,400 ($8,500). 21.VI.73

Opposite page

Left
A *Kakiemon* figure of a young man, late seventeenth/early eighteenth century, 39·5cm
London £10,800 ($27,000). 19.III.73

Opposite page
Above right
A *Nabeshima* saucer dish decorated in underglaze-blue and typical palette, the reverse with three groups of tasselled cash, the foot with comb design in underglaze-blue, eighteenth century, 14·4cm
London £2,200 ($5,500). 11.XII.72
From the W. W. Winkworth Collection
Formerly in the Stanley Smith Collection

Below right
A *Kakiemon* jar painted in bold enamels with small birds flying among flowering plants, late seventeenth century, 28·2cm
London £3,600 ($9,000). 19.III.73

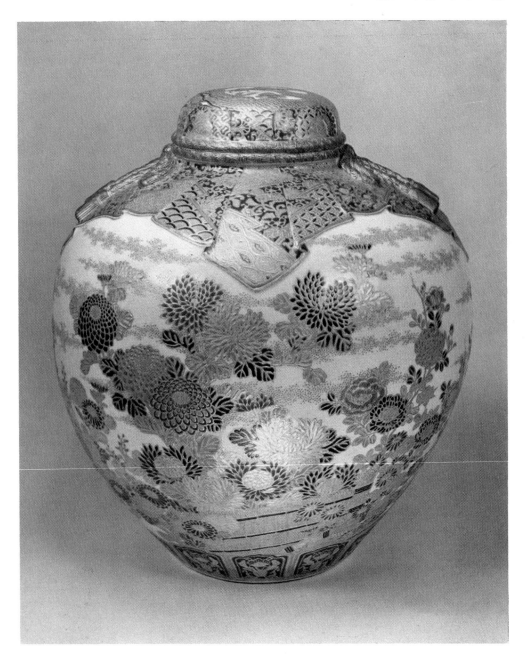

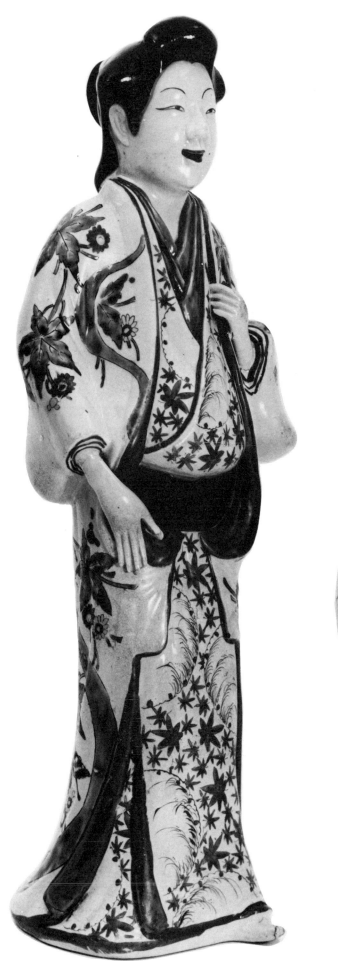

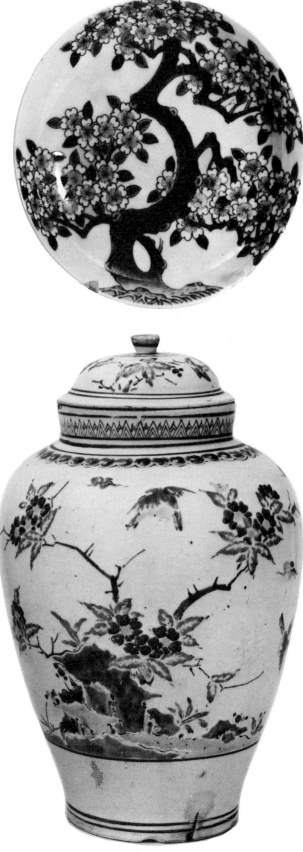

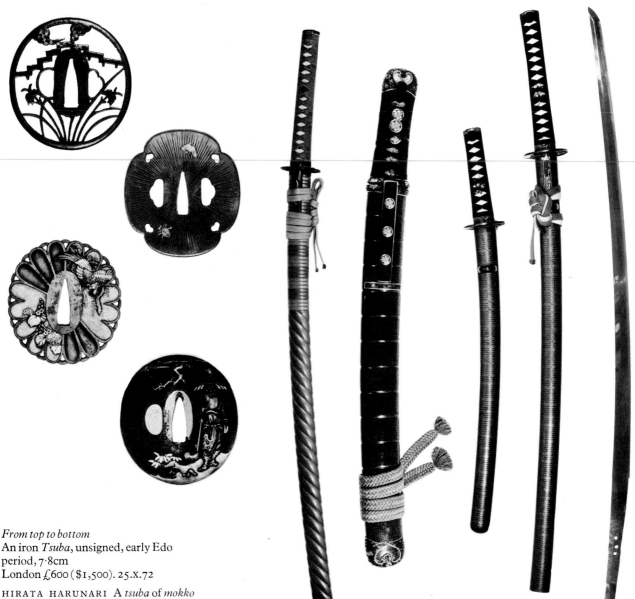

From top to bottom
An iron *Tsuba*, unsigned, early Edo
period, 7·8cm
London £600 ($1,500). 25.X.72

HIRATA HARUNARI A *tsuba* of *mokko*
form, decorated in cloisonné enamels,
signed, 7·8cm
London £1,700 ($4,250). 13.XII.72

A *tsuba*, the iron plate of *kiku* form,
applied in *shibuichi*, *shakudo*, copper,
silver, gold and cloisonné enamels, the
reverse with *shibuichi* panels of clouds,
signed *Hoshusei Seiko* with *kakihan*,
7·9cm
London £3,200 ($8,000). 17.VII.73

NARA TOSHINAGA A *shakudo nanako*
tsuba decorated in relief with details
inlaid in copper, *shibuichi* and gold, the
rim is cat-scratched gold and the *hitsu*
is plugged with gold, signed, 7·9cm
London £950 ($2,375). 25.X.72
From the collection of Henri Vever

From left to right
A *tachi* mounted as a *katana* signed *Kuni sumu hito Yoshinaga saku* length 72·1cm;
the mounts signed *Nishimura Mitsuyoshi*
London £4,200 ($10,500). 13.XII.72

An *aikuchi* by *Kinihiro*, length 30·9cm with *shakudo nanako* mounts of the Goto
School
New York $17,000 (£6,800). 31.V.73

A *daisho*, the *katana* blade signed *Musashi* (no) *kami Fujiwara Morimichi*, length
69·7cm; the *wakizashi* blade signed *Musashi* (no) *kami Morimichi*, length 46·6cm; the
mounts of soft metals signed *Omi Hikone ju Soheishi Niudo Soten sei*
London £3,700 ($9,250). 13.XII.72

A *tachi* blade by Aoe Suketsugu, signed *Bitchu* (no) *Kuni* (no) *Kami* (no) *ju Tosho Aoe
Suketsugu saku*, and dated a day in the sixth month of Showa 1 (1312), length 77·3cm
New York $70,000 (£28,000). 31.V.73

Above left A *suzuribako* decorated on the *mura-nashiji* ground in silver, brown, red and shades of gold *togidashi* with details in *kirikane*, early Edo period, 25·2cm by 23·6cm by 4·4cm £1,500 ($3,750)

Above right A *suzuribako* decorated on the *fundame* ground in gold *takamakie*, *aogai*, *kirikane* and silver, the inside cover with an *oki-hirame* ground, fitted with *suzuri*, early Edo period, 23·7cm by 21·5cm by 4·5cm £4,200 ($10,500)

Centre above
JUKEI DOJIN A *shakudo nanako kozuka* decorated in gold and *shakudo* relief, details in silver and copper, the reverse in *shibuichi* with a wavy linear design in gold *hirazogan*, the ends mounted with cat-scratched gold, signed £600 ($1,500)

Centre below
HIRATA HARUNARI and NARIMASA A *kozuka* decorated on a copper base in blue, white and green enamels, signed and dated 1847 £570 ($1,425)

Right
JOCHIKU A *shakudo* set decorated on a ground of imitation wood grain with wasps in copper and shakudo, signed £480 ($1,200)

Far right
TSU JIMPO A *shakudo nanako kozuka*, signed £640 ($1,600)
The lacquer illustrated on this page was in the collection of Henri Vever and was sold in London on 25th and 26th February 1973

KAIGYOKU MASATSUGU An ivory group of two puppies, signed £7,200 ($18,000). 6.XII.72

OHARA MITSUHIRO An ivory study of a goose, signed £3,300 ($8,250). 28.II.73

KAIGYOKU MASATSUGU An ivory study of an ape, signed £3,800 ($9,500). 23.X.72

TOMOTADA An ivory group of a tigress and cub, signed £3,200 ($7,550). 6.XII.72.

KANO NATSUO A *shibuichi ojime* in the form of a seated monkey, signed £7,000 ($17,500). 23.X.72

OKATOMO OF KYOTO An ivory study of a wolf, signed £2,800 ($7,000). 9.V.73

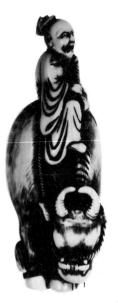

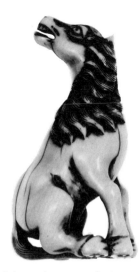

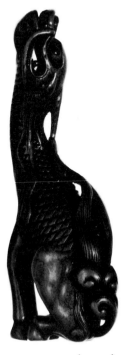

An eighteenth-century ivory figure of Roshi (Lao Tze) seated on an ox, unsigned £3,200 ($7,550). 28.II.73

An eighteenth-century ivory study of a seated horse £3,300 ($8,250). 28.II.73

TOMOTADA SCHOOL A wood model of a seated *kirin*, unsigned, eighteenth-century £2,200 ($5,500). 28.II.73

Pottery & porcelain

English pottery
English porcelain
Isnik pottery
Hispano-Moresque pottery
Maiolica
Continental pottery and porcelain
Studio pottery
Victorian porcelain

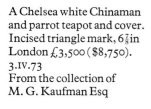

A Chelsea white Chinaman
and parrot teapot and cover.
Incised triangle mark, $6\frac{7}{8}$in
London £3,500 ($8,750).
3.IV.73
From the collection of
M. G. Kaufman Esq

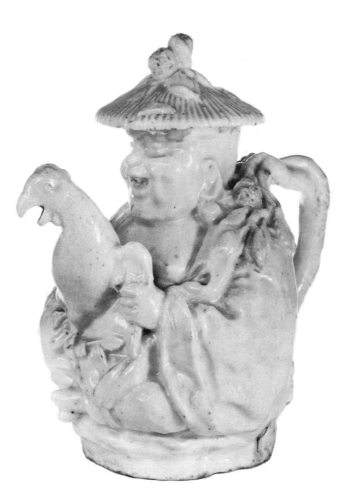

Right
A Lambeth Delft charger with an equestrian portrait of King William III, from an engraving by Cornelius van Dalen, $17\frac{1}{8}$in
London £2,000 ($5,000).
17.IV.73
From the collection of Mrs E. Moore

Below left to right
A dated Lambeth Delft pot modelled in the form of a well-fed cat. Medallion inscribed *M. B. 1671*, 6in
London £2,500 ($6,250).
17.IV.73
From the collection of M. Leatherdale Esq

A Lambeth Delft cup with the arms of the Bakers' Company and the company's motto. Initials *R.S.M.*, dated 1669 in blue, 4in
London £1,900 ($4,750).
24.X.72

A Lambeth Delft tavern punch bowl painted on the exterior with a continuous landscape, the interior with a heraldic swan. Initials *R.A.M.*, dated 1718, $11\frac{1}{2}$in
London £2,700 ($6,750).
9.I.73

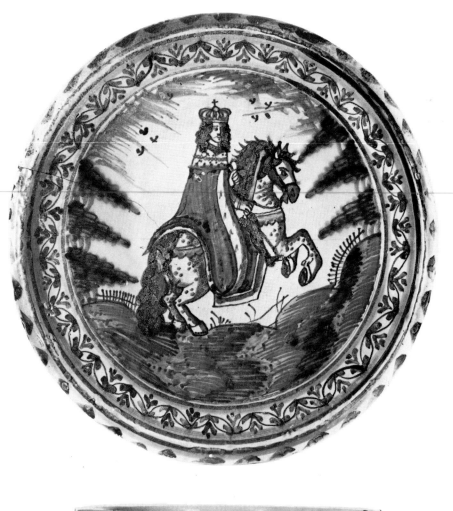

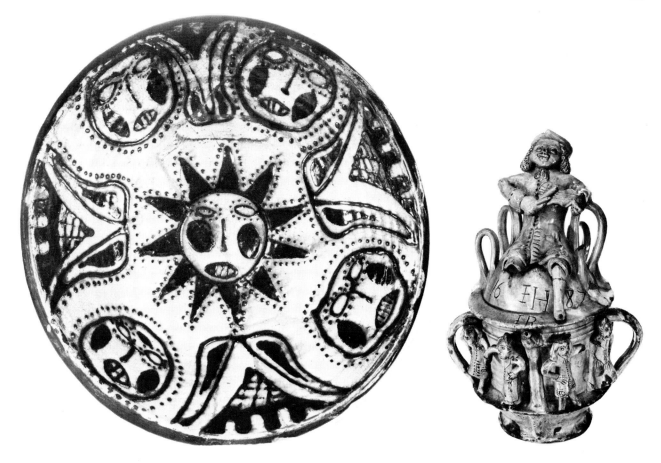

Above
A slipware dish decorated with naively drawn repeated face
motifs, 16½in
London £1,000 ($2,500). 30.v.73

Below
A Wrotham tyg by Henry Ifield, inscribed with initials and the
date 1664, 4⅞in
London £1,500 ($3,750). 24.x.72
From the collection of Mr and Mrs Walter Godfrey

Above
A West Country posset pot and cover, the body divided by a
frieze of male and female figures, dated 1687, 16in
London £1,700 ($4,250). 17.iv.73

Below centre
A medieval jug modelled in the form of an imp-like figure with
long arms and webbed hands. Fourteenth century, 4¾in
London £2,300 ($5,750). 9.i.73

Below
A silver-mounted 'Malling' jug, the mount stamped with
arabesques, 4½in
London £1,400 ($3,500). 9.i.73
From the collection of R. Brandt Esq

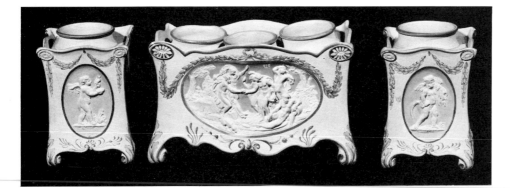

Opposite page
Above
A Wedgwood caneware garniture of three crocus pots and covers. Central piece impressed *wedgwood* and *K*, other pieces impressed *WEDGWOOD* and *M*, heights 4½in and 4¾in
New York $3,750 (£1,500). 30.III.73

Centre left
A Wedgwood and Bentley conjoined portrait medallion of Timothy and Elizabeth Bevan, by Silvanus Bevan. Impressed *Wedgwood & Bentley*, incised *Tim. Bevan & Wife*, 3¼in
London £1,900 ($4,750). 17.IV.73
From the collection of S. S. Lockhart Esq

Below left
One of a pair of Wedgwood black basaltes sphinx candlesticks. Impressed *Wedgwood and S*, *circa* 1780–98, 10in
New York $1,900 (£760). 30.III.73

Right
A Wedgwood *lekythos* from a set believed to have been purchased by the 3rd Marquess of Lansdowne in 1815, the designs taken from examples of Etruscan antiquities collected by Sir William Hamilton. Impressed mark, pencil numeral 17, 20¼in
London £1,050 ($2,625). 9.I.73
From the collection of the Most Hon. the Marquess of Lansdowne, PC

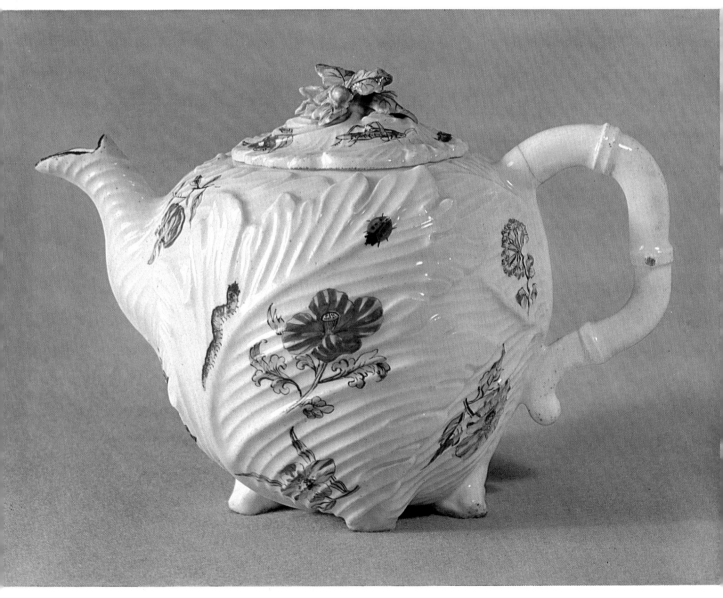

A Chelsea coloured acanthus leaf teapot and cover. Incised triangle mark, 4¾in
London £4,600 ($11,500). 3.IV.73

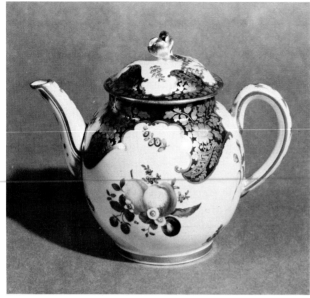

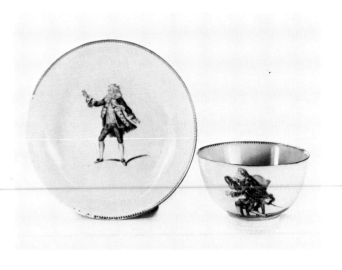

A Worcester claret-ground teapot and cover, from the Hope-Edwards service. First period, 6in
New York $5,000 (£2,000). 2.XI.72
From the Cadman Collection

A Worcester puce-decorated 'Grubbe' plate painted in the atelier of James Giles. First period, 8¾in
London £1,400 ($3,500). 17.X.72
From the collection of H. R. Creswick Esq

A Worcester teabowl and saucer painted with David Garrick as King Lear and as Sir Harry Wildair. First period.
London £750 ($1,875). 3.IV.73

A Worcester mug painted with the arms of Davenport impaling Talbot. First period, 4¾in
London £1,250 ($3,125). 17.X.72
From the collection of Dr J. Gibbs

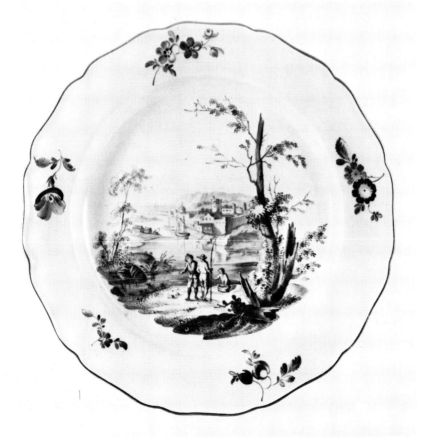

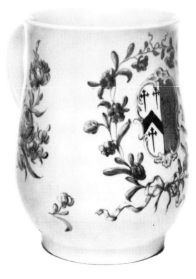

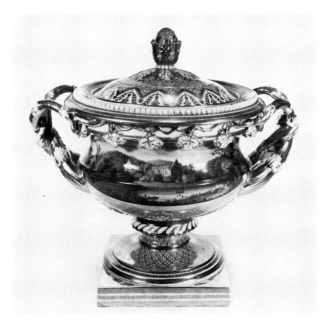

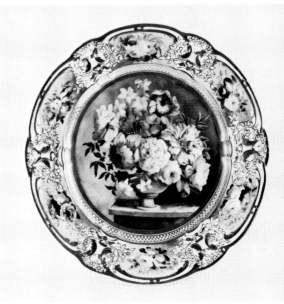

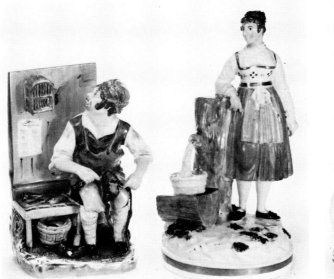

A set of six Spode tulip cups on a Spode pottery stand. Five cups marked *Spode* in red, 2¾in, the stand with Spode mark in red and impressed, 12in
London £820 ($2,050). 3.IV.73

Above left
A comport from a Chamberlain's Worcester landscape dessert service comprising 31 pieces. Script marks in iron-red
London £1,800 ($4,500). 8.V.73

Above right
A London-decorated Nantgarw plate. Impressed mark *NANT-GARW C. W.*, 9¾in London £1,200 ($3,000). 8.V.73

Below from left to right
A Rockingham figure of a cobbler, *C*3 in red, No 39 incised, 5¾in
London £340 ($850). 23.I.73
A Rockingham figure *Paysanne de Sagran en Tirol.* Impressed mark *Cl.2* in ochre, incised No 22, 7in
London £320 ($800). 23.I.73
A pair of Rockingham figures of a shepherd and shepherdess. Full impressed marks, both incised No 4, 7in and 8¼in
London £440 ($1,100). 8.V.73. The figures illustrated on this page are from the collection of Mrs B. M. L. Llewellyn

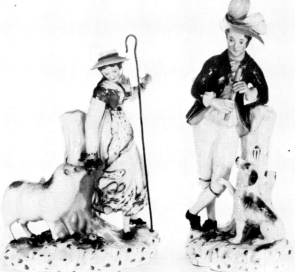

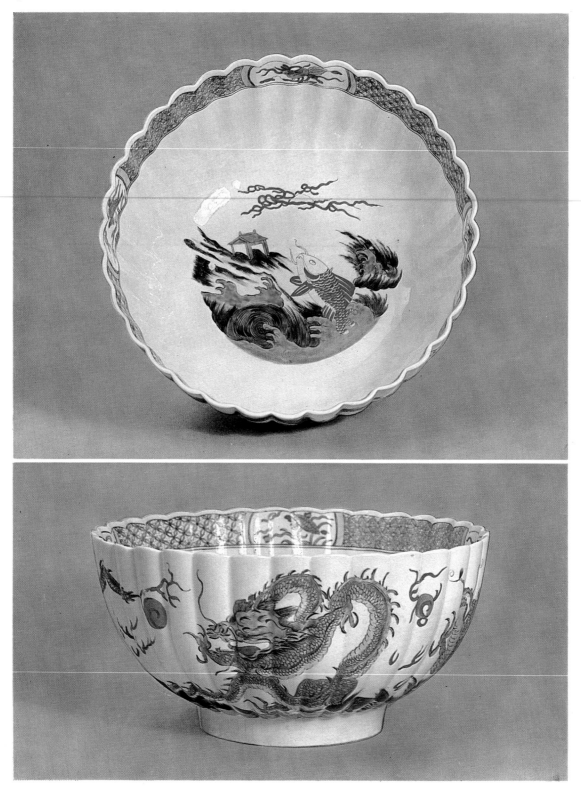

A Worcester *famille verte* bowl painted with a faithful copy of a Chinese K'ang Hsi original.
First period, 9¼in
London £5,200 ($13,000). 3.IV.73
From the collection of Mrs Donald J. Morrison

A Castel Durante dish from the Gonzaga-Este service painted by Nicola Pellipario, with Aeneas carrying his father Anchises from burning Troy, his son Ascanius following behind, taken from an engraving by the Master of the Die after Raphael, *circa* 1519, 10½in
London £20,000 ($50,000). 20.III.73
From the collection of Dr Giuseppe Caruso. Formerly from the Morosini Collection, Venice, the Mannheim Collection, Paris, the J. Pierpont Morgan Collection, and the William Randolph Hearst Collection.
This plate belongs to the service made for Isabella d'Este, wife of Gianfrancesco Gonzaga, marquis of Mantua, of which other examples are in the Victoria and Albert.Museum, the British Museum, the Fitzwilliam Museum, Cambridge, and many other collections.

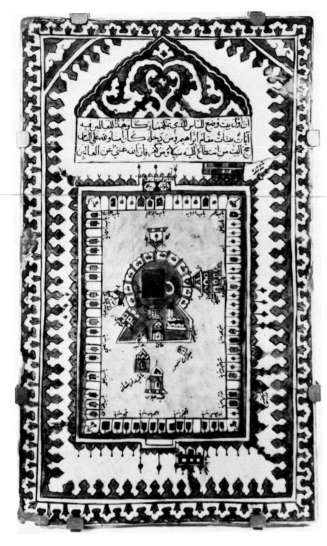

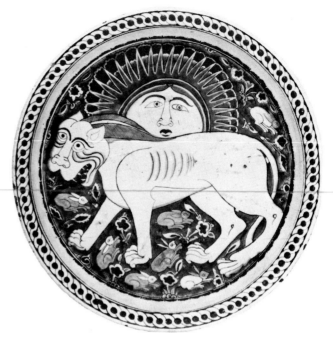

An Isnik topographical tile decorated with a plan of the Bait
Allah or Sacred Mosque at Mecca and a verse from the Koran.
Second half of the seventeenth century, 23⅝in by 14⅛in
London £1,800 ($4,500). 20.III.73
From the collection of Dr Giuseppe Caruso

Above right
An Isnik pottery dish decorated with a medallion with the
royal emblem of the Seljuk Sultans. Late sixteenth century,
diameter 14¾in
London £8,000 ($20,000). 4.XII.72

Right
An Isnik pottery pitcher painted with lobed cartouches
containing intertwining foliate arabesques. Second half of the
seventeenth century, 9in
London £1,900 ($4,750). 4.XII.72

Above
A Hispano-Moresque armorial charger, the border painted with flowers and scrolling leaves. *Circa* 1560, 16¾in
London £2,900 ($7,250). 5.XII.72

Right
A Hispano-Moresque *albarello*. Second half of the fifteenth century, height 10¾in
New York $5,250 (£2,100). 26.IV.73
From the collection of the late Sydney N. Blumberg

Far right
A Hispano-Moresque *albarello*. Mid-fifteenth century, 12¾in
New York $5,000 (£2,000). 26.IV.73
From the collection of the late Sydney N. Blumberg

A Castel Durante *istoriato* dish painted by a member of the circle of Nicola da Urbino and
Francesco Xanto Avelli. *Circa* 1520–30, 13¾in
London £12,000 ($30,000). 20.III.73
From the collection of Dr Giuseppe Caruso

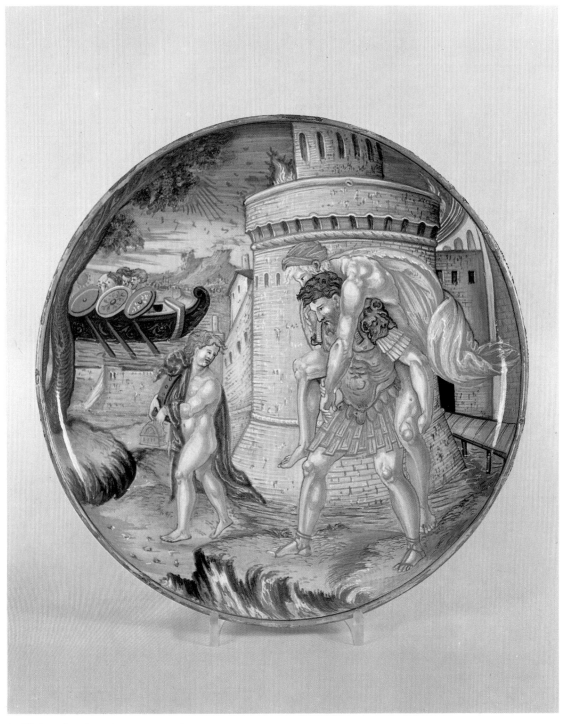

An Urbino *istoriato* dish lustred at Gubbio and painted by Francesco Xanto Avelli. Signed and dated 1532, 10½in
London £20,000 ($50,000). 20.III.73
From the collection of Dr Giuseppe Caruso

From left to right

Above

A Gubbio moulded and lustred tazza, the convex centre moulded with the emblem of St Mark the Evangelist, probably by Maestro Giorgio Andreoli, *circa* 1520, 9¾in
London £3,400 ($8,500). 20.III.73
From the collection of Dr Giuseppe Caruso

A Faenza 'sybil' dish by the 'St John painter'. *Circa* 1520, 10½in
London £11,600 ($29,000). 20.III.73
From the collection of Dr Giuseppe Caruso

Centre

An Urbino *istoriato* dish depicting Dido and Aeneas, perhaps by Francesco Xanto Avelli. *Circa* 1535–40, 11in
London £6,000 ($15,000). 20.III.73
From the collection of Dr Giuseppe Caruso

An Urbino *istoriato* dish depicting Isaac blessing Jacob, by Francesco Xanto Avelli. Signed and dated 1536, diameter 14½
New York $9,000 (£3,600). 23.III.73

Below

An early *sgraffiato* dish decorated with three young men in a fenced garden with two rabbits. Veneto, perhaps Padua, mid-fifteenth century, 15in
London £2,900 ($7,250). 20.III.73
From the collection of Dr Giuseppe Caruso

A Faenza *istoriato* dish depicting an eccentric version of the *Judgement of Paris*. *Circa* 1525, 10¼in
London £3,800 ($9,500). 20.III.73
From the collection of Dr Giuseppe Caruso

A Florentine drug-pot painted with a bird among oak leaves.
Mid-fifteenth century, height 7¾in
New York $15,000 (£6,000). 26.IV.73
From the collection of the late Sydney N. Blumberg

A Faenza portrait *albarello* painted with the head and shoulders
of a young man seen in profile. *Circa* 1475–80, height 10in,
width 7½in
London £3,800 ($9,500). 20.III.73
From the collection of Dr Giuseppe Caruso

A Faenza wet drug jar and cover, the spout flanked by
portraits of two women in profile. *Circa* 1520, 10¾in
London £3,100 ($7,750). 22.V.73

A Faenza wet drug jar, the spout in the shape of a dragon's
head, the neck flanked by busts of bearded men. *Circa* 1525,
10¾in
New York $5,250 (£2,100). 26.IV.73
From the collection of the late Sydney N. Blumberg

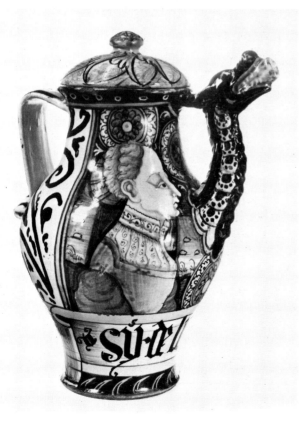

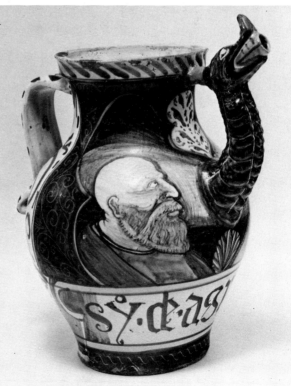

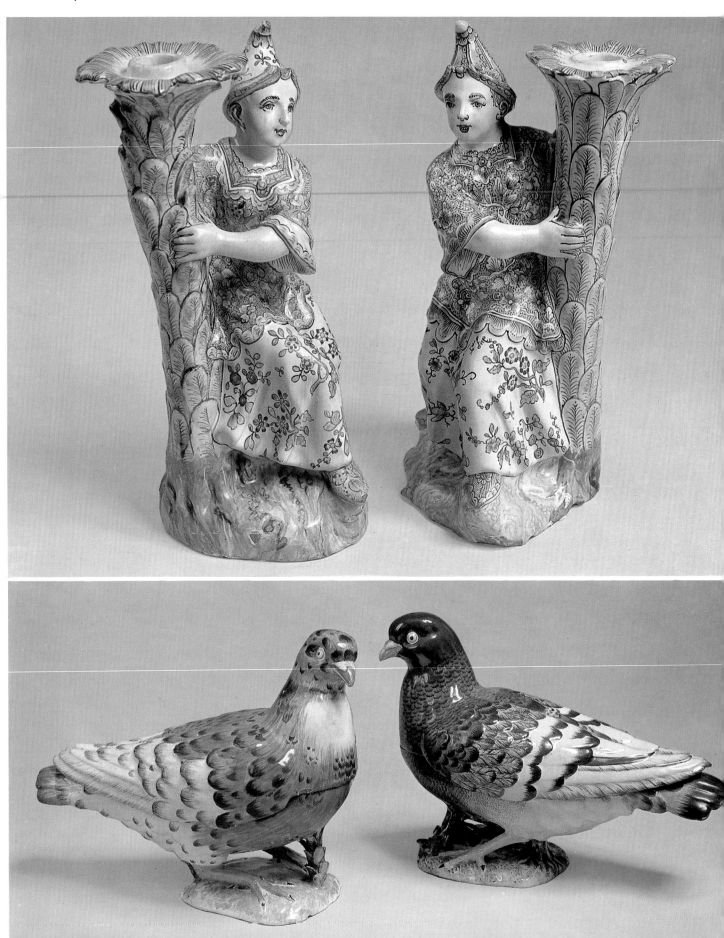

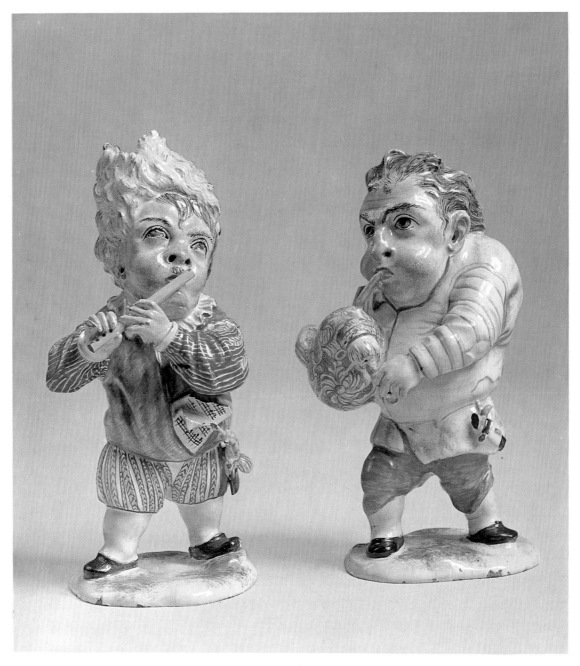

A pair of Niderviller figures of dwarfs as musicians. *Circa* 1755–60, 5¾in and 6⅛in
Zurich SF40,000 (£4,988; $12,470). 6.IV.73

Opposite page Above
A pair of Strasbourg *chinoiserie* candlestick figures by J. W. Lanz. Period of Paul Hannong, 10⅞in
Zurich SF50,000 (£6,234; $15,585). 6.IV.73

Below
A pair of Strasbourg pigeon tureens and covers modelled by J. W. Lanz. Numbered i0 and i3
twice on each, period of Paul Hannong, 9⅞in
Zurich SF200,000 (£24,938; $62,345). 6.IV.73

A pair of Sèvres *bleu céleste
seaux-à-bouteilles* from the
Catherine the Great service.
Interlaced *L*s and date letters
AA for 1778, unidentified
painter's mark *FB*, incised
numerals 4, one incised *IP*,
6¾in $30,000 (£12,000).

Below
A Sèvres *rose Pompadour* and
green *vase à oignon*. Inter-
laced *L*s and date letter *G* for
1759, painter's mark for
Taillandier in blue, 6¼in
$20,000 (£8,000). The
porcelain illustrated on this
page came from the collection
of Mr and Mrs Deane
Johnson and was sold in New
York on the 9th December
1972

Below right
A Chantilly pagoda figure
with kakiemon decoration.
Circa 1735–45, height 8¼in
$20,000 (£8,000).

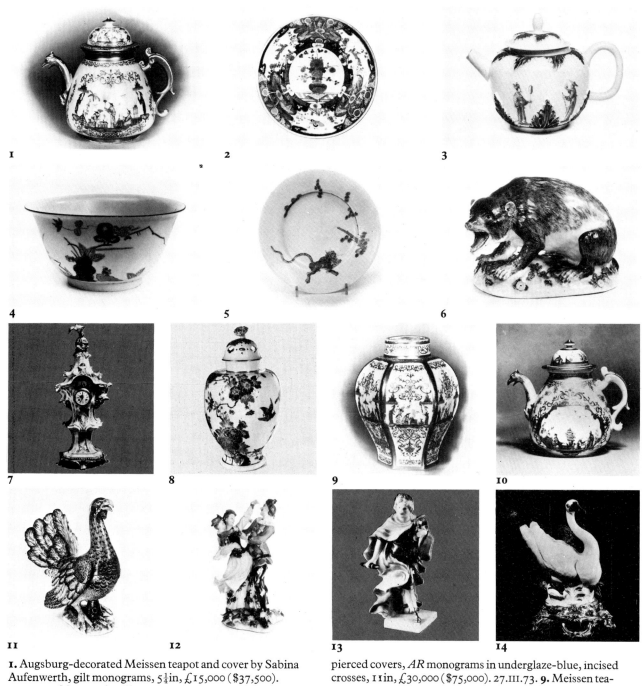

1. Augsburg-decorated Meissen teapot and cover by Sabina Aufenwerth, gilt monograms, 5¼in, £15,000 ($37,500). 7.XI.72. **2.** Meissen *famille verte* dish, large crossed swords mark in underglaze-blue, *circa* 1728–30, diameter 13½in, $9,000 (£3,600). 6.VI.73. **3.** Böttger teapot and cover, 4in, £2,800 ($7,000). 27.III.73. **4.** Early Meissen kakiemon bowl of Böttger paste, 7in, £1,500 ($3,750). 10.VII.73. **5.** Meissen red tiger plate, crossed swords mark in blue enamel and Johanneum number *N 72 W*, 9in, £2,000 ($5,000). 10.VII.73. **6.** One of pair of Meissen badgers by J. J. Kaendler, crossed swords mark in underglaze-blue, impressed numerals 42, length 7½in, $15,000 (£6,000). 6.VI.73. **7.** Early Meissen *chinoiserie* clock case by J. G. Kirchner, *circa* 1727–8, crossed swords mark in underglaze-blue, 21in, $19,000 (£7,600). 9.XII.72. **8.** One of pair of Meissen Augustus Rex vases and

pierced covers, *AR* monograms in underglaze-blue, incised crosses, 11in, £30,000 ($75,000). 27.III.73. **9.** Meissen tea-caddy and cover by Sabina Aufenwerth, gilt-monogram, 4¼in £10,000 ($25,000). 7.XI.72. **10.** Meissen *chinoiserie* teapot and cover, *circa* 1724, *KPM* mark in underglaze-blue and crossed swords in blue enamel, gilder's numeral 63, 5½in, $10,000 (£4,000). 16.II.73. **11.** Strasbourg capercailzie tureen and cover, some restoration, 20¾in, £7,500 ($18,740). 5.XII.72. **12.** Meissen group of the Harlequin family by J. J. Kaendler, 7¼in, £5,600 ($14,000). 7.XI.72. **13.** Meissen figure of Augustus the Strong, *circa* 1735–40, 4in, $6,000 (£2,400). 9.V.73. **14.** One of pair of Meissen ormolu-mounted swans, *circa* 1747, the ormolu with crowned C excise marks, 13in, $85,000 (£34,000). 9.XII.72

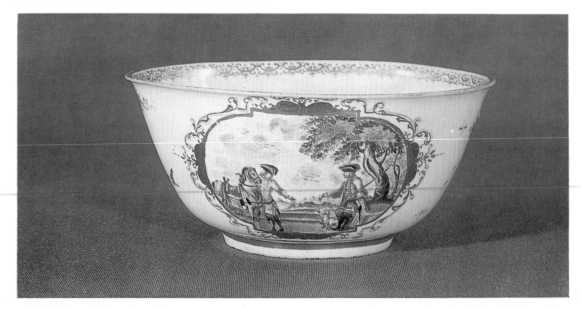

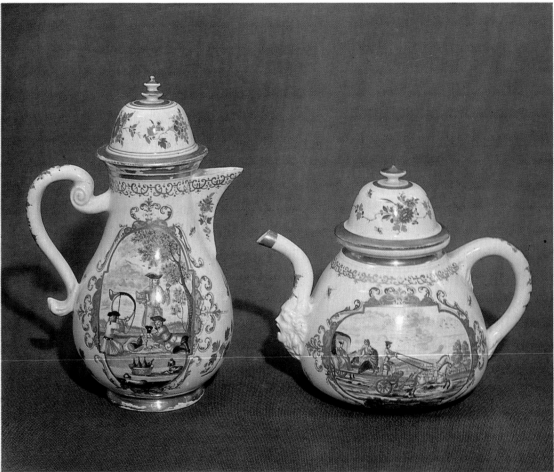

An early Meissen tea service with hunting scenes, painted by Johann Gregor Höroldt, comprising 21 pieces. *Circa* 1723, teapot and sugar box marked *KPM* in underglaze-blue, teabowls and saucers with the numeral 5 in so-called lustre
London £28,000 ($70,000). 10.VII.73

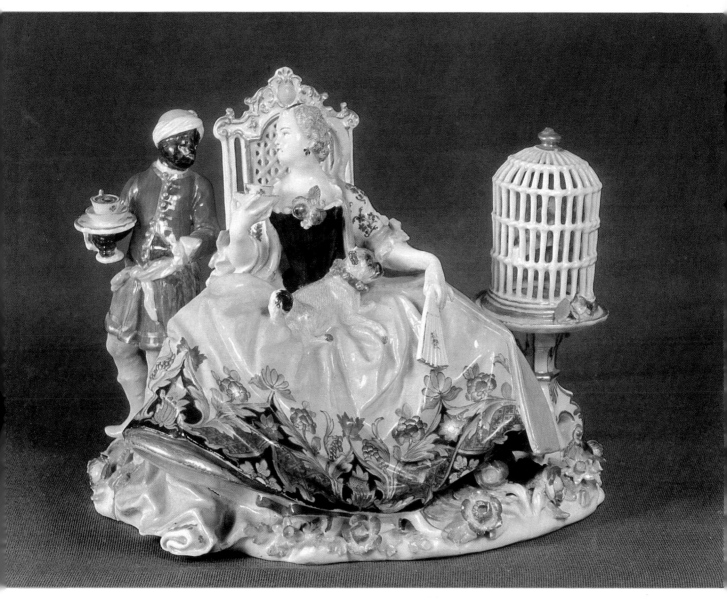

A Meissen 'crinoline' group of a lady with a blackamoor by J. J. Kaendler, adapted from an
engraving by Laurent Cars after Boucher. Height 6in, length 7½in
London £10,000 ($25,000). 10.VII.73

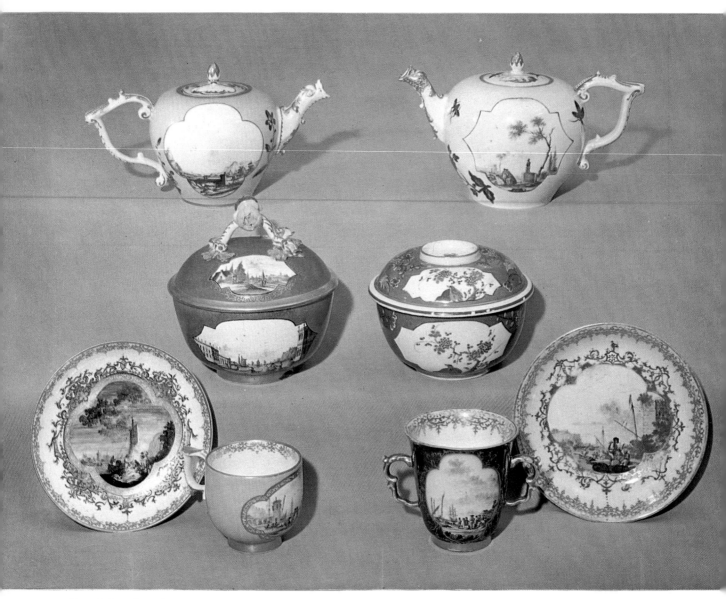

From left to right above

A teapot and cover painted with a landscape and puce sprays of *indianische Blumen* on an apricot ground, crossed swords mark in blue and painter's mark 7 in iron-red, 4in £1,600 ($4,000)

A teapot and cover painted in the manner of Heintze with a landscape and a spray of *indianische Blumen* on pale blue ground, crossed sword mark in blue and painter's mark in iron-red, 4⅝in £1,700 ($4,250)

Centre

A coral-ground covered bowl with a Dutch landscape on one side and a Venetian one on the other, crossed swords mark in blue 4⅝in £2,600 ($6,500)

A dark olive green sugar bowl and cover decorated with Kakiemon subjects, crossed swords mark in blue, diameter 4½in £3,400 ($8,500)

Below

A green-ground teacup and saucer with a night scene of a bonfire on a wharf, crossed swords mark in blue, mark of the repairer Meinert £1,200 ($3,000)

A blue-ground chocolate cup and saucer painted in the manner of C. F. Herold, crossed swords mark in blue £900 ($2,250)

The Meissen porcelain illustrated on this page was sold in London on the 10th July 1973

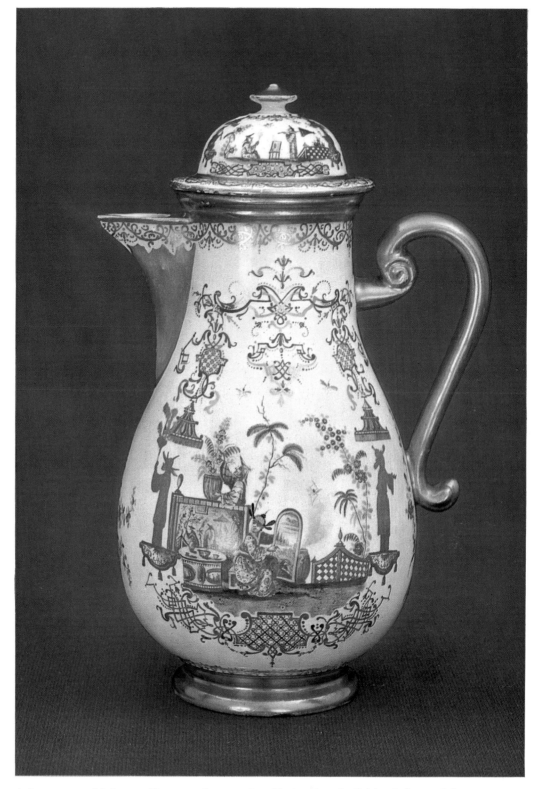

A documentary Meissen coffee-pot and cover painted in Augsburg by Sabina Aufenwerth for her husband Isaac Hosennestel on Böttger porcelain. Lid and base of coffee-pot with gilt monogram, below the spout the concealed monograms *SA* and *IH*, 8⅜in
London £40,000 ($100,000). 7.XI.72
From the collection of Mrs Mary Lees Johnstone

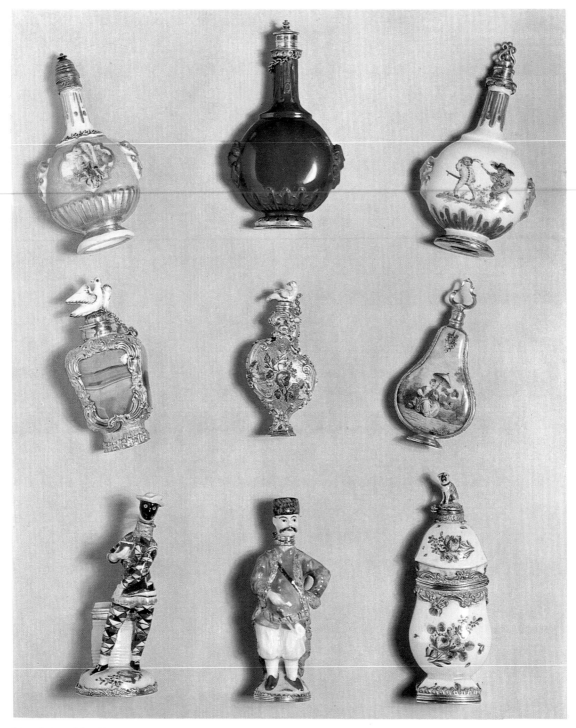

From left to right Above
A Meissen 'celadon' scent bottle in the form of a pilgrim flask, painted on one side with a battle scene after Rugendas and a scene from Don Quixote on the other. Crossed swords mark in puce enamel, 3½in £1,300 ($3,250)

A Böttger stoneware scent bottle of pilgrim flask shape, 3½in £1,400 ($3,500)

A Meissen scent bottle of pilgrim flask shape painted with Callot's *gobbi*, 3¾in £2,400 ($6,000)
Centre
An English gold-mounted hardstone scent bottle. Mid-eighteenth century, 2¾in £440 ($1,100)

A Louis XV gold and enamel scent bottle Mid-eighteenth century, 2½in £1,000 ($2,500)

A German enamel scent bottle painted with rustic figures after Watteau. Eighteenth century, 2¾in £270 ($675)

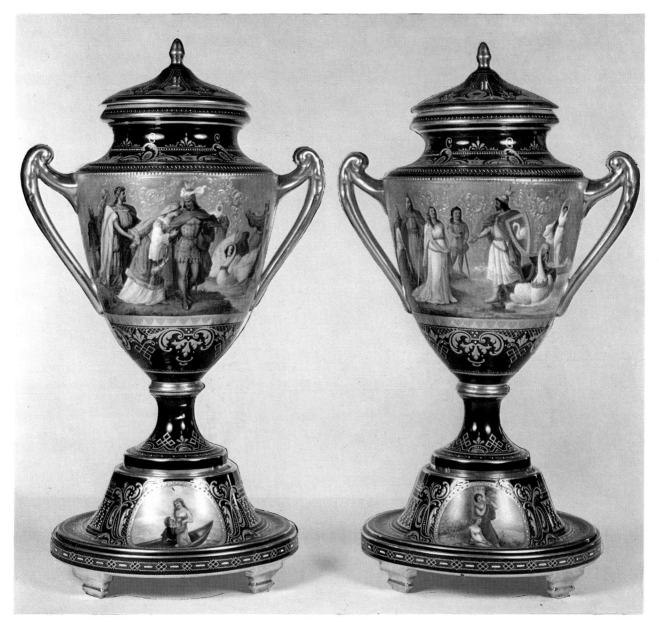

Above
A pair of Vienna Lohengrin vases and covers.
Late nineteenth-century, underglaze-blue shield, 20¾in
London £1,700 ($4,250). 31.v.73

Opposite page below
An English 'Girl in a Swing' gold-mounted double scent bottle in the form of a Harlequin, 3¼in £620 ($1,550)

An English gold-mounted Polish gallant scent bottle of 'Girl in a Swing' type, 3½in £2,500 ($6,250)

An English gold-mounted 'Girl in a Swing' combined scent bottle and nécessaire painted with flowers and two carrots, the stopper in the form of a seated pug dog, 4in £1,600 ($4,000)

The scent bottles illustrated on the opposite page were sold in London on 14th December 1972

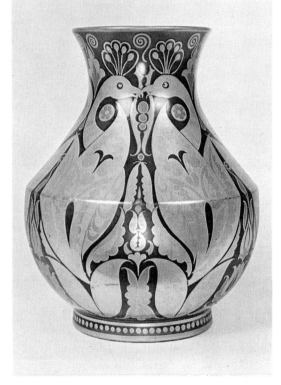

A William de Morgan dish painted with a griffinesque beast on a river bank snarling at two fish.
Late Fulham period, 1898–1907, 14⅛in
London £480 ($1,200). 15.11.73

A William de Morgan earthenware vase painted by Fred Passenger with stylised cranes. Painter's initials, late Fulham period, 1898–1907, 11in
London £780 ($1,950). 15.11.73

A large Martin Brothers' bird with detachable head. Signed and dated on head and base 12–1900, 16½in
London £1,250 ($3,125). 15.11.73
The only other birds recorded of larger size are a 17in model in a private collection and the owl in the Fitzwilliam Museum, Cambridge, sold at Sotheby's, 24th October, 1924, which is 41in

Left
A Martin Brothers' bird with a supercilious detachable head. Signed on foot and head and
dated 6–1897, 8¾in £450 ($1,125)

Centre
A Martin Brothers' penguinesque bird modelled by R. W. Martin. Signed and dated on the head
15.9.81 and on the foot in a circle *R.W. Martin London*, 9½in £600 ($1,500)

Right
A Martin Brothers' monk bird with smiling detachable head. Signed on head and base and dated
2–1901, 11¾in £720 ($1.800)

The birds illustrated on this page were sold in London on 15th February 1973

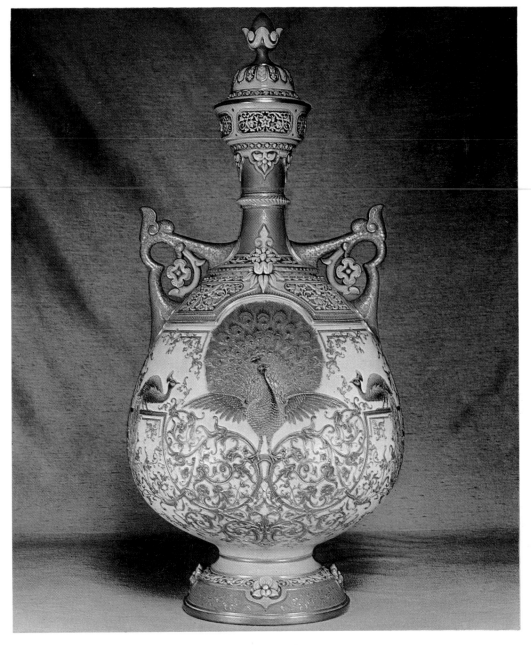

A Royal Worcester porcelain vase and cover by James Hadley. Moulded signature, impressed and printed crowned circle mark in puce, Z date code for 1888, registration of design number for 1888, shape 1264 and printed gilt *WMB* monogram, 23½in
London £1,950 ($4,875). 22.III.73

Jewellery

A diamond necklace by
Cartier, composed of 16
cushion-shaped stones collet-
set and graduating from the
centre, the largest mounted
below as a pendant drop.
Weight of pendant drop
17.68 carats; centre stone
12.15 carats; total of 14 stones
105.68 carats
Zurich SF1,350,000
(£168,539; $421,348).
17.V.73

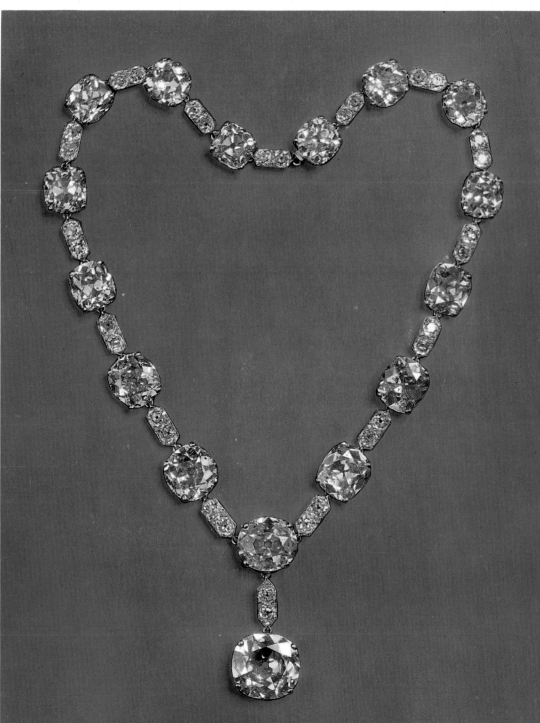

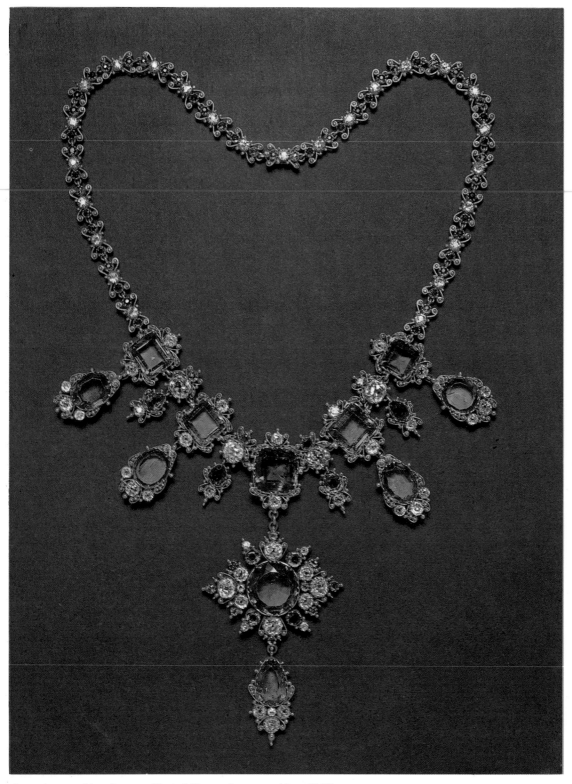

An antique necklace in emeralds and diamonds mounted in gold filigree
Zurich SF550,000 (£68,664; $171,660). 17.v.73

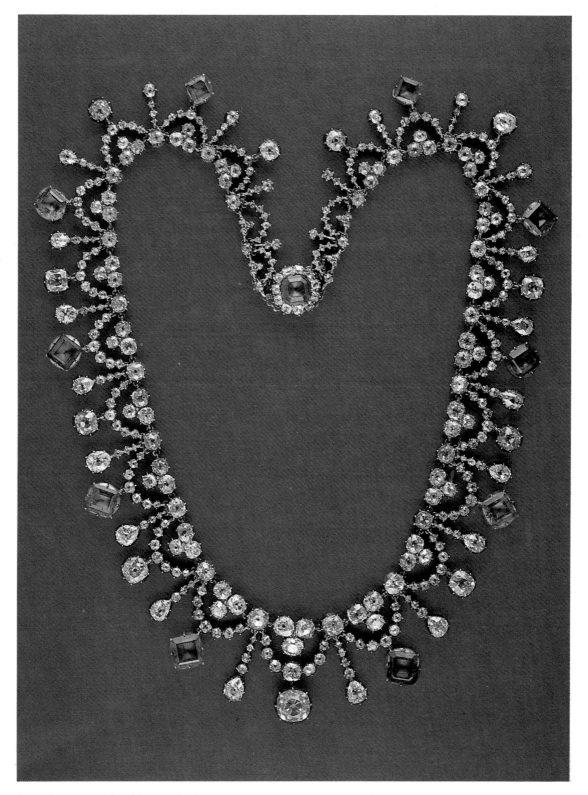

An antique emerald and diamond collar in a design of trefoils and festoons
London £36,000 ($90,000). 21.VI.73
From the collection of J. D. Acland Esq
This necklace was purchased at the time of the Congress of Vienna in 1815 by the great-great-great-grandfather of the seller, Sir Thomas Dyke Acland MP

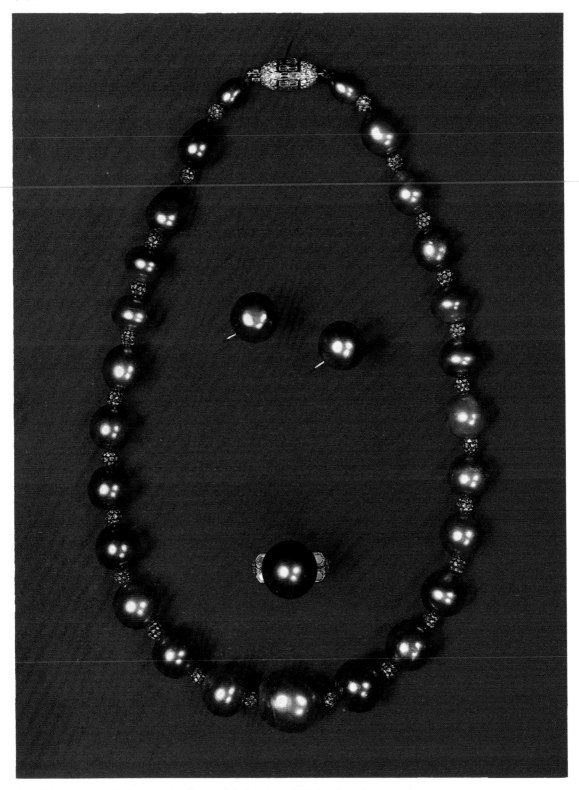

A necklace composed of 25 pearls of bronze black colour. Weight of pearls approximately 1,243 grains
Zurich SF320,000 (£39,950; $99,875). 17.V.73

A pair of black button pearls mounted as earrings. Weight of both pearls 111.88 grains
Zurich SF34,000 (£4,245; $10,613). 17.V.73
A black button pearl mounted as a ring, the shoulders set with fancy-cut diamonds. Weight of pearl 81.60 grains
Zurich SF52,000 (£6,492; $16,230). 17.V.73

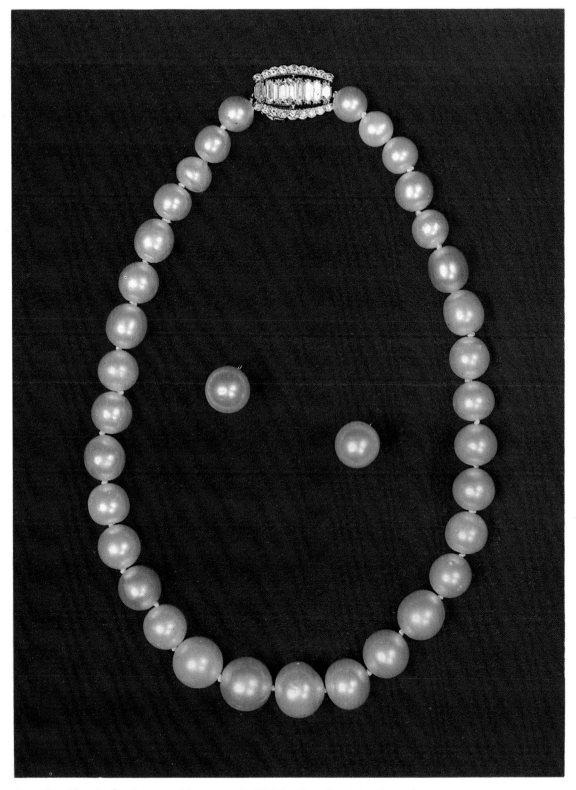

A pearl necklace by Cartier comprising 33 pearls. Weight of pearls 1,628 grains
Zurich SF250,000 (£31,211; $78,028). 17.v.73

A pair of button pearls mounted as earrings. Weight of both pearls 86.56 grains
Zurich SF36,000 (£4,494; $11,235). 17.v.73

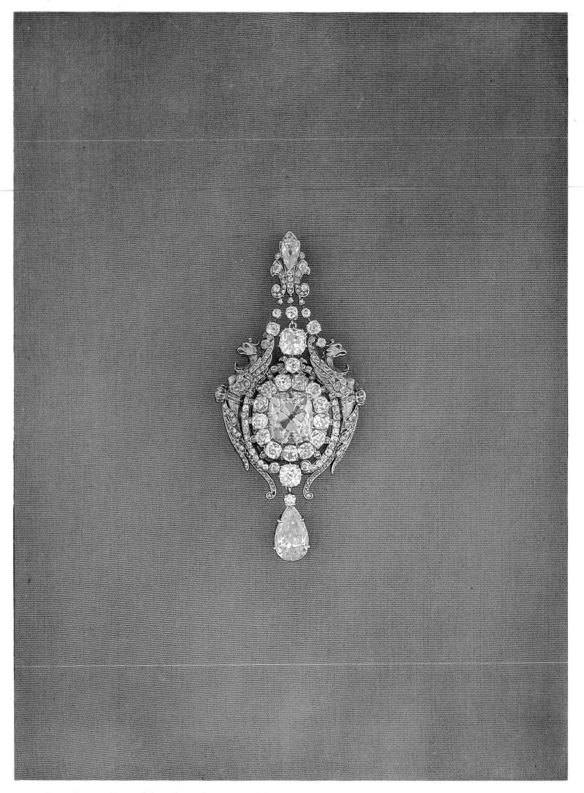

An antique diamond brooch/pendant, the centre with a large cushion-shaped canary-coloured diamond, signed on the reverse *O. Massin*, nineteenth century
Zurich SF150,000 (£16,892 ; $42,230). 23.XI.72

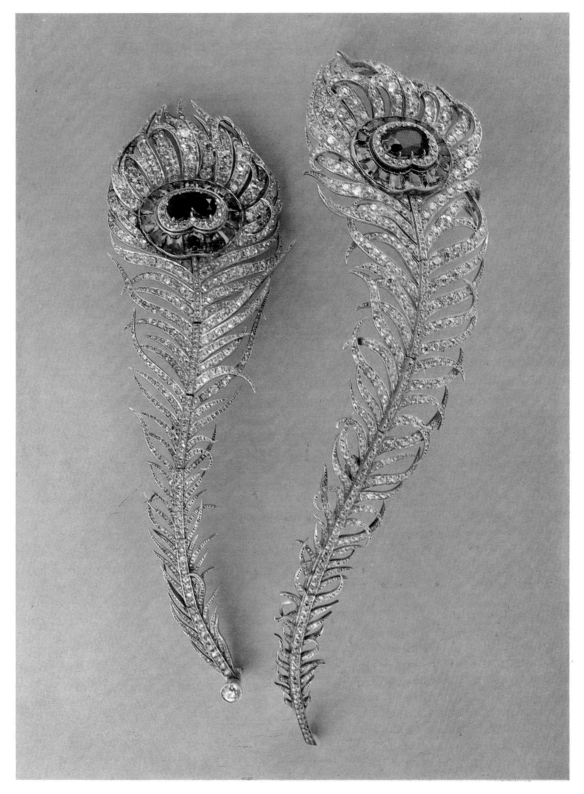

Left A diamond brooch in the form of a peacock plume, the eye set with a bean-shaped sapphire within borders of diamonds and emeralds. French, nineteenth century
London £4,800 ($12,000). 21.VI.73
It is believed that this jewel was part of Frederic Boucheron's award-winning entry at the Paris Exhibition of 1889
Right A diamond brooch in the form of a peacock plume, made *en suite* with the above
London £12,000 ($30,000). 21.VI.73
Both brooches from the collection of Lady Rosalind Pollen
They have also been worn together as a hair ornament.

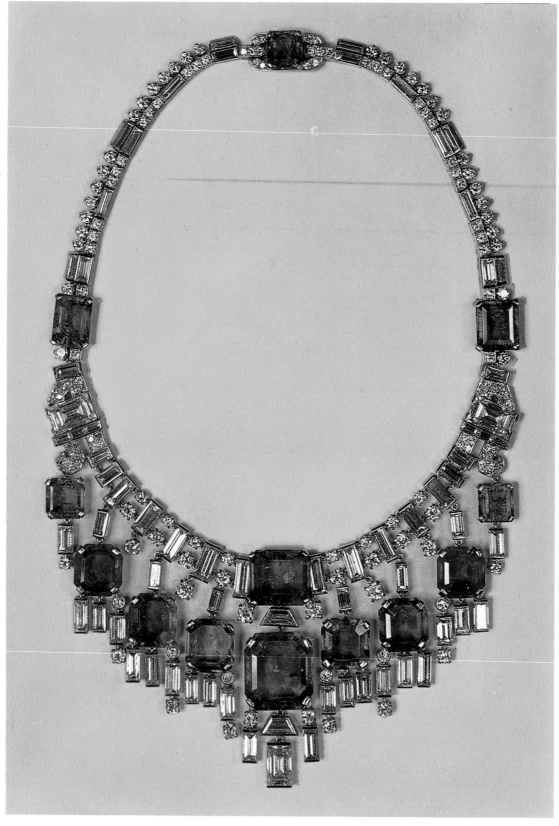

A necklace by Cartier in platinum, emeralds and diamonds
Zurich SF1,000,000 (£124,844; $312,110). 17.v.73

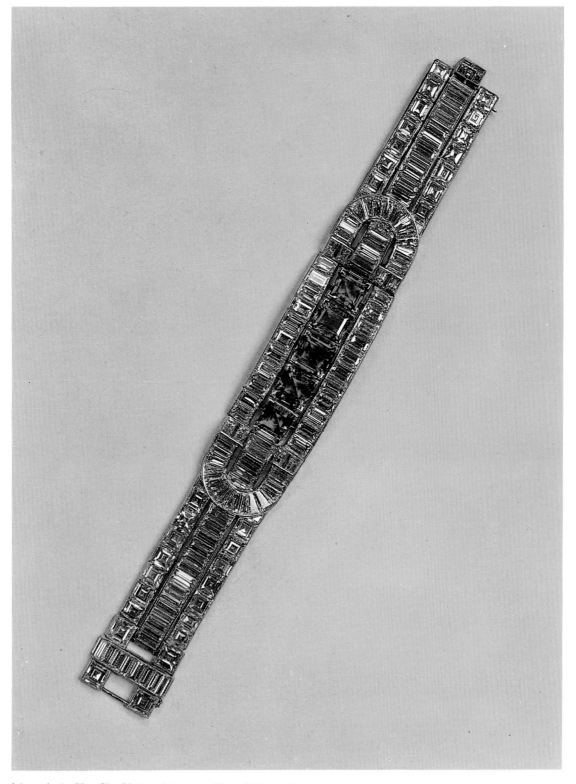

A bracelet by Van Cleef & Arpels in emeralds and diamonds
Zurich SF380,000 (£47,441; $118,603). 17.v.73

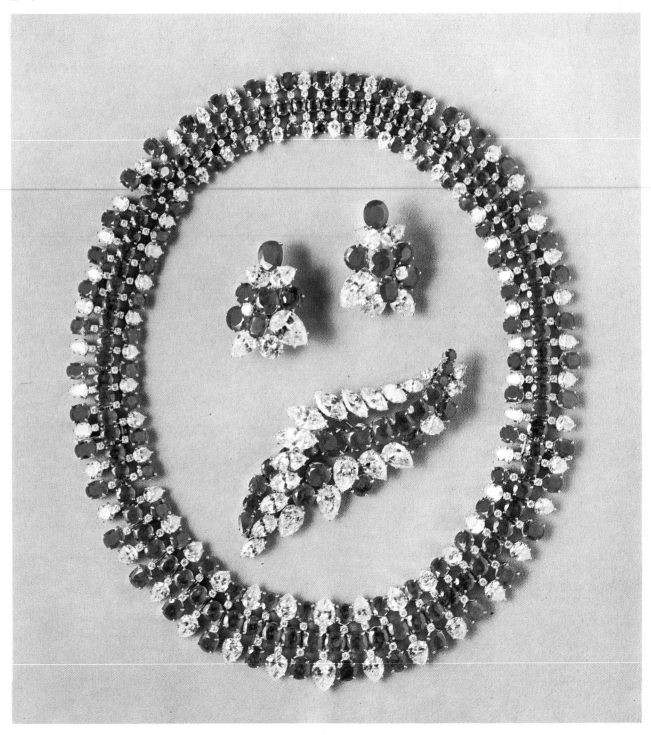

A ruby and diamond necklace by Harry Winston, which may also be worn as a pair of bracelets
New York $88,000 (£35,200). 24.v.73

A pair of ruby and diamond earclips by Harry Winston
New York $48,000 (£19,200). 24.v.73

A ruby and diamond brooch
New York $50,000 (£20,000). 24.v.73

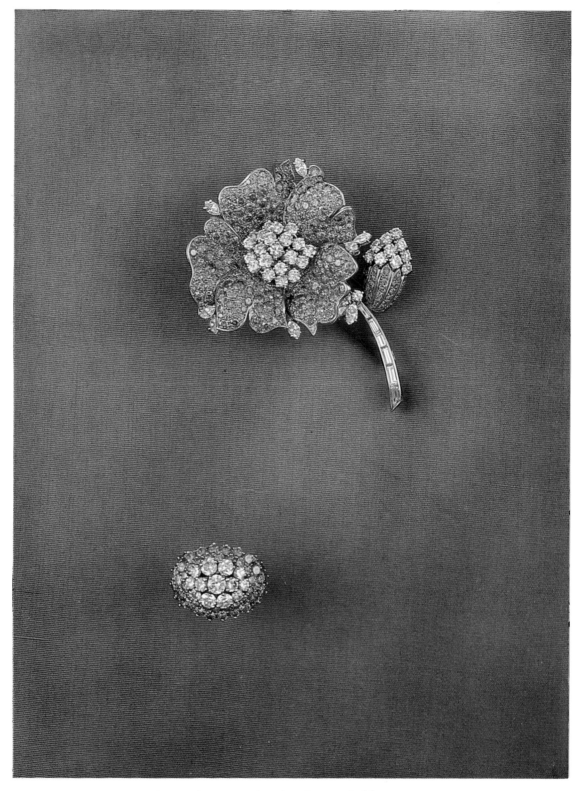

A clip in white and golden-coloured diamonds designed as a five-petalled flower
Zurich SF38,000 (£4,279; $10,697). 23.XI.72

A diamond ring in the form of an ellipse-shaped high-domed cluster, *en suite* with the above
Zurich SF8,000 (£901; $2,252). 23.XI.72

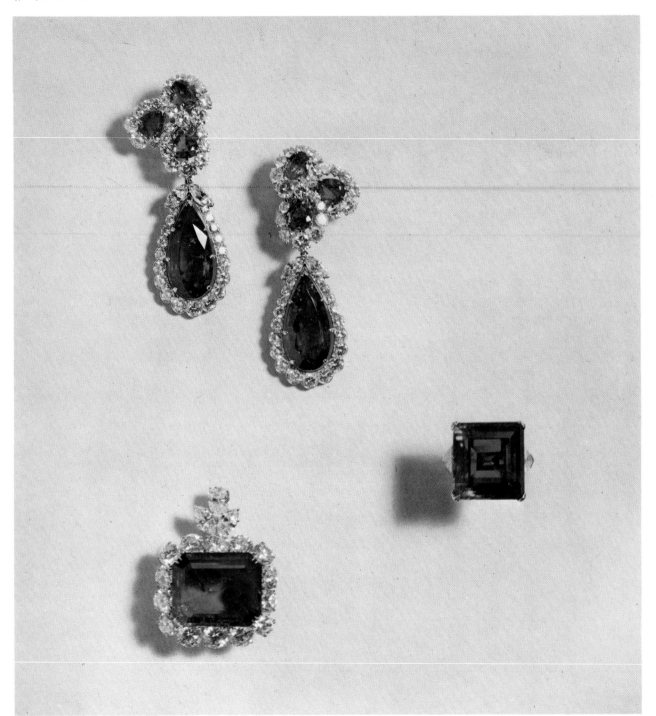

Above left
A pair of emerald and diamond earclips, by Van Cleef & Arpels.
Approximate weight of the pair of pendant pear-shaped
emeralds 32.36 carats
New York $240,000 (£96,000)

Left
An emerald and diamond brooch by Harry Winston.
Approximate weight of emerald 38.78 carats
New York $300,000 (£120,000)

Right
An emerald and diamond ring by Van Cleef & Arpels.
Approximate weight of emerald 34 carats
New York $385,000 (£154,000)

All these jewels were sold on 7th December 1972 from the
collection of Enid A. Haupt
The ring was previously sold at the same galleries on 5th
December 1968 for $265,000 (£95,832)

Opposite page
An emerald and diamond necklace with a flexible platinum
mount, by Van Cleef & Arpels.
New York $230,000 (£92,000). 7.XII.72
From the collection of Enid A. Haupt

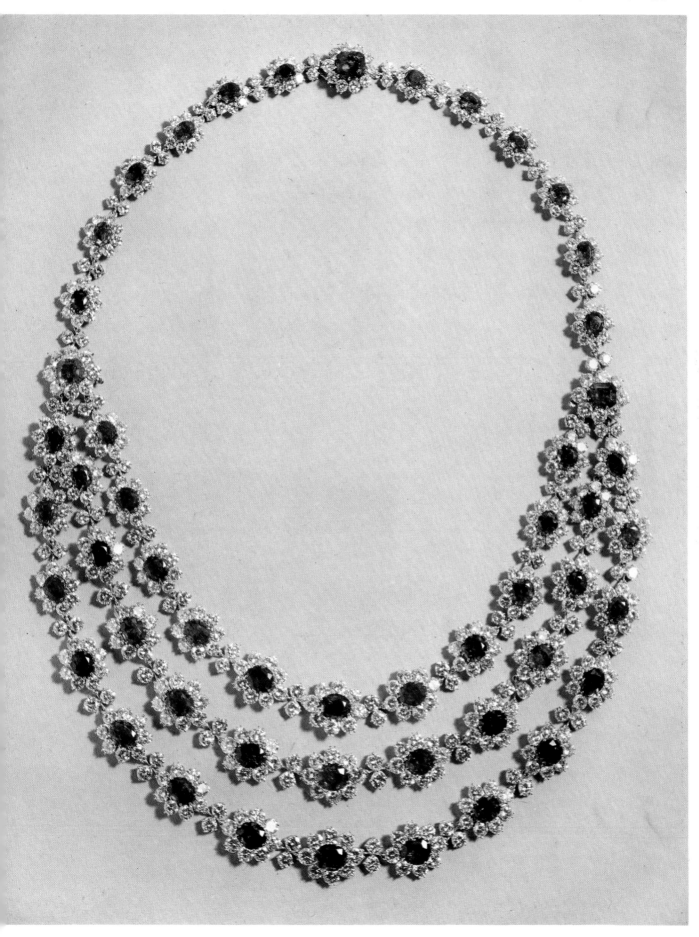

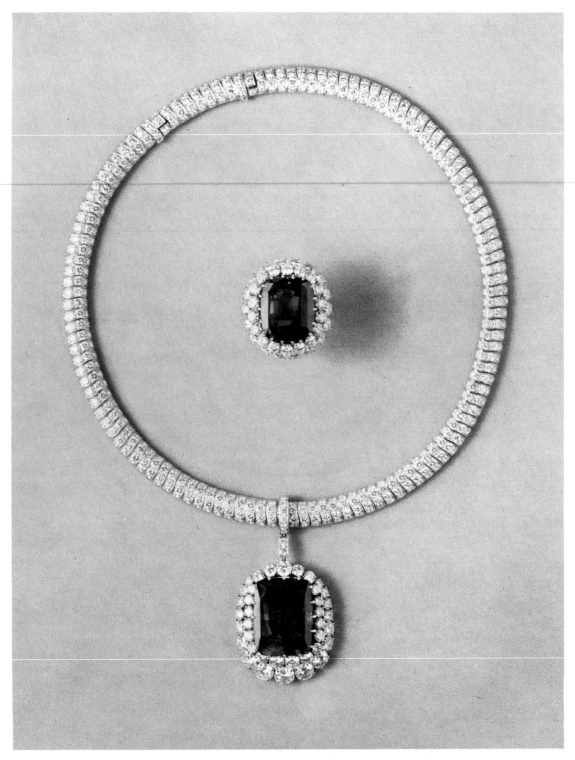

A sapphire and diamond necklace by Van Cleef & Arpels. Approximate weight of cushion-shaped sapphire 45.50 carats
New York $75,000 (£30,000). 24.v.73

A sapphire and diamond ring by Van Cleef & Arpels.
Approximate weight of cushion-shaped sapphire 33.75 carats
New York $69,000 (£27,600). 24.v.73

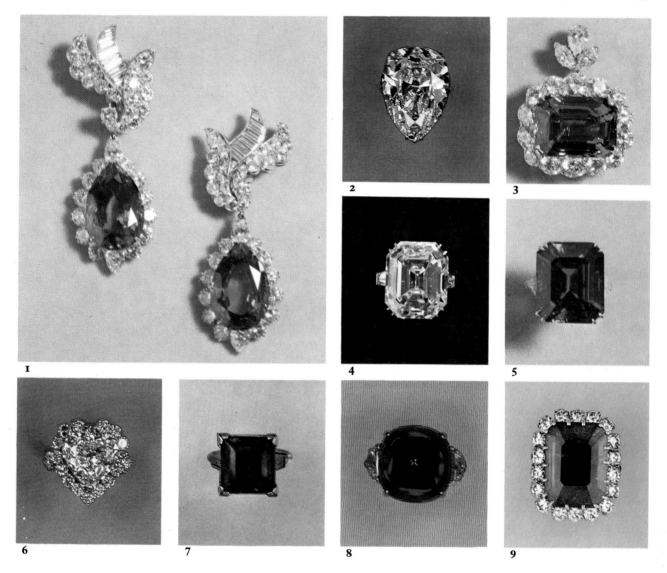

1. A pair of sapphire and diamond earclips by Van Cleef & Arpels. Approximate weight of 2 pendant sapphires 76.28 carats. New York $130,000 (£52,000). 7.XII.72. From the collection of Enid A. Haupt. 2. A pear-shaped diamond mounted as a single-stone ring 24.74 carats. Zurich SF500,000 (£62,422; $156,055). 17.V.73. 3. A sapphire and diamond brooch by Van Cleef & Arpels. Approximate weight of sapphire 56.19 carats. New York $92,500 (£37,000). 7.XII.72. From the collection of Enid A. Haupt. 4. A diamond ring with platinum mount by Harry Winston. Approximate weight of diamond 38.88 carats. New York $300,000 (£120,000). 7.XII.72. From the collection of Enid A. Haupt. 5. A sapphire and diamond ring by Van Cleef & Arpels. Approximate weight of sapphire 54 carats. New York $190,000 (£76,000). 7.XII.72. From the collection of Enid A. Haupt. 6. A heart-shaped diamond mounted within a border of circular-cut canary-coloured stones as a ring, by Van Cleef & Arpels, weight of diamond 8.65 carats. Zurich SF190,000 (£23,720; $59,300). 17.V.73. 7. A square-cut emerald mounted as a ring, by Cartier, 12.09 carats. Zurich SF400,000 (£45,045; $112,613). 23.XI.73. From the collection of the late Princess Louise Odescalchi. 8. A cabochon sapphire mounted in platinum as a ring with a half-moon-shaped diamond set in each shoulder, by Cartier. Weight of sapphire 44.98 carats. Zurich SF600,000 (£74,906; $187,265). 17.V.73. 9. An emerald and diamond ring by Van Cleef & Arpels. Weight of emerald 23.72 carats. Zurich SF560,000 (£63,063; $157,658). 23.XI.72

Florence sales

BY JOHN WINTER

The Villa dell'Ombrellino stands on the hill of Bellosguardo overlooking Florence. This famous house, once the home of Ugo Foscolo, the Romantic poet and patriot, and before him of Galileo Galilei, was bought in the early part of this century by the Hon. Mrs Alice Keppel. It was inherited by her daughter Violet Trefusis and became, until her death last year, one of the centres of Anglo-Florentine society.

The contents of the Villa were sold in May and it would be difficult to find a more impressive setting for a sale. The growing enthusiasm in Italy for sales of this type and the buoyant state of the Italian art market combined to make the sale a great success. A fine collection of Continental and English silver was particularly interesting in that the prices, rather contrary to expectation, were easily comparable with those obtainable in London. This gave some indication of the growing interest of Italian collectors in this field, it also reflected the presence of a large number of foreign buyers, encouraged to come to Italy by the lifting of the export tax on works of art, at least as regards Common Market countries.

The sales held at Palazzo Capponi, in the centre of Florence, during the same period, consisted of furniture, works of art and paintings mainly from the collection

A French silver-gilt cup, Paris, *circa* 1700, 3½in Florence, Lire 3,800,000 (£2,500; $6,250). 25.V.73

BENVENUTO DI GIOVANNI
Ecce Agnus Dei, initial letter
C, 6¾in by 6⅝in
Florence, Lire 5,000,000
(£3,400; $8,500). 24.V.73

of Count Francesco Castelbarco Albani. A fine early eighteenth-century Roman bureau-secretaire (Ill. page 349) made Lire 15.000.000 (£10,000), the sort of price normally reserved only for Venetian furniture. In fact an attempt had been made in the past to 'Venetianise' the piece by the addition of spurious cresting, typical on Venetian furniture, but making no sense on a Roman piece of these massive proportions. The growing interest in Italy for the different styles of regional furniture makes this type of adaptation pointless, going back as it does to an era when anything remotely possible was claimed as Venetian.

It was interesting to see pieces of North Italian origin finding their way back to the prosperous industrial North, often at very high prices. This was also true of some of the paintings in the sale: two fine but damaged paintings by the Bergamasque painter Fra Galgario made Lire 5.000.000 (£3,400) and Lire 9.000.000 (£5,800) respectively. A superb portrait by the early nineteenth century painter Francesco Hayez (page 91) made Lire 8.500.000 (£5,500), this price reflects the esteem with which Hayez is regarded in Italy. Meanwhile, returning to Tuscany, a beautiful initial letter from an illuminated manuscript, painted by the fifteenth-century Sienese artist Benvenuto di Giovanni, made Lire 5.000.000 (£3,400).

One of the surprises of the sale was the price (Lire 11.500.000; £7,800) reached by a fine night clock of the eighteenth-century Neapolitan Marcho Santucci. This clock

A night clock by Marcho
Santucci, first half of the
eighteenth century, height
24⅝in
Florence, Lire 11,500,000
(£7,800; $19,500). 22.V.73

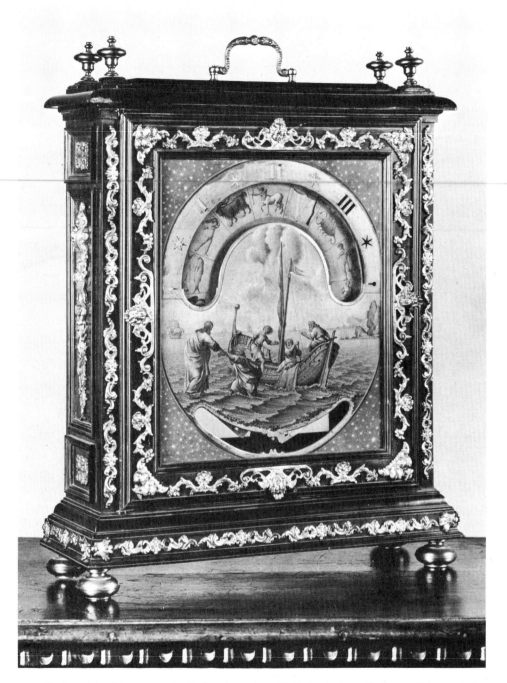

was distinguished by a particularly charming dial, depicting Christ walking on the
water, the quality of the painting was of a level unlikely to be matched on anything
other than an Italian piece.

A sale of a small and interesting collection of portrait miniatures, for the most part
Italian, brought prices that even recently would have been unthinkable in Italy, again
emphasising the growing scope of the Italian market. This interest in new fields by
Italian collectors, first noticed with the success of Russian icons and works by
Fabergé, hitherto thought virtually unsaleable in Italy, which were included in the
sales of works of art, paintings and maiolica of last October, tends to suggest a
promising future for sales in Italy.

Canadian sales

CORNELIUS KRIEGHOFF
Portrait of John Budden
Signed and dated 1847,
23in by 29in
Toronto, Can. $25,000
(£10,000). 31.X.72

Two of the Companies Officers travelling in a Canoe made of Birchbark manned by Canadians

PETER RINDISBACHER
*Two of the Companies
Officers travelling in a Canoe
made of Birchbark manned by
Canadians*
Watercolour, executed *circa*
1823 6⅝in by 9⅝in
Toronto, Can. $10,000
(£4,000). 14.V.73

Sotheby & Co (Canada) Ltd held two series of highly important auctions of Canadian art. These sales offered, in effect, not only a comprehensive index of Canadian artists but also an effective listing of current Canadian art prices.

The Autumn sale of 1972 included the most important portrait ever painted by Cornelius Krieghoff. The work entitled *Portrait of John Budden* has appeared in almost every major Canadian exhibition and most of the written works on Canadian art. The painting sold for $25,000 and established an auction record for Canadian portraits. William Raphael, a contemporary of Krieghoff, was represented by a large canvas, signed and dated 1869 depicting a typical Canadian winter which fetched $2,000. A superb watercolour of Indians in canoes by Verner realised $3,200.

The highlight of the spring sale was a small watercolour titled *Two of the Companies Officers travelling in a Canoe made of Birchbark by Canadians*; painted *circa* 1823 by Peter Rindisbacher, the earliest resident painter in Western Canada, it fetched $10,000. Several outstanding works by Canada's Group of Seven in the sale included *Land of Contentment* by Frank Hans Johnston ($5,800); *Winter Sun Over Old Toronto* by Alfred Joseph Casson ($7,000); and *Autumn Evening, Gatineau* by Alexander Young Jackson ($3,400). Two works by Coburn each depicting winter scenes with sleighs fetched $6,500 and $6,600. A small oil by Cornelius Krieghoff of a habitant brought $13,000, the highest price for a work of this type yet attained. This sale also included a considerable number of Canadian topographical works, prints, maps and books.

Above
WILLIAM RAPHAEL, OSA,
RCA
Canadian Winter
Signed and dated 1869,
24in by 42in
Toronto, Can. $2,000 (£800).
31.X.72

Below
ALFRED JOSEPH CASSON,
OSA, PRCA
Winter sun over old Toronto
Oil on board, signed,
30in by 36in
Toronto, Can. $7,000
(£2,800). 14.V.73

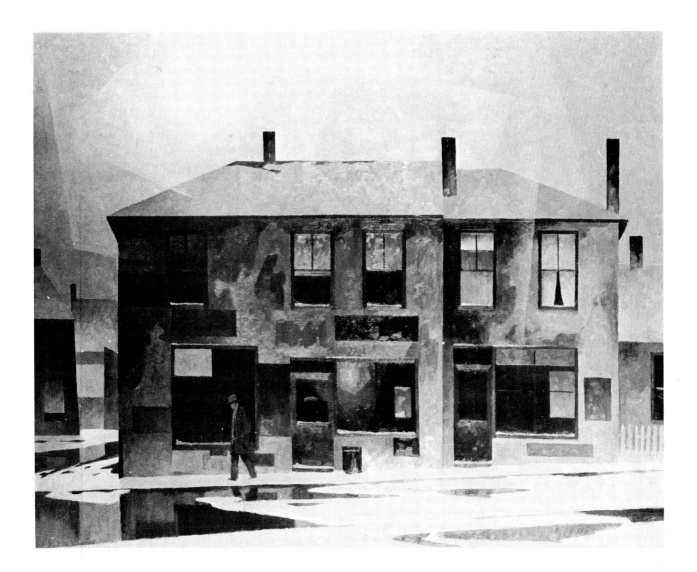

Wine sales

During this season the sales of the Wine Department have risen by 48 per cent to reach a total £590,395, approximately a third of London's wine auction market. Several factors have influenced this increase, not least the high opening prices of the 1971 and 1972 vintages of Bordeaux wines, our entry into the Common Market, and a lack of confidence in currency.

In addition to the ten wine sales last season, two more than in the previous year, Sotheby's co-operated with one of the leading Parisian *commissaire-priseurs*, Ader Picard Tajan, in a special charity sale to celebrate the 150th anniversary of the French wine merchant Nicolas. This took place on 21st November 1972 in Paris, and bids were transferred simultaneously by telephone from Sotheby's auction rooms in London and Los Angeles. A world record price was achieved by a very rare jeroboam of Château Mouton Rothschild, 1970, which fetched 55,000 FF (£4,661; $11,652) from a buyer in Los Angeles, and the sale total, 453,050 FF (£38,071; $95,177), was donated to 'Venice in Peril'.

Although the price of that jeroboam was exceptional, world wine prices generally are undergoing considerable changes, and the rise at Bordeaux, the most important wine-producing area, can be considered a good yardstick. After nine years of a comparatively stable market for *crus classés*, it was inevitable that prices would rise with demand, although the increase was not expected to be of 200–300 per cent over a period of two years. Overseas markets, notably in North America and Japan, continue to expand rapidly as more people become able to afford fine wines. While supplies remain virtually constant, even the stocks of maturing wines which the merchants used to hold in reserve have been exhausted, and clarets which need six or seven years to mature are now being sold at a very early age to investors. These wines, especially of the 1970 and 1971 vintages, will achieve optimum prices at auction after they have spent several years in the bottle.

For these reasons, the auction price of fine claret continued its upward movement during the year, although at a slower rate than before, and at the end of the season that of some classed growths in greater supply remained constant or fell slightly. This may have been due to the exceptionally high prices achieved earlier on, which turned investors towards other areas. Vintage Port, in particular, rose steeply at the end of the season. For example, a dozen bottles of Croft 1963, for which a price of £34 was expected at the end of 1972, fetched £48 in July. The trend having been established so late in the season, port prices may well continue to advance during next season.

In conclusion, as demand continues to outstrip supply, wine may prove to be one of the best investments that can be made for the future.

Right
A jeroboam of Château
Mouton Rothschild 1870,
Paris, FF.55,000 (£4,661;
$11,652). 21.XI.72

Far right
An imperial of Château
Mouton Rothschild 1924
London £1,000 ($2,500).
4.X.72

From left to right
A bottle of Château Margaux
1888, £60 ($150)
A jeroboam of Château
Ausone 1923, £330 ($825)
A tappit hen of Sandeman
Port, believed vintage 1935,
£27 ($67.50)
A magnum of Taylor 1924,
£25 ($62.50)
All sold in London on 29th
November 1972

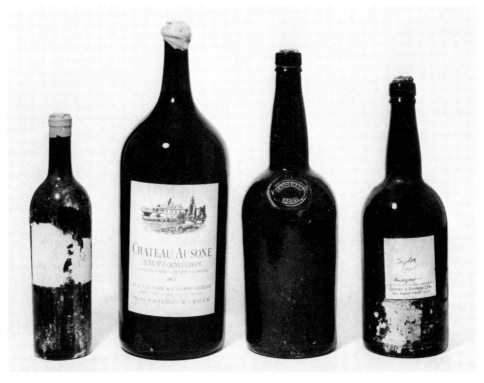

Collectors' sales

Above left
A street organ automaton, the player dressed in late eighteenth-century costume. Height 1ft 9in, under dome
London £820 ($2,050) 18.v.73

Below right
A clockwork battleship, the *Mars*, flying four British flags. Trade plaque *G.B.N.*, German *circa* 1910, length 24½in
London £270 ($675) 18.v.73

Above
An Edwardian clockwork limousine with driver. Stamped *G.B.N.* on the base, German *circa* 1905, height 10in, length 16in
London £400 ($1,000) 18.v.73

Right
The motor tug *Hendon*, on display base. Length 4ft 6in
London £380 ($950) 18.v.73

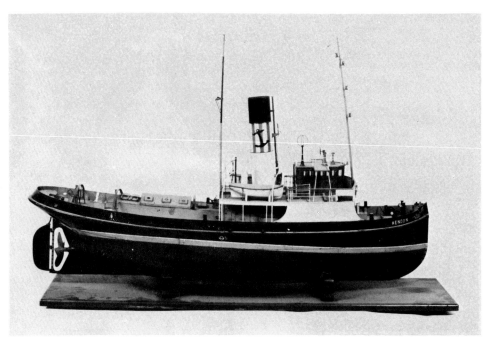

Acknowledgements

Messrs Sotheby Parke Bernet are indebted to the following who have allowed their names to be published as the purchasers of the works of art illustrated on the preceding pages.

OLD MASTER PAINTINGS

F. W. G. Bolt, Kingston-on-Thames, on behalf of the continental buyer; Collection of the Brod Gallery, London; P. & D. Colnaghi & Co., London; J. V. Feather, Worplesdon, Surrey; Richard Green (Fine Paintings), London; Leonard Koetser Ltd, London; The Leger Galleries Ltd, London; Leggatt Brothers, London; T. Rogers & Co (Packers) Ltd, London; Edward Speelman Ltd, London; Manuel Ulloa, Madrid; Villiers Gallery, London.

OLD MASTER DRAWINGS

C. G. Boerner, Düsseldorf; Brod Gallery, London; P. & D. Colnaghi & Co Ltd, London; Dr A. C. R. Dreesmann, Amsterdam; Cyril Humphris, London; S. Ovsievsky, London; Yvonne Tan Bunzl, London; David Titman, Rome.

ENGLISH PICTURES

Thos. Agnew & Sons, London; Banco Espirito Santo & Comercial de Lisboa, Lisbon; Baskett & Day, London; P. & D. Colnaghi & Co Ltd, London; Crane Kalman Gallery, London; G. R. Cyriax, London; Anthony d'Offay, London; The Fine Art Society Ltd, London; Frost & Reed Ltd, London; Richard Green (Fine Paintings) London; Lambeth Arts, London; Leggatt Brothers, London; Mayor Gallery, London; Roy Miles (Fine Paintings), London; Chas. J. Sawyer, London; Spink & Son Ltd, London; C. Thomas, London; Herner Wengraf, London; Charles Woollett & Son, London.

EUROPEAN NINETEENTH-CENTURY PICTURES

Frost & Reed Ltd, London; The Indianapolis Museum of Art, Indiana; MacConnal-Mason & Son Ltd, London; W. H. Patterson Fine Arts Ltd, London; Ira Spanierman Inc, New York.

PICTURES RELATING TO AMERICA, AUSTRALIA, NEW ZEALAND AND SOUTH AFRICA

Richard Green Fine Paintings, London; Trevor J. Leigh, Braintree, Essex; Pawsey & Payne on behalf of The Sporting Gallery Inc, of Middleburg, Virginia; George Vago, Sidney.

AMERICAN PICTURES

ACA Galleries, New York; Herbert Allen Snr., New York; Lee Ault & Company, New York; Mrs Harry Lynde Bradley, Milwaukee, Wisconsin & Naples, Florida; Andrew Crispo Gallery, New York; Danenberg Galleries, New York; F. D. Gottwald, Richmond, Virginia; Dr John J. McDonough, Youngstown, Ohio; Nantenshi Gallery, Tokyo; Thyssen-Bornemisza Collection, Switzerland.

IMPRESSIONIST AND MODERN PAINTINGS AND SCULPTURE

Acquavella Galleries Inc, New York; Mrs Harry Lynde Bradley, Milwaukee, Wisconsin & Naples, Florida; R. Cano, Mexico City; Fischer Fine Art Ltd, London; Forum Gallery, New York; Galerie Beyeler, Basle; Stephen Hahn Gallery, New York; Mr &

Mrs Henry J. Heinz II, Pittsburgh, Pennsylvania; Mrs Daniel Neal Heller, Miami Beach, Florida; The Lefevre Gallery, London; Modarco Collection; R. G. Navarro, Beaconsfield, Buckinghamshire; Antoine Sapiro, Galerie Kriegel, Paris; Arthur Tooth & Sons Ltd, London; The Waddington Galleries, London.

CONTEMPORARY PICTURES

Australian National Gallery, Canberra; Des Moines Art Center, Iowa, gift of the Gardner Cowles Foundation in memory of Florence Call Cowles; André Emmerich Gallery, New York; Kasmin Ltd, London; Alistair McAlpine, London; Mr & Mrs Riklis, New York; Situation Gallery, London.

IMPRESSIONIST AND MODERN DRAWINGS

Mr & Mrs Eli Broad, Los Angeles, California; Fischer Fine Art Ltd, London; Dr Rudolf Leopold, Vienna.

PRINTS

Thos. Agnew & Sons Ltd, London; Associated American Artists, New York; Richard Berk Gallery, West Bloomfield, Michigan; Nelson Blitz Jr, New York; C. G. Boerner, Düsseldorf; P. & D. Colnaghi & Co Ltd, London; P. D. Christopoulos, London; The Fine Arts Society Ltd, London; Kornfeld & Cie, Berne; August Laube, Zurich; Margo Leavin Gallery, Los Angeles, California; R. E. Lewis Inc, Nicasio, California; Christopher Mendez, London; Reiss-Cohen Inc, New York; William Weston Gallery, London.

BOOKS AND MANUSCRIPTS

Abas Trading Corporation, Richmond, Surrey; J. N. Bartfield Inc, New York; Baskett & Day, London; Stanley Becker, Great Neck, New York; B. H. Blackwell Ltd, Oxford; Martin Breslauer, London; Taylor Clark, Baton Rouge, Louisiana; The Dolphin Book Co Ltd, Oxford; Francis Edwards Ltd, London; John F. Fleming, New York; Gothan Book Mart, New York; Joe Gradenwitz, London; W. F. Hammond, Lymington, Hampshire; House of Books Ltd, New York; House of El Dieff Ltd, New York; John H. Jenkins, Austin, Texas; Maggs Bros Ltd, London; Marlborough Rare Books Ltd, London; Bernard Quaritch Ltd, London; Redfern Gallery Ltd, London; Justin G. Schiller Ltd, New York; Hans Schneider, Munich; Dr J. E. Teale, Leeds Toronto Public Library, Osborne Collection, Toronto, Charles W. Traylen, Guildford; B. Weinreb Ltd, London.

SILVER AND METALWORK

Herman Baer, London; Robin Bellamy Antiques, Witney, Oxfordshire; N. Bloom & Son Ltd, London; The Brooklyn Museum, H. Randolph Lever Fund, New York; J. Christie, London; Clark & Lee & Harris Antiques, London; E. Malachy Doris, Cookstown, Co Tyrone, Eire; Graham Gallery, New York; H. R. Jessop Ltd, London; E. & C. T. Koopman & Son Ltd, London; M. McAleer, London; Frank Partridge & Sons Ltd, London; S. J. Phillips Ltd, London; Rare Art Inc, New York; James Robinson Inc, New York; J. M. E. Santo Silva, Lisbon; J. H. Bourdon-Smith Ltd, London;

Southern Comfort Corporation, St Louis, Missouri; Spink & Son Ltd, London; C. J. Vander (Antiques) Ltd, London; Walter H. Willson Ltd, London; The Worshipful Company of Goldsmiths, London.

CLOCKS, WATCHES AND SCIENTIFIC INSTRUMENTS
Camerer Cuss & Co, London; Malcolm Gardner (Charles Allix), Sevenoaks, Kent; Geoffrey Heywood, Liverpool; Ronald A. Lee, London; Mrs Stefanie Maison, London; Edgar Mannheimer, Zurich; Meyrick Neilson of Tetbury Ltd, Tetbury, Gloucestershire; Frank Partridge & Sons Ltd, London; Jan Skala, New York; E. F. J. Stenderl, St Michielsgestel, Holland; Dursley Stott, Douglas, Isle of Man; Wartski, London.

ARMS AND ARMOUR
Robert Abels, Hopewell Junction, New York; Peter Dale Ltd, London; W. Keith Neal, Warminster, Wiltshire; Frank Partridge & Sons Ltd, London; Howard Ricketts, London; Marcel Spichiger, Derendingen, Switzerland; Swiss National Museum, Zurich; The Warwick Castle Collection.

MUSICAL INSTRUMENTS
Peter Dale Ltd, London; Dr F. L. Fenyves, Basle; Michael Guttman, Brussels; Dr & Mrs Robert Rosenbaum, Scarsdale, New York; Edward Speelman Ltd, London.

ANTIQUITIES, INDIAN, AFRICAN AND PRIMITIVE ART
Herman Baer, London; Coins & Antiquities Ltd, London; Gilbert M. Denman Jr, San Antonio, USA; The J. Paul Getty Museum, Malibu, California; K. John Hewett, London; G. I. Lipton, London; Bruce McAlpine, London; George Ortis, Geneva; Norton Simon, Los Angeles; Henri E. Smeets, Weert, Holland; Spink & Son Ltd, London; Mr & Mrs Martin Wright, New York.

WORKS OF ART
Herman Baer, London; Blumka Gallery, New York; A. di Castro, Rome; Christopher Gibbs Ltd, London; Cyril Humphris, London; Edgar Mannheimer, Zurich; Alexis Merab, San Francisco; S. Ovsievsky, London; Robert C. Spalding, Maidstone, Kent; James Trigg, London.

ICONS AND RUSSIAN WORKS OF ART
F. Anavian, New York; Bentley & Co, London; Personal collection of Mrs Marina Bowater, London; Nuri Farhadi Inc, New York; Isi Fischzang, New York; E. & C. T. Koopman & Son Ltd, London; K. Mahloudji, London; R. A. D. Buchanan-Michaelson, London; Frank Partridge & Sons Ltd, London; The Temple Gallery, London; Wartski, London.

OBJECTS OF VERTU AND MINIATURES
Asprey & Co Ltd, London; Bentley & Co, London; Paul Delplace, Brussels; D. Drager, London; Dr A. C. R. Dreesmann, Amsterdam; Laurence W. Ford & Co, New York; M. Hakim, London; D. S. Lavender (South Molton Antiques Ltd), London; Limner Antiques, London; S. J. Phillips Ltd, London; Rare Art Inc, New York; Spink & Son Ltd, London; Wartski, London.

FURNITURE AND DECORATIONS, CARPETS AND TAPESTRIES
Ernest Alexander & Sons (Antiques) Ltd, Glasgow; J. Benardout, Wimbledon; Mrs Mitzi Briggs; W. G. T. Burne (Antique Glass) Ltd, London; Catheralls of Chester; E. W. Davidson, London; Delomosne & Son Ltd, London; The Fine Art Society Ltd, London; A. Fredericks & Son Ltd, London; C. John, London; Dolph Leuthold, New York; Littlecote Antiques, Hungerford; Edgar Mannheimer, Zurich; Redburn (Antiques), London, Ebrahim Rokhsar of American Foreign Trade Development Co, New York; Frank Partridge & Sons Ltd, London; Israel Sack Inc, New York; C. H. Sherwood, Worcestershire; Spink & Son Ltd, London; The Vigo Sternberg Galleries, London; Charles Wrightsman, London.

ART NOUVEAU AND ART DECO
The Fine Art Society Ltd, London; Daniel Katz, London; Frances and Sydney Lewis, Richmond, Virginia; Lillian Nassau Collection, New York.

GLASS AND PAPERWEIGHTS
Robert Biedermann, Lome, Togo; Cecil Davis Ltd, London; Richard Dennis, London; The Cinzano Collection, Bristol; Eila Grahame, London; E. Pinkus Antiques Inc, New York; Spink & Son Ltd, London; Alan Tillman (Antiques) Ltd, London.

NATURAL HISTORY
Brian Roberts, Desart, Armagh, Northern Ireland; Ulster Museum, Belfast; J. Vlug, Brussels.

CERAMICS
A. F. Allbrook, London; Albert Amor Ltd, London; The Antique Porcelain Company, London and New York; Mrs D. Birshanpour, London; Brimo de Laroussilhe, Paris; Eskenazi Ltd, London; José Luis Várez Fisa, San Sebastien, Spain; Fundação Medeiros e Almeida; Graham & Oxley, London; K. John Hewett, London; How (of Edinburgh), London; Dr Julius H. Jacobson II, New York; Jellineck & Sampson, London; Mrs Joseph S. Kornfeld, New York; Cyril Humphris, London; The Metropolitan Museum of Art, New York; The Charles E. Sampson Memorial Fund, 1973; David B. Newbon, London; Oliver-Sutton Antiques, London; Frank Partridge & Sons Ltd, London; Howard Stein, Scarsdale, New York; Tilley & Co (Antiques) Ltd, London; Alan Tillman (Antiques) Ltd, London; Dr A. Torré, Zurich; Robert Vater, Frankfurt; Dr Giuseppe Violante, Rome; Winifred Williams, London & Eastbourne.

JEWELLERY
Altman & Wachtler, New York; J. & S. S. De Young Inc, Boston, Mass; R. Esmerian Inc, New York; Nuport Inc, New York; S. J. Phillips Ltd, London.

COLLECTORS SALES
Mark H. Douma, Amsterdam; D. E. Pressland, London; Thomas Reed & Co Ltd, Sunderland.

PHOTOGRAPHIC SALES
Lunn Gallery/Graphics International Ltd, Washington, DC.

CHINESE CERAMICS AND WORKS OF ART
The Antique Porcelain Company, London and New York; N. Bloom & Son Ltd, London; Bluett & Sons Ltd, London; Mr & Mrs Peter Button, Guernsey; Mrs Raoul Coombes, Marlborough; Eskenazi Ltd, London; Mrs Helen Glatz, London; S. Matsuoka & Co Ltd, Tokyo; Hugh M. Moss Ltd, London; Mrs F. Ourisman, Bethesda, Maryland; Myriam Veiga Pinheiro, Lisbon; Rare Art Inc, New York; John Sparks Ltd, London; Spink & Son Ltd, London.

JAPANESE WORKS OF ART
Sten S: son Ankarcrona, Stockholm; The Antique Porcelain Company, London & New York; Bon G. Dale, London; Eskenazi Ltd, London; London Gallery Ltd, Tokyo; J. S. Rasmussen Fine Arts, London; Robert G. Sawers, London; Sam Someya, Tokyo; Nihon Token, London; Arthur Tooth & Sons Ltd, London; E. A. Wrangham, Northumberland; Douglas J. K. Wright Ltd, London.

Index